A Royal Treasur Afterlive Clock Sa

Edited by Timothy Schroder
and Dora Thornton

The British Museum

This publication has been generously supported by

The Goldsmiths' Company Charity

The Rothschild Foundation

ROTHSCHILD
FOUNDATION

Publishers
The British Museum
Great Russell Street
London WC1B 3DG

Series editor
Sarah Faulks

A Royal Renaissance Treasure and its Afterlives: The Royal Clock Salt
Edited by Timothy Schroder and Dora Thornton

ISBN 9780861592272
ISSN 1747 3640

Printed and bound in the UK by 4edge Ltd, Hockley

Papers used by the British Museum are recyclable products
made from wood grown in well-managed forests and other
controlled sources. The manufacturing processes conform to
the environmental regulations of the country of origin.

Contents

Acknowledgements

In addition to specific acknowledgements made in the text, we would like to thank the following people: Thierry Crépin Leblond at the Musée national de la Renaissance, Ecouen; Dr Eloise Donnelly at the Victoria and Albert Museum; Tom Fotheringham at Stanton Williams Architects; Kirstin Kennedy at the Victoria and Albert Museum; Clarissa Pearson Bruce, photographer; Dr Jeremy Warren, independent sculpture consultant; and Matthew Winterbottom at the Ashmolean Museum, Oxford.

At the Goldsmiths' Company, we wish to thank Sir David Reddaway, the Chief Executive of the Goldsmiths' Company, the Court of Assistants, Michael Prideaux and the Publications Sub-Committee for supporting the project from the outset; Eleni Bide and her team in the Library and Archives; Irene Galandra Cooper, Rebecca Ingram, Frances Parton, Stephanie Souroujon and Charlie Spurrier in the Curatorial Department. We would like to thank Lord Rothschild, Hannah Rothschild, and the Rothschild Foundation, especially Fabia Bromovsky and Pippa Shirley and her team at Waddesdon Manor. At the British Museum, we are grateful to Dr Andrew Meek and Oliver Cooke for organising the analysis of the Royal Clock Salt so smoothly; Sir Richard Lambert, former Chairman of Trustees; the Director, Dr Hartwig Fischer; Dr JD Hill, Chair of the British Museum Research Board; Dr Jill Cook, Dr Rachel King, Dr Naomi Speakman and Dr Lloyd de Beer of the Department of Britain, Europe and Prehistory; Jim Peters and his team; and the Photographic Department, especially for their new photography of the painted Limoges enamels illustrated in the volume. We also wish to thank the copyeditor, Linda Schofield, and the indexer, Nicola King.

Timothy Schroder and Dora Thornton
October 2021

Note to the Reader

The text contains a number of references to currency, weights and purities of alloy. The following is a brief guide to help the reader through these often confusing units of measure.

English money is expressed in *pounds, shillings* and *pence*, but occasionally in *marks* as well. Before 1970 the pound was divided into 20 shillings and the shilling into 12 pennies (or pence). These units are abbreviated in documents to *L*, *s* and *d* (for *libra, solidus* and *denarius*, the notionally equivalent units of ancient Roman coinage). The *mark* was a unit of account rather than a coin and equalled two-thirds of a pound (13s 4d).

The most frequently encountered foreign currencies are the *ducat* (mainly used in Italy, Spain and the Holy Roman Empire) and the *crown* (in France). Exchange rates fluctuated but as a broad rule of thumb, for most of Henry VIII's reign the two coins were of similar value and were worth between 4s and 5s or between a fifth and a quarter of a pound. In England in 1525, for example, the ducat was exchanged at 4s 6d, making 800 ducats worth £180.

Inventory clerks and others compiling records of plate tended to keep scrupulous records of weight because weight related directly to value. In England precious metals and gemstones were usually weighed in troy measure. The *troy pound* (as distinct from the avoirdupois pound which was used for other commodities and which was slightly heavier) was divided into *ounces, pennyweights and grains*. There are 12 troy ounces to a troy pound, 20 pennyweights to an ounce and 24 grains to a pennyweight. Weights in inventories and goldsmiths' bills are normally expressed in ounces (*oz*) and pennyweights (*dwt*). A troy ounce is the equivalent of about 30 grams, making a kilogram slightly more than 32 ounces. Occasionally plate is weighed in *marks*, a unit that related to the troy pound as the monetary mark did to the monetary pound: it equated to about 8 ounces or two thirds of a pound.

The other essential measure for plate was the purity of its alloy. During the period covered by this book the legal standard for silver plate in England was sterling, or 92.5% silver mixed with 7.5% base metal; in Paris the alloy was established by royal decree in 1378, at the rather higher level of 95.7%.

One further clarification might be helpful: the great inventory compiled after Henry VIII's death (Starkey 1998) is referred to throughout the text, but inconsistently. This massive document, comprising nearly 18,000 entries, was commissioned in September 1547 but took several years to compile. As a result, some authors have in the past referred to it as the 1551 inventory (the year in which it was finished), while others prefer 1547. Since its opening words describe it as '… the inventory of the… goodes belonging to our late Souerayne lorde Henry VIII' and since, therefore, all the objects described were – in theory – in the king's possession in 1547, the editors of this book refer to it as the 1547 inventory.

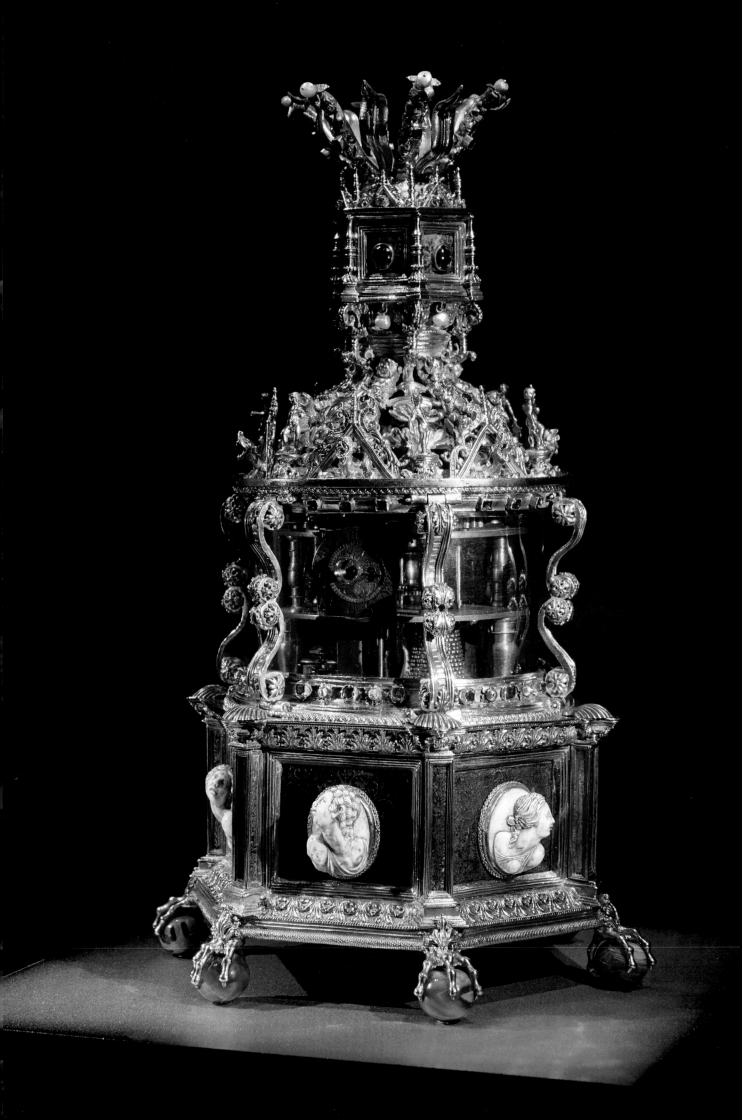

Introduction: A Royal Treasure and its Role in the Renaissance Court: the Royal Clock Salt

Timothy Schroder and Dora Thornton

The extraordinary confection known as the Royal Clock Salt is one of the Goldsmiths' Company's greatest treasures. This volume brings together the papers given at an international conference dedicated to this object and its history that was held at Goldsmiths' Hall in London in November 2018.

Timothy Schroder's proposal of a loan by the Goldsmiths' Company of the Clock Salt to the British Museum offered new opportunities, It allowed the Company to share freely a little-known national treasure with up to six million visitors a year. The loan also enabled scientific research (including non-invasive analysis) to be carried out by the British Museum team to learn more about its origin, history and construction. Not only that, but it prompted the idea of forming a four-way research partnership between the Goldsmiths' Company, the British Museum, the Rothschild Foundation and Waddesdon Manor to consider the history of the Clock Salt from different angles. International specialists were brought together to explore the making and meaning of this Renaissance treasure.

The Clock Salt was lent by the Goldsmiths' Company to the British Museum from 2018 to 2020 and was displayed in the Waddesdon Bequest Gallery (**Fig. 1**). This gallery was created in 2015 for the famous collection of medieval and Renaissance works of art given to the Museum by Baron Ferdinand Rothschild (1839–1898) as a princely *Kunstkammer* in 1898. The scheme incorporated a special case for 'visiting objects' and it was this space that the Clock Salt occupied during its loan to the Museum.

Displayed in this context, the Clock Salt amplified the story of the Bequest as a courtly treasure. Made in Paris around 1530 by the royal goldsmith to Francis I, Pierre Mangot (*c.* 1485–after 1551), the Clock Salt is somewhere between a jewel, the latest fashion accessory and a table ornament. Its early history and how it came to England are a matter of conjecture. It may have been a gift from King Francis I of France (r. 1515–47) to King Henry VIII of England (r. 1509–47), or to one of Henry's courtiers, but it was almost certainly in the king's possession by the time of the great inventory compiled after his death. The loan of the piece allowed it to be closely compared with the Sibyls Casket in the Waddesdon Bequest, another remarkable example of the goldsmith's art that can be attributed to the same maker, as discussed by Dora Thornton in Chapter 4. Its shell cameos[1] have close parallels within the British Museum collection, including pieces from the founding bequest of Sir Hans Sloane (1660–1753).

Viewed within the context of the wider British Museum collection, other connections emerge. The Clock Salt exemplifies the Renaissance tradition of cultural diplomacy and gift giving that lay at the heart of contemporary politics. One of the two known drawings recording Renaissance clock salts is in the British Museum: the design made by Hans Holbein the Younger (1497/8–1543) for Sir Anthony Denny's (1501–1549) gift to Henry VIII on New Year's Day 1544. A photograph of the Holbein drawing was shown on the gallery label during the loan (**Fig. 2**), and the relationship between drawing and object is analysed by Olenka Horbatsch in Chapter 5, showing how different the latter is from Holbein's style (see Chapter 5, pp. 87–8).

Figure 1 (opposite) The Royal Clock Salt *in situ* while on temporary display from 2018 to 2020 in the Waddesdon Bequest Gallery, British Museum. Photograph: British Museum

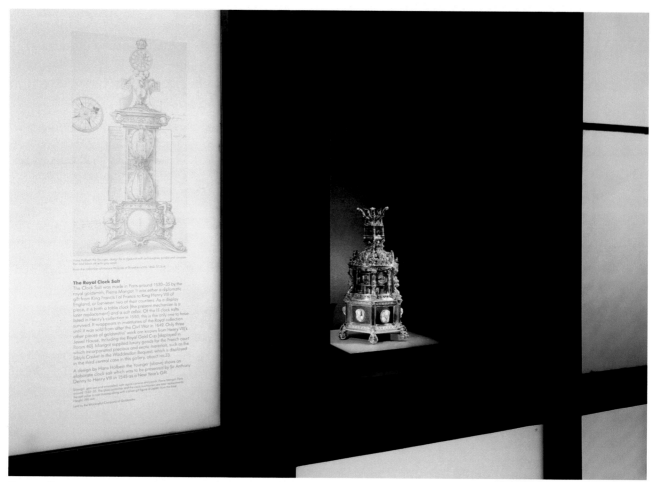

Figure 2 Hans Holbein's clock salt design made for Sir Anthony Denny's gift to Henry VIII alongside the Royal Clock Salt in the Waddesdon Bequest Gallery, British Museum. Photograph: British Museum

Dating of the current clock mechanism and speculation as to how it might originally have looked and functioned could be carried out by comparison with other pieces in the national horological collection for the first time, as discussed by Oliver Cooke in Chapter 8.

As Timothy Schroder demonstrates in Chapter 1, the significance of the Clock Salt in the context of Henry VIII's collection cannot be overstated. The final inventory of Henry's possessions, compiled between 1547 and 1551, lists an incredible quantity of plate, jewels and jewelled objects. Around 3,000 of the total 18,000 entries relate to gold and silver of one sort or another and many of these entries comprise multiple objects, such as dozens of bowls, multiple dozens of spoons or hundreds of finger rings. But the inventory does nothing more than provide a snapshot of a moment in time. Throughout the reign the collection had been in a constant state of flux as old plate was sent for refashioning, or to the mint for coining. Jewels, too, were regularly refashioned and stones sent to the royal lapidary to be recut. This process continued apace after his death, so that by the end of the 16th century little remained of Henry's once great collection. It should come as no surprise, therefore, that what has survived until today is almost nothing. Of the vast swathes of plate and jewels that once lined the shelves of the Jewel House at the Tower of London or filled the coffers and cabinets of the privy chamber at Whitehall Palace, just four extant pieces have been firmly identified. Other than the Clock Salt, these are the French

Royal Gold Cup in the British Museum, a rock-crystal and silver-gilt cup (or vase) in Florence and a gold and jewel-mounted rock-crystal bowl in Munich.

The so-called French Royal Gold Cup was inherited by Henry VIII and has an extraordinary history (**Fig. 3**). Made for the duc de Berry *c.* 1370–80, he gave it to his nephew, Charles VI of France (r. 1380–1422). In 1434 it was acquired by John, Duke of Bedford (1389–1435), who bequeathed it to Henry VI of England (r. 1422–61). Surviving a brief episode when Henry VI pawned it, it was kept in the royal Jewel House until 1604, when James I (r. 1603–25) presented it to the Spanish ambassador, Juan de Velasco (*c.* 1550–1613). Velasco presented it in turn to the convent of Medina de Pomar near Burgos, where it remained until the British Museum acquired it in 1892.

The cup is 23.6cm high and has a relatively shallow bowl and cover and a spreading foot and stem. Its chief glory is the spectacular translucent enamels depicting the symbols of the evangelists and the story of St Agnes. Further enamelled roundels of Christ in blessing and St Agnes receiving instruction are inside the cover and bowl. The technical and artistic quality of these depictions has arguably never been surpassed in enamel. The enamels themselves are extraordinarily thin and the figures are modelled through tiny variations in the depth of the engraved ground that condition the thickness of the enamel and the amount of light that is reflected back from the underlying gold. At the same time the plain surface of the areas not bearing enamel

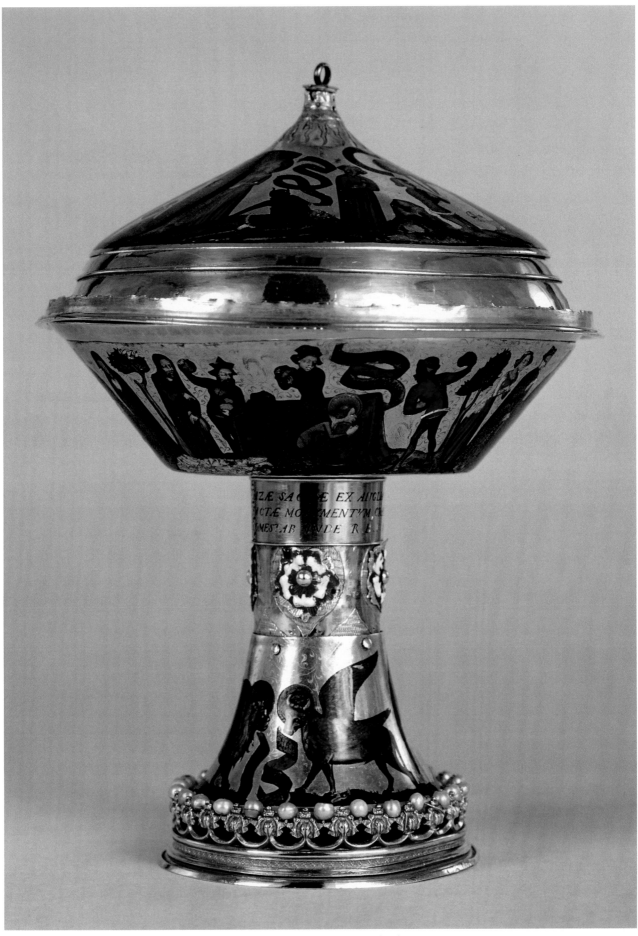

Figure 3 The Royal Gold Cup, *c.* 1370–80, France, gold, enamelled, h. 23.6cm, diam. (cup) 17.8cm. British Museum, 1892,0501.1

Figure 4 The 'Holbein bowl', *c.* 1540, possibly southern Germany, gold, rock crystal, enamel, pearls and precious stones, h. 16cm. Residenz München, Schatzkammer, inv. no. ResMüSch.0040. © Bayerische Schlösserverwaltung, Maria Scherf / Rainer Herrmann, Munich

has been articulated by finely pricked scrolling foliage. The cup is not entirely in its original condition, however. Two disfiguring areas of damage are the replacement of the finial with a simple ring and the heavy damage to the border of the cover, which would originally have matched the pearled crown-like gallery around the foot. In 1521 there were 62 pearls; today there are fewer than 30.[2] The stem has two extensions, one with enamelled red and white Tudor roses on a crudely worked ground, and the other with an engraved inscription recording its presentation to Juan de Velasco. The ring on the cover replaces what was described in 1521 as a crown imperial (itself probably a Tudor replacement).

The rock-crystal vessel in Florence, the second of this group of three, has the distinction of being the only surviving piece from Henry VIII's treasury whose mounts were made in England. It is preserved in the Medici church of San Lorenzo in Florence (see **Fig. 11**). Standing 32.3cm high and bearing London hallmarks for 1511–12, it was sent to Italy, presumably as a gift to one of the two Medici popes, Leo X (1475–1521) or Clement VII (1478–1534), and has been in the church since 1532. Repurposed in Italy as a reliquary, it was originally a secular piece and is devoid of religious ornament. The mounts enshrine a much older two-handled rock-crystal vessel that dates from as early as the 14th century and is probably Italian or Sicilian. The foot and cover mounts are embossed in high relief with gadroons and the foot and lip are connected by vertical straps enamelled with alternating red and white roses. Two Italianate putti surmount the handles, and the finial, which is lost, we know

to have been in the form of St George and the dragon.[3] In addition to this repertoire of Tudor badges, the foot is decorated with pomegranates, the personal badge of Catherine of Aragon (1485–1536).

The San Lorenzo cup is very different from the final object in the group, which is a rock-crystal bowl with extraordinarily sophisticated gold, enamelled and jewelled mounts that is preserved in the Schatzkammer of the Residenz in Munich (**Fig. 4**). The crystal bowl is hollowed out to an exceptional thinness and is carved on the outside with spiralling flutes; like the San Lorenzo piece, this is much older than the mounts. The foot mount is decorated with polychrome enamel, chased with a laurel wreath, modelled with harpies and set with stones; the lip is chased with exquisitely refined fleurs-de-lis and foliage; and the handle is modelled and enamelled with a female mask with an elaborate headdress of fruit. The cover is immensely complex. Modelled around a circle of five convex crystal discs, the spaces between are filled with the 'five roses of diamonds' set within extremely elaborate cartouches, all of which are composed of different motifs. This zone surrounds a domed ring enamelled with polychrome arabesques and Latin inscriptions on white shields with strapwork cartouches. The treatment of the inside of the cover is hardly less intense and is completely covered with an intricately engraved carpet of Moresque foliage centred around a polychrome enamelled disc. In comparison with all this, the finial, formed as a turned crystal 'capstan' with stones and pearls around its base, seems muted. But this is not how it

was in Henry VIII's time and a still-life painting by Willem Kalf (1619–1693) of 1678 reveals its original appearance: attenuated and delicate, the finial rose to about three times its present height in a series of stages, each embellished with pendant pearls. We do not know who made this extraordinary jewel but, although the design has traditionally been attributed to Holbein, it is certainly not English and was probably made in a south German court workshop. Most likely, it was one of Henry's extravagant purchases from abroad.[4]

This is unlikely to be the definitive list of extant goldsmiths' work from Henry VIII's treasure. In 1955 Arthur J. Collins wrote confidently that only a single piece – the French Royal Gold Cup – had survived;[5] the Henrician history of the other three has been recognised more recently[6] and others are almost sure to follow.[7] But even so, the total number in comparison with the quantities described in the inventories will always remain vanishingly small and the significance of this tiny number of survivors is correspondingly impossible to exaggerate. Thinking about these pieces and the Clock Salt together as vestiges from Henry's collection has allowed greater understanding of the role they played in the life of the Tudor court.

We will never be able to recreate a full picture of Henry VIII's vast treasure, but these pieces stand for different strands within it. The French Royal Gold Cup reminds us that even in the courts of fashion-conscious princes, there remained a role for precious heirlooms that linked their owners with their forebears, giving a sense of continuity and validation. The San Lorenzo vase reminds us of the importance of prized hardstones in court culture, some of which went through multiple incarnations as the valuable material was repeatedly stripped of its old-fashioned mounts and clothed in new ones; it also gives us a rare window into the prevailing style of Henry's court goldsmiths at the start of the reign. The Royal Clock Salt reminds us, contrary to the French cup, of the importance of owning objects that enshrined not only the latest fashions but the latest technology too. And, finally, the so-called 'Holbein bowl', as much as any single surviving item from the period, is the epitome of the princely craving for objects that combined stellar value (through its materials) with extraordinary design and concentrated virtuosity; it is the *non plus ultra* of princely objects.

The Clock Salt is a remarkable display piece, made of silver gilt and incorporating decorative elements of enamel, shell, agate, pearls and garnets, in addition to the clock mechanism contained within a crystal cylinder. Standing on six agate and silver-gilt claw and ball feet, the lower part of the object is hexagonal and set with shell cameo busts carved in high relief. The busts are mounted on blue enamel plaques embellished with gilding and each side is separated by an architectural pilaster. The cylinder containing the clock is surrounded by free-standing double scroll brackets connecting the upper and lower sections. Above this is an openwork dome incorporating gable-like pediments, standing male nude figures and vase motifs. The topmost surviving elements are a hexagonal knop echoing the shape of the base and an open calyx of leaves that formerly supported a now-lost crowning element; the calyx is

probably a modification, perhaps dating from the 17th century (see Chapter 6, p. 95).

The Clock Salt is not hallmarked but it is in the style of a number of pieces by one of Francis I's principal goldsmiths, Pierre Mangot, and can safely be attributed to him. Mangot is documented in the royal service between 1514 and 1551.[8] Given the destruction of almost all French court goldsmiths' work from the first half of the 16th century, this corpus of objects, all of which are mounted rather than made entirely of precious metal, have been comparatively fortunate in their survival and give us an unusually clear insight into his distinctive style. The Clock Salt is typical of his oeuvre and is exactly the sort of object that would have been described in the 16th century as a jewel. It is a work of art whose aesthetic impact is multilayered, contributed to by its gemstones, its virtuosity and its visual complexity. The ornament is largely classically inspired and the carved shell cameos allude to ancient Roman busts, although with a distinctly Mannerist *contrapposto*. But it is not wholly 'antique' (the term used in English 16th-century documents to refer to classically inspired ornament) and certain elements, such as the sharply angular gables above the clock mechanism, recall the Gothic style that only a decade or two earlier still pervaded northern European courtly art: despite its advanced appearance, the Clock Salt has something of a transitional quality.

Jewel-like though it is, however, it would have appeared even more so when it was made. The enamels have mostly deteriorated and their refined gilded surface enrichment is much faded; the clockwork mechanism is later and the whole of the original crowning element has been subject to more than one radical alteration. As we will see, this was probably either a receptacle for salt or a miniature sculptural group of Jupiter and Ganymede.

The importance of the Clock Salt does not rest solely in its royal associations; it is also an exceedingly rare type of object. Different forms of clock salt – all of them now lost – are listed in contemporary inventories across Europe, the most famous being the vertical table clock that is recorded in a pen-and-wash drawing of about 1570 by Hans Mielich (1516–1573) in the pictorial inventory of the treasury of Duke Albrecht V of Bavaria (1528–1579) (see **Fig. 118a**). The latter, discussed by Oliver Cooke in Chapter 8, like the Royal Clock Salt, is constructed around a rock-crystal cylinder containing the clock mechanism; it has a salt cellar shown below whereas it has long been suggested that the salt cellar on the Goldsmiths' Company's Clock Salt might have been at the top, which has since been altered.[9] Even in its incomplete and damaged state, the Royal Clock Salt is of unique significance as the only recorded European piece of its type to have survived from the Renaissance.[10]

It is these very issues of incompleteness and restoration, however, that make it difficult to interpret the exact original appearance of the Clock Salt or what its primary function was. There is no doubt about its timekeeping role as the descriptions are very clear on that point: the mechanisms were actual clocks. But was the use of the term 'salt' merely figurative, because it had the shape and appearance of one rather than its function? And what, anyway, could be the reason for combining two such very different functions as a

timepiece and a condiment holder? If the Clock Salt ever actually contained a salt dish there is no trace of it now, nor is there any sign of where it might have been fitted. Yet there cannot be any real doubt that some such items were actual as well as ostensive salts, because the 1547–51 inventory ('1547' hereafter) includes them (or most of them) under the heading 'salts'. There are at least two possible explanations for this, both deeply speculative. The first is that during extended banquets (and some of them ran for several hours) the king might well have wished to keep track of the time while disguising the timekeeper in front of him as a salt. The second, quite different but not incompatible, is that elaborate standing salts and timepieces were both symbols of high status, the first long established and the second quite new. What better way to symbolise the modernity of a great prince than to combine the two?

To judge from the 1547 inventory, Henry VIII clearly had a taste for clock salts. These combined his passion for clocks in general (there are close to 200 timepieces of one sort or another in the inventory) with his love of luxury objects. The first recorded example in his possession (which he may have acquired some years earlier) is listed in the Whitehall inventory compiled in 1542. Like the surviving example, this was studded with cameos and stones.[11] But the 1547 inventory includes no fewer than 12 such pieces, one of which was of gold. When the Clock Salt was consigned for sale at Christie's in 1967, John F. Hayward pointed out that it appeared to correspond to two separate entries in the inventory. These read as follows:

> Item one Salte of silver and gilt with a cover standing vppon vj rounde Balles of Jasper with vj white Agath heddes standing in Collettes of Silver within the same a rounde Cristall and therin a Clocke wt seames and other Joyntes of Latten and Iron apperteyneng to the same the Salte garneshed with course stones and certen hanginge peerles the cover garneshed wt small white heddes of Agathe and small counterfeite Emerades having a man setting vppon an Egle vppon the toppe of the cover weing altogether Cviij oz.[12]

and

> Item oone Clocke within Christall garneshed with silver gilt conteyning a salte in the toppe and standing vppon vj Balles of Agath with vj Camewes heddes benethe nexte the foote and diuerse small Camewes heddes vpon the toppe garneshed with diuerse garnettes and course Turquise and small ragged peerles weing all together Cxv oz.[13]

Given the alterations that it has undergone over the intervening centuries, it is not surprising that neither entry fits the Royal Clock Salt perfectly. In the first, for example, the agate feet are described as jasper and the shell cameos as agate. Despite these discrepancies, Hayward considered the first to be the closer match, a point that is more than academic, since it shaped the restoration he oversaw after its acquisition by the Goldsmiths' Company (see Chapter 6, pp. 91–5). Hugh Tait of the British Museum, after examining the Clock Salt at the Museum following the sale, took, on balance, the opposite view. Both agreed, however, that it could almost certainly be identified with an item listed a century later in the 1649 inventory of the Upper Jewel House of the Tower of London. This entry, also quoted in Chapter 6, reads:

> 2 Faire large Saltes of silver-gilt with a clocke in it, garnisht with 6 ivory heads about the bottome, and enriched with stones and little gold heads enamelled, with a man upon a falcon a top of it, valued at £40.[14]

This description, briefer than the Tudor ones, also raises questions, not least by its reference to 'two salts' and by the curious fact that it makes no mention of the conspicuous rock-crystal cylinder. It does however seem possible, probable even, that this is the Royal Clock Salt, although it might already have undergone alterations. Regarding the 'two salts' discrepancy, the most plausible explanation is the one offered in the Christie's catalogue entry (compiled by Arthur Grimwade): that it was simply a clerical error and 'that the maker of this inventory mistook the hexagonal base as another salt so describing the piece as "2 Faire large Saltes", since the phrases "a clocke" and "a top of it" clearly refer to a single item.'

The history of the Clock Salt since its sale in 1649 can be found in Chapter 6 of this volume. Since its acquisition by the Goldsmiths' Company and prior to its loan to the British Museum in 2018, the Clock Salt was lent to two major exhibitions: *Henry VIII at Greenwich* in 1991 and *Holbein in England* in 2006.[15] A research programme has long been needed in order to understand the Clock Salt in its historical context; taken together, this is what the contributions collected in this volume represent.

The purpose of this book is to present the latest findings about the Clock Salt and to place it in its broader cultural and historical context. Timothy Schroder sets the scene in Chapter 1 by discussing cultural diplomacy between the rival kings, Francis I and Henry VIII. Princely gifts built the status of both giver and receiver, and reflected glory back on their owner, as Paulus Rainer notes in Chapter 2 in which he examines the precious goldsmiths' work owned by Francis I, such as the gold salt cellar by Benvenuto Cellini (1500–1571), which is now in the Imperial Kunstkammer in Vienna. In Chapter 3 Michèle Bimbenet-Privat introduces the maker of the Clock Salt, Pierre Mangot, who supplied luxury goods to the French court that incorporated luxurious and exotic materials. Dora Thornton discusses in Chapter 4 a closely comparable piece attributed to Mangot, the Sibyls Casket in the Waddesdon Bequest in the British Museum, which may also have links with the French court around 1530. In Chapter 5 Olenka Horbatsch explores the role of Holbein the Younger as a goldsmith and designer at Henry VIII's court, looking especially at his drawing for a clock salt that was presented by Sir Anthony Denny to Henry VIII as a New Year's Gift in 1545. Rosemary Ransome Wallis in Chapter 6 traces the history of the Clock Salt since the reign of Charles I (r. 1625–49) and discusses its restoration after it came to the Goldsmiths' Company. In Chapter 7 Julia Siemon considers it in another light, looking at the enormous influence of the Rothschild family, a 19th-century banking dynasty that, like latter-day Renaissance princes, built its cultural status through the art it collected. Finally, in Chapter 8 Andrew Meek draws together the findings of horologists, conservators and scientists at the British Museum in analysing the Clock Salt as a uniquely important object that has undergone substantial alterations during its long and complex history.

This book breaks new ground, not only for the questions it raises but also because of the picture that has emerged, not least in terms of the cultural context of the Royal Clock Salt. But there are still questions to be answered. The means by which it came to England and whether it was in fact a gift or a purchase remains, and will perhaps always remain, uncertain. The true function of the object – how it was used and how it was displayed – is, other than in a very general sense, unknowable. Although this and others like it are described as 'clock salts' and placed in the parts of inventories devoted to such items, it is unclear whether they were ever intended to be used as salts or merely had a shape suggestive of one. Holbein's drawing for Anthony Denny's 'clock salt', for example, although of a form associated with stately salt cellars, gives no indication of a receptacle for salt.

Notes

1 This material has caused much confusion. The 1547 inventory described it as either agate or cameo and in 1649 it was taken for ivory. Christie's 1967 sale catalogue description correctly identifies them as 'shell cameos'.

2 The 1521 description (Trollope 1884, 165) reads: 'A cup of gold enamelled with imagery, the knop a crowne imperial and about the border of the cover and foot a crown garnished with lxij garnishing pearls poyzt lxxix oz'. In March 2018 I was given special access to the cup and noted the following technical features: the bowl and cover are double-skinned with the enamel applied to the thin outer sheet. The cup has undergone several interventions beyond the additions to the stem. The lip has been rehammered, possibly after being dented; underneath the bowl and visible inside the stem is a strange, crudely amputated, square section that is hard to understand; traces of red enamel remain on the engraved sunburst on top of the cover; the top of the cup, where it meets the finial ring, is broken off and is very rough.

3 This is known from an illustrated inventory of the reliquaries housed in San Lorenzo and compiled in the late 1530s (see Schroder 1995, 356–66).

4 For a fuller account of all three pieces and detailed photographs, see Schroder 2020.

5 Collins 1955, 198.

6 The Clock Salt in 1967, when it appeared for auction, the 1511 vase by Timothy Schroder in 1994 (see Schroder 1995) and the 'Holbein bowl' by John Hayward in 1973.

7 The Burghley nef, made in Paris in 1527–8 and now in the Victoria and Albert Museum, corresponds closely to a description in the 1547 royal inventory (Starkey 1998, no. 3024).

8 Bimbenet-Privat 1992, 544–5, and in Chapter 3.

9 Hayward 1973, 28.

10 The Rogers salt in the collection of the Goldsmiths' Company, hallmarked for 1601–2, although stripped of its mechanism, is thought to have been a late example of the form.

11 Hayward 2004, no. 109.

12 Starkey 1998, no. 1353.

13 Starkey 1998, 46, no. 1367. Virtually identical descriptions with small variant spellings appear in the 1574 Jewel House inventory (Collins 1955, nos 914 and 913).

14 Brand 1806, 287.

15 Starkey 1991, cat. IX.9, and Foister 2006, cat. 82.

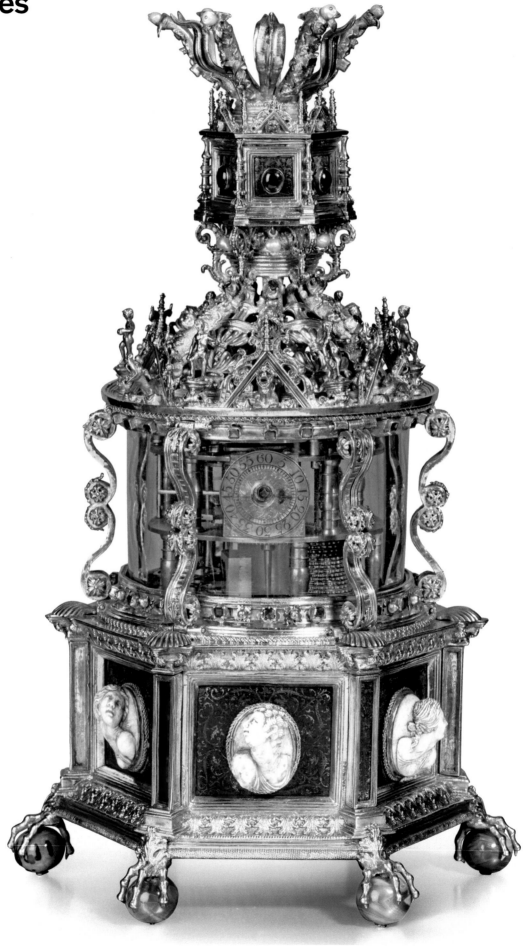

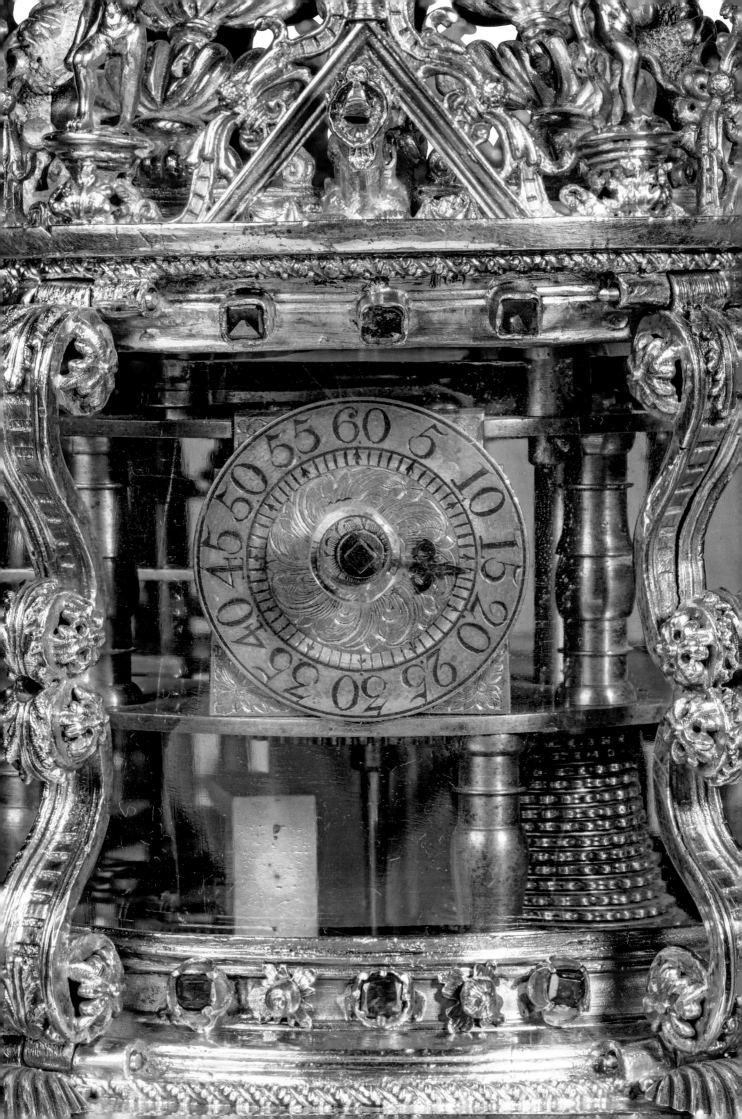

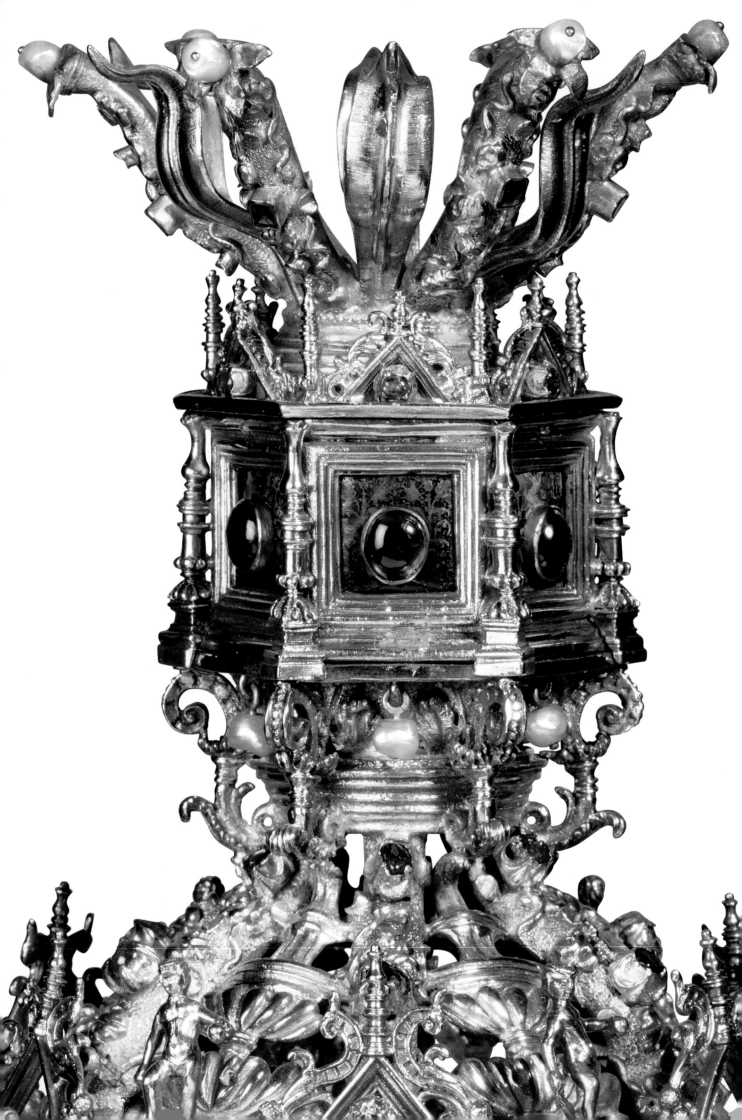

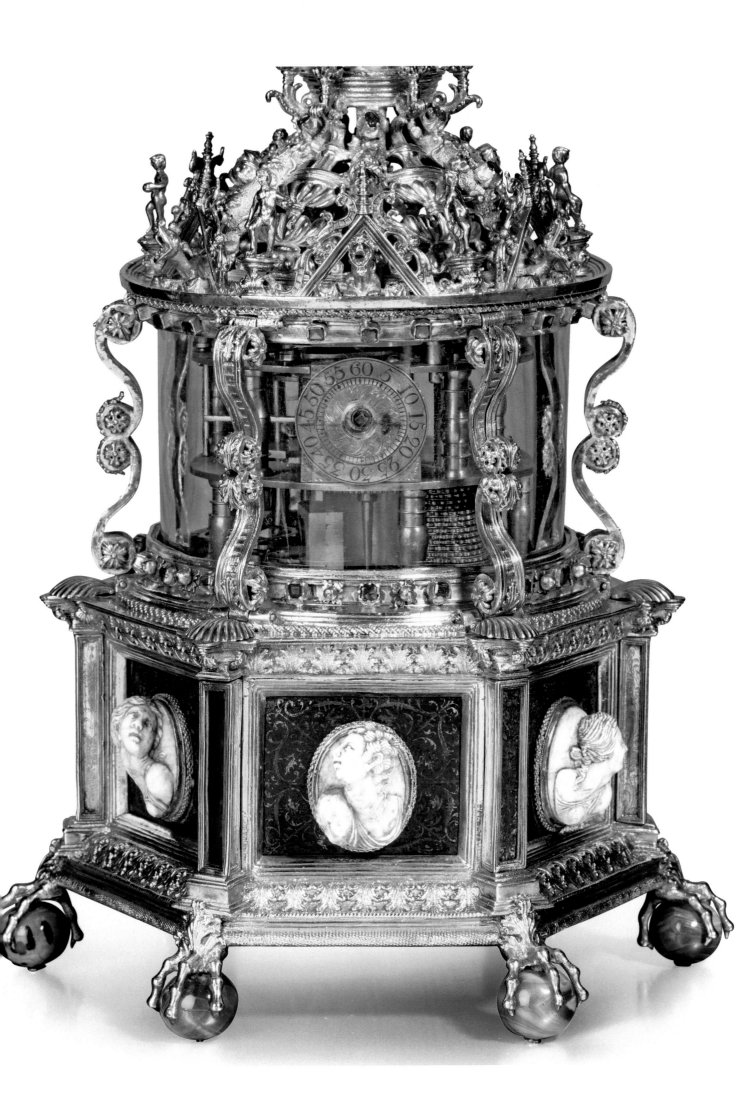

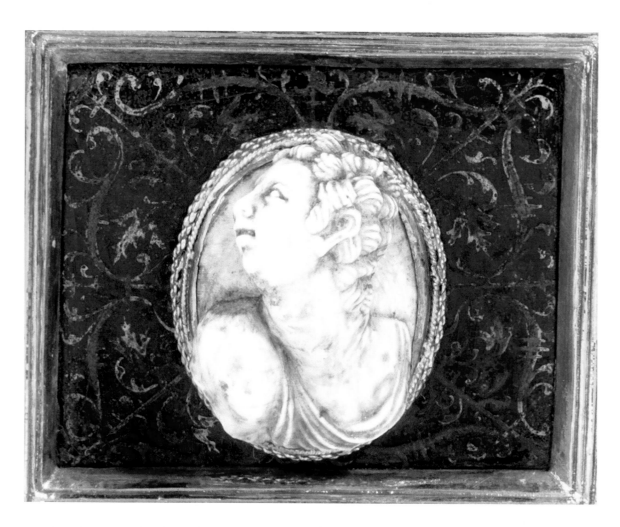

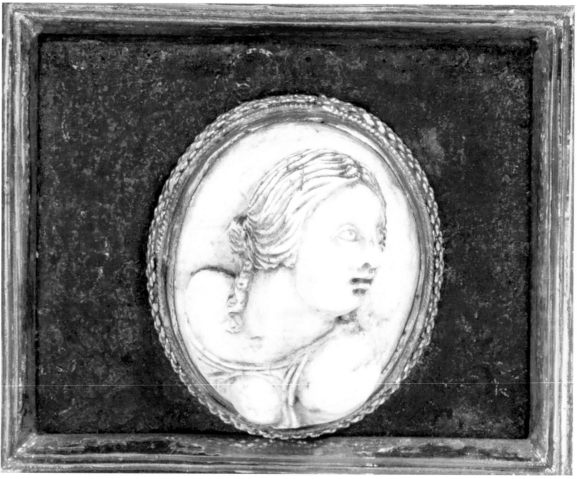

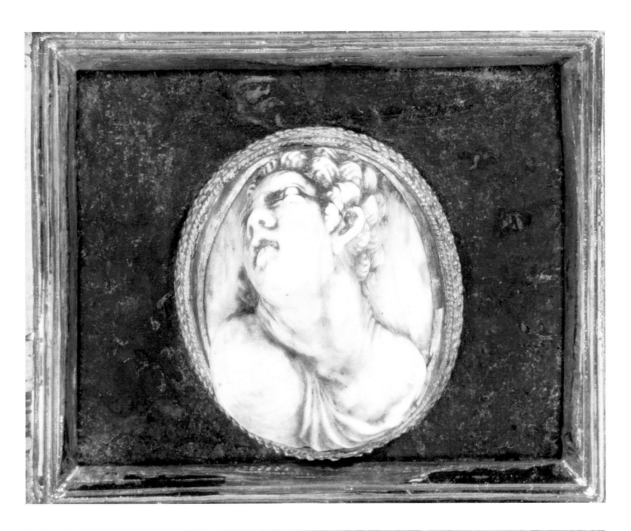

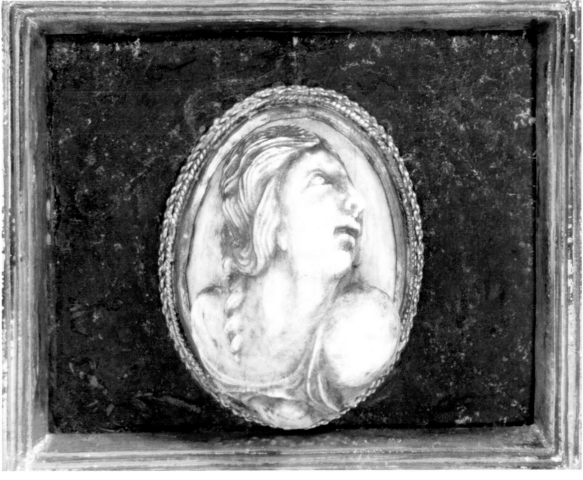

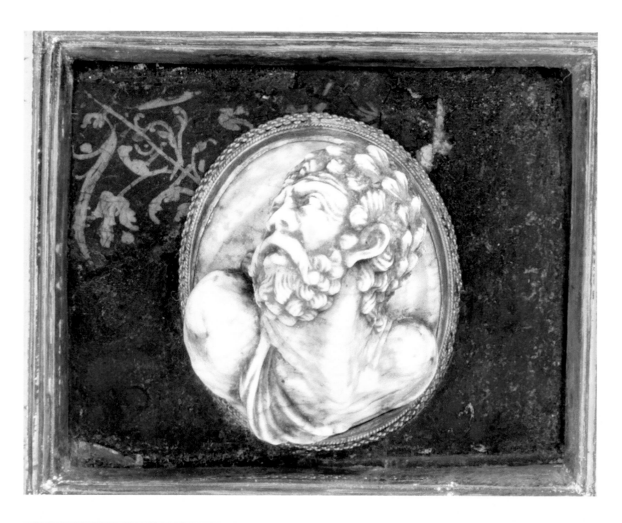

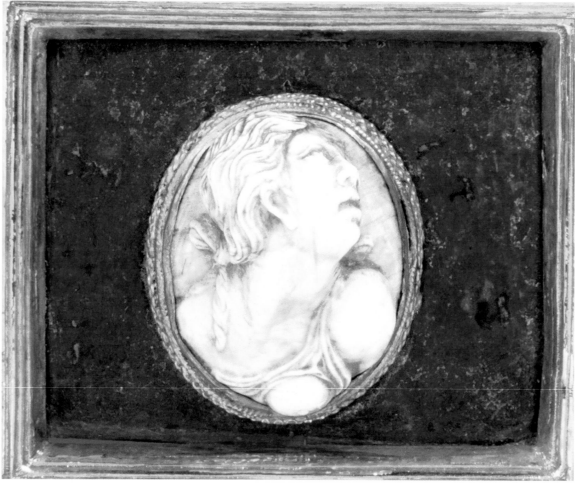

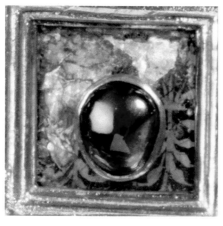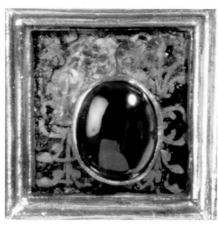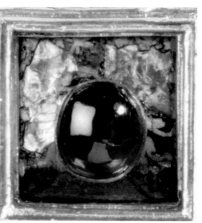
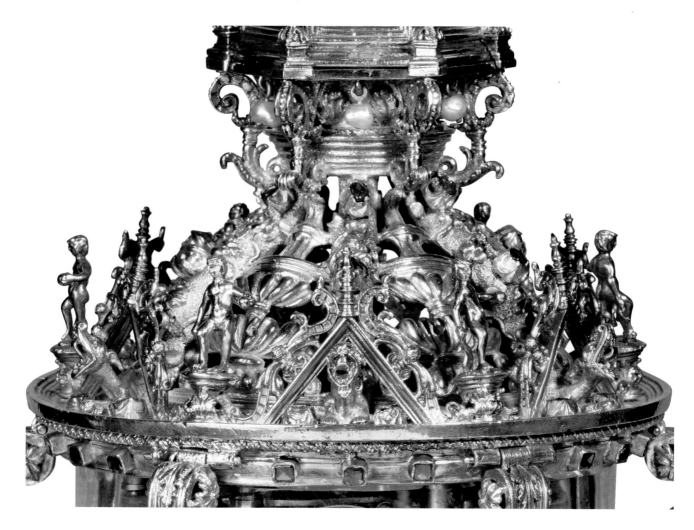

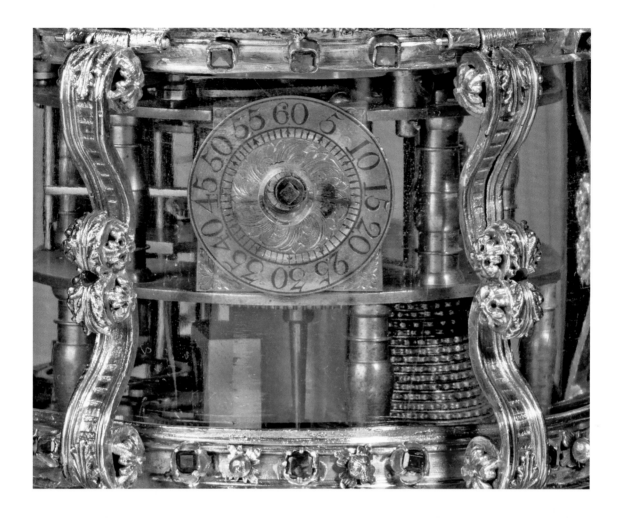

Chapter 1
Diplomatic Gifts between Francis I of France and Henry VIII of England

Timothy Schroder

When Francis I (r. 1515–47) (**Fig. 5**) came to the throne in 1515, Henry VIII (r. 1509–47) (**Fig. 6**) had already been king for six years. He was, by comparison, an experienced monarch. Not only that, but he was king of a country that had long laid claim to sovereignty over France and had dealt a humiliating blow to French pride through his invasion of that country just a couple of years earlier. Henry and Francis had much in common but, given such a background, the relationship between the two was never going to be easy and throughout their reigns they oscillated between war, amity and uneasy truce. But even when they were the best of friends their relationship was coloured by an underlying sense of rivalry that affected virtually all their dealings. Henry was said by contemporaries such as the philosopher and scholar Desiderius Erasmus (*c.* 1466–1536) to be the more intellectually engaged of the two, but for much of his reign Francis had greater artistic talent at his disposal, a fact that often vexed Henry. The French king also clearly had a sense of artistic superiority and although he never visited England he suspected he had the measure of Henry's taste when he commented on one occasion, via the English ambassador, that 'he heard you used much gilding in your houses, especially in the roofs [whereas] for his part he preferred natural wood … which was more durable.'[1] Not only that, but in better taste too, he seems to imply.

The exchange of gifts between the two monarchs and their courts must be seen against this background of shifting relations. But before turning to the gifts themselves we need to consider the conventions that governed them and the wider context of 16th-century diplomacy. The 16th century saw the beginnings of the modern system with the emergence of resident ambassadors. The Holy Roman Emperors and the Venetian Republic, for example, both kept permanent envoys at Henry's and Francis's courts. These were professionals; they had a small support staff, they earned a decent enough living, and it was customary for the king to present them with a gift at the end of their term. But they did not live like princes, nor were such gifts hugely munificent. Typical was the gift to retiring Venetian ambassadors, who generally received a gold chain worth about 80 to 100 pounds on their departure from England.

Two of the French ambassadors to England during this period, Jean de Dinteville (1504–1555) and Georges de Selve (1508–1541), were immortalised by the celebrated double portrait of 1533 by Hans Holbein the Younger (1497/8–1543), in the National Gallery, London (**Fig. 7**). They are shown as civilised, cultured men of the world and are surrounded by objects that reinforce this view. But the status of their legations was quite different from that of the great embassies that came for some special purpose, such as a high-level negotiation or the signing of a treaty. The latter were huge, often numbering hundreds of men and horses, accompanied by long baggage trains. Unlike resident embassies, these were headed by men of immensely high rank, appointed as their masters' personal representatives. As such, they were received almost as if they were the prince himself and the entertainments laid on for them were spectacular and costly.

The conclusion of several years of hostilities between England and France in 1527, for example, was marked by the dispatch of massive embassies in both directions. The

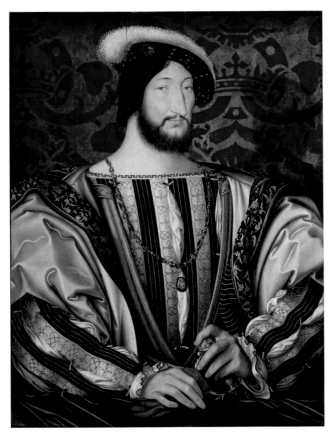

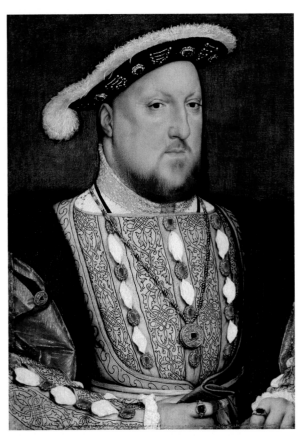

Figure 5 Jean Clouet, *Francis I of France*, c. 1530, oil on panel, h. 96cm. Musée du Louvre, Paris, inv. no. 3256. Photo © RMN-Grand Palais (Musée du Louvre) / Michel Urtado

Figure 6 Hans Holbein the Younger, *Henry VIII*, c. 1537, oil on panel, h. 28cm. Museo Nacional Thyssen-Bornemisza, Madrid, inv. no. 1934.39. © 2020. Museo Nacional Thyssen-Bornemisza/Scala, Florence

French delegation, headed by Claude d'Annebault (1495–1552), the Admiral of France, comprised more than 900 people and was received with prodigious displays of munificence. After an enormous banquet hosted by Cardinal Wolsey (c. 1470–1530) at Hampton Court, Henry laid on an even greater one at Greenwich. This was probably the most magnificent of the entire reign. It consisted of a specially erected dining hall with two buffets of gold and silver-gilt plate 'reaching from the floor to the roof, forming a semicircle'[2] and a separate pavilion to which the company repaired for post-prandial entertainments. The temporary structures were spectacularly decorated and featured a triumphal arch and a ceiling painted with the constellations and signs of the zodiac. The feast itself was merely the centrepiece of a series of celebrations that lasted several days. The chronicler Edward Hall (1497–c. 1547) wrote in fulsome, if frustratingly imprecise, terms that 'to tell you of the costly banquet houses that were built, and of the great banquets, the costly masques, the liberal huntings that were shown to [the Admiral], you would much marvel, and scant believe.'[3]

An essential part of such occasions, normally left until last, was the presentation of gifts, the value of which usually reflected the recipient's status. These were often immensely valuable and those in 1527 were no exception. Hall's account continues:

On Friday following, [the Admiral was] rewarded with a cupboard of plate, to the value of twelve hundred pound, [he then] returned to London, and on Sunday took his galleys and

departed. Beside this, diverse of his company had much plate, and many horses, and greyhounds given them. Also, the Admiral had given him, of the City of London, two flagons gilt, and two parcel gilt, to the sum of an hundred and six and thirty pounds, beside wine, wax and torches: and thus they laden with more riches than they brought, returned into France.

Twelve hundred pounds was a vast sum, about 24 times the salary of a senior court official, such as the master of the Jewel House, or the equivalent of the annual revenues of a well-endowed bishopric or a middle-ranking nobleman.

This may seem excessive to the point of profligacy, but there was a rationale behind such gifts that we need to understand. This reflected the doctrine of magnificence, which can be traced back to Aristotle and which says, essentially, that to be a proper prince, you had to look like one and act like one.[4] Part of that requirement was that you had to be liberal in your gestures and gifts. But the doctrine also required reciprocity. Colossal though these gifts were, princes would not have given them – not on such a scale anyway, and not habitually – unless there was an expectation that gifts of a similar value would be received in return. But the policy was not without risk. For reciprocity was conventional, not contractual, so no matter how strong the expectation of receiving an equivalent gift, it was nonetheless freely given.

The preferred material for ambassadorial gifts was silver plate (the generic name for wares of gold and silver), because it was prestigious, because its value was known and because (although no one would dream of saying so) it was easy to

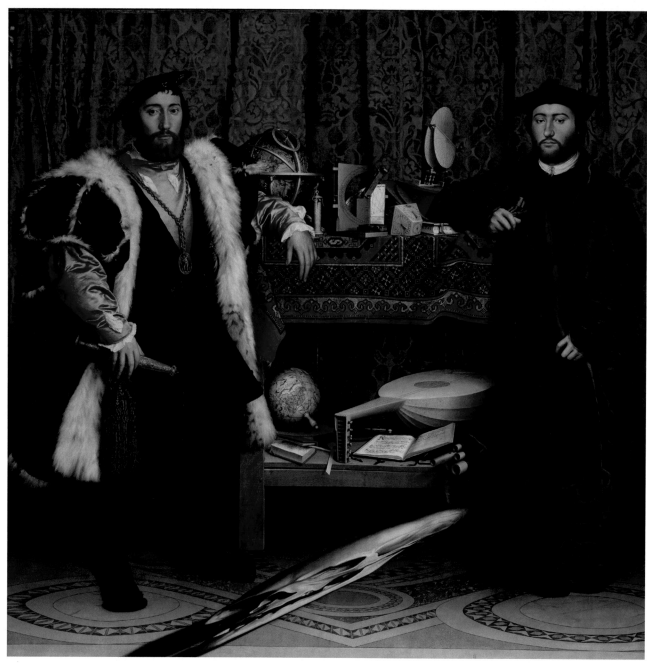

Figure 7 Hans Holbein the Younger, *Jean de Dinteville and Georges de Selve ('The Ambassadors')*, 1533, oil on oak, h. 207cm, w. 209.5cm. National Gallery, London, NG1314. © The National Gallery, London

cash in. An amusing story from the end of the reigns describes what must have been quite common practice. The resident English ambassador to France, Nicholas Wotton (c. 1497–1567), wrote of how, after receiving a gift of plate from Francis, he took it straight to the goldsmiths and sold it. It was all second-hand and, indeed, he recognised two of the cups as ones that he had been given on a previous occasion, when he had also sold them. And 'since I had them as cheap first as now I will sell them again trusting that they love me so well that they will not be long away.'[5] This was a well-known practice in the 18th century, when the normal currency of diplomatic gifts was gold boxes, but it is interesting to see it already well established two centuries earlier.

We do not know exactly what the 'plate to the value of twelve hundred pound' given to Claude d'Annebault comprised, but it was probably similar to that given to one of his predecessors, Guillaume Gouffier, seigneur de Bonnivet

(c. 1488–1525), when he came to London with another expansive entourage in 1518 as royal proxy at the betrothal of the two-year-old Princess Mary (1516–1558) to Francis (1518–1536), the infant dauphin of France. Hall tells us 'when the time came the king gave the Admiral of France a garnish of gilt vessel'. This he goes on to list:

> a pair of covered basins gilt, twelve great gilt bowls, four pairs of great gilt pots, and a standing cup of gold, garnished with great pearl. To some others he also gave plate, to some chains of gold, and to some rich apparel … so that every gentleman was well rewarded: which liberality the strangers much praised.[6]

Almost nothing from the period remains to help us envisage the kinds of plate presented on these occasions, but a few chance survivals do at least illustrate some of them. We can be reasonably confident, for example, that the basins would not have been very different from a pair bequeathed to Corpus Christi College, Oxford, by its founder, Bishop

Figure 8 Bishop Fox's ablution basin, 1514–15, London, silver gilt and enamel. Ashmolean Museum, Oxford, LI305.3. Lent by permission of the President and Fellows of Corpus Christi College, Oxford. Image © Ashmolean Museum, University of Oxford

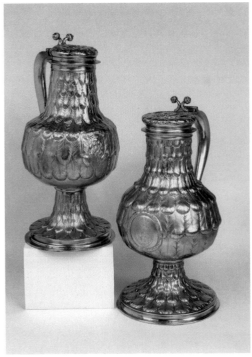

Figure 9 Pair of pots chased with feathers, 1660–1, London, attributed to James Beacham, silver gilt, h. 52cm Jewel House, Tower of London, Royal Collection, RCIN 31756. Royal Collection Trust / © Her Majesty Queen Elizabeth II 2020

Figure 10 The Leigh Cup, 1513–14, London, silver gilt and enamel. The Mercers' Company, London. Courtesy of the Mercers' Company. Photo by Louis Sinclair

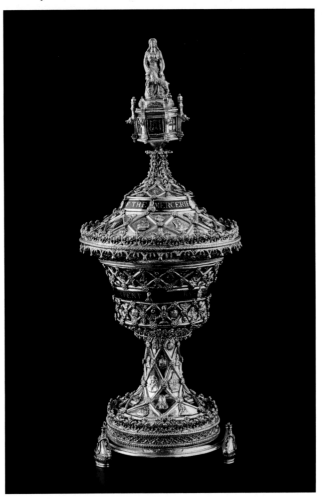

Richard Fox (c. 1448–1528). Each displays the bishop's enamelled arms in the centre, within a chased surround of radiating sunrays, just like a number of those listed in the royal Jewel House inventory of 1521 (**Fig. 8**). The pots and standing cup might be represented, in form if not in ornament, by the so-called 'feather flagons' in the Royal Collection (**Fig. 9**) and the Leigh Cup of 1513–14 in the collection of the Mercers' Company (**Fig. 10**). The former were actually made in 1660 but are believed to be copies of now-lost originals from the early 16th century.[7]

Bonnivet's garniture was probably not decorated in this way but would have made an impressive display. We do not know what it all weighed but 1,200oz may not be too far off the mark. At the going rate of 5s per ounce, plus the gold cup, it must have cost at least half of the £1,829 14s paid out to the goldsmiths,[8] so the gifts to the other members of his entourage must, collectively, have been considerable too.

Conveying a sense of such sums in terms of modern money is very difficult, since the relative values of everything have shifted so much that it can only be misleading. The ratio of the value of sterling silver to 22-carat gold today, for example, is about 1:100, whereas in the 16th century it was closer to 1:10; today its costs very little to send a letter to Rome, but in the 16th century it was hugely expensive; the same might be said of a pomegranate or an orange. Establishing a benchmark for inflation, therefore, depends very much on which basket of goods is chosen. Even so, it is a telling comparison that the cost of the plate given to the ambassadors was about half that of a brand new warship or a tenth of the cost of rebuilding Richmond Palace in the latter part of Henry VII's reign (r. 1485–1509).

An essential feature of the system was consistency and when another French admiral (Philippe de Chabot [c. 1492–

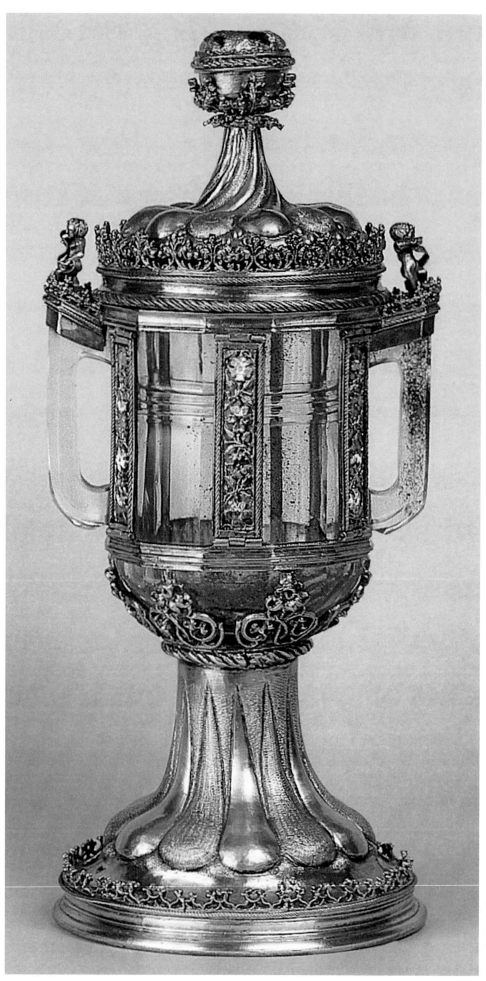

Figure 11 The San Lorenzo vase, 1511–12, London, maker's mark a cross, silver gilt, rock crystal and enamel, h. 32.3cm. Church of San Lorenzo, Florence. Photo by Marcello Bertoni, Florence

1543] on this occasion) came in 1534, Thomas Cromwell (c. 1485–1540) made a note reminding himself to find out 'the gift to be given by the King to the Admiral … [and] to know the value of the last gift given to the Admiral at Calais.'[9] Precedent was vitally important because the value of the gift, in comparison with others, sent a clear message about the success or otherwise of the mission. In the event, the visit in 1534 concluded with the admiral leaving with plate said to have been worth 8,000 ducats, or £3,400, because that was the precedent set two years earlier.[10]

Equally, values could be adjusted downwards to send a coded, if unsubtle, message and a year earlier, when Jean du Bellay, bishop of Paris (1492–1560), came to explain Francis's latest diplomatic manoeuvres with the Pope, Henry VIII was not pleased and, as a result, according to one rumour, awarded the bishop with 'only half the present the King at first thought of giving him'.[11]

In comparison with these munificent but stereotyped ambassadorial gifts, those exchanged between princes themselves tended to be less standardised. One of the small group of surviving objects from Henry VIII's treasury described in the Introduction (pp. 2–4) falls into this category, because it was undoubtedly a diplomatic gift to a prince, in this case, a prince of the Church. The extraordinary silver-gilt and rock-crystal vessel in the Medici church of San Lorenzo in Florence (**Fig. 11**) has been in the church since 1532 and must have been a gift from the king to one of the two Medici popes, Leo X (1475–1521) or Clement VII (1478–1534). We have no record of when it left England but it could have been dispatched among the gifts to one or other of the two popes at the end of Cardinal Campeggio's (1474–1539) visits to London in 1518 or in 1527. It was not quite new at the time and its London hallmarks are for 1511–12, but being rock crystal rather than 'mere' silver gilt it would have been seen as a more prestigious gift than those normally given to ambassadors.

The most famous meeting of kings in the 16th century was that between Henry VIII and Francis I near Calais in June 1520, at the so-called Field of Cloth of Gold. The site is flat, featureless and unprepossessing and it requires a lively imagination to recreate any sense of the magnificence of this vast two-week extravaganza. The event was essentially a tournament, but the jousting was accompanied by great church services, feasting and, for Henry, the erection of an enormous temporary palace. The Field's sobriquet comes from the lavish use of costly cloth of gold, which was employed not only for clothes and wall hangings, but also to cover the inside and outside of many of the French and English tents. Each side was attended by up to 6,000 people and altogether the expense was colossal. On the English side alone, the costs of the event have been estimated as the equivalent of an entire year's normal expenditure of the Royal Household.

But the Field was much more than a sporting event. It was, in modern terms, a summit conference and at various stages came the exchange of presents. Carefully planned in advance, these were of three kinds: those that the kings gave to senior courtiers on the other side; those that English and French courtiers gave to each other; and, finally, the gifts between the sovereigns themselves.

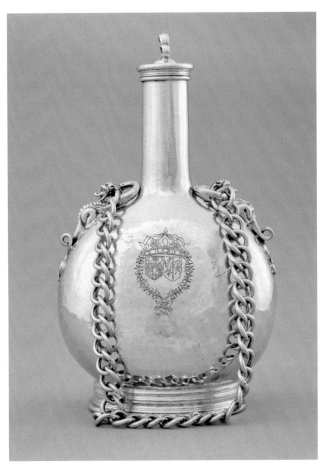

Figure 12 Flagon or bottle, Noël Delacroix, 1581–2, Paris, silver gilt, h. 30.8cm. Musée du Louvre, Paris, inv. no. MR561. Photo © RMN-Grand Palais (Musée du Louvre) / Stéphane Maréchalle)

The royal gifts to the courtiers were extraordinary. The Venetian ambassadors reported that Henry gave Bonnivet, Cardinal Wolsey's opposite number, jewels and gold plate worth 14,000 crowns; to the duc de Bourbon, Constable of France, he gave a jewelled gold cup worth 6,000; and to the Master of the Horse plate worth 2,800.[12] In return, Francis gave Wolsey gold 'vases' (a generic term for plate) worth 20,000 crowns, while Francis's mother, Louise of Savoy (1476–1531), gave him a jewelled crucifix worth 6,000. While 20,000 crowns, the equivalent of about £4,000, may sound exaggerated, it is probably correct. When Wolsey fell from grace in 1529 his property was forfeit to the king, and in addition to the many entries in the 1532 Jewel House inventory that reveal their provenance by their reference to 'Cardinal's hats' or 'the Cardinal's arms', there is a service of gold plate, all bearing friars' girdles (one of Francis's badges) and the arms of France.[13] This comprised the usual range of wares: covered bowls, basins, ewers (with serpent spouts) and flagons. Altogether the service weighed 1,583oz of solid gold. Adding in the cost of making, this would not have left much change from 20,000 crowns. We do not know what these objects looked like, but since the inventory only mentions the girdles and arms (and the dragon spouts), they were presumably otherwise relatively plain: perhaps something like a silver-gilt flagon, or bottle, of 1581–2 in the Musée du Louvre (**Fig. 12**).

The gifts in the second category – those exchanged between courtiers – were impressive too. Wolsey gave

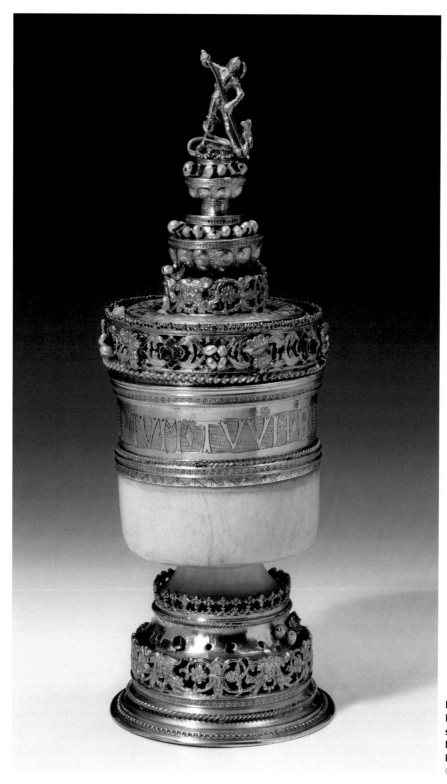

Figure 13 The Howard Grace Cup, 1525–6, London, ivory, silver gilt, pearls and precious stones, h. 27.3cm. Victoria and Albert Museum, London, M.2680:1, 2–1931. Given by Lord Wakefield, through The Art Fund. © Victoria and Albert Museum, London

Bonnivet 'a very large salt-cellar, all of gold, studded with a number of very beautiful jewels, and surmounted by a St George'.[14] None of these wonderous objects survives and we have no real idea what they looked like, but in the case of Wolsey's gift to Bonnivet we may have a stylistic clue in the San Lorenzo vase (**Fig. 11**) or the Howard Grace Cup in the Victoria and Albert Museum (**Fig. 13**). Made in 1525–6, the latter is silver gilt rather than gold and it is a cup rather than a salt, but it is encrusted with jewels and, most importantly, it is surmounted by a St George.[15]

The principal gifts between the kings themselves were all carefully planned in advance in order to ensure absolute

equality. They were not necessarily more valuable than the others, but they were certainly more varied. In keeping with princely convention, the two kings exchanged fine Arab horses and hounds. But they also exchanged other kinds of gifts. Henry gave a splendid sword to Francis. This was described as 'of the Spanish fashion, the pommel haft and chape of gold with a blue girdle well wrought upon with gold and the buckle pendant and other garnishings of gold and enamelled'.[16] 'Spanish fashion' suggests it could have been the same sword that Ferdinand II of Aragon (r. 1479–1516) gave to Henry in 1515, as part of a gift that Cardinal Wolsey had valued at 100,000 ducats.[17] Henry wrote to Ferdinand at

the time saying that 'great as the value of the presents is, he values them principally because they show [Ferdinand's] love and benevolence towards him.'[18] But that was then; five years later he had a more expedient use for it.

There was, however, an altogether more politically sensitive category of gifts and that was those that had *not* been planned. Princes often made spontaneous gifts to ambassadors, precisely because they were not equals. In 1514, for example, Henry impulsively took off his gown of cloth of gold and gave it to a visiting French nobleman,[19] and in 1532, when he happened to invite the French ambassador to join him on a visit to the Tower of London Jewel House, he equally suddenly and on a whim presented him with one of the finest cups stored there.[20] On neither occasion was any gift offered in exchange, nor was any embarrassment caused. But between monarchs this mattered more, because they *were* equals. One such occasion was when Francis decided to pay an unscheduled call on Henry at Guînes during the Field of Cloth of Gold. Henry was unprepared for the visit – indeed, he was not yet fully dressed – but he felt obliged to respond appropriately: 'Having embraced each other the king of England gave [Francis] a collar of jewels and pearls of great value.' Now it was Francis's turn to be wrong-footed. Presumably having nothing else to hand, he 'gave in exchange to the king of England his gold bracelets studded with jewels of great value, [then], doubting whether the gift was an equivalent for the present received, he sent in addition six coursers [jousting horses] of great price.'[21] The danger of spontaneous gifts in such circumstances was that it was not always possible to reciprocate equally.

Twelve years later the two kings met again, in Calais and Boulogne. This was quite a low-key event relative to the other, but it still involved magnificent gifts: those from Francis included six 'remarkably beautiful horses' and an extraordinary 'camp bed', bought at Paris (or Lyons – the sources differ). According to the French 19th-century historian P.A. Hamy, this cost 35,000 livres,[22] 'to say nothing of the curtains and their garniture.' Not only that, but he presented Anne Boleyn (*c.* 1500–1536) with a splendid diamond worth 15,000 or 16,000 crowns. The dukes of Suffolk and Norfolk did well too. They were given silver-gilt services and gold cups (rather like Bonnivet had received in 1518), and were also honoured with membership of the Ordre de Saint-Michel; other courtiers received gold chains. Altogether, Hamy claims that the French gifts cost no less than 100,000 livres, or about £10,000.[23]

In return, the English gave large sums of money to the French. There were also elaborate horse harnesses about which rather little is said but which might have looked quite like the great caparisons made for the Westminster Tournament in 1511 (**Fig. 14**).

This turned out to be the last time that Henry and Francis would meet in person. But gifts of all sorts were frequently exchanged from afar. Francis's tended to be quite imaginative. In 1526 he proposed sending Henry a shipload of wild swine because he had heard that there were few such animals in England and because 'the hunting of them was very pleasant [and] a king's game';[24] and in 1540 he suggested to Henry that, if it would interest him, he would be delighted to have casts made of certain classical sculptures

that he had acquired in Italy. He even offered to send him 'the pattern' of the decorations of Francesco Primaticcio's (1504–1570) gallery at Fontainebleau.[25] Quite how such condescending generosity went down we do not know for sure.[26] Then there were the more valuable gifts of goldsmiths' work and works of art. In 1544, for example, on the brink of war with England, Francis dispatched 'a very excellent and wonderfully rich ring … for a present to the queen of England or the king's daughter.' This was a coded bid for peace – unsuccessful, as it turned out – and the writer added 'God grant that it may be agreeable to the king in order that Christendom may rest in peace.'[27]

Two gifts that aroused much comment were a clock given by Francis to Henry in 1531 and an extraordinary pair of portraits in 1526. The clock was described as 'a very ingenious clock, showing the movements of the spheres and the course of some of the planets.'[28] The portraits intrigued a Venetian who happened to see them and he described them in great detail. Each was essentially a diptych, with a finely worked gold cover, opening to reveal a painted miniature, one of Francis and the other of his two sons. The image of Francis faced a beautiful *impressa* of two columns separated by water but joined at the top, with a Latin motto to the effect that the two lands separated by sea are joined by friendship. The writer goes on to say that 'it would be difficult to express the delight these gifts caused his majesty, for the demonstration was extreme.'[29] The gift was almost certainly in thanks for Henry's role in securing Francis's release from captivity after the Battle of Pavia, but it would have conveyed an obligation of its own, apparently repaid by Henry's gift to Francis six months later of a double portrait of himself and Princess Mary. This went down very well and Francis wrote to Henry that he 'found it so perfect that it could not be more so'.[30] Even more telling is the account that Henry's envoy, Bishop John Clerk (d. 1541), wrote immediately after presenting the gift:

> at the first sight of the king's physiognomy he took off his bonnet, saying he knew well that face, and further, 'Je prie Dieu que il lui done bone vie et longue' [I pray God to give him a good life and a long one]. He then looked at the Princess's, standing in contemplation and beholding thereof a great while, and gave much commendation and laud unto the same. He kept it for some time, without showing it to any creature, and then sent it by the Grand Master to his mother.[31]

It is in the context of such gifts that we come to the object that is the principal focus of this publication, the so-called Royal Clock Salt. The piece itself, its complex ornament, attribution and altered condition are all discussed in detail elsewhere in this volume and I confine myself here to the question of how it came into Henry VIII's possession and the degree to which it represented his taste.

We are unlikely ever to know whether the Clock Salt really was a gift from Francis to Henry, as has generally been supposed since its emergence in 1967. Hamy mentions nothing like it and we have no compelling reason for believing it was given in 1532, nor would it appear to answer to the 'ingenious clock, showing the movement of the spheres' given in the previous year, unless its changes were a good deal more extensive than we think. Nevertheless, from what we know of the gifts that Francis *did* give to Henry, we

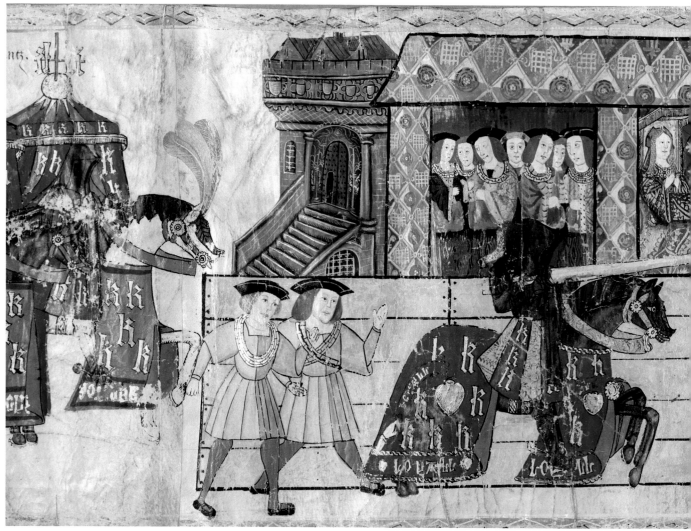

Figure 14 *Henry VIII Breaking his Lance in a Joust*, from the *Westminster Tournament Roll*, 1511. College of Arms MS Westminster Tournament Roll, membranes 25–6. Reproduced by permission of the Kings, Heralds and Pursuivants of Arms

can at least say that the Clock Salt would not have been out of character with them, in virtuosity, richness or inventiveness. Moreover, that Henry had a predilection for such intellectually engaging objects is clear from the fact that no fewer than 12 clock salts are listed in the 1547 posthumous inventory of his possessions,[32] and Francis's awareness of this is clear from his gift in 1531. But equally, royal gifts were by no means the only avenue through which Henry accessed luxurious French works of art. Indeed, it is known that he paid huge sums for costly jewels and works of art from French merchants when he was in Calais, and it is possible that this was one of his many purchases.[33] These were normally described at the time simply as 'jewels' but this is a term that had wider application than precious objects of adornment and referred to any virtuoso or jewel-encrusted goldsmiths' work.

Regardless of how it arrived in England, we know that the Clock Salt *was* here – almost certainly – by the time of the 1547 inventory[34] and as such it performed a role that often fell to diplomatic gifts, namely the transference of style from one culture to another. Aware though Henry and the English court were of Italianate fashions, France was ahead of the game. Francis and his predecessors, Charles VIII (r. 1483–98) and Louis XII (r. 1498–1515), had all led military expeditions into northern Italy and, as a result, had had

direct experience of Italian art, whereas Henry had not. Francis was also more successful in attracting Italian artists to his court, such as Leonardo da Vinci (1452–1519), Rosso Fiorentino (1494–1540) and Francesco Primaticcio (1504–1570). A greater coup still lay ahead in the person of Benvenuto Cellini (1500–1571). Henry's direct contact with French art and design in 1520 and 1532, and through sophisticated objects such as the 'ingenious clock' and the Pierre Mangot Clock Salt, helped focus artistic patronage and kept the English court in touch with Continental developments. Whatever shifts towards Renaissance style were already taking place in England were undoubtedly accelerated in this way. No one would question Holbein's genius as an artist or a designer, but it is hard *not* to see the influence of an object like the Clock Salt on his slightly later design for the Seymour Cup, probably made in 1536 (see **Fig. 80**). The two objects, of course, are quite different, but the decorative vocabulary is strikingly similar (see Chapter 5).

Before we leave the subject of presents and turn to other ways in which the monarchs could show each other favour, one more object might be mentioned as a possible gift from Francis to Henry. The 1547 inventory is the first and only glimpse we are afforded of the extraordinarily closed and inaccessible world of the privy chamber. This, as its name implies, was the private preserve of the king to which only

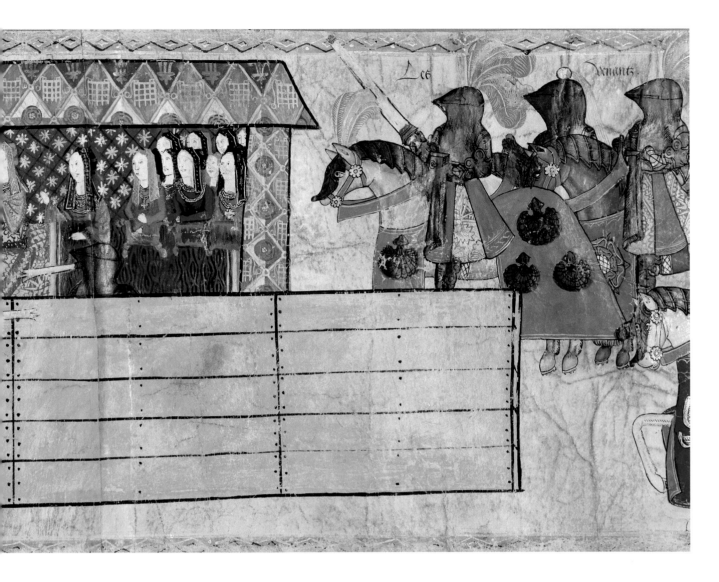

intimate servants and favoured courtiers had any hope of admission. Certainly, it was beyond the reach of foreign ambassadors and others on whom we depend for the most colourful accounts of Tudor court life. One of the first objects described is very striking:

> There is set into the wall in the privy chamber a thing artificially made like a rock wherein is many devices of 'friers' and diverse other things having in it a fountain of alabaster which is sore decayed and upon the top of the fountain a round ball of crystal wherein was three heads of gold which are gone and xiij stones made like heads also gone which are supposed to be cameos being set about in a border every one of the compass of a groat all which fountain and rock is locked up with two leaves like windows the which leaves are garnished with pearl and gold thread pearled.[35]

The inventory description was probably not written until some years after Henry's death, possibly as late as 1550,[36] and the object seemed no longer to have been in the best condition: the fountain was 'sore decayed' and various gold and stone heads were 'gone'. But it must have been an amazing work of art, made, apparently, in the form of a triptych, 'locked up with two leaves', or wings, that could be closed over the fountain but which were lavishly decorated with pearls and gold embroidery. The clues to its provenance are 'many devices of friers'. This is a strange term, suggesting the friar's girdle motif that was one of

Francis I's badges and which decorated the gold vessels given by Francis to Wolsey at the Field of Cloth of Gold. Could this extraordinary confection have been a gift from Francis?

Two other kinds of gifts between the two monarchs should be mentioned: christening presents and membership of each other's chivalric orders. Henry stood godfather to two French royal children: in 1519 to the dauphin and in 1546 to a child of the next generation. Both occasioned special gifts and ambassadorial missions. On the first the York herald was dispatched with a salt, a cup and ewer, all of gold, for Sir Thomas Boleyn (1477–1539), the resident ambassador, to present on behalf of the king. These were standard christening gifts from godparents of such elevated rank and when Louis XII performed the same office to the short-lived Prince Henry in 1511 his gifts had been of exactly the same forms. But the 1519 presents were much praised and Boleyn reported Francis as saying that 'whenever it shall be the king's fortune to have a prince, he would be glad to do for him in like manner.'[37]

The 1519 christening came at a time of fundamentally good relations between the two countries, but the circumstances in 1546 were very different. Peace had just been concluded after an expensive and acrimonious war. As a result, the birth of Francis's grandchild was an opportunity to seal their restored amity and Henry sent a high-level delegation bearing valuable presents. These were described

by the imperial ambassador to France as a gold-mounted jasper cup, a clock with a crystal cover and a gold salt cellar. The latter had a gold stand and a cover chased with stags and other animals.[38] Two of the presents were of the traditional form, a cup and a salt, but one, the clock, departed entirely from precedent. Moreover, the decoration and the inclusion of costly hardstones imply if not an exceptional artistic level then at least a move away from routine royal gifts of plate.

The exchange of the two chivalric orders – the Garter and Saint-Michel – was the highest honour that the two kings could confer on each other. Reciprocity was essential and called for synchronicity. The process was instigated by Francis in August 1527, when Wolsey was attending the French king at Amiens a little before the great celebrations at Greenwich that we have considered already. Wolsey reported to Henry that Francis

> entered into communication of the perpetual peace between your majesties; and, holding the image of St Michael, which he had on his neck, said 'Now the king my brother and I be thus knit and married in our hearts together, it were well done, it seemed, that we should be knit *par colets et jambe*, alluding to the Garter.'[39]

Wolsey wrote that 'it is for your majesty to decide whether this interchange of orders would be advisable'. Henry clearly decided that it was and the exchange duly took place in October. Sir Anthony Browne (*c.* 1500–1548) attended the ceremonies in France and reported to Henry, less than graciously and perhaps less than truthfully, that he saw in it 'nothing to be praised. They follow the fashion of your order but fail in everything.'[40]

When Henry VIII died in January 1547 Francis I was said to have been moved to tears by the news and died himself just a few months later. The relationship between them, while often fractious, was special. It was fuelled by a long history of enmity between the two nations and heightened by a personal rivalry that was conditioned by their similar age and ambitions. This rivalry undoubtedly gave an edge to the sorts of personal gifts that they exchanged throughout their reigns. But underlying this was a well-established set of conventions concerning the appropriate kinds and values of gifts that should be given to foreign ambassadors. Set against these, the majority of cross-channel diplomatic gifts exchanged during the two kings' reigns were entirely conventional.

Notes

1 *LP*, vol. 16, no. 276.
2 *CSP, Venetian*, vol. 4, no. 105.
3 Hall 1904, vol. 2, 360. For a fuller account of these banquets, see Schroder 2020, 98–100 and 135.
4 Aristotle 2004, 83, lines 24–7; 85, lines 28–31.
5 *LP*, vol. 21, part 2, no. 190.
6 Hall 1904, vol. 1, 172.

7 There are several reasons for thinking so: a number of pots in the 1521 Jewel House inventory are described as 'feather fashion'; the form of the 1660 pots is more typical of the early 16th than the mid-17th century; and the thumbpiece, formed as a double fruit, is exactly like one of the more commonly found 16th-century patterns.
8 The king's book of payments, *LP*, vol. 2, p. 1479 (October 1518).
9 *LP*, vol. 7, no. 1436.
10 *LP*, vol. 7, no. 1507.
11 *LP*, vol. 7, no. 14.
12 *CSP, Venetian*, vol. 3, no. 94. The exchange rate at the time was about five crowns to the pound.
13 The inventory is arranged under types of wares and the various parts of the service are scattered around the document, but the references to its decoration and the fact that it was all of gold suggest that they were *en suite*.
14 *CSP, Venetian*, vol. 3, no. 94.
15 The San Lorenzo vase and the Howard Grace Cup both incorporate much older vessels that give them a somewhat atypical profile.
16 See Hayward 2007, 376, A309.
17 *CSP, Venetian*, vol. 2, no. 653.
18 *CSP, Spain*, vol. 2, no. 231.
19 *CSP, Venetian*, vol. 2, no. 482.
20 According to the report of the imperial ambassador, Eustace Chapuys (*c.* 1490/2–1556) (*CSP, Spain*, vol. 4, part 2, no. 1033).
21 *CSP, Venetian*, vol. 3, no. 77.
22 About £3,500.
23 Hamy 1898, 72–3.
24 *LP*, vol. 4, part 1, no. 2481.
25 *LP*, vol. 16, no. 276.
26 Henry thanked Francis for the offer (*LP*, vol. 16, no. 318) but it is not known if it was taken up.
27 *LP*, vol. 19, part 1, no. 553.
28 *LP*, vol. 5, no. 187.
29 *CSP, Venetian*, vol. 3, no. 1451.
30 *LP*, vol. 4, appendix, no. 110.
31 *LP*, vol. 4, no. 3169.
32 Starkey 1998, nos 92, 96, 100, 1353, 1356, 1365–7, 1376, 1384, 1413 (2).
33 On 4 November the king authorised payments of about £740 to four French jewellers, and on the following day £1,749 4s 8d to 'Allard Plymmer the jeweller for such jewels as the king's grace bought of him at Calais' (Nicholas 1827, 270–1).
34 The inventory was commissioned after the king's death in 1547 but not completed until 1551 (see Starkey 1998).
35 Starkey 1998, no. 16922.
36 Immediately after the king's death the privy chamber was sealed off on the orders of John Dudley, 1st Duke of Northumberland (1504–1553. For a further account, see Schroder 2020, 299–314.
37 *LP*, vol. 3, part 1, no. 289. A barbed comment, it seems, since Francis was well aware that Henry's continued failure to father a prince was a point on which he must have been highly envious of Francis.
38 *CSP, Spain*, vol. 8, no. 294.
39 *LP*, vol. 4, no. 3350.
40 *LP*, vol. 4, no. 3472.

Chapter 2
For the Honour of the King: Some Thoughts on the Function of *Objets d'Art* at the French Court of Francis I

Paulus Rainer

In the 1530s, around the time that Pierre Mangot (*c.* 1485–after 1551), goldsmith to King Francis I (r. 1515–47), was creating the work of art that we now know as the Royal Clock Salt, his employer made enquiries in other directions with a view to acquiring various remarkable and distinguished pieces. From a Flemish goldsmith he ordered a golden goblet to feature as the crowning glory of a credenza on display at a political summit. In Toulouse he spotted an antique cameo that he was determined to possess at all costs, although this did not preclude its use for political showboating. The famous salt cellar, which Francis commissioned a decade later from his new *orfèvre du roy* (royal goldsmith), Benvenuto Cellini (1500–1571), fits into this group. Like the other pieces, it is highly complex, accomplished with the utmost technical and artistic skill, and practically unparalleled. As such, it also fulfilled a particular purpose within the political and diplomatic sphere when it was given to the House of Habsburg as a gift. All of these works of art, which are conceptually comparable with the Royal Clock Salt and probably share its provenance, are now in the Kunsthistorisches Museum in Vienna. Examining them may shed some light on the shared context in which they were produced, on their sociocultural setting at the French court and, not least, on the collecting endeavours of Francis I. With regard to the last, Francis's aspirations and understanding of art are of principal interest, as they are indicative of the appreciation of art that existed at that time, particularly on the part of a ruler, and ultimately shaped the genesis of the Royal Clock Salt. In this respect, this chapter aims to reveal whether and to what extent the objects in question may be regarded as kindred spirits of Mangot's extraordinary creation.

> The King being satisfied with my work, returned to his Palace, and left me loaded with so many favours as it would take a long time to relate. The next day at dinner-time he sent to summon me. The Cardinal of Ferrara was present who was dining with him. When I came in the King was still at the second course. Upon my approaching His Majesty, he immediately began to chat with me, saying that since he had so fine a basin and so beautiful an ewer of my workmanship, as company for these things he demanded a fine salt-cellar, and that he wished that I would make a design for it; but that he would like to see it soon.[1]

There is plenty that we can read into these lines written by Cellini, arguably the greatest goldsmith, yet possibly also the biggest braggart, of the early modern age, as they give an insight on everything from Cellini's work on behalf of the French king to his self-perception as a Renaissance artist, and even the nature of banquets at the French court. For our present purposes, however, one particular point stands out. This short passage gives us a glimpse of how commissions might have been awarded at the French court of Francis I, at least according to the artist. The king is said to have summoned his goldsmith during dinner, simply to issue an order for a salt cellar. This was reportedly the starting shot for the creation of the *Saliera*, the golden salt cellar now in the collection of the Kunsthistorisches Museum in Vienna and which is one of the most remarkable pieces of goldwork from the early modern age (**Fig. 15**).[2] But did the king issue this command on a mere whim, the idea having suddenly occurred to him as he dined? Or had his conversation with

Figure 15 Benvenuto Cellini, *Saliera*, 1542–3, Paris, gold, enamel, ebony, ivory, h. 26.3cm w. 21.3cm, l. 32.8cm. Kunsthistorisches Museum, Kunstkammer, Vienna, inv. no. KK 881. Image © KHM-Museumsverband

Ippolito II d'Este (1509–1572) sparked the idea? The latter, in Cellini's report described as the 'Cardinal of Ferrara', was also well known to Cellini. It was he who had campaigned for the artist's release from house arrest, which had been imposed by papal command, and he who had brought the Florentine artist to the French court, thus enriching the Italian 'crew of artists' in Paris and Fontainebleau. Cellini had already made a model of a salt cellar for Ippolito back in 1540. Therefore, could Ippolito perhaps have been the one behind the order to create the *Saliera*, having put the idea into the king's head at dinner? Or could the king simply have wanted to see the completion of an existing design? The answer remains unknown.

What we *do* know – if we are to believe Cellini – is that the king commissioned this work of art while dining. Before work on it proceeded, however, he would have wanted to see a design, and as soon as possible. Patience is not thought to

have been one of Francis's virtues when it came to art. Moreover, things had to run according to his own ideas and correspond with his vision, rather than relying solely on the artist's creativity. This is certainly the impression that can be gleaned from these few lines. On this occasion, the king is the one firmly holding the reins, demanding the highest standards, yet appearing to extend the necessary magnanimity when it came to the artist's fulfilment of them. Ippolito d'Este, on the other hand, was reluctant for the commissioning of the *Saliera* to go ahead, having heeded his adviser Gabriele Cesano (1490–1568), who regarded this project as 'work which could not be completed in the lifetime of ten men'.[3] Ippolito expressed his reservations when Cellini finally presented the design, in the form of a wax model: 'Sire, this is a very great work; however, I would not be suspicious of anything except that I do not believe that we shall ever see it finished.'[4] Francis took a different view,

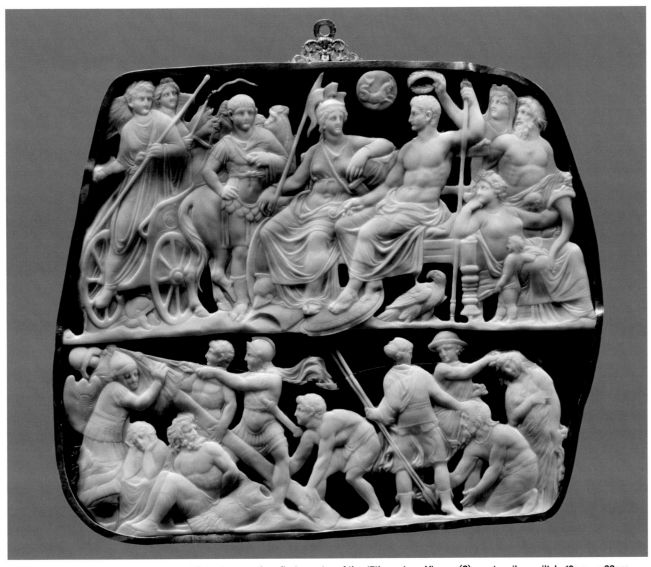

Figure 16 *Gemma Augustea*, Roman, AD 9/10–12; mounting: first quarter of the 17th century, Vienna (?), agate, silver, gilt, h. 19cm, w. 23cm. Kunsthistorisches Museum, Vienna, Collection of Greek and Roman Antiquities, inv. no. IXa 79. Image © KHM-Museumsverband

'saying that whoever looked so narrowly after the end of a work, would never begin anything; and he said this in a special manner, indicating that such works as these were not suited to men of small enterprise.'[5] He had no such doubts and wanted this work, which he considered to be 'one hundred times more divine' than he had imagined it,[6] to be executed in gold. This may reflect the view that the status of a work of art should be equivalent to the rank of its owner: an expectation that great art should lie in the possession of great men. For Francis I, art had to meet this expectation. Certainly, we would see the genesis of the *Saliera* in this light were we to accept Cellini's account of events. But maybe this was just the overweening exaggeration of an artist hungry for recognition, who thus presents himself as being on an equal footing with the king, laughing and joking at the monarch's table. Whether things actually happened as he describes, or whether this is a bit of literary licence applied in the context of the *paragone* debate,[7] which was still raging, cannot be determined. After all, we only have the artist's version of events, written down in retrospect, some two decades after they occurred, and, moreover, recounted at a time when he was smarting from insults, a lack of acclaim and recent humiliation: Cellini had been sentenced for the

crime of sodomy and had lost his Florentine citizenship.[8] As such, we cannot accept his statements with blind faith. The question of whether there is an element of veracity to the picture that he paints of his French patron can perhaps only be answered by looking at other works of art and their acquisition by Francis I.

Equal to the *Saliera* in sheer magnificence and no less significant to the history of art is a work in the Collection of Greek and Roman Antiquities of the Kunsthistorisches Museum, thought to be of French provenance: the piece known as the *Gemma Augustea* (**Fig. 16**).[9] Assuming that the oral tradition relating to the acquisition of this low-relief cameo chimes with the reality, it can grant us important insights into what such works of art meant for Francis I.

The *Gemma Augustea* was created in AD 9/10–12 and depicts the reception of Tiberius and Germanicus by Augustus after the victory over the Dacians and Pannonians.[10] In Vienna the cameo is first documented as part of the estate of Matthias, Holy Roman Emperor (1557–1619), in 1619, where it is listed as Number 900.[11] The exquisite agate cameo was thus part of the inheritance of the Habsburg emperors, having initially been acquired for the dynasty by Emperor Rudolph II (1552–1612). This

information relies on the testimony of the French polymath and collector Nicolas-Claude Fabri de Peiresc (1580–1637), who claims to have seen the cameo in Venice before Rudolph II purchased it for 12,000 gold coins ('*duodecim millibus aureorum*').[12] Delving further back into the history of this Roman work of art usually requires us to refer to the writings of Fernand de Mély (1851–1935), who identified it as the famous 'Camasiel' or 'Camayeul' from the abbey of Saint-Sernin in Toulouse. He set out the initial proof of identity in the *Gazette archéologique* in 1886, which provides the oldest known inventory evidence for the cameo.[13] In an inventory from Saint-Sernin dated 14 September 1246 the cameo is listed as being in the sacristy ('*In sacrastania est quidam lapis preciosus qui vocatur Cammaheu*').[14] While this identification is considered to be reliable, we still do not know how the treasure made its way to Toulouse. However, it seems plausible that it came to France from Constantinople.

There is another legend that surrounds the cameo , according to which it was found by the biblical Joshua in the wastes of Ethiopia. From there he supposedly took it to Jerusalem, where it cracked in two at the moment of Christ's death. The story goes that Charlemagne (768–814) himself wore it as a breastplate after his purported journey to Jerusalem, or even after performing a crusade, before giving it to the abbey.[15] The fact is that Charlemagne neither travelled to Jerusalem nor took part in a crusade, yet the legend thus explains the presence of the cameo at the abbey, while at the same time justifying the adoption of this heathen work of art within a Christian setting, and forging a connection between the piece, the Passion of Christ and the Holy Roman Emperor.

As the interest in the rediscovery of classical antiquity grew during the Renaissance, this legend waned in prominence, while the work of art itself returned to the spotlight. The first detailed descriptions date from the mid-15th century. In his *Trattato di Architettura*, Antonio Averlino (known as Filarete) (*c.* 1400–*c.* 1469) refers to it as one of the most remarkable things he has ever seen ('*una delle più degne cose ch'io abbia veduto*').[16] He is not, however, writing about the original, but a plaster cast that he had seen and held. He describes it as a square, each side a third of a *braccio*, and mentions the crack ('*grande un terzo di braccio per ogni verso, e anche si vede essere un poco rotta*').[17] He states that it commemorates a victory ('*trofeo*') and features around 24 figures ('*circa di ventiquattro figure d'ogni ragione, d'ogni qualità: figure d'uomini, di femmine, vecchi, giovani, puttini, armati, cavalli, a sedere, ritti e in vari atti e maniere*').[18] Filarete also tells us that this masterpiece is said to have belonged formerly to the duc de Berry (1340–1416), and that it was currently in the sacristy of the main church in Toulouse. Apart from the reputed provenance from the estate of the duc de Berry, which has not yet been confirmed, the description tallies with the *Gemma Augustea* so precisely that there is simply no question it can refer to anything other than the cameo.[19]

From Toulouse we learn that from 1453, at the latest, this precious work of art was stored in an iron coffer protected with four locks. The keys to these locks were held by the abbot, the prior, the city council and the royal procurator.[20] Various attempts to acquire the cameo were resisted over the

years. In 1470 Pope Paul II (1417–1471) apparently sought to purchase it, offering to have a stone bridge built over the Garonne for the city in return, as well as a sum of 50,000 écus,[21] but to no avail, as the treasure remained secure in the abbey. Up until 1533, that is, at which point our story takes a turn. This was the year in which Pope Clement VII (1478–1534) and Francis I met in Marseilles to negotiate the marriage contract between Catherine de' Medici (1519–1589) and Henry de Valois-Angoulême (r. 1547–59). In other words, it marked the betrothal of the Pope's great-niece and the second-born son of the French king, later Henry II of France. On his way to Marseilles, Francis visited the treasury of Saint-Sernin in Toulouse, where he was so taken with the *Gemma Augustea* that he asked the monks at the chapter house and the city officials to give him the cameo. This did not go down well with the cameo's guardians in Toulouse, who exhausted every diplomatic avenue in their attempts to evade the monarch's wishes. Their initial strategy was to appeal directly to the Pope, as without papal dispensation the precious piece could not be removed from the abbey. However, the king let it be known that he wanted the cameo to show to the Pope when they met, which would have increased his odds of obtaining papal permission. Next, there was the pretext of the key: the coffer was sealed with four different locks, each held by two secular and two clerical dignitaries. For various reasons, not all of the keys could be summoned up,[22] resulting in further delays to the retrieval of the piece and its transportation to Toulouse. Eventually, the royal request became an order. On 7 November the king commanded that the cameo be sent to Marseilles. Its keepers finally ceded to the request and dispatched the cameo to Marseilles on 11 November.[23] Ultimately, however, the king did not show or even have the opportunity to present it to the Pope, for the simple reason that, by the time the cameo arrived in Marseilles on 14 November, the Pope had already been gone for two days. As such, he never saw this impressive antique work, nor could he accept it as a gift. The cameo subsequently appears listed in the inventory of the Cabinet du Roy in Fontainebleau. Its former owners in Toulouse seem to have remained under the illusion that the cameo had gone on to Rome with the Pope's retinue. Instead, the French king had acquired it for himself; it had become the property of the Crown. This is the story that has been accepted as largely proven ever since the research conducted by Fernand de Mély in the late 19th century.

If we scrutinise this account of events carefully, however, it becomes evident that it contains a number of weaknesses. Strictly speaking, we cannot actually prove that the cameo was in the possession of Francis I – at least, not directly. We first come across it in the inventory of the valuables of the Cabinet du Roy in Fontainebleau in 1560–1,[24] which was compiled 13 years after the king's death. Under Number 379 in the most cited version of this inventory, transcribed by Paul Lacroix (1806–1884), we read: '*Un grant tableau d'agathe, taillée en camahieu anticque, feslée par la moité, enchâssée en cuivre, que l'on dit estre venu de Jherusalem, estimé VI*' (A great slab of agate, carved in antique cameo, cracked half through, set into copper, which is said to be come from Jerusalem, reckoned VI).[25] This entry might well make us wonder whether it can refer to the *Gemma Augustea* at all. It talks

about a cameo that is said to have come from Jerusalem with a crack in the middle, in a copper frame. Its value is given as 6 écus. By way of comparison, under Number 107 in the same inventory we also find the aforementioned *Saliera* by Cellini, which is assigned a value of 924 écus.[26] Why would the cameo that Francis I had devoted so much cunning and perseverance to obtaining be given a value 150 times lower than that of his golden salt cellar? This is a striking discrepancy, even in spite of the decidedly higher material value of the gold vessel. Moreover, the stated provenance of Jerusalem does not fit with the *Gemma Augustea*, unless it was based on the fictitious origin given in the legend.

De Mély had similar misgivings and came to various conclusions as a result. In a postscript to his first report in 1886, he notes that Lacroix's transcription may have contained a copying error, with the provenance actually being Toulouse.[27] A quick glance at the two inventories reveals that de Mély was right. Both inventories use an abbreviation for the city of Toulouse, which was later incorrectly understood to mean Jerusalem, and transcribed accordingly.[28] An examination of the inventory also eliminates the second area of doubt: the low estimated value of the cameo. In fact, the cameo was valued at not 6 but 600 écus: a little 'c' above the six was simply overlooked. This stands for one hundred, which is then multiplied by the six. In this light, therefore, it is clear that the inventory entries refer to a large, classical agate cameo that is said to have come from Toulouse, with a crack in the middle and valued at the not inconsiderable sum of 600 écus – plus a copper frame of no material value. All of this now fits much better with the *Gemma Augustea*, confidently dispelling the aforementioned doubts. Yet, there remain a few gaps in the biography of this object – for example, its journey from Fontainebleau to Prague, via Venice, which probably took place between 1590 and 1600 – that have yet to be filled.[29]

For our present purposes, however, this is of little importance, as we are only concerned with the means by which the *Gemma Augustea* came into the possession of Francis I. In view of the references discussed above, we are inclined to accept this understanding of events as probable, as it fits with the picture of Francis as a collector.

In order to elaborate on this a little more, it is worth looking at another work of art from the collections of the Kunsthistorisches Museum in Vienna, and which is also listed in the inventory of the Cabinet du Roy from 1560–1. Under Number 109 we read: '*Une grande couppe dor garnie de festons et enrichie de pluisieurs perles rubiz, et diamantz, avec son couvercle et ung s.ct Michel dessus aussi enrichy de diamantz, et de quelques perles dont il, en deffault six de celles qui pendent pesant nf marcz, une once, estimeé XVc LII*' (A great goblet of gold garnished with festoons and enriched with several pearls, rubies, and diamonds, with its lid and a Saint Michael above also enriched with diamonds, and some pearls of which, in default six of those hanging down weighed nine marks, one ounce, reckoned XVc LII).[30] This description is so specific that there can be little doubt it relates to the piece known as the St Michael's Goblet (**Fig. 17**). In addition, in the version of the inventory held at the Bibliothèque de l'Arsenal, the entry comes with a marginal note stating that the goblet was taken out of storage to be given to Archduke Ferdinand II

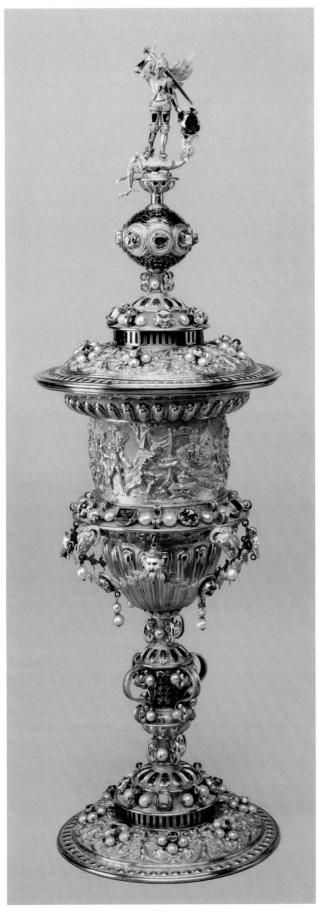

Figure 17 Joris Vezeleer, St Michael's Goblet, 1532, Antwerp, h. 51.7cm, weight 2,490g. Kunsthistorisches Museum, Vienna, Kunstkammer, inv. no. KK 1120. Image © KHM-Museumsverband

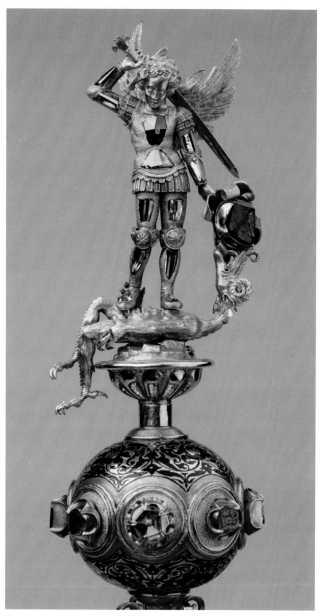

Figure 18 Joris Vezeleer, St Michael's Goblet, 1532, Antwerp, detail showing St Michael. Kunsthistorisches Museum, Vienna, Kunstkammer, inv. no. KK 1120. Image © KHM-Museumsverband

Figure 19 Jean Fouquet, title page of the *Statuts de l'ordre de Saint-Michel*, c. 1469–70, detail showing a collar of the order with St Michael fighting the dragon. Bibliothèque nationale de France, Paris, Département des Manuscrits, Français 19819, fol. 1r. Image: Bibliothèque nationale de France

(1529–1595) as a token of thanks for representing King Charles IX (r. 1560–74) at his marriage to Elisabeth of Austria (1554–1592).[31] Together with the *Saliera*, the Burgundian Court Goblet and the Onyx Jug,[32] the goblet made its way into the Central European Alps in 1570, pausing at Ambras Castle before proceeding to Vienna.[33] In the French inventory of 1560–1 the St Michael's Goblet was valued at the colossal sum of 1,552 écus, making it the third most expensive object among the more than 800 works of art recorded at the Cabinet du Roy. Only a bejewelled gold cross and a gem-laden crown were assigned a greater value.[34] The reason for this high valuation is the materials from which the goblet is constructed. It is made of gold, richly decorated with pearls, sapphires, diamonds and emeralds: 2 emeralds, 27 rubies (or spinels), 88 diamonds and 123 pearls stud the gold surface. The crowning figure of St Michael, slaying the dragon, is alone adorned with 12 substantial, beautiful diamonds, and his shield with a big ruby.[35] This truly is a goblet fit for a king.

Thanks to the research conducted by Michèle Bimbenet-Privat, there is a wealth of detail about the object's history.[36] Through her studies, we know the goblet was one of 31 pieces that the Flemish goldsmith Josse Vezeler (Joris Vezeleer) (1493–1570) delivered to the French court in the 1530s (see Chapter 3, p. 51).[37] Vezeleer was not only a goldsmith, but also a collector and dealer with agents in Paris and Lyon. The French king seems to have used him repeatedly as a supplier, as he could deliver quickly and in large quantities, unlike his later court goldsmith, Benvenuto Cellini. Admittedly, Cellini was capable of creating visionary and completely unparalleled works of art, but he simply could not be relied upon: of the 12 life-size statues of the Roman gods that he was supposed to make for Francis I, for example, he only managed to complete *Jupiter* over the whole five years of his time in Paris.[38] By contrast, Vezeleer seems to have been reliable: a sought-after quality for clients looking to commission works of art for specific occasions. And it has been very convincingly demonstrated that the St Michael's Goblet, like other works of art supplied by the Flemish goldsmith, served a particular purpose: to be displayed on a credenza at a summit between two European kings. In October 1532 Francis I and Henry VIII (r. 1509–47) met in Boulogne-sur-Mer to negotiate what would later be set down in their agreement in Calais,[39] namely a treaty envisaging a military alliance against the Ottoman Empire. To mark the occasion, the refectory of the monastery of Notre-Dame was decked out as a state room. The walls were decorated with a series of tapestries portraying the story of Scipio Africanus (c. 236–c. 184 BC), who defeated Hannibal.[40] The royal table was crowned with a canopy depicting the allegorical figure of Charity, and a sumptuous, six-tier

credenza was positioned opposite it. The sides of the individual tiers were swathed in crimson, pearl-embroidered cloth, and gilded vessels and goblets were placed on top. The St Michael's Goblet was among these items, alongside others that Vezeleer had brought directly to Boulogne from Antwerp.[41]

It stands to reason that the design of such an exquisite goblet, which had been created especially for that occasion, would also contain some references to that particular moment. Nevertheless, this has not been determined beyond doubt, as the iconography of the goblet has still not been established conclusively. Ernst Kris goes only as far as to say that 'the depictions of the reliefs … are yet to be construed'.[42] John F. Hayward, meanwhile, merely states that the frieze on the goblet wall 'refers to the pleasure of drinking wine'.[43] Rudolf Distelberger points out a possible allusion to the myths of Icarius, Oeneus or Oenopion,[44] but is unable to offer a more precise interpretation. Michèle Bimbenet-Privat prefers to equate the scenes with episodes from the myths of Oeneus, but does not suggest how the scenes should be interpreted.[45] In contrast, the crowning figure on the goblet is easily identified as the Archangel Michael defeating Satan (**Fig. 18**). This is a reference to the fight of Christendom against the Ottomans and thus an allusion to the purpose of the very gathering for which the goblet had been fashioned.[46] At the same time, however, it also denotes the Ordre de Saint-Michel, which was founded in 1469 by Louis XI of France (r. 1461–83). The title page of the *Statuts de l'ordre de Saint-Michel* by Jean Fouquet (*c.* 1420–1481), dating from 1469–70, shows a collar of the order with a pendant featuring a St Michael fighting the dragon that is close in appearance to the figure on the goblet (**Fig. 19**).[47] The rest of the goblet design is very different from the crowning figure. Inside the lid we find a medallion depicting a female figure holding a horn of plenty, with vine tendrils sprouting from it. Kris has identified this figure as Pomona, the Roman goddess of fruitful abundance.[48] The scenes on the walls of the cup show a man sitting on a throne, wine being pressed and a reclining figure being served wine and food, to musical accompaniment (**Figs 20–2**). Could these images be scenes from the story of Icarius, whom Dionysus inducted into the art of winemaking as a reward for receiving the god with such hospitality? A Roman marble relief from the 2nd century BC, today in the Musée du Louvre in Paris,[49] bears at least a slight resemblance to the detail of the reclining figure on the St Michael's Goblet (**Fig. 23**). Or could these be scenes from the life of Oenopion, the son of Dionysus, who also learned winemaking from his father? Alternatively, we could even be looking at a depiction of Isaac blessing Jacob. There are similarities with that tale, at least at first glance.

Despite all of these possibilities, it is not possible to provide a definitive explanation of what is being shown in these scenes; the only thing that seems clear is that winemaking plays a key role, which seems fitting for a drinking vessel created for a spectacular credenza. However, if we now turn to the iconographic furnishings of the place where they were displayed, including the series of tapestries depicting Scipio and the canopy showing the Christian virtue of Charity, we are led to wonder whether

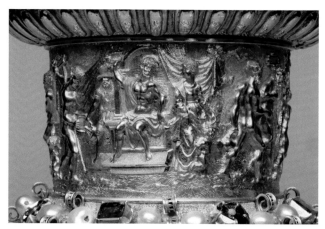

Figure 20 Joris Vezeleer, St Michael's Goblet, 1532, Antwerp, detail of enthroned figure. Kunsthistorisches Museum, Vienna, Kunstkammer, inv. no. KK 1120. Image © KHM-Museumsverband

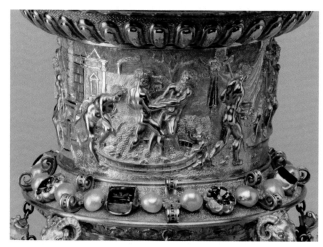

Figure 21 Joris Vezeleer, St Michael's Goblet, 1532, Antwerp, detail of wine press. Kunsthistorisches Museum, Vienna, Kunstkammer, inv. no. KK 1120. Image © KHM-Museumsverband

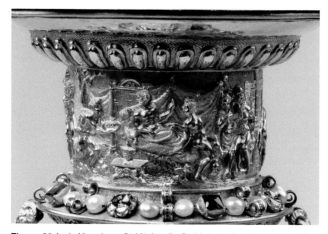

Figure 22 Joris Vezeleer, St Michael's Goblet, 1532, Antwerp, detail of reclining figure. Kunsthistorisches Museum, Vienna, Kunstkammer, inv. no. KK 1120. Image © KHM-Museumsverband

Figure 23 *Le festin d'Icarios*, Roman, 2nd century BC, marble, h. 79cm, w. 135cm. Musée du Louvre, Paris, Albani Collection, inv. no. MA1606. Photo © RMN-Grand Palais (Musée du Louvre) / Hervé Lewandowski

the emphasis on wine production also seeks to make a certain statement. Perhaps we might even conjecture – and this is, admittedly, something of a reach – that it is an allusion to the rumours that had been circulating about French wine barrels filled with gunpowder in the run-up to the first meeting between Francis I and Henry VIII at the

Field of Cloth of Gold.[50] It seems improbable, but Francis may have dared to make reference to it in the form of an erudite in-joke. Whatever the truth, it is impossible to come to a conclusion about the imagery. Ambiguity and ambivalence were characteristic of Mannerist art as it blossomed at the French court in the reign of Francis I, along

Figure 24 Benvenuto Cellini, *Saliera*, 1542–3, Paris, detail of elephant. Kunsthistorisches Museum, Vienna, Kunstkammer, inv. no. KK 881. Image © KHM-Museumsverband

Figure 25 Benvenuto Cellini, *Saliera*, 1542–3, Paris, detail of Vertumnus (?). Kunsthistorisches Museum, Vienna, Kunstkammer, inv. no. KK 881. Image © KHM-Museumsverband

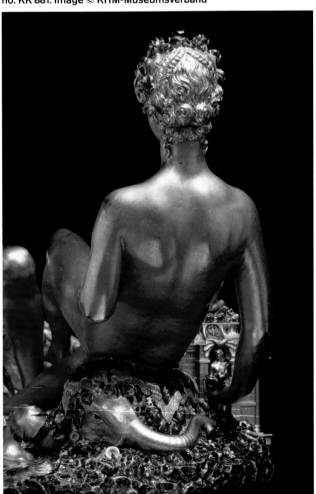

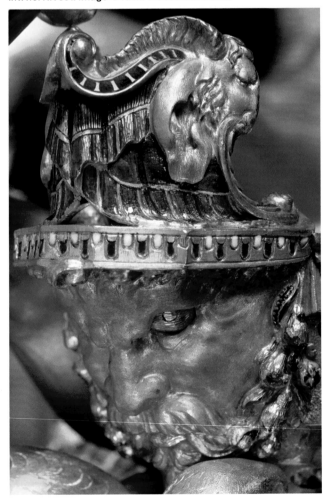

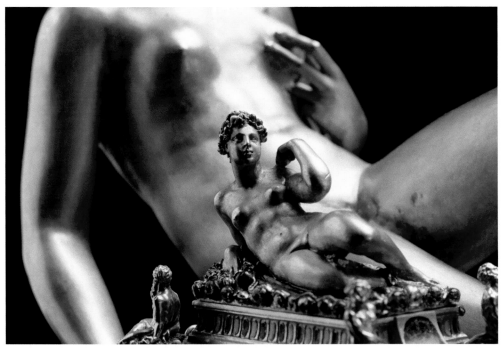

Figure 26 Benvenuto Cellini, *Saliera*, 1542–3, Paris, detail of Pomona (?). Kunsthistorisches Museum, Vienna, Kunstkammer, inv. no. KK 881. Image © KHM-Museumsverband

with an openness to a range of interpretations, something that is apparent from an examination of the furnishings of the Grand Galerie in Fontainebleau.

We could also describe Cellini's salt cellar as having this same 'complex ambiguity'. In terms of content, it plays with the contrasts between salt and pepper, water and land, man and woman, and all of the oppositions that arise from such dichotomies. In this case, however, interpreting what is shown is a much simpler task – indeed, the goldsmith himself shares the origins of his masterpiece with us in his autobiography. Here, as in his *Trattati* of 1568,[51] he offers us a way of understanding his portrayal:

> I made an oval shape of the size of well over half a *braccia* – almost two thirds – and upon the said shape, as though to display the Sea embracing the Earth, I made two figures considerably more than a palm in height, which were seated with their legs entwined one with another, just as one sees certain long arms of the sea which run into the land; and in the hand of the male figure, the sea, I placed a very richly decorated ship: in this same ship much salt could be well and conveniently placed; beneath the said [figure] I had arranged those four sea-horses; in the right hand of the said Sea I had placed his trident. The Earth I had made a woman of such beauteous form as I could and knew how, handsome and graceful; and in the hand of the said figure I had placed a temple rich and decorated, placed upon the ground, and she leant upon it with the said hand; this [temple] I had made to hold the pepper. In the other hand I placed a Horn of Plenty, adorned with all the beauties that I possibly knew. Beneath this goddess and in that portion that I showed to be [intended for] the earth, I had arranged all the most beautiful animals that the earth produces. Beneath the portion of the sea I had represented all the handsome kinds of fishes and little snails, that could be included within that small space: in the width of the remainder of the oval I devised many very rich ornaments.[52]

He expands upon this description elsewhere in his autobiography.[53] Even if some details differ from the actual execution, this is a rare case of an artist handing us the key

to interpreting his own work. We can certainly count ourselves lucky in this regard. Yet on closer inspection it soon becomes clear that, while Cellini tells us a lot of things, he remains silent about much else. Why, for instance, is the naked goddess representing the earth sitting on the head of an elephant – the very animal with which Francis I identified himself (**Fig. 24**)?[54] The person whose face is depicted on the stern of the salt ship is also a mystery (**Fig. 25**). Is it a self-portrait of the artist, as has been suggested?[55] Or could it be an allusion to Vertumnus?[56] And who is the reclining woman on the triumphal arch over the pepper container? Could she be the Nymph of Fontainebleau, or Pomona as a counterpart to Vertumnus, or even Pandora (**Fig. 26**)?[57]

There is a variety of possible answers to these questions, but ultimately they remain unresolved. After all, in many cases there is no one answer, but several. Ambiguity is an integral part of the concept, not only for the *Saliera*, but also, in all likelihood, for the St Michael's Goblet. Of course, this raises the question of whether the impetus for this ambiguity came from the artist or the one who commissioned the piece: a patron whose erudite taste and costly and artistically exquisite orders and acquisitions vied with those of other monarchs, and in particular his eternal rival, Charles V, Holy Roman Emperor (1500–1558). If he was the instigator of all this mysteriousness, what was the reason for it? Once again, the *Saliera* may hold the answer. When actually used at the table, such a salt cellar marked the place of the host or a person of honour, thus establishing a certain hierarchy. Yet the French king's salt cellar gave him the opportunity not only to set himself apart in terms of possessions and rank, but also to distinguish himself on an intellectual plane. The richly allusive design of the object, hinting at multiple meanings without committing fully to a particular one, allowed the king to elevate himself above those around him. Inviting the people at his table or in his company to look at and attempt to interpret it would inevitably culminate in a demonstration of his intellectual and scholarly superiority.

Given its complex content, the work of art could only be understood and its ambiguity deciphered once explained by the king.[58] This object, like other masterpieces owned by the king, thus manifests itself not only as an expression of royal power, an instrument of distinction, but also as a way of asserting his sovereignty of interpretation, which stems from his intellectual prowess. The king would become Alexander the Great (356–323 BC), cutting the Gordian Knot with the utmost ease. His superiority would be palpable to his interlocutors, thus reinforcing the sense of hierarchy then and there. Francis I may well have been completely aware of this in attaching so much importance and going to such lengths to commission and acquire outstanding works of art. In doing so, he was asserting his entitlement as monarch: the honour and glory of his office. In light of this, the question arises as to whether an almost equally complex creation – the Royal Clock Salt – should be seen in a similar context. For the moment, this question remains to be answered.

Notes

1 Cust 1910, vol. 2, 139.

2 For a recent discussion of the work, see Rainer and Haag 2018.

3 Cust 1910, vol. 2, 95.

4 Ibid., vol. 2, 140.

5 Ibid.

6 Ibid.

7 The *paragone* was a debate in the Italian Renaissance, comparing the qualities of painting and sculpture in order to define the supremacy of one art form over the other. Cellini was a vigorous advocate of the superiority of sculpture.

8 On 27 February 1557 Cellini was sentenced to a fine of 50 scudi, four years in prison and the loss of his rights of citizenship. See Trento 1984, 48 ff. In 1558 he began dictating his life story; see Rossi 2003, 305.

9 A comprehensive iconographical and historical portrayal can be found in Zwierlein-Diehl 2008, 98–123, 263–82.

10 For dating, possible attributions and interpretations, see Zwierlein-Diehl 2008, 268–82.

11 Inventory of the estate of the Emperor Matthias from 1619, in *Jahrbuch der kunsthistorischen Sammlungen des Allerhöchsten Kaiserhauses* 20(2), 1899, 65, no. 900.

12 Gassendi 1655, 111. See Meulen 1994, 177.

13 Mély 1886, 252.

14 Mély 1894, 67.

15 As reported in the Registres de l'Hotel de Ville de Toulouse. Zwierlein-Diehl 2008, 119.

16 Filarete 1972, 680: 'one of the most meritorious things that I have seen'.

17 Ibid.: 'a third of a *braccio* long on every side, and it is also seen to be a little broken'.

18 Ibid., 681: 'around twenty-four figures of every kind, of every quality: figures of men, of women, old, young, little putti, men-at-arms, horses, seated, standing upright and in various actions and fashions'.

19 If the eagle and three horses are counted among the figures, then 24 figures are actually depicted. The dimensions of 19cm x 23cm also corresponded to one-third of a *braccio*.

20 See Mély 1894, 70 ff.

21 Ibid., 74 ff.

22 Ibid., 75.

23 Ibid., 87.

24 *Inventaire des vaisselles et joyaulx d'or et argent doré, pierres, bagues et autres choses precieuses trouvées au cabinet du roy, à Fontainebleau*. There are two editions of this inventory in the Bibliothèque nationale de France in Paris: one in the Département des manuscrits, Français 4732, and one in the Bibliothèque de l'Arsenal, Ms-5163 réserve. Both editions list the agate cameo under Number 379.

25 Lacroix 1856–7, 452.

26 Ibid., 342.

27 Mély 1886, 253: '*il faut probablement lire "venu de Thoulouse"*'.

28 *Inventaire des vaisselles et joyaulx d'or et argent doré, pierres, bagues et autres choses precieuses trouvées au cabinet du roy, à Fontainebleau*, Bibliothèque nationale de France, Paris, Département des manuscrits, Français 4732, and Bibliothèque de l'Arsenal, Ms-5163 réserve, in each case with the following note under Number 379: '… *que l'on dit estre venue de Thle*'. The abbreviation starts with *Thl*, but the rest is not very clear. As a result, the 'T' was apparently misread as J (for Jerusalem). I am grateful to Michèle Bimbenet-Privat for pointing this possible confusion out.

29 Kähler writes that the cameo went astray in 1591, in the course of the Wars of Religion and the plundering of the Cabinet du Roy, whereafter it was sold to the Emperor Rudolph. He based this on Peiresc and Gassendi; see Kähler 1968, 22 and 34 n. 34. In fact, Gassendi writes: '*Achates est similiter, sed superiore nonnihil minor, quem Philippus Pulcher Pissiaci monialibus legaverat (cùm habuisset ipse ab Hierololymitanis Equitibus, illum in Palaestina nactis) quémque per bella civilia furto sublatum, Mercatores quidam detulerunt in Germaniam, ac divendiderunt Rudolpho secundo duodecim millibus aureorum.*' Gassendi 1655, 111.

30 *Inventaire des vaisselles et joyaulx d'or et argent doré, pierres, bagues et autres choses precieuses trouvées au cabinet du roy, à Fontainebleau*, Bibliothèque nationale de France, Paris, Département des manuscrits, Français 4732, fol. 6v, no. 109.

31 *Inventaire des vaisselles et joyaulx d'or et argent doré, pierres, bagues et autres choses precieuses trouvées au cabinet du roy, à Fontainebleau*, Bibliothèque de l'Arsenal, Ms-5163 réserve, fol. 6v, no. 109: '*A este prise lad couppe pour en fa present a monsieur larchiduc ferdinand en qsideration de ce quilfianca la princesse Elisabeth au nom de sa ma.te faict a Paris le xxiiie jour de sept 1570.*' See Lacroix 1856–7, 343 n. 1.

32 The *Saliera* (inv. no. KK 881), the Onyx Jug (inv. no. KK 1096) and the St Michael's Goblet (inv. no. KK 1120) are on display in the Kunstkammer of the Kunsthistorisches Museum in Vienna, while the Burgundian Court Goblet is in the treasury (inv. no. KK 27). For the provenance of the pieces, see Leithe-Jasper 1970, 227–42.

33 The journey that the pieces took from France to Vienna is described in detail by Konrad Schlegel (2018) with reference to the *Saliera*.

34 'Un croix d'or …' is listed in the inventories, under Number 3, with a value of 2,820 écus, while 'Une grande couronne d'or …' appears under Number 637, valued at 2,200 écus. See Lacroix 1856–7, 336, 525.

35 See also Tillander 1995, 79.

36 Bimbenet-Privat 1991, 127–35.

37 See also Bimbenet-Privat 2017–18, 298–306.

38 See also Pope-Hennessy 1985, 102.

39 Bimbenet-Privat 2017–18, 301.

40 Hamy 1898, 50.

41 Bimbenet-Privat 2017–18, 301.

42 Kris 1932, 21, no. 33.

43 Hayward 1976, 365, no. 289.

44 Bimbenet-Privat 1991, 129 fn. 10.

45 Bimbenet-Privat 2017–18, 304.

46 Ibid.

47 *Statuts de l'ordre de Saint-Michel*, Bibliothèque nationale de France, Paris, Département des manuscrits, Français 19819, fol. 1r.

48 Kris 1932, 21.

49 *Le festin d'Icarios*, Musée du Louvre, Paris, inv. no. MR 719 (MA 1606).

50 The preliminary arrangements for the meeting between the two rulers had been plagued by mistrust and suspicion; indeed, due to the rumours that the wine casks brought by the French actually contained gunpowder and that France was drawing troop contingents towards Calais, it risked failing altogether on a number of occasions. See Tauber 2009, 91.

51 Cellini 1568. Cellini describes his salt cellar on fol. 23r.

52 Cust 1910, vol. 2, 94 ff.

53 Ibid., 198 ff.

54 Prater 2018, 57.

55 Meller 1994, 15.

56 Karin Zeleny (2018, 121) opts for this reading of events – very convincingly, in my view – in her fictitious dialogue between Benvenuto Cellini and Giglio Gregorio Giraldi.

57 The latter interpretation is proposed by Helke 2018, 159–78.

58 Tauber 2009, 177.

Chapter 3
Pierre Mangot and Goldsmiths at the Court of Francis I of France

Michèle Bimbenet-Privat

Pierre Mangot (c. 1485–after 1551) was goldsmith to King Francis I of France (r. 1515–47) but was barely known to history until the 1990s.[1] Until then, he was only a name mentioned in the royal accounts, to whom almost no surviving work could be ascribed. He was just one among many other goldsmiths, including Jean Hotman (act. c. 1520–1543), Mathieu Marcel (act. c. 1510–c. 1545), Jean de Crêvecoeur (act. 1497–c. 1540) and Renaud Danet (act. c. 1520–1541).

In 1965 Ilaria Toesca (1928–2014), *soprintendente per i beni artistici e storici di Mantova, Cremona e Verona* (curator of Italian historic monuments in Mantua, Cremona and Verona), was the first historian to recognise the significance of an object that was later attributed to Mangot when she discovered a small casket on the top shelf of a cupboard in the sacristy of Mantua cathedral (**Fig. 27**).[2] It is made of mother-of-pearl plaques applied with silver-gilt fleurs-de-lis and superbly enriched by a silver gilt mount. As she searched for marks, Toesca realised that the casket was not Italian but from Paris, and precisely dated to 1533–4. By a process of comparison, she then identified three other pieces from the same workshop: a ciborium and two candlesticks, which were part of the treasure of the Ordre du Saint-Esprit, now in the Musée du Louvre, Paris (**Figs 28–9**).[3] By 1969 a distinctive corpus of work by a single goldsmith had begun to emerge. His identity, however, remained a mystery, as Toesca had read his maker's mark as a horizontal 'B' (**Fig. 30**), to which she could not match any known maker.

In 1974 John F. Hayward also attributed the unmarked Royal Clock Salt to the same goldsmith (see Chapter 6, p. 95).[4] This piece was already well known, having been listed in the English royal inventories since the 16th century. The Goldsmiths' Company of London acquired it and set about restoring it. Hayward added to this corpus a larger casket with plaques of mother-of-pearl, then in the collection of Michael Wellby and now in the Louvre (**Fig. 31**).[5] He was thus in a position to present for the first time six objects attributed to the mysterious goldsmith, which he published in his groundbreaking book, *Virtuoso Goldsmiths and the Triumph of Mannerism*.[6]

It was during research for my PhD on Renaissance goldsmiths in Paris that I realised the maker's mark was not a 'B' as previously suggested, but a Gothic 'M'.[7] I was then able to look for further information in the archives about this goldsmith, his life and his contacts with Francis I, and that is how Pierre Mangot was brought to life again for us all.

Pierre Mangot was first recorded in Blois, one of several towns that developed in the Loire Valley from the 15th century onwards when Charles VII (r. 1422–61), known as 'the little king of Bourges', moved his seat of power to the area at the end of the Hundred Years' War (1337–1453).[8] Numerous castles were built there by princes and, with the return of peace, these were transformed into residential palaces.[9] Creative industries such as goldsmithing were influenced in style by the work being produced in Paris, Flanders and Italy. As the main providers to the royal courts, the cities of Blois, Orléans and Tours, along with their merchants and goldsmiths, became wealthy. Traditionally, goldsmiths had followed the king to his various houses rather than having a fixed workshop in a

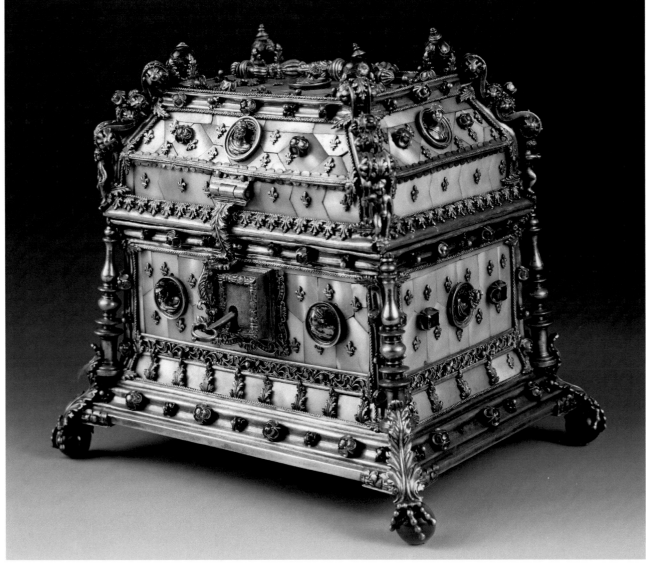

Figure 27 Pierre Mangot, small mother-of-pearl casket mounted in silver gilt, 1533–4, Paris, h. 13cm, w. 16cm, d. 13cm. Diocesan Museum, Mantua. Image © 2020. De Agostini Picture Library/Scala, Florence

particular town.[10] These craftsmen reached the height of their success when Louis, duc d'Orléans, became king of France as Louis XII in 1498 (r. 1498–1515).

Mangot's birthplace is unknown, but he was probably born into a family from Tours in about 1485–90 and became an apprentice to the royal goldsmith Henri Duzen in Blois.[11] He later settled in Blois and worked with Henri's son, Louis Duzen, and then married Louis's widow, Jeanne Boullyer. Queen Anne, duchesse de Bretagne (1477–1514), had herself commissioned Henri Duzen in 1506 to work on the superb silver-gilt and cornelian nef that she had been given by the city of Tours.[12] In accordance with the queen's wishes, Duzen provided the nef with its religious iconography. He added 12 gold and enamel figures representing St Ursula and the Eleven Thousand Virgins (**Fig. 32**). St Ursula's overdress of magnificent translucent, red enamel picked out in gold, exemplifies a technique of which Mangot would have been a master (**Fig. 33**), and its use here suggests he may have collaborated on this piece. A number of goldsmiths from Blois, perhaps including Mangot himself, were responsible for creating Queen Anne's reliquary after her death. This gold-and-enamel casket, which held her

heart, was transported to Nantes, her Breton home town, where it remains to this day.[13]

Mangot is not mentioned in the royal accounts until Louis XII's death in 1515, when he was commissioned, together with Louis Duzen, to repair and embellish with jewels the gold crown that was to be displayed on the king's funeral effigy.[14] From then until 1551, Mangot's name appears repeatedly (more than 70 times) in relation to various payments for work carried out for both Francis I and Henry II.[15] The majority are for items of jewellery or badges and chains of the Ordre de Saint-Michel, evidently reflecting the fact that Mangot was foremost a jeweller working with gold and a superlative master of enamelling and jewellery techniques. From 1528 onwards, upon his return from captivity in Spain after he was defeated by Charles V at Pavia, Francis I broadened his commissions and Mangot's workshop produced a wide variety of silver and gold plate, in addition to jewellery. As was expected of a goldsmith to the king, Mangot moved his workshop to Paris, which explains why the only marked pieces bear his Paris maker's mark, the Gothic 'M', with or without the Paris wardens' mark. Unfortunately, the archives of the

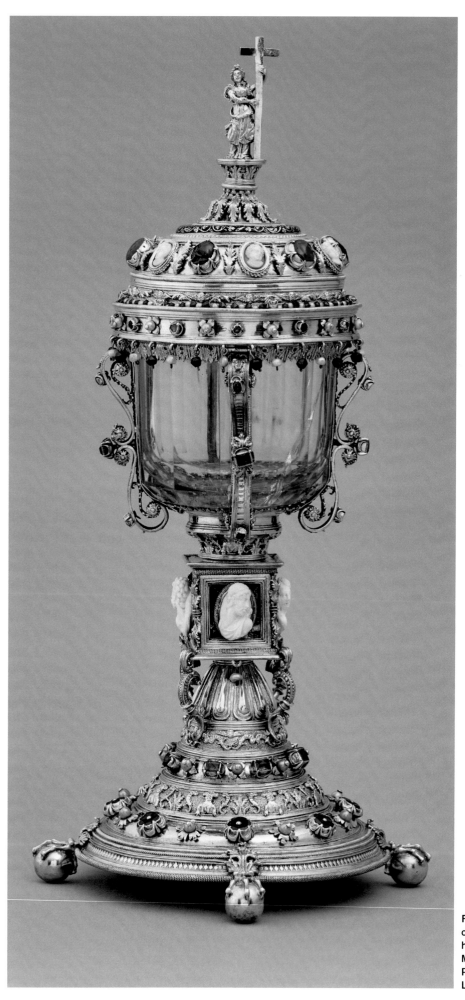

Figure 28 Pierre Mangot, rock-crystal ciborium mounted in silver gilt, h. 22.5cm, before 1528, Paris or Blois (?). Musée du Louvre, Paris, inv. no. MR 547. Photo © RMN-Grand Palais (Musée du Louvre) / Stéphane Maréchalle

Figure 29 Pierre Mangot, pair of rock-crystal candlesticks mounted in silver gilt, before 1528, Paris or Blois (?), h. 40.5cm and h. 41cm. Musée du Louvre, Paris, inv. nos MR 545 and 546. Photo © RMN-Grand Palais (Musée du Louvre) / Stéphane Maréchalle

community of goldsmiths of Paris provide little information about the workshop, its location or the role it played in the city. Over the course of his career, Mangot was convicted only once by the Paris Chambre des monnaies; this was in 1542, following an inspection of the purity of the gold content of the *hocquetons* (short-sleeved skirted jackets) that he had made for the king's archers. The magistrates asked him which refiners or goldsmiths had supplied him with the gold. Mangot was economical in his response: 'Refusing to name them and saying that he did not know the names of these individuals and that they were people who frequent his place of residence with their servants.'[16] One suspects that Parisian goldsmiths might not have been particularly

Figure 30 Hallmarks of the small mother-of-pearl casket in Figure 27: hallmark of Pierre Mangot with the 'M' and crowned guild mark 'E' for 1533–4

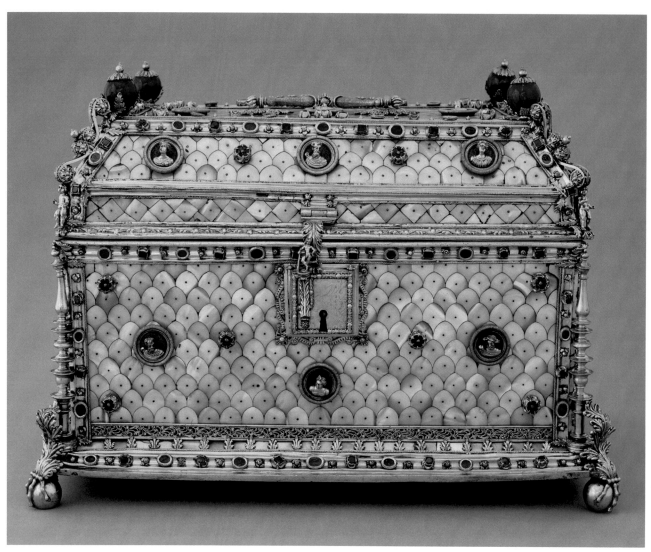

Figure 31 Pierre Mangot, large mother-of-pearl casket mounted in silver gilt, 1532–3, Paris, h. 29cm, w. 40cm, d. 26cm. Musée du Louvre, Paris, inv. no. OA 11936. Photo © RMN-Grand Palais (Musée du Louvre) / Stéphane Maréchalle

welcoming, which could explain why Mangot was never elected warden of the Paris guild. At the same time he maintained his links with the town of Blois, his wife, Jeanne Boullyer, having chosen to remain there with Françoise (the daughter from her marriage to Louis Duzen) and all her Blois relatives.[17]

How did a provincial goldsmith gain the king's trust and patronage? Detective work in the archives has retraced his ascent, which started with Louise of Savoy (1476–1531), King Francis I's mother. A miniature portrait with an elaborate frame in *Gestes de Blanche de Castille*, written by Étienne Leblanc (*c.* 1490–*c.* 1565) and illustrated in Paris by the painter Noël Bellemare (active 1512–1546),[18] provides us with a picture of this 'strong' woman dating from 1520–5 (**Fig. 34**). Although she was never queen, Louise was twice regent – in 1515–16 during the Marignano campaign, and then from 1525 to 1526 when the king was taken captive at Pavia and imprisoned in Spain – which is why she is shown here at the helm of the kingdom.

What do we know about the works Louise of Savoy commissioned from Pierre Mangot? Some were described in 1531 in an inventory drawn up following her death;[19] others in 1537 were described as hers among the 'tableware' and 'reliquaries' that were soon to make up the 'Cabinet' of

Fontainebleau (see Chapter 4, p. 74).[20] On each occasion, the pieces comprised decorative silverware: ewers, bowls, pots and flasks of silver gilt, probably richly engraved. Six of them were embellished with 'porcelain cameos' (that is, cameos made of shells), one of the signature features of Mangot's style (**Fig. 35**). Deposited at Fontainebleau among the treasures of the Crown, Mangot's works must certainly have been contemplated, handled and admired by Francis I and no doubt had an influence on the king's taste, for a while at least. They may also have been sought-after by other reigning princes. We know that Louise, dubbed 'Dame Prudence' in the literature of the time, was a brilliant negotiator, and also that there was a close connection between diplomacy and gold and silverware. Meetings between sovereigns gave rise to lavishly decorated banquets, and (as we see in Chapter 1) it was customary for peace treaties to be accompanied by an exchange of gifts between princes. It was Louise, for instance, who negotiated the Treaty of Amiens with King Henry VIII of England (r. 1509–47) in 1527. Did she present works by Mangot as gifts to the English king on this occasion? Future research may reveal this. None of Mangot's extant pieces can be matched with Louise's vessels, apart from a ciborium, now in the Louvre, which may possibly be one of her commissions (see

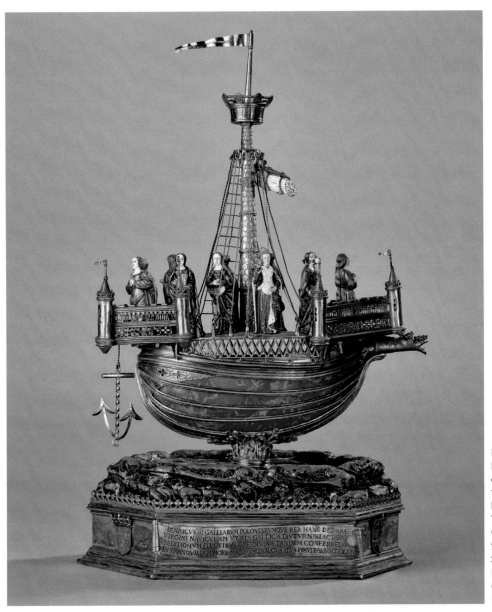

Figure 32 Raymond Guyonnet and Henri Duzen, St Ursula nef in carnelian mounted in silver gilt, 1499–1500, Tours, and 1506, Blois, h. 46cm, w. 28cm, d. 16.5cm. Treasury of Notre-Dame Cathedral, Reims, on deposit at the Palais du Tau, inv. no. TAU 2008000176. Photographer: Benjamin Gavaudo. Reims, Palais du Tau. © 2021. CMN dist. Scala, Florence

Fig. 28; see Chapter 4, p. 75). Its finial is an elegant silver-gilt figure of St Helena, and it is recorded that Louise praised her son as a 'Caesar' or 'Constantine' and frequently identified herself with St Helena (mother of the Emperor Constantine, *c.* 274–337).[21]

Based on our current state of knowledge, Mangot's corpus can be divided into two groups: the unmarked pieces; and those struck with Paris marks. The first group comprises a remarkable set of rock-crystal objects, probably coming from a royal chapel and consisting of a ciborium (see **Fig. 28**),[22] two candlesticks (see **Fig. 29**),[23] and an altar cruet set, all now in the Louvre (**Fig. 36**).[24] These objects were recorded at Fontainebleau in 1561 and were later taken from the Royal Collections to be used during the meetings of the Ordre du Saint-Esprit, the famous chivalric order created by Henry III (r. 1574–89) in 1578. In addition, there is the Royal Clock Salt owned by the Goldsmiths' Company,[25] and the Sibyls Casket, now in the British Museum (see **Fig. 48**).[26]

The second group comprises the following objects with Paris marks: a small agate cup and cover, perhaps used as a *baguier* (small jewellery box), with Mangot's maker's mark

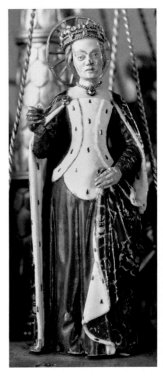

Figure 33 Detail of Figure 32: Henri Duzen, Statuette of St Ursula in enamelled gold with gold appliqué work on red enamel, 1506, Blois. Treasury of Notre-Dame Cathedral, Reims, on deposit at the Palais du Tau, inv. no. TAU 2008000176. Photographer: Benjamin Gavaudo. Reims, Palais du Tau. © 2021. CMN dist. Scala, Florence

Figure 34 Noël Bellemare, *Louise of Savoy Depicted as Regent of France*, frontispiece of the manuscript of the *Gestes de Blanche de Castille* by Étienne Leblanc, miniature on parchment, c. 1520–2, Paris, h. 25cm, w. 17.5cm. Bibliothèque nationale de France, Paris, Manuscript Department, Français 5715, fol. Av. Image © Bibliothèque nationale de France

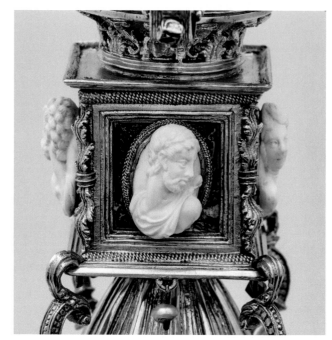

Figure 35 Shell cameo of a male bust, detail of the ciborium in Figure 28. Musée du Louvre, Paris, inv. no. MR 547. Photo © RMN-Grand Palais (Musée du Louvre) / Stéphane Maréchalle

only – held in the church of Saint-Paul in Paris until the French Revolution but now in the collection of the Bibliothèque nationale de France (**Fig. 37**; see Chapter 4, p. 75);[27] a small agate cup, possibly employed as a salt, dated 1528–9 – currently in a private collection, which I have had the privilege of examining (**Fig. 38**);[28] a large veneered mother-of-pearl casket, dated 1532–3 and studied by John Hayward – acquired by the Louvre from Michael Wellby in 2002 but with no provenance before the 1820s (see **Fig. 31**);[29] a small veneered mother-of-pearl casket, dated 1533–4 and discovered in Mantua, which probably came from the Royal Collections of the French kings (see **Fig. 27**);[30] and another smaller enamelled casket, previously unknown and unfortunately in damaged condition. I was first shown the latter quite recently and it requires close study before it can be associated with royal or princely patronage. It bears Mangot's maker's mark and the Paris mark for 1535–6 (**Fig. 39**).[31]

Altogether, 12 works of art are recorded and attributed to Mangot, including six items from the Royal Collections and four jewellery caskets, as far as we can identify their function. Such a number of pieces by the same goldsmith is quite exceptional, especially considering the great rarity of French Renaissance silver in general. Interestingly, all the marked objects are from after 1528, which is a crucial date in

Mangot's career, as it might correspond to the opening of his workshop in Paris. It also coincides with the moment when, having returned from his captivity, Francis I decided to establish the main royal institutions in Paris on a permanent basis, thus attracting many artists to the French capital. I would suggest that Mangot's earlier pieces were made in Blois, which would explain why they are unmarked. In fact, goldsmithing was not regulated in Blois at that time and therefore no marks are recorded there before 1571.[32] This is a theory that requires further investigation.

Although fascinating, the existing pieces do not reflect fully Mangot's wider production, which included, as mentioned in the 16th-century archives, silver-gilt ewers and basins, salts, cadinets and flagons. These were melted down during later wars. Items of jewellery were almost all destroyed and their stones were probably recut. In contrast, mounted gems (such as agates, sardonyx or rock crystals) have survived in quantity, because the low silver content of these objects meant they were not worth melting down. Mangot's extant works thus give a distorted picture of his overall output.

Mangot's techniques and decorative elements are distinctive, with or without his maker's mark. In common with all craftsman of the period, he created a repertoire of ornament that he cast and applied to his works, such as busts of children and angels' heads with wings (**Fig. 40**), husk borders (**Fig. 41**) and raised medallion profiles (**Fig. 42**). The majority of his works have ball and claw feet, surmounted by acanthus leaves. This characteristic was not exclusive to Mangot: the celebrated Burghley nef now in the Victoria and Albert Museum, dating to 1527–8,[33] is mounted on six comparable feet, and the same feature appears at the base of the large silver candleholders given, in March 1531, by the city of Paris to Eleanor of Austria (1498–1558), second wife of Francis I (**Fig. 43**).[34] All these details are typical of the earliest years of the French Renaissance, which was

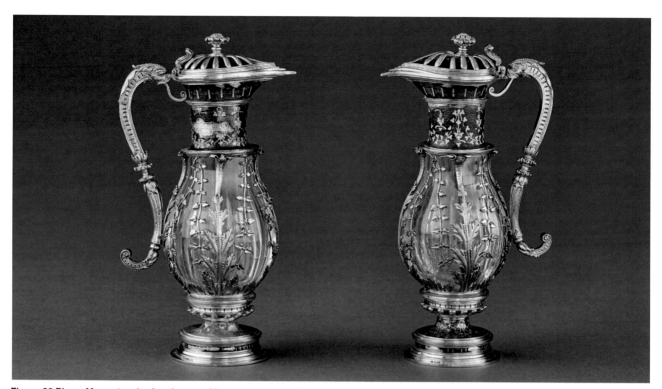

Figure 36 Pierre Mangot, pair of rock-crystal burettes mounted in enamelled silver gilt, before 1528, Paris or Blois (?), h. 16.1cm and h. 16.3cm. Musée du Louvre, Paris, inv. nos MR 548 and 549. Photo © RMN-Grand Palais (Musée du Louvre) / Stéphane Maréchalle

Figure 37 Pierre Mangot, cup and cover in agate mounted in silver gilt, c. 1528, Paris, h. 17cm. Bibliothèque nationale de France, Paris, Coins, Medals and Antiques Department, inv. no. 55.487. Image: Bibliothèque nationale de France

Figure 38 Pierre Mangot, cup or salt in agate mounted in silver gilt, 1528–9, Paris. Private collection

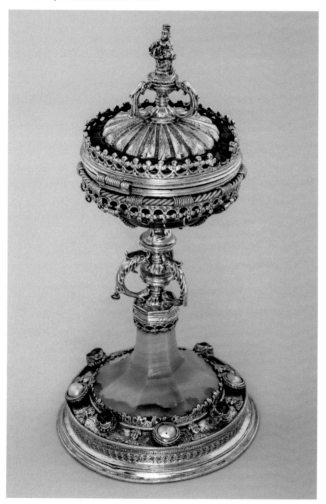

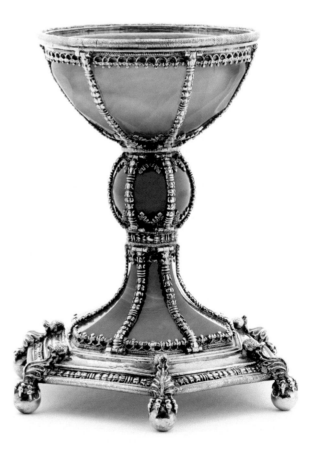

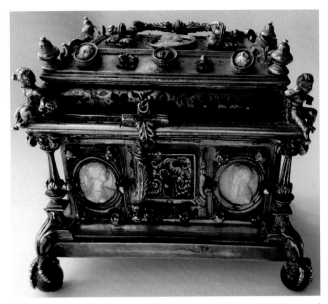

Figure 39 Pierre Mangot, small jewel casket in silver gilt and enamel decorated with shell cameos, 1535–6, Paris, h. 9.9cm, w. 11.2cm, d. 8.4cm. Private collection

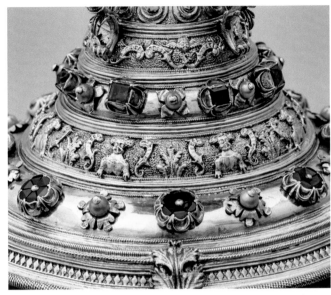

Figure 40 Detail of the foot of the ciborium in Figure 28. Musée du Louvre, Paris, inv. no. MR 547. Photo © RMN-Grand Palais (Musée du Louvre) / Stéphane Maréchalle

influenced by Lombardy, as the French armies had invaded the duchy of Milan in 1499. Ilaria Toesca compared Mangot's small casket with the façade of the Charterhouse in Pavia, and quite rightly so. However, a comparison with the architecture of the Château de Chambord – its upper storeys embellished with black marble motifs and portrait medallions, its windows decorated with small elegant columns and its pediments brought to life with figures in full relief – is also convincing. Mangot skilfully applied the most fashionable decorative elements without altering the structure of the objects, which are only superficially embellished by his mounts.

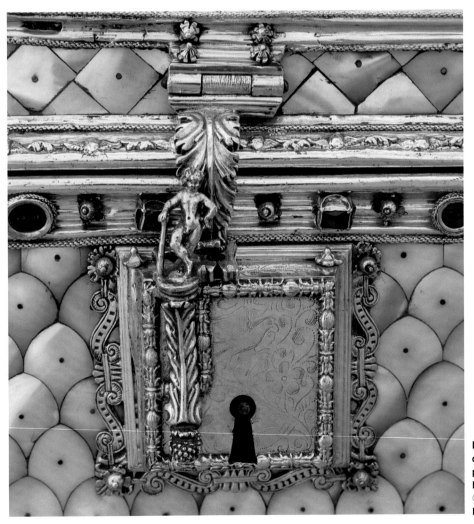

Figure 41 Detail of the keyhole decoration of the large mother-of-pearl casket in Figure 31. Musée du Louvre, Paris, inv. no. OA 11936. Photo © RMN-Grand Palais (Musée du Louvre) / Stéphane Maréchalle

Figure 42 Detail of one of the medallions on the large mother-of-pearl casket in Figure 31, with a female bust on an enamelled silver ground decorated in gold. Musée du Louvre, Paris, inv. no. OA 11936. Photo © RMN-Grand Palais (Musée du Louvre) / Michèle Bellot

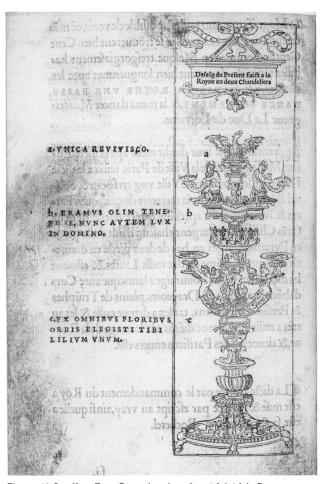

Figure 43 Geoffroy Tory, *Desseing du présent faict à la Royne en deux chandeliers* (Drawing of the gift of two candlesticks made to the queen), wood engraving, from Simon Bochetel, *L'Entree de la Royne en sa Ville & Cité de Paris* (Entry of the queen into the town and city of Paris), 1531, Paris. Bibliothèque nationale de France, Paris, rare book deposit, 8° H 12585. Image: Bibliothèque nationale de France

Figure 44 Spinel intaglio engraved with the profile of a man, detail from one of the candlesticks in Figure 29. Musée du Louvre, Paris, inv. no. MR 546. Photo © RMN-Grand Palais (Musée du Louvre) / Stéphane Maréchalle

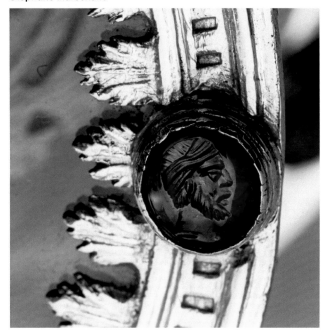

Mother-of-pearl caskets were undoubtedly an outstanding feature of Mangot's production and were considered as highly fashionable curiosities at the French court. Teak wood caskets with veneered mother-of-pearl were produced in Gujarat, in north-west India, where Portuguese explorers came across them; the use of mother-of-pearl veneer was first mentioned in 1502, when Vasco da Gama (c. 1460–1524) was presented with a bed made of mother-of-pearl and gold.[35] Portuguese traders started importing these precious objects to Europe in the 1520s. In the 1530s Indian caskets were in great demand, which explains why Mangot was commissioned to embellish them with mounts in the latest Paris fashion. The Royal Accounts mention the purchase of '*un chalict marqueté à feuillages de nacle de perle faict au pays d'Andye ensemble d'une chaire faicte à la mode dudit pays*' (a mother-of-pearl veneered bed and a chair made in India) from a French merchant as early as 1529, evidence of the king's enthusiasm for such exotic pieces.[36] His interest was probably reinforced by his marriage in 1530 to Eleanor of Austria, widow of King Manuel I of Portugal (r. 1495–1521). The new queen prized the imports from India, which she had first encountered in Lisbon. In a letter discovered by Annemarie Jordan-Gschwend, King John III of Portugal (r. 1521–57) promised that Honoré du Caix, the French ambassador, would 'provide Madame with the best Indian merchandise available in Lisbon'.[37] It is telling that the two mother-of-pearl caskets by Mangot correspond to the first years of Eleanor's time at the French court (1530–47).

Pierre Mangot's technique and style are certainly distinctive, bridging Europe and the East, as well as the Middle Ages and the Renaissance. His works reflect the traditional court style of the period; they are loaded with pearls and garnets set into or suspended from their mounts, embellished with tiny fragments of cornelian and garnets, sometimes as intaglios (**Fig. 44**), or with painted inscriptions in Latin and in Italian (**Fig. 45**). Such details cannot have gone unnoticed by a man as cultivated as Francis I: this was the king who created the Collège des lecteurs royaux (now the Collège de France) and who personally supervised the enrichment of the royal library inherited from Louis XII with a collection of volumes in Latin and Greek, to which he turned for his daily reading.[38] In a humanist environment such as this, it is not difficult to imagine Mangot's work being examined closely and with delight.

This opulent goldsmithing was also dominated by polychromy. Mangot's favourite enamel colours were opaque black, such as on the lid of the ciborium in the

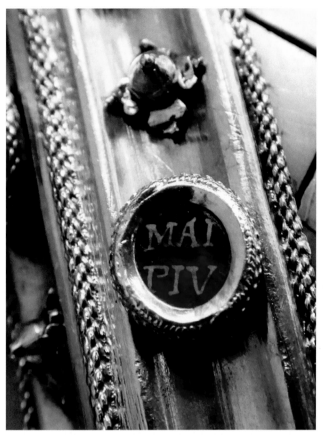

Louvre (see **Fig. 28**), and translucent blue on a silver ground, generally picked out in gold, often used to contrast with silver-gilt busts and shell cameos (see **Fig. 42**). Unfortunately, these delicate gold applications are fragile and, where not crudely restored,[39] are now almost invisible to the naked eye: this is true, for example, of the lid of the small bowl, or *baguier*, in the Bibliothèque nationale.[40] They certainly reflect Mangot's focus on minuscule details. This focus is even more evident in the most refined stipple-engraved scenes depicting birds flying among scrollwork that appear on the surface of casket keyholes and on the underside of the lid of the ciborium in the Louvre (**Fig. 46**). Mangot's style is a perfect demonstration of *horror vacui*: a tendency to leave no surfaces undecorated.

Was Mangot a skilled chaser? This is a difficult question, as a closer look reveals the uneven and occasionally mediocre quality of his chased figures and raised profiles (see **Fig. 42**). The best goldsmiths, by contrast, were praised for their talents as sculptors and chasers, even on the smallest scale. Sometimes Mangot's faces show a lack of fine and harmonious features. Such strange characteristics can be also found on his shell cameos (**Fig. 47**). These contorted, thick-lipped faces could be considered as 'grotesque', while others, with a more regular appearance, could be read as a reference to antiquity. It is possible that their bizarre profiles were shaped by the form of the shell itself. Shell cameos were indeed used as cheaper versions of ivory cameos, just as garnets were employed instead of rubies. Their maker, probably a Parisian lapidary, is yet to be identified. His

Figure 45 Carnelian table painted with the Italian inscription 'MAI/ PIU', detail of the large mother-of-pearl casket in Figure 31. Musée du Louvre, Paris, inv. no. OA 11.936. Image: Michèle Bimbenet-Privat

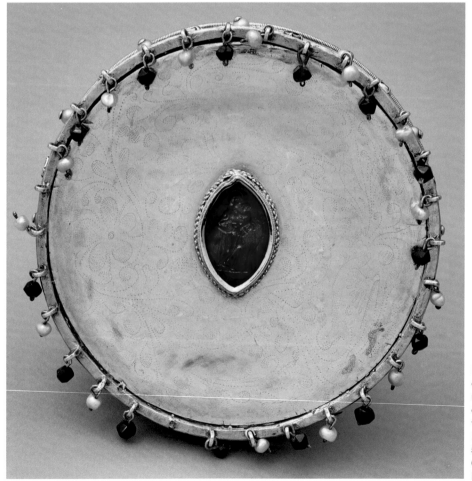

Figure 46 Reverse of the lid of the ciborium in Figure 28: cut carnelian mounted in the centre of a plaque of carved and gilded silver, decorated with *rinceau* (scrolls) work and birds. Musée du Louvre, Paris, inv. no. MR 547. Photo © RMN-Grand Palais (Musée du Louvre) / Stéphane Maréchalle

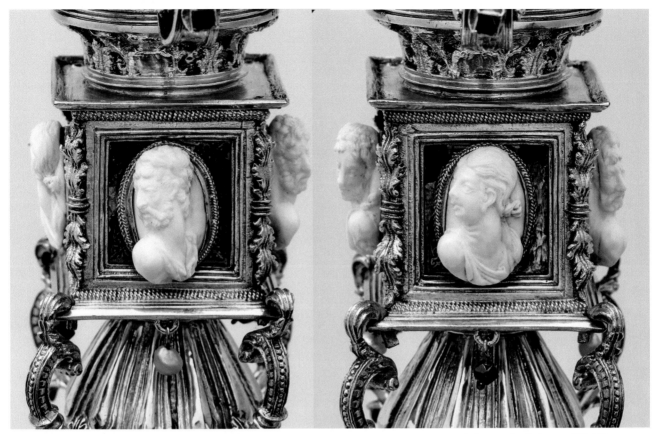

Figure 47 Shell cameos with male and female profiles, details of the ciborium in Figure 28. Musée du Louvre, Paris, inv. no. MR 547. Photo © RMN-Grand Palais (Musée du Louvre) / Stéphane Maréchalle

unique style can be seen in many of Mangot's pieces, revealing an ongoing collaboration between the two artists.

In conclusion, Mangot's production evidently reflects a crucial moment for French silver, at the juncture between the medieval period and the Renaissance (see Introduction, p. 5). It should not, however, be considered as providing a full picture of the French style of silversmithing during the early part of King Francis I's reign. The king was an impulsive art lover with eclectic tastes: the large Flemish gold cup sold by Joris Vezeleer (1493–1570),[41] the book pendant bought from the merchant Allard Plommyer (recently acquired by the Louvre)[42] and the *Saliera* by Benvenuto Cellini (1500–1571) (see also Chapter 2) have nothing in common.[43] And, when compared with Cellini's genius, Mangot seems to fall short. These different commissions demonstrate that there was no single standard style during the reign of Francis I, but rather a maturation of the king's personal taste, until he summoned Italian artists to settle at Fontainebleau.

However, Mangot's style and techniques did play an important part in the development of French royal silver. Just as Mangot had been an apprentice to a royal goldsmith, he himself trained apprentices who would become goldsmiths to future kings. François Dujardin (active 1538– c. 1580), for example, entered Mangot's workshop in 1538 and, 20 years later, became Catherine de' Medici's (1519– 1589) favourite goldsmith.[44] In 1571 he created for the queen mother a beautiful emerald pendant, now in the Bibliothèque nationale de France in Paris.[45] With a pupil of such calibre, Mangot, the creator of the Royal Clock Salt, must be considered one of the major links in the long chain of talent that, throughout the *Ancien Régime*, brought together the best goldsmiths of the kings of France.

Appendix: biographical sources for Pierre Mangot

This appendix provides a summary of Pierre Mangot's list of works known from archival sources. Unfortunately, many of the objects detailed below have not been preserved. Entries in bold refer to silver works made for Louise of Savoy and the Royal Household, and provide a useful comparison to those pieces that have survived.

Notes on French terms

Argenterie: office of the Royal Household created to supervise the provision of clothing and furnishings to the king.

Chambre aux deniers: office responsible for requesting funds to make payments on behalf of the Royal Household.

Chambre des comptes: court of auditors responsible for dealing with various aspects of the financial administration of France.

Chambre des monnaies: office similar to the Mint, responsible for checking the quality of coins, gold and silver.

Écurie: the (Royal) Stables.

Épargne: office more or less equivalent to the coffers of state, collecting taxes and paying out monies on behalf of the monarch.

Finances extraordinaires et parties casuelles: office created to deal with out-of-the-ordinary or unexpected expenses.

hocquetons: short-sleeved, skirted jacket

Hôtel-Dieu: Church-run institution caring for orphans and the poor.

Livres tournois: 'Tours pounds' – one of the many regional currencies used in France in the medieval period. Lower denomination coins included **écus**, **sous** and **deniers**.

Marc, **once**, **gros** and **grain:** medieval units of weight measurement – marc ≈ 245 grams; once ≈ 30 grams; gros ≈ 4 grams; grain ≈ .065 grams.

Menus Plaisirs: department of 'lesser pleasures' responsible for the preparations for ceremonies, events and festivities.

Originally from Blois or Tours, Pierre Mangot came from a long line of goldsmiths born in the Loire Valley who for centuries had supplied the dukes of Orléans and who, from the reign of Louis XII, were goldsmiths to the kings of France. His predecessors included Jean du Lutz and du Lutz's son-in-law Henri Duzen, followed by Duzen's son, Louis.

Believed to have been born between 1485 and 1490, Mangot trained at the Duzens' studio and married Louis Duzen's widow, Jeanne Boullyer. Records show that his family remained in Blois and he himself resided there from time to time, although his work as goldsmith to the king took him to Paris, probably in 1528. Indeed, some of Mangot's work bears his Paris master goldsmith's mark: a Gothic letter 'M' surmounted by a crowned fleur-de-lis flanked by two dots.

At the same period, there are records of other goldsmiths from the Mangot family working in Tours: André Mangot, goldsmith to King Louis XI (r. 1461–83), who created a reliquary for the head of St Martha and delivered it to Tarascon in 1478; and Hans Mangot , who produced a statue of St Maurice for Angers cathedral in 1509. For this reason,

historians of Tours have included Pierre Mangot among the goldsmiths of Touraine, although there is nothing to suggest that he should be considered an inhabitant of Tours (Giraudet 1885, 280–3).

Following in his father's footsteps, Pierre Mangot's son Robert Mangot and his son-in-law Gilles de Suramond also became goldsmiths to the king, while his 'messenger', François Dujardin, entered the service of Catherine de' Medici (Bimbenet-Privat 1992, 468–9, 545, 596).

In 1613 certain descendants of Pierre Mangot, who were royal office holders, were still living in Blois: François Mangot, 'goldsmith to the king, living in Bloys' – probably a grandson of Pierre Mangot; and Pierre Mangot, 'gardener to His Majesty in the upper gardens of Bloys castle' (Loir-et-Cher Departmental Archives, Blois, 3E 19/116).

1514 Louis Duzen and Pierre Mangot, goldsmiths to the king, repair the gold crown '*en façon d'empire, garnie de fils tors, de crestes et feux*' (in the imperial style, decorated with filigree, crests and stones) for the king's funeral effigy, and execute a double fleur-de-lis, a fleuron and a ring in silver gilt '*pour mettre au doigt de la main de justice*' (to place on the finger of the hand of justice), for the funeral of Louis XII.

Laborde 1872, 161, 207

Undated deed (1515, according to the date of the events). Letter from Francis I to the superintendents of taxes instructing them to take from the account of Jean Brachet (according to this letter), or from that of Jean Prunier (according to the superintendents of taxes and the other instruments), the sum of 11,939 livres tournois, 4 sous and 6 deniers, to pay the goldsmith Pierre Mangot for the gilded and white dishes he supplied to the king to be distributed among several princes, lords, officers and members of the house of the archduke of Austria, prince of Spain, '*en faveur de ce qu'ilz sont venuz en ambassade devers le roi, tant en la ville de Compiègne que en ceste ville de Paris*' (in recognition of their attendance on an embassy to the king, both in the town of Compiègne and in this city of Paris), on behalf of the said archduke; letter from the superintendents ratifying the above letter; certificate issued to Jean Prunier by Maître Gilbert Jarriel, testifying that the said Prunier had indeed handed over, in his presence, the quantity of silver employed in the silverware and the sum that he had been ordered by the king to give to the 'count of Nanssot [*sic*: Nassau], to the count of 'S. Pire [Sempy] and others' forming part of the above-mentioned embassy; deed indicating that 'Pierre Mangot, goldsmith to the king', confirms that he has received from 'Maître Jehan Prunier' the sum allotted to him in payment of the said silverware.

Bibliothèque nationale de France, Paris, Ms Français 5118, fols 36–8

1520 20 August: order sent to the receivers general regarding monies to be paid to Louis Duzen and Pierre Mangot in the sum of 1,143 livres, 8 sous and 9 deniers in payment of the goldsmithery carried out for the *hocquetons* (short-sleeved skirted jackets) of the French and Scottish captains and archers.

Marichal 1887–1908, no. 1220

1526 31 May: order to the treasurer of the Épargne to pay to Pierre Mangot, goldsmith to the king, the sum of 1,261 livres and 15 sous for two chains of the Ordre de Saint-Michel to replace the one lost by the king in Pavia, and the one that the seigneur of Lautrec was forced to sell during his time as lieutenant general in Italy.
Marichal 1887–1908, no. 18673

1526 26 September: order to the treasurer of the Épargne to pay to Pierre Mangot, goldsmith to the king, the sum of 1,219 livres, 10 sous and 6 deniers for two chains of the Ordre de Saint-Michel, one for Anne de Montmorency, who had given his to comte Hugues de Pepoli when he was made a knight, the other to the seneschal of Armagnac, master of the artillery.
Marichal 1887–1908, no. 18819

1526 8 December: order to the treasurer of the Épargne to pay to Pierre Mangot the sum of 602 livres, 3 sous and 3 deniers for a chain of the Ordre de Saint-Michel given by the king to Jean Stuart, Duke of Albany, to replace the one that the latter had been obliged to sell when serving as the king's lieutenant general in Romagne.
Marichal 1887–1908, no. 2499

1526 11 December: order to the treasurer of the Épargne to pay the sum of 1,800 livres tournois, 3 sous and 3 deniers to Pierre Safray, receiver of Écurie, who is to hand over this sum owed to Pierre Mangot, goldsmith, in payment of the balance of the supplies needed for the provision of the *hocquetons* of the French and Scottish archers of the guard during the years 1522, 1523 and 1524.
Marichal 1887–1908, no. 18887

1527 29 January: order to the treasurer of the Épargne to pay to the goldsmith Pierre Mangot, 734 livres tournois, 3 sous and 3 deniers for a number of items of silverware delivered to the king before his last journey to Italy, and 605 livres tournois, 8 sous and 3 deniers, being the price of a lidded ewer and a bowl with its lid, all in silver gilt, supplied for the use of the dauphin.
Marichal 1887–1908, no. 18973

1527 7 May: order to the treasurer of the Épargne to pay to Pierre Mangot, goldsmith to the king, 603 livres tournois and 19 sous for a large Order chain of office weighing 3 marcs, 4 onces, 1 gros, 2 deniers and 16 grains of gold that the king gave with its case to the comte de Saint-Pol, to replace the one that he was obliged to have melted down in Italy, for reasons of war.
Marichal 1887–1908, no. 19154

1527 7 May: order to the treasurer of the Épargne to pay to Pierre Mangot 612 livres tournois, 18 sous and 6 deniers for a large Order chain of office weighing 3 marcs, 4 onces, 5 gros, 2 deniers and 10 grains of gold, with its case, that the king gave to Monsieur de Lautrec to replace the one that the king had ordered him to hand over to comte Pedro Navarro.
Marichal 1887–1908, no. 19155

1527 7 May: order to the treasurer of the Épargne to pay to Pierre Mangot 612 livres tournois, 18 sous and 6 deniers for an Order chain of office weighing 3 marcs, 4 onces, 5 gros, 2 deniers and 12 grains of gold, with its case, given by the king to Monsieur de La Trémouille, whom he had recently made knight of the Ordre de Saint-Michel.
Marichal 1887–1908, no. 19156

1527 7 May: order to the treasurer of the Épargne to pay to Pierre Mangot 588 livres tournois and 1 sou for an Order chain of office weighing 3 marcs, 3 onces, 3 gros of gold, given by the king, with its case, to the Duke of Albany.
Marichal 1887–1908, no. 19157

1527 7 May: order to the treasurer of the Épargne to pay to Pierre Mangot 588 livres tournois and 1 sou for an Order chain of office weighing 3 marcs, 3 onces, 2½ gros of gold, given by the king, with its case, to Louis de Clèves, on making him a knight of this Order.
Marichal 1887–1908, no. 19158

1528 11 June: order to the treasurer of the Épargne to pay Pierre Mangot, goldsmith to the king, the sum of 591 livres, 10 sous and 6 deniers for a large Order chain of office, given by the king to Ercole II d'Este, Duca di Ferrara.
Marichal 1887–1908, no. 3009

1528 8 September: order to the treasurer of the Épargne to pay to Pierre Mangot, goldsmith to the king, the sum of 588 livres, 16 sous and 9 deniers for a large Order chain of office given by the king to the grand equerry Jacques de Genouillac, known as Galiot.
Marichal 1887–1908, no. 3144

1528 Pierre Mangot supplies a lantern for one of the king's chandeliers (*lustres*).
Laborde 1872, 355

1529 9 April: Pierre Mangot, goldsmith to the king, is paid 63 livres and 5 sous for six silver-gilt cassolettes, a gold chain from which to hang a diamond cross belonging to the king, and a tool in the form of scissors supplied to Jean de Nysmes, surgeon to the king.
Archives nationales, Paris, KK 100, fols 52–52v (Menus Plaisirs accounts)

1529 10 October: the sum of 303 livres, 1 sou and 6 deniers is recorded in the Menus Plaisirs accounts against Pierre Mangot, goldsmith to the king, for a box with a portrait of the king, several gold rings with assorted gemstones, the repair of an enamelled headpiece, a silver-gilt ewer, fittings for two chests together with their packaging and transportation to Paris.
Archives nationales, Paris, KK 100, fol. 104v–106 (Menus Plaisirs accounts)

1530 29 January: order to the treasurer of the Épargne to pay 2,445 livres and 13 sous to Pierre Le Messier, servant of the goldsmith Pierre Mangot, for a gold chain given by the

king as a gift to George Boleyn, vicomte de Rochefort, former ambassador of the king of England.

Marichal 1887–1908, no. 3594

1530 29 March: Pierre Mangot, goldsmith to the king, receives 103 livres tournois and 15 sous in payment of a decorative trim for female clothing adorned with 13 small rubies and 14 pearls, and of a decorative trim for a sword belt, ordered by the king.

Archives nationales, Paris, KK 100, fol. 26v (Menus Plaisirs accounts)

1530 18 November: order to the treasurer of the Épargne to pay to the goldsmith Pierre Mangot the sum of 1024 livres for a gold chain given by the king as a gift to Jean de Vaulebourg, an envoy sent the previous August by the king of England.

Marichal 1887–1908, no. 3804

1530 To Pierre Mangot, goldsmith to the king, for several decorative borders, sleeve trims and rosary beads, 250 écus.

Laborde 1877–80, vol. 2, 389

1531 To Pierre Mangot, goldsmith, 157 livres, 1 sou and 11 deniers for the manufacture and supply of silver and fabrics for the king's royal seal chest, with a deduction of 43 livres and 15 sous, this being the value of the silver obtained from the old chest, to be taken from the accounts of this present January quarter.

Marichal 1887–1908, no. 27812; Laborde 1877–80, vol. 2, 203

1531 25 March: to Pierre Mangot, goldsmith to the king, in payment of a gold chain given to Sebastiano Giustiniani, the Venetian ambassador, 2,050 livres.

Marichal 1887–1908, no. 27751; Laborde 1877–80, vol. 2, 202

1531 25 March: to Pierre Mangot, goldsmith to the king, for another gold chain, given to Jérôme Canale, secretary to the seigneury of Venice, who accompanied the aforementioned ambassador to France, 615 livres.

Marichal 1887–1908, no. 27752; Laborde 1877–80, vol. 2, 202

1531 26 March: order to the treasurer of Menus Plaisirs to pay 250 écus to Pierre Mangot, goldsmith to the king, for several borders, sleeve trims and gold rosaries.

Marichal 1887–1908, no. 3925

1531 11 April: order from Francis I to Guillaume Prudhomme, treasurer of the Épargne, commanding him to pay 2,666 livres tournois to the goldsmith Pierre Mangot for two gold chains given, one to Sebastiano Giustiniani, the Venetian ambassador, and the other to Jérôme Canale, secretary of the Seigneury. Original parchment formerly sealed with a parchment flap.

Bibliothèque nationale de France, Paris, Manuscript Department, Ms Chappée 25, 1, 10

1531 24 June: to Pierre Mangot, goldsmith, 410 livres in payment of a chain given by order of the king to the secretary of the king of Denmark.

Marichal 1887–1908, no. 27568; Laborde 1877–80, vol. 2, 200

1531 30 October–3 November: in the inventory following the death of Louise of Savoy, mother of Francis I, there is mention of '*une buye faite des bassins et essaiz baillez à Mangot, pesant 11 marcs 1 once 6 gros*' (a large vase made with the metal of bowls and goblets given to Mangot, weighing 11 marcs, 1 once and 6 gros).

Archives nationales, Paris, J 947, no. 2 Crépin-Leblond and Barbier 2015, no. 67)

[1531?] To Pierre Mangot, goldsmith, in payment of a chain given to the grand equerry of Savoy, 1,025 livres, for the gold, for the waste and for the manufacture.

Marichal 1887–1908, no. 27693

[1532 August?]: order to Jean Laguette, receiver general of the Finances extraordinaires et parties casuelles, to pay to the admiral (Chabot) the sum of 100 écus soleil for 'the addition of gold and refashioning of an old insignia of the Ordre de Saint-Michel, which was reworked by Pierre Mangot, goldsmith to the king, and given to the admiral to replace his own, which he had lost'.

Marichal 1887–1908, no. 28324

1532 20 December: order to the treasurer of the Épargne to pay to the goldsmith Pierre Mangot 621 livres tournois, 7 sous and 6 deniers for an Order chain of office weighing 3 marcs, 2 onces, 7 gros and 18 grains of 22-carat gold, given by the king to the dauphin, to be taken from the monies set aside for the king's personal expenses.

Marichal 1887–1908, no. 5157; Laborde 1877–80, vol. 2, 391

1533 (N.S.), 3 January: Pierre Mangot, goldsmith to the king, receives 180 livres tournois for serving as an officer of the king's Écurie during the year 1532, at the rate of 15 livres per month.

Archives nationales, Paris, KK 95, fol. 526 (king's Écurie accounts for 1532)

1533 13 January: Françoise Duzen, daughter of Louis Duzen and Jeanne Boullyer (who by then had married Pierre Mangot), wife of Bertrand Droulin, merchant of Blois.

Piquard 1975, 345, 348

1533 April–June: Pierre Mangot supplies various offices of the Royal Household with a substantial amount of silverware, remanufactured after melting down old or broken pieces – dishes, cups, ewers, bowls – the majority delivered to Fontainebleau.

Nocq 1926–31, vol. 3, 184–5 (Hôtel du roi accounts)

1533 1 April: order to the treasurer of the Épargne to pay to Pierre 'Le Mercier' [Le Messier], servant to the goldsmith

Pierre Mangot, 617 livres tournois, 18 sous and 9 deniers for a large Order chain of office weighing 3 marcs, 2 onces and 2 gros of gold, destined for Admiral Chabot.

Marichal 1887–1908, no. 5617

1533 10 April: to Pierre Le Messier, servant to Pierre Mangot, goldsmith to the king, 274 livres and 5 sous in payment of the gold crown made for Madame the duchesse d'Orléans for her nuptials, including 20 livres for the manufacture and waste gold, and which the king has given as a gift to Madame.

Laborde 1877–80, vol. 2, 217

1533 July–December: new repairs to the silverware handed over to Mangot by the offices of the King's Household. Part of this silverware was delivered to Lyon and to Marseille to be used at the marriage of Henri de Valois-Angoulême [the future Henry II] and Catherine de' Medici.

Nocq 1926–31, vol. 3, 184–5; Archives nationales, Paris, KK 93 (Hôtel du roi accounts)

1533 1 August: order to the treasurer of the Épargne to pay to Pierre Le Messier, servant to Pierre Mangot, goldsmith to the king, 660 livres tournois, 2 sous and 6 deniers for a large Order chain of office weighing 3 marcs, 4 onces and 1 gros of gold, given by the king to the grand equerry Jacques de Genouillac, to replace that given by the latter to the Duke of Suffolk, when the king was in Boulogne (in 1532).

Marichal 1887–1908, no. 6104; Laborde 1877–80, vol. 2, 217

1533 4 August: order to the treasurer of the Épargne to pay to Pierre Le Messier, servant to Pierre Mangot, goldsmith to the king, 653 livres, 7 sous and 6 deniers for a large Order chain of office weighing 3 marcs, 4 onces, 1 gros and 1 denier of gold, given by the king to the king of Navarre, to replace the one given by this prince to the king to give to Hieronymus Jarosław Laski, voivode of Transylvania, in Caen.

Marichal 1887–1908, no. 6131

1533 1 November: order to the treasurer of the Épargne to pay to Pierre Le Messier, servant to Pierre Mangot, goldsmith to the king, 667 livres tournois, 10 sous and 6 deniers for a flat gold chain given by the king to Raoul, jester to Cardinal de' Medici (deed executed in Marseille).

Marichal 1887–1908, no. 6424; Laborde 1877–80, vol. 2, 217

Late 1533 To the receiver of the king's Écurie, 1457 livres, 12 sous and 6 deniers to be given to the goldsmith Pierre Mangot, in respect of the damages and losses he experienced in the over-purchasing of the gold and white silver used by him for the goldsmithery of the *journades des hocquetons* (short-sleeved, skirted jackets worn by some members of the military) of the Scottish and French archers in the companies of the seigneurs d'Aubigny and de Nancy, and of the quartermasters, doormen, lieutenant and provost of the Household during the years 1529, 1530 and 1533.

Marichal 1887–1908, no. 31254

1534 January–March: remanufacture of and repairs to silverware by Pierre Mangot. Supply of a silver and powdered glass ewer weighing 5 marcs and 6 onces, to be given to the queen to replace the one lost at the celebrations given by the king in the main hall at the Louvre at Shrovetide, 1532; supply of a cupbearer's cup in silver gilt to replace the one lost at the isle of Martives [Martigues] '*quand le pont fondit soubz ceulx qui suyvoyent le roy notre sire en allant à Marseille à la venue du Pape*' (when the bridge collapsed under those following the king en route to Marseille for the arrival of the Pope) (in 1533).

Nocq 1926–31, vol. 3, 185; Archives nationales, Paris, KK 93 (Hôtel du roi accounts)

1534 24 January: order to the treasurer of the Épargne to pay to Pierre Le Messier, servant to Pierre Mangot, goldsmith to the king, 657 livres tournois for a large Order chain of office weighing 3 marcs, 4 onces, 3 gros and 8 grains of gold given by the king to Monsieur de Canaples.

Marichal 1887–1908, no. 6719; Laborde 1877–80, vol. 2, 391

1534 2 March: order to the Paris Chambre des comptes to assign to the 1533 accounts of Guillaume Prudhomme, 665 livres tournois and 4 deniers paid by him on 30 July to the goldsmith Pierre Mangot for an Order chain of office weighing 3 marcs, 4 onces, 5 gros, 2 deniers and 18 grains of gold, given by the king to Charles Chabot, sieur of Jarnac.

Marichal 1887–1908, no. 6804; Laborde 1877–80, vol. 2, 389–90

1534 13 May: order to the treasurer of the Épargne to pay to the goldsmith Pierre Mangot, 573 livres tournois, 12 sous and 6 deniers for a large Order chain of office weighing 3 marcs, 6 onces, 1 gros and 1 denier of gold, to include the manufacture and the case, given by the king to the duc d'Orléans.

Marichal 1887–1908, no. 7034; Laborde 1877–80, vol. 2, 391 (dated 1538)

1534 April–June: Mangot adds to, repairs and regilds pieces of silverware from the Royal Pantry, Buttery and Game Larder, including '*deux cadenatz carrez dont il y a à l'un une sallière*' (two square cadinets, one of which contains a salt).

Nocq 1926–31, vol. 3, 185; Archives nationales, Paris, KK 93 (Royal Household accounts)

1534 23 May: order to the treasurer of the Épargne to pay to the goldsmith Pierre Mangot, 669 livres tournois, 2 sous and 6 deniers for a large Order chain of office weighing 3 marcs, 4 onces, 7½ gros and 6 grains of gold, given by the king to Monsieur de Boisy.

Marichal 1887–1908, no. 7057; Laborde 1877–80, vol. 2, 390–1 (dated 1538)

1534 September–December: Mangot receives 25 livres for replacing the enamel on the box used as a pax in the chapel of St Roch and St Sebastian, and for regilding and rewelding the candlesticks of this chapel.

Nocq 1926–31, vol. 3, 185; Archives nationales, Paris, KK 93 (Royal Household accounts)

1535 Mangot executes numerous refurbishments to silverware, some of which is delivered to Fontainebleau.

Nocq 1926–31, vol. 3, 185; Archives nationales, Paris, KK 93 (Royal Household accounts)

1535 26 May: Pierre Mangot, goldsmith to the king, becomes godfather in the parish of Sainte-Solenne, Blois, to Pierre Droulin, son of Betrand Droulin, a merchant in Blois.

Piquard 1975, 345, 348

1536 Pierre Mangot is mentioned in the Household accounts in respect of many pieces of work carried out on the silverware of the Cellar and Buttery; the Argenterie accounts record 33 livres tournois for 100 armorial badges, both round and flat, engraved with the French coat of arms with the words '*Au roi*' (To the king) and enamelled in azure blue, to be used with the birds in the Falconry.

Nocq 1926–31, vol. 3, 185 (Argenterie accounts)

1537 7 January: Charles de Pierrevive, treasurer of France charged by the king with the safekeeping of the precious silverware and reliquaries kept in the Cabinet du Louvre, has an inventory of the contents drawn up. This document contains a description of the gold and silverware of Louise of Savoy and that ordered from Mangot by Louise before her death: '*En ce premier chapitre ensuyvent celles qui feurent prinses par led. Bourdyveau des meubles de feue Ma Dame mere du roy es gallatas estans sur la chambre de lad. dame ou chateau d'Amboise.*' (In this first chapter there follow those items taken by the said Bourdyveau from among the furnishings of the late queen mother in the attic above the chamber of the said lady or the Château d'Amboise.)

1. Deux grans potz sizelez d'argent vermeil dorez façon de Portugal, a chacun desquelz a un lyon par dessus le couvescle tenant les armes de feue Ma Dame mere du roy, le pied de l'un desquelz est dessouldé, poisant vingt neuf marcs six onces et demye. (Two large, engraved silver-gilt jars in the Portuguese style, each of which has a lion on the lid holding the coat of arms of the late queen mother, the foot of one having become detached, weighing 29 marcs, 6½ onces.)

2. Deux autres potz a vin aussy vermeil dorez et de semblable façon aux armes de lad. dame, poisant ensemble vingt huit marcs demye once. (Two more silver-gilt wine jars of similar style, bearing the lady's coat of arms, together weighing 28 marcs and half an once.)

3. Quatre grans bassins vermeil dorez d'un costé aussi sizelez de pareille façon et aux armes de lad. dame, poisant ensemble cinquante troys marcs sept onces. (Four large basins in silver gilt also engraved on one side in a similar fashion and bearing the lady's coat of arms, together weighing 53 marcs and 7 onces.)

4. Item troys drageouers aussi vermeil dorez d'un coste sizelez façon de Portugal et aux armes de lad. dame, poisant ensemble dix huit marcs six onces. (Item: three drageoirs [a covered cup for *dragées* (sweet)] also in silver gilt, engraved on one side in the Portuguese style and bearing the lady's coat of arms, together weighing 18 marcs and 6 onces.)

5. Item troys grans sallieres aussi d'argent vermeil dorees, en deux desquelles sont les armes du roy au fons, poisant ensemble trente troys marcs deux onces. (Item: three large salts also in silver gilt, at the bottom of two of which are the king's coat of arms, together weighing 33 marcs and 2 onces.)

6. [Ajout, en marge] Item une petite nef d'argent vermeil doré garnye de son couvescle aux armes de mad. dame, poisant ensemble quinze marcs et demy. ([Added in the margin] Item: a small silver-gilt nef with its lid bearing the lady's coat of arms, together weighing 15½ marcs.)

7. Item une grande croix d'argent vermeil doré a esmaulx, et au pied de lad. croix une Notre Dame, un sainct Jehan et la Magdeleine, faiz de bosse et relievence aux armes de lad. dame, poisant vingt marcs six onces. (Item: a large crucifix in silver gilt and enamel and, at the foot of the cross, Our Lady, St John and Mary Magdalene, embossed and in relief, with the lady's coat of arms, weighing 20 marcs and 6 onces.)

8. Item deux grans chandeliers d'eglise d'argent vermeil dorez et goderonnez et a feuillages d'antique aux armes de lad. dame, poisant ensemble dix sept marcs. (Item: two large church candlesticks in silver gilt with gadrooning and antique foliage, bearing the lady's coat of arms and together weighing 17 marcs.)

9. Item deux autres petitz chandeliers d'eglise d'argent vermeil dorez faiz a plumetz, poisant ensemble cinq marcs cinq onces. (Item: two more small church candlesticks in silver gilt decorated in the style of feathers, together weighing 5 marcs and 5 onces.)

10. Item une grant bouete a dragee d'argent vermeil doree aux armes de lad. dame avec son couvescle, poisant ensemble quatre marcs six onces. (Item: a large sweetmeat dish in silver gilt with the lady's coat of arms and lid, together weighing 4 marcs and 6 onces.)

11. Item une douzaine d'assiettes d'argent vermeil dorees poisant ensemble douze marcs troys onces. (Item: a dozen silver-gilt plates, together weighing 12 marcs and 3 onces.)

12. Item ung calice a ouvraige avec sa platine et deux chopinectes d'argent vermeil dorees, poisant le tout ensemble neuf marcs demye once. (Item: a decorated chalice with its stand and two silver-gilt burettes, together weighing 9 marcs and half an once.)

13. Item troys bouetes a dragee avec barres d'argent doré et une medalle a chacun des couvescles, et deux autres moyennes de pareille façon, poisant ensemble dix sept marcs et demy. (Item: three sweetmeat dishes with silver-gilt banding and a medallion on each of the lids, and two medium dishes in a similar style, together weighing 17½ marcs.)

…

Ensuyt en ce chappitre la vaisselle qui fut baillee aud. Bourdyveau par Me Victor Barguyn, trésorier de feue Mad. Dame. **(In this chapter there follows the silverware that was given to the said Bourdyveau by Maître Victor Barguyn, treasurer to the deceased lady.)**

20. Ung grant rafreschissouer d'argent vermeil doré aux armes de lad. dame, poisant quatre vingtz douze marcs six onces. (A large silver-gilt wine cooler with the lady's coat of arms, weighing 92 marcs and 6 onces.)

21. Item une grant buye aussi d'argent vermeil doré aux armes de lad. dame, poisant vingt troys marcs quatre onces. (Item: a large vase also in silver gilt with the lady's coat of arms, weighing 23 marcs and 4 onces.)

22. Item deux torches avec leurs pates de cinq piedz de hault dorez en aucuns endroictz, aux armes de feue Ma Dame, poisant ensemble six vingtz ung marcs et demye. (Item: two torch holders with their feet, 5 feet high, ungilded, with the late lady's coat of arms, together weighing 621½ marcs.)

23. Item ung grant chandelier d'argent pour servir en salle avecques

ses branches doré en aucuns endroitz, poisant cent marcs cinq onces. (Item: a large silver candleholder for room use, with its branches ungilded, weighing 100 marcs and 5 onces.)

24. Item soixante douze platz et cent dix neuf escuelles d'argent vermeil doré aux armes de feue Ma Dame tant de fruicterie que de cuysine, le tout poisant ensemble quatre cens soixante sept marcs deux gros. (Item: 72 dishes and 119 bowls in silver gilt with the late lady's coat of arms, both for fruitery and kitchen, together weighing 467 marcs and 2 gros.)

25. Item quatre flacons aussi d'argent vermeil doré aux armes de lad. dame, poisant ensemble quarante quatre marcs cinq onces. (Item: four flagons also in silver gilt with the lady's coat of arms, together weighing 44 marcs and 5 onces.)

26. Item une petite couppe d'or plaine avec son couvescle, poisant ensemble cinq marcs cinq gros et demy. (Item: a small plain gold bowl with its lid, together weighing 5 marcs and 5½ gros.)

27. Item ung cadenat d'or a salliere avec une cuilliere aussi d'orée poisant ensemble deux marcs troys onces quatre gros. (Item: a gold salt cadinet with a spoon also gilded, together weighing 2 marcs, 3 onces and 4 gros.)

28. Item une grande buyre a cordelieres aussi d'argent vermeil doré aux armes de feue Ma Dame mere du roy, poisant vingt six marcs une once et demye. (Item: a large cordeliere [cord] vase also in silver gilt with the late queen mother's coat of arms, weighing 26 marcs and 1½ onces.)

29. Item huit flambeaulx d'argent vermeil dorez aux armes de feue Mad. Dame, poisant ensemble vingt huit marcs. (Item: eight torches in silver gilt with the late lady's coat of arms, together weighing 28 marcs.)

…

Le mercredi ensuyvant dix septiesme jour dud. moys et an, en procedant a la confection dud. inventaire furent inventoriees les vaisselles d'or et d'argent et autres choses cy apres declarez et delivrez de Pierrevyve. (The next Wednesday, the seventeenth day of this month and year, in drawing up this inventory, the following gold and silverware was recorded, along with other items, stated hereafter and delivered by Pierrevyve.)

30. Premierement une grande salliere d'argent vermeil doré aux armes de feue Mad. Dame mere du roy faicte a pilliers et feuillage, poisant quatre marcs six gros. (First, a large silver-gilt salt with the late queen mother's coat of arms, decorated with columns and foliage, weighing 4 marcs and 6 gros.)

31. Item deux aiguyeres couvertes d'argent vermeil dorees mises par inventaire à escailles, touteffoys sizelees de feuillage antique aux armes de feue Mad. Dame, poisant ensemble dix neuf marcs deux onces. (Item: two lidded ewers in silver gilt, inventoried as decorated with shell but in fact engraved with antique foliage and the late lady's coat of arms, together weighing 19 marcs and 2 onces.)

32. Item deux bassins d'argent vermeil dorez aux armes de lad. dame, poisant ensemble quatorze marcs cinq onces. (Item: two silver-gilt basins with the lady's coat of arms, together weighing 14 marcs and 5 onces.)

33. Item une couppe garnye de son couvescle d'argent vermeil doree sans armoyries, poisant six marcs quatre onces. (Item: one bowl with its lid in silver gilt without coat of arms, weighing 6 marcs and 4 onces.)

34. Item une buye d'argent vermeil doree plaine aux armes de lad.

feue dame, poisant quatorze marcs deux onces et demye. (Item: a plain, silver-gilt vase with the late lady's coat of arms, weighing 14 marcs and 2½ onces.)

35. Item quatre drageouers, les deux vermeil dorez par dedans sizelez d'antique et les deux autres verez aussi sizelez aux armes de lad. dame, poisant ensemble seize marcs six onces et demye. (Item: four drageoirs, two made of silver, gilt inside, engraved in the antique style and two others with gilded edges also engraved with the lady's coat of arms, together weighing 16 marcs, 6½ onces.)

36. Item une chappelle d'argent blanc à distiller eaue, poisant neuf marcs et demy (Item: a white silver alembic head for distilling water, weighing 9½ marcs.)

37. Item une esguyere d'argent vermeil doré sizelee poisant unze marcs six gros. (Item: an engraved silver-gilt ewer, weighing 11 marcs and 6 gros.)

38. Item deux grans potz ou vazes d'argent vermeil dorez sizelez a l'antique et a doubles ances avec leurs couvescles, poisant ensemble soixante troys marcs une once et demye. (Item: two large jars or vases in silver gilt engraved in the antique style and with double handles and their lids, together weighing 63 marcs and 1½ onces.)

39. Item deux petitz flacons d'argent neufz dorez par les garnitures armoriez aux armes de feue Madame mere du roy, poisant ensemble dix marcs quatre onces et demye. (Item: two new, small silver flagons with gilded decorations bearing the coat of arms of the late queen mother, together weighing 10 marcs and 4½ onces.)

…

'Autre vaisselle baillee et fournye par led. Babou qui s'est trouvee dedans led. cabinet estant au dessus de la chambre du concierge dud. Louvre, faicte par Pierre Mangot orfevre dem. a Bloys du commandement et ordonnance de feue Ma Dame mere du roy. (Other silverware given and supplied by the said Babou, which was found within the chambers above the chamber of the concierge of the Louvre, made by Pierre Mangot, goldsmith residing in Blois at the command and order of the late queen mother.)

98. Deux grans potz d'argent vermeil dorez enrichyz de camayeulx de pourcelyne poisant ensemble quatre vintz dix neuf marcs deux onces. (Two large jars in silver gilt adorned with porcelain cameos, together weighing 99 marcs and 2 onces.)

99. Item deux autres potz en forme de flacons aussi garniz de camayeulx de semblable façon, poisant ensemble cinquante huit marcs sept onces, en ce comprins le remplast de fer qui est dedans. (Item: two more jars in the form of flagons also garnished with cameos in a similar style, together weighing 58 marcs and 7 onces, including the iron liner within.)

100. Item deux grans bassins d'argent vermeil dorez aussi garniz de camayeulx, a hault pied, poisant ensemble quatre vingt seize marcs une once. (Item: two large silver-gilt basins also decorated with cameos, with tall feet, together weighing 96 marcs and 1 once.)

Bimbenet-Privat 1995, 59

1537 January–June: Mangot is mentioned in the Royal Household accounts for all manner of repairs and supply of silverware: dishes, bowls, flagons.

Nocq 1926–31, vol. 3, 185; Archives nationales, Paris, KK 93 (Royal Household accounts)

1538 To Pierre Le Messier, servant of Pierre Mangot, goldsmith to the king, 656 livres tournois, 3 sous and 9 deniers in payment of a large Order chain of office given by the king to the comte de Saint-Pol, to replace another similar one that he had requested from him for sieur 'Canyn de Baugé' [Bagé], recently made a knight of the Order.

Marichal 1887–1908, no. 28865; Laborde 1877–80, vol. 2, 390

1538 To Pierre Le Messier, servant of Mangot, goldsmith to the king, 221 livres tournois, 9 sous and 1 denier in payment of a gold chain, which the king purchased himself to dispose of at his pleasure, to be taken from these coffers of this April, May, June quarter.

Marichal 1887–1908, no. 28850; Laborde 1877–80, vol. 2, 390

1538 27 September: to François Dujardin, messenger to Pierre Mangot, goldsmith to the king, 13 livres and 10 sous in payment of a gold image sold to the king at Villeneuve de Tende, last June and given to the 'plaisant du Pape' (Pope's jester) named Le Roux.

Marichal 1887–1908, no. 31815; Laborde 1877–80, vol. 2, 249–50

1538 [October]: to François Dujardin, messenger to Pierre Mangot, goldsmith to the king, 607 livres, 7 sous and 9 deniers in payment of a large Order chain of office weighing 3 marcs, 1 once, 6½ gros of gold in écus, together with a taffeta-padded case, given to the duc d'Estouteville to replace his own, which he gave to the duc de Somma when he was made a knight of the Order.

Marichal 1887–1908, no. 31814; Laborde 1877–80, vol. 2, 249

1539 2 January: order to the Chambre des comptes to pay from the current year accounts ending 31 December 1539, of the treasurer of the Épargne, the sum of 48 livres, 10 sous and 2 deniers paid by him to the goldsmith Pierre Mangot, to the embroiderer Robert Duluz and the merchant Pierre Galland, for a purse of violet velvet sewn with small, gold fleurs-de-lis, to hold the seal, for the repair of the small silver-gilt casket to hold this purse, and for the purchase of another leather casket decorated with fleurs-de-lis to hold this casket.

Marichal 1887–1908, no. 30813; Laborde 1877–80, vol. 2, 239

1541 … he supplies 100 vervelles 'tant rondes que plattes' (both round and flat) for the birds of the king's Falconry, which he gilds and on which he engraves the words 'Au Roy' (To the King) accompanied by the French coat of arms enamelled in azure blue; he delivers an Ordre de Saint-Michel 'des deux costez' (double-sided), with shells on one side and on the other, a rock.

Archives nationales, Paris, KK 92 (Argenterie accounts for 1541, fols 152v–153)

1541 1 March: order to the treasurer of the Épargne to hand over to Jacques Bernard, master of the Chambre aux deniers, the sum of 338 livres tournois, 7 sous and 8 deniers for the requirements of his office and in particular for the payment of the goldsmith Pierre Mangot, for a 'fer à goffres d'argent' (silver waffle iron).

Marichal 1887–1908, no. 11849

1541 April–June: is paid 14 livres, 4 sous and 6 deniers for 'une embouchure d'or taillée à moresque à espargne pour servir à la trompe du roi' (a gold mouthpiece engraved in the Moorish fashion of Spain for use on the king's trumpet) and the manufacture of the mouthpiece.

Nocq 1926–31, vol. 3, 185; Archives nationales, Paris, KK 92 (extraordinary Argenterie accounts for 1541, fol. 152v)

1541 July–December: for the price of 216 livres and 13 sous, plus 13 livres and 10 sous for the manufacture, creates the 'chapeau ducal' (ducal crown) of the princess of Navarre, for the day of her nuptials (207 livres plus 13 livres for the manufacture), and the fittings of a small casket in which to place the princess's essentials for the night. This was Jeanne d'Albret, daughter of Marguerite of Navarre and niece of the king, married in 1541 to Guillaume de Clèves.

Nocq, 1926–31, vol. 3, 185; Archives nationales, Paris, KK 92 (extraordinary Argenterie accounts for 1541, fol. 280)

1542 6 March: Pierre Mangot appears before the Chambre des monnaies de Paris regarding the quality of the hocquetons that he had made for the king's archers. The magistrates ask him who the refiners or goldsmiths were that had supplied the gold. 'A esté reffusant de les nommer et a dict qu'il ne scet les noms desdites personnes et que ce sont gens qui hantent en son hostel avec ses serviteurs' (But he refused to name them and said that he did not know the names of these individuals and that they were people who frequent his place of residence with their servants).

Archives nationales, Paris, Z1B 639 (Bimbenet-Privat 1992, 545)

1542 10 March: Mangot is authorised to take 120 marcs in silver (30kg) from the refiners for the hocquetons of the king's guard.

Nocq 1926–31, vol. 3, 185

1543 11 June: Pierre Mangot, goldsmith to the king, becomes godfather to Jean Droulin, fifth child of Betrand Droulin, a merchant in Blois; the godmother is his daughter, Madeleine Mangot, wife of Gilles de Suramond, goldsmith to the king.

Piquard 1975, 345, 348

1549 17 July: the accounts of the Hôtel-Dieu de Blois show a bequest of 10 livres left by Pierre Mangot to the poor. It therefore appears that Mangot drew up a will.

Verlet-Reaubourg (unpublished, typed text provided by the author, page 127)

1551 Pierre Mangot is a signatory to the goldsmiths' protest against the goldsmiths' statute, declaring that only very great works can be executed in the finest gold and that lesser works should only be executed in 22-carat gold.

Gay and Stein 1887–1928, vol. 1, 325; Nocq 1926–31, vol. 3, 185; Bimbenet-Privat 1992, 545

[Between 1551 and 1563]: It was during this period that Pierre Mangot died. The absence of documents after 1551 suggests a date shortly after 1551.

1563 Death of Jeanne Boullyer, Pierre Mangot's widow. Verlet-Reaubourg (unpublished, typed text provided by the author, page 127)

Notes

1 I would like to give my warmest thanks to Alice Minter, curator at the Victoria and Albert Museum, for her translation of my lecture.
2 Toesca 1965.
3 Toesca 1969.
4 Hayward 1973; Hayward 1976, pl. I.
5 Hayward 1976, pl. 251.
6 Hayward 1976.
7 Bimbenet-Privat 1992.
8 Chancel-Bardelot 2010.
9 Pérouse de Montclos 2000.
10 In French, they were known as *orfèvres suivant la cour* (goldsmiths following the court).
11 Was Mangot from Blois, as his career implies, or from Tours, as the frequency with which his surname occurs in that city would suggest? In fact, there was a goldsmith to Louis XI named André Mangot who worked in Tours and created a reliquary for the head of St Martha (now lost) which he took to Tarascon in 1478. In 1509 a certain Hans Mangot of Tours produced a silver statue of St Maurice for Angers cathedral. These two goldsmiths could have been respectively the father and brother of Pierre Mangot, although there is no documentary evidence to prove this. Eugène Giraudet includes Pierre Mangot in his dictionary of Tours artists (Giraudet 1885, 280–3).
12 Notre-Dame Cathedral Treasury, Reims, on deposit at the Palais du Tau, inv. no. TAU 2008000176. See Le Roux de Lincy 1849; Oman 1966. Oman's article corrects erroneous traditions about the nef and identifies its creator as the goldsmith Raymond Guyonnet de Tours. See also Bimbenet-Privat 1995a; Crépin-Leblond in Crépin-Leblond, Taburet and Wolff 2010, 105–6, no. 31.
13 Musée Dobrée, Nantes, inv. no. D. 886-1-1. The detailed account of the funeral of Anne of Brittany at Saint-Denis, dated 1514, provides the names of the Blois goldsmiths commissioned to produce the crown and other decorations for the late queen's coffin but does not mention the names of those responsible for producing the casket for her heart. (Archives départementales de Loire-Atlantique, Nantes, E 208/2. See Santrot 1988; Brown *et al.* 2013; Barthet 2014, 53–9; Santrot 2017).
14 This was a gold crown 'in the imperial style' (i.e. a closed crown), with a double fleur-de-lis, a fleuron and a silver-gilt ring 'to place on the finger of the hand of justice' (Laborde 1872, 161).
15 See the list of works in the Appendix to this chapter.
16 Bimbenet-Privat 1992, 545.
17 For more on the Duzen, Mangot and Droulin families in Blois, see Piquard 1975.
18 Hermant in Hermant 2015, no. 44.
19 National Archives, Paris, J 947, no. 2 (see Crépin-Leblond and Barbier 2015, no. 67).
20 Bimbenet-Privat 1995a, 59.
21 Lecoq 1987, 264–5.
22 Musée du Louvre, Paris, inv. no. MR 547. Rock crystal; cast silver, engraved, enamelled and gilded; chalcedony and shell cameos; chalcedony intaglios; spinels, turquoise, garnets; pearls and seed pearls, *pâtes de verre*. No mark. Provenance: former Royal Collections. Bibliography: Barbet de Jouy 1868, no. 80; Marquet de Vasselot 1914, no. 230, pl. XXIII; Toesca 1965, 311, fig. 3; Toesca 1969, 294, fig. 5; Hayward 1976, 89, 360, fig. 250; Bimbenet-Privat 1992, 223; Alcouffe 2001, 539; Crépin-Leblond and Barbier 2015, no. 64.
23 Musée du Louvre, Paris, inv. no. MR 545 and 546. Rock crystal; cast silver, engraved and gilded; spinels, garnets, pearls and fake precious stones. Marks on the candle rings only, for 1581–2. Provenance: former Royal Collections. Bibliography: Barbet de Jouy 1868, no. 81, 82; Marquet de Vasselot 1914, no. 241, pl. XXIII; Toesca 1969, 294, fig. 7; Hayward 1976, 86, 89; Alcouffe 1987, 135, fig. 1; Bimbenet-Privat 1992, 248–9, ill.; Alcouffe 2001, 539, ill.; Crépin-Leblond and Barbier 2015, no. 64.
24 Musée du Louvre, Paris, inv. no. MR 548 and 549. Rock crystal; cast silver, engraved, enamelled and gilded. No mark. Provenance: former Royal Collections. Bibliography: Barbet de Jouy 1868, nos 84, 85; Marquet de Vasselot 1914, no. 228, pl. XXII; Alcouffe 2001, 539, ill.; Crépin-Leblond and Barbier 2015, no. 62, 129.
25 Hayward 1973; Hayward 1976, pl. I.
26 Tait 1988, 20; Alcouffe 2001, 163; Thornton 2015, 108–15; Crépin-Leblond in Pébay-Clottes, Menges-Mironneau and Mironneau 2017, 46.
27 Bibliothèque nationale de France, Paris, Coins, Medals and Antiques Department, inv. no. 55.487. Agate and silver gilt and enamelled in blue; pearls and garnets. Mark of Pierre Mangot only. Provenance: church of Saint-Paul, Paris, then revolutionary confiscation in 1796. Bibliography: Babelon 1897, 52, no. 97; Bardiès-Fronty, Bimbenet-Privat and Walter 2009, 319, no. Ec80; Hermant in Hermant 2015, no. 118.
28 Unpublished object (Private collection).
29 Musée du Louvre, Paris, inv. no. OA 11936. Teak covered in mother-of-pearl flakes; cast silver, engraved, enamelled, gilded; spheres of fake emerald, garnets, carnelian and agate. Mark of Pierre Mangot and Paris guild mark, a crowned 'D' for December 1532–December 1533. Provenance: Gregorio Franchi (1769–1828); William Foster; George Stanhope, 6th Earl of Chesterfield (1805–1866); Lady Evelyn Stanhope (d. 1875); Earls of Carnavon at Bretby Hall, Derbyshire; William Randoph Hearst (1863–1951); Michael Wellby (1928–2012). Bibliography: Toesca 1965, 295, figs 4, 10–13; Hayward 1976, pl. I; Hernmarck 1977, fig. 785; Snodin and Baker 1980, 822 n. 33; Bimbenet-Privat 1992, 244–5, no. 5; Mabille 2000; Bimbenet-Privat 1995b, no. 73a.
30 Mantua, cathedral treasury. Teak covered in mother-of-pearl shapes; cast silver, engraved, enamelled, gilded; simulant emeralds, garnets. Mark of Pierre Mangot and Paris guild mark, a crowned 'E' ['D'?] for December 1533–December 1534. Provenance: probably gifted by Henry IV (r. 1589–1610) to Francesco Gonzaga, bishop of Mantua, *c.* 1594–6. Bibliography: Toesca 1965; Toesca 1969; Bimbenet-Privat 1992, no. 5 bis, 246–7; Bimbenet-Privat 1995b, no. 73b.
31 Unpublished object (Private collection).
32 I should like to thank Mr Rémi Verlet who generously sent me the work by Madame Nicole Verlet-Réaubourg on the goldsmiths of Blois, unpublished at the author's death. In this, I was able to check the chronological information given here based on the appearance of marks in Blois.
33 Victoria and Albert Museum, London, M.60–1959 (Lightbown 1978, 28–34, no. 19).

34 The two candleholders formed part of the decor for the meeting between France and England at Boulogne-sur-Mer in 1532 and then for the meeting between Francis I and Pope Clement VII in 1533. They were destroyed at an unknown date. However, their image has been preserved thanks to a wood engraving illustrating the festival book of the entry of the queen into Paris by Guillaume Bochetel, published in Paris by Geoffroy Tory in 1531. We do not know the name of the goldsmith who created them (Bimbenet-Privat 1995b, no. 67).

35 Felgueiras in Vassallo e Silva 1996, 145.

36 National Archives, Paris, KK 100, fols 109r–109v (comptes des Menus Plaisirs, 10 October 1529). I thank Philippe Malgouyres who pointed out the meaning of '*chalict*', instead of 'chalice' that had been previously transcribed.

37 A. Jordan Gschwend., '"*Ma meilleur soeur": Leonor of Austria, Queen of Portugal and France*', in Checa 2010, vol. 3, 2577.

38 See Hermant 2015, *passim*.

39 This is particularly true of the two burettes from the treasury of the Ordre du Saint-Esprit kept in the Louvre (see **Fig. 36** and note 24 above).

40 See note 27 above.

41 Kunsthistorisches Museum, Vienna, inv. no. KK 1120. See Bimbenet-Privat 1991.

42 Musée du Louvre, Paris, inv. no. RFML.OA2018.1.1.1. See Malgouyres 2018.

43 Kunsthistorisches Museum, Vienna, inv. no. KK 881. See Rainer and Haag 2018.

44 Bimbenet-Privat 1992, 468–9.

45 Bibliothèque nationale de France, Paris, Coins, Medals and Antiques Department, inv. no. 56.336. See Hackenbroch 1966.

Chapter 4
The Sibyls Casket in the British Museum as an Early Work Attributed to Pierre Mangot and its Relationship to the Royal Clock Salt

Dora Thornton

Pierre Mangot (*c*. 1485–after 1551) had a distinctive manner as a goldsmith, blending elements of late French Gothic with an Italianate Renaissance style. This has made it possible to firmly attribute a number of works to him despite the fact that they are unmarked. Among these is the Sibyls Casket in the Waddesdon Bequest in the British Museum, which bears many similarities with Mangot's marked objects in terms of its design and making. The loan of the Royal Clock Salt (another unmarked object attributed to Mangot) to the Museum, and its display in the Waddesdon Bequest Gallery near to the Sibyls Casket, enabled the two objects to be minutely compared and studied using the same analytical techniques. It also enabled the enamelled plaques on the Sibyls Casket to be examined alongside other enamels in the Museum and beyond that are thought to be the work of the same artist, traditionally known as the Master KIP. Its shell cameos (see Introduction, p. 1, Chapter 3, pp. 50–1 and Chapter 8, pp. 117–18) have close parallels within the British Museum collection, such as in the founding bequest of Sir Hans Sloane (1660–1753).

Taken together, the Sibyls Casket and the Clock Salt illuminate Mangot's interest in supplying the French court with fashionable and luxurious items that incorporated the very latest techniques, including gem engraving, clockmaking and painted enamel. These two objects, which can now be dated to early in his career, demonstrate his ability to work collaboratively with a range of specialist artisans and luxury materials in his Parisian royal workshop.

The Sibyls Casket is one of the highlights of the Waddesdon Bequest in the British Museum.[1] The Bequest is a highly select cabinet collection of medieval and Renaissance artefacts that was left to the Museum by Baron Ferdinand Rothschild (1839–1898) at his death in 1898. He named it after Waddesdon Manor, his splendid mansion in Buckinghamshire where the collection was housed in his lifetime. As a museum within a museum, the Bequest has been continuously studied and published since 1902.[2] It comprises the rarest work of the Renaissance goldsmith, from jewellery, gems, rock crystal and hardstones to silver and gold, from reliquaries to secular plate. Every object is small in scale and innately precious, often with a distinguished provenance or a good story attached. Many of the objects are princely, imperial or aristocratic in origin: works of art that enhanced the prestige of their owner and publicised networks of power and allegiance in Renaissance courts. The collection in its entirety could at first sight have come straight from a Baroque *Kunstkammer* of northern or central Europe, though it is of course a 19th-century pastiche of one.[3] At a deeper level, however, the Bequest offers a snapshot of Rothschild self-fashioning as this energetic new dynasty rose from the Frankfurt Jewish quarter to become bankers to the world in the 19th century.[4] They did not just collect art, but used it to shape plutocratic codes of social behaviour in their European mansions, in which the works of art were in effect part of the political and social life around them, as key elements in elite corporate entertainment. The Bequest is built around two poles: the Rothschild relationship to the Renaissance, and the Rothschild relationship to the art market, with a scattering of fascinating forgeries to prove the latter point.[5]

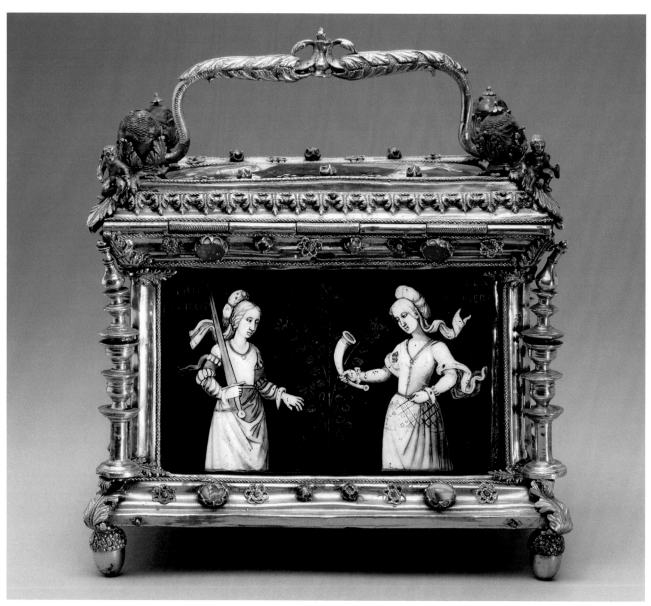

Figure 48 The Sibyls Casket: casket with five enamelled plaques of sibyls, some signed 'IP' for an enameller traditionally known as the Master KIP, with the silver-gilt mounts attributed to Pierre Mangot, c. 1530–5, Paris. The feet are later additions. Painted grisaille enamel on copper, silver-gilt mounts set with engraved gems, gemstones and enamelled elements, h. 16.6cm, l. 14.5cm. Waddesdon Bequest, British Museum, WB.23

A new gallery curated for the Bequest in 2015, funded by the Rothschild Foundation, reappraised the collection and suggested new research questions that were explored in the book about the gallery and in the conference that accompanied the opening of the gallery in 2015.[6]

Among the objects in the Bequest to be reassessed during the research for the new gallery was the Sibyls Casket. Made for the French court, it represents the very latest French design and craftsmanship of the years around 1530.[7] More of a jewel than a piece of goldsmiths' work, its silver-gilt surfaces are encrusted with cameos and small gems in quatrefoil settings or applied with filigree elements, tiny silver-gilt figures, columns, a dolphin handle and scrolling leaf elements that add to the rich miniaturistic detail. Cable-twist edgings frame sophisticated painted enamels in grisaille of the sibyls, enriched by gilding, while blue enamel balls crown the lid and add a vivid touch of colour. The enamelled plaques around which this casket was constructed by Mangot present 8 of the 12 sibyls, prophetesses in the

ancient pagan world of the coming of Christ. Painted in enamel on copper, the sibyls are portrayed as three-quarter length figures of young women in grey monochrome, or *grisaille*. The figures are modelled in layers of white enamel fired onto the dark blue ground, using a technique known as *enlevage*. These layers are ruched with a needle to create a slight sense of relief and modelling, and scratched through to the dark ground to draw outlines or details in a sketchy, almost impressionistic way. The sibyls wear a mixture of fanciful classical and contemporary court dress reflecting the long history and tradition of sibyls in Western art.[8] Each is identified by her attribute and by her name, written in gold, while between them the enameller has painted leaves and flowers in delicate touches of gilding. On the front of the casket is the Persian sibyl with her lantern and the Libyan sibyl with her lighted torch, both referring to the coming of Christ (**Fig. 56**). On the back are the Cimmerian sibyl with a horn of plenty alluding to the Golden Age to come, and the European sibyl with a sword referring to the Massacre of

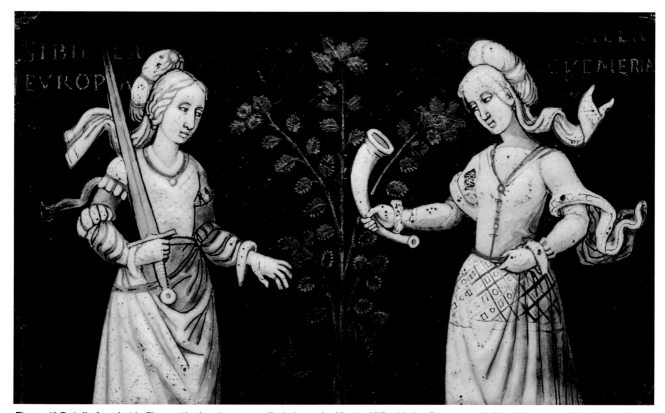

Figure 49 Detail of casket in Figure 48, showing enamelled plaque by Master KIP with the European sibyl holding a sword alluding to the Massacre of the Innocents and the Cimmerian sibyl holding a horn of plenty referring to the Golden Age to come

the Innocents (**Figs 48–9**). On the ends of the casket are single figures of the Tiburtian sibyl holding a hand alluding to the scourging of Christ, and the Samian sibyl with the cradle of Christ's nativity (**Fig. 50a–b**). On the lid are the Erythraean sibyl with the rose of the Virgin May and the Cumaean sibyl with a bowl symbolising the birth of Christ (**Fig. 51**).[9] The figures are thought to be loosely adapted from a French *Book of Hours for Roman Usage* of *c.* 1502, printed in Paris by Pigouchet for Simon Vostre (fl. 1486–1518), of which two copies survive in Paris and in London, but they could derive from workshop drawings after similar models. As the same woodcuts appear in another book printed in Paris in 1529 by Jean Bertaud (born 1502) there is uncertainty as to which edition of the woodcuts the enameller might have used as his source.[10] The enameller has simplified and concentrated the presentation, truncating full-length figures into three-quarter lengths, editing out the architectural frameworks and standing each sibyl against a dark ground for clarity. He has taken the first eight sibyls in the series, presumably because that is all he had room for with a casket in mind for his plaques. We cannot identify the enameller, although his monogram, 'IP', is etched into the dark ground of a white scroll in the lower right-hand corner of the lid (**Fig. 50c**). The monogram here, one of a series of variants employed by this enameller, as well as the idiosyncratic style, allow around 109 enamels to be attributed to him. He seems to have trained as a goldsmith and his enamels always have a miniaturistic decorative quality. He often worked in grisaille, recalling ancient and contemporary cameos and plaquettes in his figure style and design sense. He specialised in small-scale plaques like these, intended to be set into caskets or paxes. The Sibyls

Casket is his most complete and distinguished piece, and perhaps one of his earliest.[11]

Before considering the identity and significance of the enameller of the plaques, what makes the Sibyls Casket the work of Mangot and what links it to the Clock Salt and his other pieces that are either hallmarked or attributed to him on stylistic and technical grounds?

Susan Godsell (a PhD student at Cambridge University who studied the enameller responsible for the sibyls plaques and who was advised by Hugh Tait at the British Museum) was the first to find a Parisian attribution for the Sibyls Casket by comparing the silver-gilt mounts with those on two hallmarked caskets.[12] In doing so, both were building on a lead from an Italian scholar, Ilaria Toesca, published in an article of 1965, in which she discussed two superb caskets as Parisian and by one maker, without identifying him.[13] The first is a mother-of-pearl casket with silver-gilt mounts that was in the collection of Michael Wellby in London at the time that Toesca was writing, but which was later acquired by the Musée du Louvre (see Chapter 3, p. 46 and **Fig. 41**). The casket bears the Paris hallmark, the date letter for 1532–3 and the crowned 'M' mark of the Parisian maker, Pierre Mangot, as identified in 1992 by Michèle Bimbenet-Privat.[14] The second casket, which is smaller, is in the cathedral treasury in Mantua and is marked by Mangot and for Paris and dated 1533–4 (see **Fig. 27**). The Mantuan casket is thought to have been a diplomatic gift to the Gonzaga from the French during the 16th century.[15] Both caskets have a wooden core that has been covered with overlapping plaques of mother-of-pearl, a speciality of Gujarat in north-west India. By adding jewelled mounts Mangot fashioned luxury imports to European, and specifically French, royal taste.

Figure 50a Detail of casket in Figure 48, showing enamelled plaque with the Tiburtian sibyl holding a hand alluding to the scourging of Christ

Figure 50b Detail of casket in Figure 48, showing enamelled plaque with the Samian sibyl with the cradle of Christ's nativity

Figure 50c Detail of casket in Figure 48, detail of 'IP' signature in lower right-hand corner of the lid

The different mounting of the mother-of-pearl scales has led Bimbenet-Privat to suggest that the Louvre casket with its fish scales is Gujarati work merely embellished by Mangot, whereas the smaller Mantuan one, finished the following year, might have been put together from separate polygonal elements by Mangot himself, each piece nailed with a stud in the form of a fleur-de-lis, and mounted in groups to back Italianate portrait roundels.[16]

As Godsell noted, the silver-gilt mounts on these two superb caskets compare closely with those on the Sibyls Casket; there are striking resemblances of form and detail indicating that the Sibyls Casket must derive from Mangot's workshop at much the same date. As she points out, the materials are different, in that plaques of painted enamel, supplied to Mangot by another maker, take the place of plaques of mother-of-pearl. The classical tomb-like structure is seen on all three with their pedestal bases. Each has a concave strip along the base moulding embellished with semi-precious stones. They all have four free-standing balusters or columns that on the Sibyls Casket splay oddly

outwards in an anti-classical manner to fit the cornice, although this peculiarity is seen in a less pronounced form on the Louvre casket. The sibyl plaques are framed with rope twists, as are the mother-of-pearl plaques on the Louvre and Mantuan caskets, and the palmette strip on all three bears the same odd horizontal scoring (see Chapter 8, p. 120 and **Fig. 110a**). All three caskets have tiny putti sitting or standing at the corners of the lid, and blue enamelled blobs in the form of acorns within silver-gilt leaves, set onto the corners. The dolphin-headed handles are also extremely close in their design and making.[17] A view of the Sibyls Casket when taken apart shows exactly how the piece has been put together with separate elements pinned in layers through the silver-gilt panels into a wooden core (**Fig. 52**).

Recent examination of the Sibyls Casket by Fleur Shearman of the British Museum revealed marks above the head of the Cumean sibyl in the silver-gilt frame moulding, made visible by the fact that a filigree element is missing. Bimbenet-Privat comments of this mark: 'it could be a part of a Gothic date letter: it is straight and does not seem to be the result of damage'.[18] It is difficult to say anything more, but it is worth noting that blurred, stamped markings were found in the same area on the Paris casket and were used to support attribution of the casket to Pierre Mangot.

Thanks to Bimbenet-Privat, we can attribute further pieces to Mangot's production, such as the marvellous ciborium in the Louvre, which is documented in the Royal Collection from 1561 and is part of the treasury of the Ordre of Saint-Esprit. It is unmarked, but is very similar, as Toesca first noticed, to the caskets in its use of semi-precious stones, scrolls, filigree elements and tiny figures. The rock-crystal body, pendant pearls and shell cameos stand out on this object.[19] They take us to the Clock Salt, as Toesca also noted, which in turn takes us back to the Sibyls Casket and a

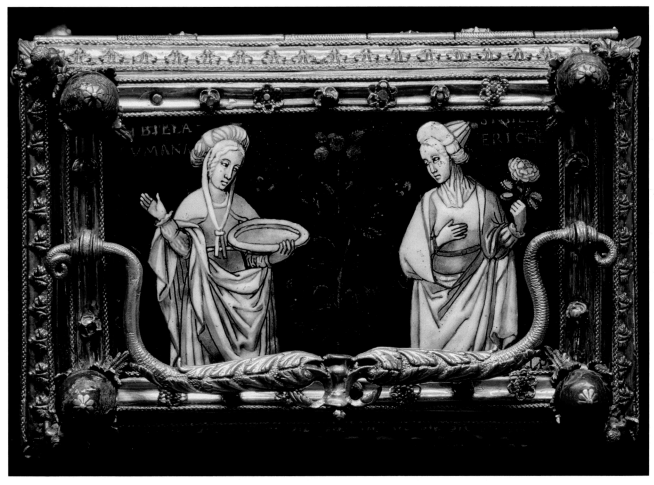

Figure 51 Detail of casket in Figure 48, showing the Erythaean sibyl with the rose of the Virgin Mary and the Cumaean sibyl with a bowl symbolising the birth of Christ

Figure 52 The Sibyls Casket in Figure 48, taken apart in conservation to show its construction and the various elements

Figure 53 Shell cameo with two heads, a man's superimposed on a woman's, from the founding collection of Sir Hans Sloane, h. 38.78mm, w. 26.78mm, d. 14.22mm. British Museum, SLBCameos.186

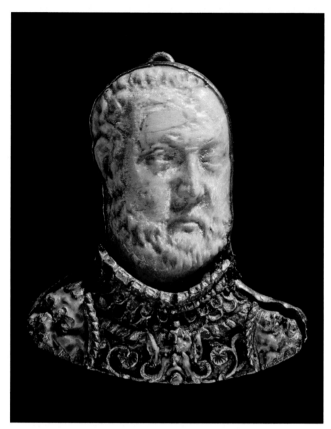

Figure 54 *Commesso* jewel, with male portrait bust in three-quarter view, possibly portraying Duke Cosimo de' Medici in *all'antica* armour, shell cameo in enamelled gold setting, 16th century, Florentine [?], h. 30.72mm, w. 27.13mm, d. 6.49mm. British Museum, 1890,0901.11

comparison between the two pieces now in the British Museum.[20]

The striking cameos that stud the base of the Clock Salt have been identified by Caroline Cartwright of the British Museum as being made of shell, not agate. These were a French speciality in the early 16th century; a set of early examples, supplemented by 19th-century additions, appears on a Munich-made cup in the Waddesdon Bequest.[21] A typical cameo out of several in the Sloane Bequest in the British Museum shows a man's head superimposed on that of a woman (**Fig. 53**). It was described by Sloane in his Latin catalogue as '*2 Bustum incogn[i]tum in torta*' (2 unknown heads in shell).[22] A sense of the popularity of shell cameos with

Figure 55 Silver-gilt acorn foot, added to the Sibyls Casket in Figure 48 after 1857

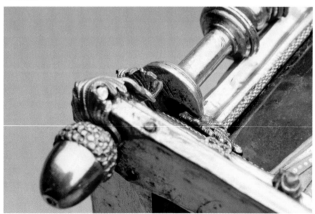

Renaissance courts and their potential for use in the highest-quality gold enamelled settings in the mid- to late 16th century is suggested by a fine but battered *commesso* jewel in the Museum with a male cameo bust in elaborate *all'antica* armour in enamelled gold (**Fig. 54**). This has traditionally been considered French but has recently been attributed to Florence, and tentatively identified as the Grand Duke, Cosimo de' Medici (1519–1574).[23]

The scooped quatrefoil settings for the gems and intaglios on the Clock Salt are closely comparable to those of the four on the Sibyls Casket; two glass replacements can now be identified. The column elements are similar and on both objects there are scratched assembly marks in Roman numerals to show how the different elements were put together in Mangot's workshop. The palmette ornament with its odd scoring is clear on both pieces, as is the rope-twist ornament, seen around the cameos on one and framing the enamels on the other.

X-ray fluorescence (XRF) analysis of the blue colourant on the enamelled plaques of the Sibyls Casket and for the balls on its lid (as on other Mangot pieces) revealed that they have different enamel compositions and are therefore of different dates. The enamelled plaques on the Clock Salt are strikingly blue whereas those on the Sibyls Casket, forming a ground for the grisaille painting, are a very dark blue-purple that appears black: the result of the mixture of cobalt and manganese in their making. The use of blue, rather than the more common manganese purple, for the dark ground is unusual for Limoges painted enamels (see Chapter 8, pp.

116–17). XRF shows that the cobalt in the sibyl plaques was found in association with nickel, bismuth and arsenic. In contrast, the cobalt in the balls on the Sibyls Casket was found in association with nickel only. These elements are a feature of the specific cobalt ore that was employed and the ways in which it was processed. A cobalt-nickel-arsenic-bismuth cobalt source is most often dated to after *c.* 1520–30, while cobalt-nickel is dated to before this period. As the Sibyls Casket is thought to have been made around the time of this changeover of cobalt sources, just before or around 1530, all we can really say is that the balls are likely to predate the plaques. Perhaps the Mangot workshop produced a quantity of these balls, as 'stock items' to be applied to a wide variety of objects, as the evidence of the surviving artefacts suggests. The plaques were created by a different enameller/goldsmith for a particular piece. Might they have been a special commission, given to Mangot by a patron to be made up into a casket?

We can be certain that the silver-gilt acorn feet on the Sibyls Casket are modern replacements, probably substitutes for the original claw and ball feet as seen on the caskets and on the Clock Salt (**Fig. 55**).[24] The nail holes in the wooden core of the Sibyls Casket indicate where the ball feet were attached, and we can date the change to a period after the casket was sold in the famous sale of the collection of Ralph Bernal (1784–1854) in 1855.[25] Bernal was an MP, but, in the words of one contemporary:

> It is not, however, so much as a politician, as from his judgement and taste in the collection of specimens of mediaeval art that Mr. Bernal will be best remembered, and his son used to say that it might almost be said that the South Kensington Museum had its cradle in his house in Eaton Square.[26]

Of his collecting, James Robinson Planché (1796–1880) wrote that Bernal was: 'Distinguished amongst English Antiquaries by the perfection of his taste, as well as the extent of his knowledge … Mr. Bernal could be tempted by nothing that was inferior.'[27]

In the sale catalogue the casket was admiringly (and unusually) described: 'A beautiful casket, in original silver-gilt mounting, highly-embellished with gems, camei [*sic*] etc.'[28] In 1857 it was thought worthy of a closely observed engraved illustration by A.J. Mason in Henry G. Bohn's illustrated catalogue of the Bernal Collection, which shows it without feet of any kind (**Fig. 56**).[29] The casket was acquired at the Bernal sale by another MP, Martin Smith (1803–1880), a member of a prominent and wealthy Whig banking dynasty who served as a director for the East India Company.[30] He lent it to the South Kensington Exhibition in 1862, to which the Clock Salt was also lent, where it was catalogued with other fine painted enamels of Limoges by the great scholar curator of the British Museum, Augustus Wollaston Franks (1826–1897). Smith lent it again in 1874 to the Special Exhibition of Enamels. His name is pencilled on the base and the original label recording his loan to the 1874 exhibition is kept inside the casket. Baron Ferdinand Rothschild bought it privately between 1874 and 1897. We know that Baron Ferdinand relied on the advice of the conservator and jeweller Alfred André (1839–1919) in designing his New Smoking Room at Waddesdon Manor from 1896 and that some of the repairs on enamels in the

Figure 56 The Sibyls Casket as engraved by A.J. Mason for Henry G. Bohn's illustrated catalogue of the collection of Ralph Bernal, London, 1857, lot 1565, p. 165. British Library, 2502.b.5, p. 165. Image © The British Library Board

Bequest are by André.[31] Perhaps it was Baron Ferdinand who ordered the acorn feet to be added to improve the casket for display, in which case he is likely to have employed André to do the work.

Baron Ferdinand had a pronounced taste for enamels and for jewel-like miniature pieces. The Sibyls Casket scores on both fronts. The privately printed *The Red Book* of 1897 recording his creation at Waddesdon Manor shows his careful curation of the casket in the New Smoking Room. He placed it in symmetry with the superb casket that he had inherited from his father Baron Anselm von Rothschild (1803–1874), studded with enamelled plaques in grisaille telling the story of Tobit (**Fig. 57**).[32] Like the sibyls, the biblical characters on the Tobit Casket are depicted in contemporary court dress. Attributed to the anonymous enameller who signed himself M.P around 1540, the enamels reveal 'subtle delicacy of the gradations of tone' and 'a complete mastery of the technique of grisaille enamelling' (**Fig. 58**).[33] Baron Ferdinand's acquisition of the Sibyls Casket placed him in distinguished company among scholar collectors to whom the enameller signing 'IP', as on this piece, was a source of fascination and debate.

This Limoges enameller signing 'IP' can be shown to have employed a variety of marks and monograms in his work. Known (and referred to hereafter) as the Master KIP, he signed himself 'KIP', 'IP' as on the Waddesdon Bequest casket, or 'IP' written within a 'G'. Sometimes he used a

Figure 57 Photograph showing the Sibyls Casket and the Tobit Casket on the third shelf of a vitrine in Baron Ferdinand Rothschild's New Smoking Room at Waddesdon Manor, taken from *The Red Book* of 1897. Photograph: British Museum

poinçon or stamp on the reverse of his pieces underneath the transparent counter enamel, with letters 'IK' above, 'P' below and a lion in a roundel (**Fig. 59**). As a result of these variant signatures, the literature is contradictory and confusing, as well as being full of inaccuracies and far-fetched speculation. Analysed in detail by Godsell in 1981, it can only briefly be summarised here. First mentioned in the literature in 1843, it was suggested in 1861 that this enameller could be identified with the goldsmith Jean Poillevé as documented in the Limoges archives. That idea took root with some specialists, including Franks, while others thought him likely to have been a member of the Jean Pénicaud workshop. No definite identification for him has yet proved possible.[34] He had a very particular style in

grisaille, producing small-scale, jewel-like work to be set into caskets or paxes. He used a needle to ruche and sculpt layers of enamel and to 'draw' through them in a scratchy, nervous way. The eyes of his figures share an idiosyncratic, stylised form of modelling, as in this detail, which is easier to recognise than it is to describe (**Fig. 60**).[35]

Comparison between the sibyls plaques and other enamels marked by this maker suggests the kind of artist he was and his likely training as a goldsmith.[36] The sibyls, as Godsell has argued, appear to be an early series from around 1530, given their slight rigidity of style and the fact that their counter enamel is of a distinctly old-fashioned type. Instead of being transparent, as developed later in the 1530s, the counter enamel here is an opaque, pale blue-grey (**Fig. 61**). Both characteristics can be seen on the closest comparable work signed 'IP': a conical base, perhaps for a candlestick, enamelled with dancing peasants, which is now in the Victoria and Albert Museum.[37] Blue-grey counter enamel also features on another signed plaque in the British Museum, showing the Annunciation (**Fig. 62**). This object, which is simplified from a print by the French engraver signing 'JG', is signed 'KI' on a small scroll in the bottom right-hand corner.[38] It was given to the Museum by Franks from his own collection in 1891, testimony to his interest in the identity and work of this enameller from 1862, when he catalogued items signed 'IP' and 'KIP' for the Special Loan Exhibition at South Kensington. The collector Hollingworth Magniac (1786–1867) offered Franks help in his cataloguing by sending him one of his own plaques signed 'KIP' to study. In a letter to Franks that reveals much about the practice of contemporary scholarship, he suggested bringing other artefacts that 'I thought might be interesting in your researches. I will run down to the [South] Kensington Museum in the afternoon for the chances of seeing you & [will] take the enamels with me … I am delighted to assist in my feeble way in your most interesting researches.'[39] In writing about the work of his enameller, Franks took issue with the inaccuracies of French scholars.[40] He had no doubt that Master KIP was of great interest to curators and collectors in the field of painted enamels of Limoges in the early 16th century:

> A few very rare enamels of small size have on them letters or initials which are presumed to indicate the work of an enameller of the name of Kip [*sic*], of whom nothing further is known than may be derived from his works. Only four signed pieces have been described on which the signatures vary … His style is very peculiar, timid, rather hard, but highly finished.[41]

Two KIP enamels were lent by private collectors to the South Kensington Exhibition, as selected and published by Franks in the catalogue. It says much for his skills as a curator that both pieces ended up in the British Museum. The first was from the Hamilton Palace Collection:

> a quadrangular plaque painted in grisaille on a black ground with a few touches of gold; it represents an allegorical subject, known as the *Calumny of Apelles*, being an imaginary reproduction of the painting executed by that artist, in allusion to the false accusation of Calumny brought against him by Antiphilus. This composition was drawn by Mantegna and engraved by Mocetto. To the left is seated Folly or Midas, supported by Ignorance and Suspicion, before whom

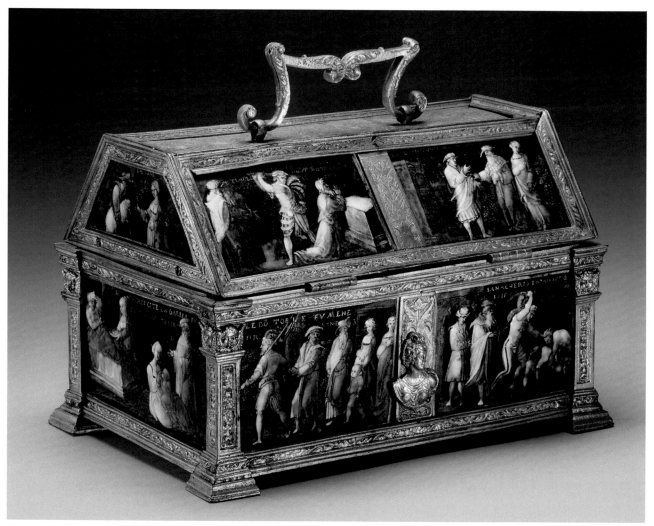

Figure 58 The Tobit Casket: copper-gilt casket set with enamelled plaques in grisaille telling the story of Tobit, signed by Limoges enameller M.P., *c.* 1540, Limoges, h. 10.5cm, l. 17.5cm. Waddesdon Bequest, British Museum, WB.22

Innocence is being dragged by Calumny, assisted by Envy, Ambition, and Guile; behind are Penitence and Truth; the background represents the Piazza of SS. Giovanni e Paolo at Venice. The back is clear enamel, with a few red streaks, through which is seen a stamp, [in fact two stamps] with I.K and a lion passant.[42] (**Fig. 63**)

The second enamelled plaque in the 1862 exhibition was the *Battle of Greeks and Amazons*: 'the foreground and the flesh

of the figures are executed in grisaille; the remainder of the figures, the horses, and other details are in gold *camaieu*; the ground is of a blueish-black enamel; at the right-hand corner is the signature KIP' (**Fig. 64**). This plaque, with badly worn gilding, was, like the *Calumny*, evidently intended as one of a set to be mounted on a casket. It was lent to the exhibition by Magniac, then sold at that collector's sale in 1892 and acquired by the Reverend Arthur H. Sanxay

Figure 59 *Poinçon* or stamp of the Limoges enameller Master KIP, punched into the copper substrate beneath the transparent counter enamel on the back of the plaque in Figure 63, with letters 'IK' above, 'P' below and a lion in a roundel

Figure 60 Detail of 'smoky eye' on the figure of Envy (Invidia) in *The Calumny of Apelles* plaque (Figure 63)

Figure 61 Reverse of one of the enamelled copper plaques from the Sibyls Casket in Figure 48 showing the opaque blue-grey counter enamel

Barwell (1834–1913) who left it to the British Museum in 1913.[43]

Proof that this enameller specialised in small plaques to be mounted on caskets is provided by two caskets and a group of unmounted enamels signed 'IP'.[44] One of the caskets with silver-gilt mounts had belonged to Horace Walpole (1717–1797) at Strawberry Hill and was lent by Magniac to the 1862 exhibition; it was certainly known to Baron Ferdinand (**Fig. 65**). The plaques on this casket, acquired by the Victoria and Albert Museum in 1982, show battle scenes derived from Renaissance Italian intaglios that are now in the British Museum.[45] A second casket with scenes from the life of Samson, three of them signed 'IP' as on the Sibyls Casket, is now in the Wernher Collection.[46] Sir Julius Wernher (1850–1912) had acquired the casket at the famous Spitzer sale in 1891, the indirect source of a number

of pieces in the Waddesdon Bequest. Baron Ferdinand knew the notorious dealer Frédéric Spitzer (1815–1890), who was a Rothschild afficionado, and his collection, as is evident from his memoir on art collecting.[47] The Spitzer sale was one of the sales of the century and it seems likely, although unproven, that Baron Ferdinand would have noted such a well-publicised casket as it passed through the sale room as a comparison for his own Sibyls Casket.[48]

The plaques on the two caskets are signed 'IP' in a similar way to that on the Sibyls Casket, and have distinguished collecting histories, giving us a sense of the perceived value of the Sibyls Casket on the art market at the point at which Baron Ferdinand acquired it.

It is just possible that we can trace the Sibyls Casket back further. In 2014 Jeremy Warren noted a fascinating reference in the inventory of the château of the kings of Navarre at

Figure 62 *The Annunciation*, signed 'KI' for Master KIP in a scroll at the lower right, grisaille enamel on copper, *c.* 1540, Limoges, l. 11.20cm, front and back. British Museum, 1894,0413.4

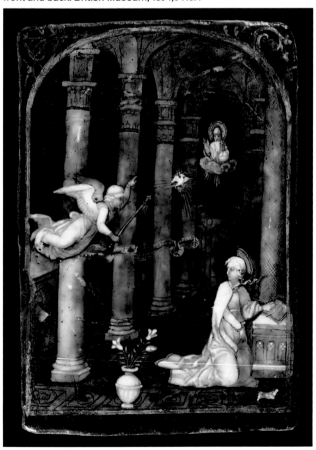

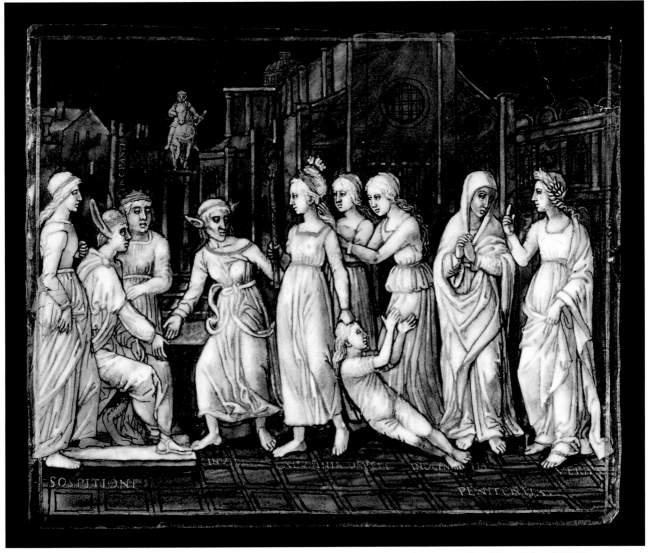

Figure 63 *The Calumny of Apelles*, enamelled grisaille on copper, by Master KIP, stamped on reverse (see Figure 59), *c.* 1540, Limoges, l. 11cm. British Museum, 1882,0717.1

Pau, compiled in 1561: 'Another coffer of Limoges enamel, with Sibyls, set in copper-gilt mounts'.[49] The mention of copper-gilt mounts is unusual for an inventory, although it is a common setting for enamel plaques, and the mounts on the Sibyls Casket in the Waddesdon Bequest are silver gilt, but it is possible that this is indeed the piece. We cannot prove it, but should that be so, then Louise of Savoy (1476–1531) or her daughter Marguerite d'Angoulême, queen of Navarre (1492–1549), could be said to have owned the Sibyls Casket. Louise died in 1531, which is perfectly possible as a *terminus ante quem* for the casket on technical and stylistic grounds. The blue counter enamel is an early feature, almost certainly before 1530. Stylistically, too, the sibyls on the enamels compare well with the woodblock illustration in the presentation copy on vellum for a history compilation printed in Paris in 1529. Louise is shown seated above the nobility and clergy, and flanked on either side by the figures of two Jewish heroines, Judith and Esther, represented full length in court dress in a very similar way to that of the sibyls on the Waddesdon Bequest casket.[50] According to Thierry Crépin-Leblond, the casket might fit the noticeably pious tastes of Louise as a widow or those of her daughter Marguerite, who, already by 1530, was identifying herself in

her writings with the hope of religious reform without ever deserting Catholicism.[51]

The sibyls were a popular theme with enamellers of Limoges from the 1530s into the 1540s. Léonard Limosin (*c.* 1505–1575/7), for instance, made a fine set of 12 coloured plaques depicting sibyls around 1540, which is now in the British Museum.[52] Caskets set with enamelled plaques showing sibyls are extremely rare. The only example apparently recorded in the literature is one by the Limoges enameller Couly Nouhailer, which is now in the Victoria and Albert Museum. Dating from 1550, it is much cruder in workmanship than the Waddesdon casket, both in terms of the sketchy enamels and their mounts, although it does have copper-gilt mounts as described in the Pau inventory of 1561.[53]

The link between the Sibyls Casket in the British Museum and the one described in the Pau inventory can only be tentative. It does, however, accord well with what we know about Louise of Savoy and her artistic interests. We know that she was supplied with goldsmiths' work by Pierre Mangot: his name appears in her post-mortem inventory of 3 November 1531 listing her jewels, clothes and silver, as the maker of a set of silver basins.[54] Louise may have owned

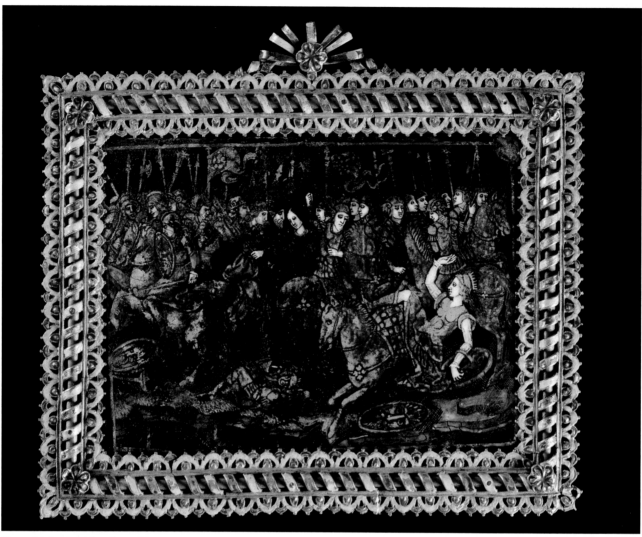

Figure 64 *Battle of Greeks and Amazons*, grisaille and gilded enamel on copper, signed 'KIP' for Master KIP on a scroll in the lower right corner, *c.* 1540, l. 11.70cm. British Museum, 1913,1220.29

Figure 65 Casket formerly owned by Horace Walpole at Strawberry Hill, cavalry battle scenes painted in grisaille enamel on five copper plaques, two signed 'IP' for Master KIP, set in silver-gilt mounts, *c.* 1540–50, Limoges, h. 16cm. Victoria and Albert Museum, C.49–1982. © Victoria and Albert Museum, London

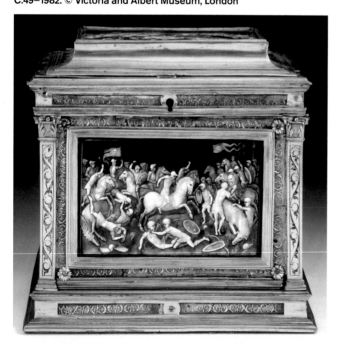

goldsmiths' work by Mangot that incorporated blue gilded enamel, as seen on the Clock Salt and the Sibyls Casket. The ciborium of the Ordre du Saint-Esprit has blue enamel on its lid and behind the shell cameos on its base, both of which are delicately painted with gilt scrolls and arabesques like the similar plaques with cameos on the Clock Salt. On the ciborium, the presence of the figure of St Helena, patron saint of Louise of Savoy, has been taken to suggest her ownership of the piece and might indicate that she directly patronised Mangot.[55] Also attributed to Mangot on stylistic grounds (see Chapter 3, p. 45), and listed in the same 1561 Pau inventory, are two small burettes made from blue enamel, silver gilt and rock crystal that resemble the descriptions of two little flasks in the Pau inventory of 1561, suggesting very similar tastes in goldsmiths' work between Louise, her pious daughter Marguerite and her son, Francis I (r. 1515–47).[56] All these works have the character of jewels, as does another precious object mentioned in the inventory of the Château de Pau, the *Book of Hours* that was recently acquired by the Louvre (see Chapter 3, p. 51). Bought by Francis from the jeweller, Allard Plommyer, on 1 January 1538, the *Book of Hours* reveals similar collaborations between specialists to make a Turkish Ottoman-style binding on a Flemish

Figure 66 Conrad Meit, miniature busts in boxwood of Margaret of Austria and Philibert of Savoy, c. 1515–25, Mechelen, h. 29cm (including bases). Waddesdon Bequest, British Museum, WB.261

manuscript that was probably given by Francis in the late 1530s to his niece, Jeanne d'Albret (1528–1572).[57]

Beyond the art she owned and commissioned, Louise of Savoy herself is mostly remembered as mother to Francis I, to whose interests she was dedicated. Recently, historians and art historians have sought to present her as a more dynamic political figure.[58] She was highly cultivated and politically astute, acting twice as regent of France. She did this first to a limited extent in 1515–16 while Francis was campaigning in Italy, earning her the praise of Antonio de Beatis, the cultivated chaplain to Cardinal Luigi of Aragon (1474–1519), as a woman who 'plays the governess without restraint'.[59] Her second regency was longer and offered her greater scope since it occurred at a time of crisis, in 1525–6, when Francis was defeated and captured at the Battle of Pavia in 1525, then held hostage.[60] Her success as a political operator, a sovereign in all but name, ensured her continued role as a peace-broker in the 1520s. She negotiated a major peace treaty with the Holy Roman Empire in 1529. Known as the Ladies' Peace, the treaty was made between Louise of Savoy and Margaret of Austria (1480–1530), regent of the Netherlands and aunt to the Holy Roman Emperor, Charles V (1500–1558). Like Louise, Margaret was a powerful woman who had acted twice as regent, in her case of the Netherlands, in 1507–15 and again in 1515–19. Margaret was also the widow of Louise's handsome brother, Philibert of Savoy (1480–1504), to whose memory she remained devoted following his death in 1504 after only three years of marriage. The two women shared artistic interests. Margaret was a major patron and collector of the arts at her court in Mechelen, commemorating her dead husband and their short marriage in a series of works of art, not least in two superb miniature busts that are, like the Sibyls Casket, in the Waddesdon Bequest (**Fig. 66**). Carved from boxwood by Conrad Meit (1480–1550/1) around 1515, they are perhaps studies for large-scale busts in marble such as the pair documented in Margaret's library at Mechelen.[61] Louise is depicted in a comparable manner but on a different scale in

a very Italianate terracotta bust. This terracotta, with a bust of Louise's chancellor, Antoine Duprat (1463–1535), was first recorded in 1880 at the Château de La Péraudière at Saint-Cyr-sur-Loire; both busts were acquired by the Louvre in 1949 (**Fig. 67**).[62]

An exemplary Renaissance princess, there is no doubt that Louise of Savoy was a key influence on her son Francis I in cultural as well as political matters. She was viewed by contemporaries as a tastemaker who was knowledgeable about the latest developments in Italian art and design. Gian Stefano Ronzone wrote from the French court on 23 May 1516 to the famous patron, Isabella d'Este, Marchioness of Mantua (1474–1539), recommending Louise as a suitable recipient for a Mantuan court painting: 'some perfect painting of a male or female saint, for she takes much

Figure 67 Terracotta bust of Louise of Savoy, maker unknown, 1515, h. 46.9cm. Musée du Louvre, Paris, inv. no. RF2659. Photo © RMN-Grand Palais (Musée du Louvre) / Martine Beck-Coppola

Figure 68 Enamelled terracotta altarpiece with
The Birth of the Virgin, from the chapel at the
Château de Cognac, by Girolamo della Robbia,
c. 1530. Cité de la céramique, Sèvres, inv. no.
MNC9100. Photo © RMN-Grand Palais (Cité de
la céramique, Sèvres) / Thierry Ollivier

pleasure in this and is also knowledgeable'.[63] As Crépin-
Leblond has pointed out, the fact that Francis and Louise
shared an interest in the new Florentine medium of
enamelled terracotta sculpture is seen in the altarpiece at
Cognac on which both their coats of arms appear within the
lower frame (**Fig. 68**). At the centre is *The Birth of the Virgin*.
Louise herself is thought to be the woman in contemporary
dress standing gracefully as patron and observer on the
right. Documents attest to Girolamo della Robbia's (1488–
1566) presence in France in the service of Louise and Francis
between 1518 and 1519 and it is thought that this altarpiece
would have been made and fired on site.[64] From the manor
of Sansac, before 1529, is Girolamo's superb portrait roundel
in enamelled terracotta of Francis, surely a royal

commission that underlines his taste for all things Italian
(see Chapter 2, p. 48).[65] Like her son, Louise was not only
interested in the latest developments in ceramic art but also
in the painted enamel of Limoges. Enamelled portraits of
Louise are listed in the Pau inventory of 1561 and at
Fontainebleau among other pieces clearly described as
'*d'esmail de Lymoges*', including 'The painting of the late
madame Louise of Savoy, mother of the King, in Limoges
enamel, framed in gold'.[66] Louise realised the power of her
own image. She had commissioned a remarkable collection
of 51 labelled portrait drawings of the French royal family
– including one of herself – as a propaganda tool after the
disastrous French defeat at the Battle of Pavia in 1525.
Enamelled portraits were durable and colourful and could

become part of the furnishing of the room in which they were shown.[67]

The Sibyls Casket has a strong feminine character through its imagery and likely function as a jewel box, as does the small mounted cup designed for jewels that is marked by Mangot and can be dated to around 1528. Sharing many features with the Sibyls Casket, it is now in the Cabinet des Médailles in Paris (see **Fig. 37**). It has a bust of a woman on the finial and female busts on the foot, and has been compared with a low cup used for rings and necklaces in a picture of a woman at her toilet that is now in Dijon (**Fig. 69**).[68] The painting is after François Clouet around 1560, much later than Mangot's little cup, which still combines Gothic and Renaissance detailing and probably dates from the late 1520s. André Chastel is surely right in classifying the painting as 'cool, serious glorification of a beauty glimpsed during a moment of intimacy'.[69] The picture suggests the kind of feminine, intimate ambience in which one might imagine the Sibyls Casket; this same sensuous Italianate world appears in another painting of around 1540–60 by the Master of Flora, which is in the Metropolitan Museum of Art, New York. It presents the *Birth of Cupid*. Handmaidens hold *all'antica* vases as Venus lies on a splendid flower-strewn daybed: elegance itself.[70] The role of a jewel casket is central to the message of several later Italian paintings. In the National Gallery, London, Guido Reni's (1575–1642) Venus swoons at her toilet, attended by the Graces, in a painting of around 1620–5.[71] To her left is a small open jewel casket with special pins fixed inside it to secure her earrings. Annibale Carracci's (1560–1609) *Venus Adorned by the Graces* in the National Gallery of Art, Washington, dates from the 1590s and shows a jewel casket being opened by Cupid to take out or replace a pearl necklace.[72] It may be that Louise of Savoy was a pious widow who wore relatively few jewels with her widow's weeds, as suggested by the Compiègne post-mortem inventory of 1531, but the Sibyls Casket seems to bridge the worlds of Christian piety and secular, worldly sensuousness as a small jewel in itself. What could be more flattering to a powerful, intellectual woman of François I's court than to compare her, every time she opened the casket, with the great prophetesses of classical antiquity and the far-sighted vision of a Christian future?

Close comparison between the Royal Clock Salt and the Sibyls Casket raises the status and significance of both pieces as French royal treasures. Each illuminates aspects of the making and meaning of the other, and both fit well with what we now know about Mangot's early production. The fine sibyls painted in grisaille enamel on the casket are sophisticated early examples of this new technique, made by another unidentified French craftsman who was probably trained as a goldsmith. The Sibyls Casket and the Clock Salt show how Mangot could draw on different skills, materials and supply networks. He must have worked collaboratively with a number of specialists in particular techniques, either in his large Parisian workshop or outsourcing beyond it. These specialists included enamellers, gem engravers and hardstone cutters in rock crystal and semi-precious stones, as well as clockmakers. Even if we cannot definitely link the Sibyls Casket with Louise of Savoy, we can see how well this

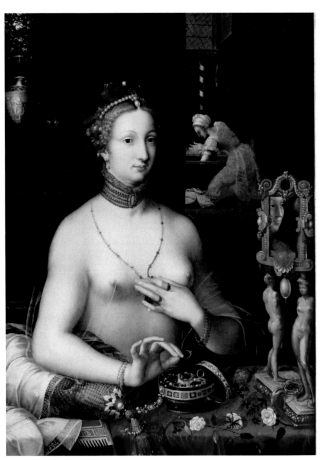

Figure 69 *Woman at her Toilet,* after François Clouet, c. 1560, France, oil on canvas, h. 105cm, w. 76cm. Musée des Beaux Arts de Dijon, inv. no. CA 118. © Musée des Beaux-Arts de Dijon/ Bruce AUFRERE / TiltShift

jewelled treasure would have belonged to the ambience of the French royal court in the late 1520s and early 1530s. Like the Clock Salt, the Sibyls Casket had high status as a collectors' piece that was valued from the minute it was assembled in Pierre Mangot's Parisian workshop around 1530.

Notes

1 For the Waddesdon Bequest, see Read 1902; Dalton 1927; Tait 1981; Tait 1986a; Tait 1988; Tait 1991a; Thornton 2015; Shirley and Thornton 2017; and the Introduction.

2 Read 1902; Dalton 1927; Tait 1981; Tait 1986a; Tait 1988; Tait 1991a; Thornton 2015; Shirley and Thornton 2017.

3 Thornton 2001; Thornton 2015; Shirley and Thornton 2017.

4 Ferguson 1998.

5 Thornton 2017; Cordera 2017; Rainer 2017.

6 Thornton 2015; Shirley and Thornton 2017.

7 Bernal Sale 1855, lot 1565; South Kensington Museum 1862, cat. no. 1685; Bohn 1857, no. 1565; Anon. 1874, no. 561; Mitchell 1909, 284, pl. III; Read 1902, cat. 23; Dalton 1927, cat. 23; Godsell 1981, vol. I, cat. I; Tait 1981, 45–6 and pl. XIVb; Thornton 2015, 108–15.

8 Mâle 1931, 253–79.

9 Thornton 2015, 108–15.

10 First noted by Godsell 1981, vol. I, 181–4, cat. I; Thornton 2015, 108–15 for illustrations and commentary.

11 Godsell 1981, vol. I, 174, cat. I.

12 Ibid., 193–5.

13 Toesca 1965.

14 Ibid.; Toesca 1969, 296–7; Hayward 1976, pl. 1; Tait 1981, 45; Bimbenet-Privat 1992, 244–5, cat. 5; Bimbenet Privat 1995b, cat. 73a; Thornton 2015, 114, fig. 10. For Mangot's biography, see Bimbenet-Privat 1992, 544–5.

15 Toesca 1965; Toesca 1969; Tait 1981, 45; Godsell 1981, vol. 1, 193–4; Bimbenet-Privat 1992, 247, cat. 5b; Bimbenet-Privat 1995b, cat. 73b; Cremonesi 2002; Thornton 2015, 114.

16 Bimbenet-Privat 1995b, 112.

17 Thornton 2015, 110–14.

18 Personal communication, 10 January 2019.

19 Molinier and Mazerolle 1892, cat. 114; Alcouffe 2001, 539; Crépin-Leblond and Barbier 2015, cat. 64; Scailliérez 2017, 305, fig. 109. A very similar unmounted shell cameo with a male bust close to one of those on the Clock Salt is in the Archaeological Museum in Naples, see Gasparri 1994, 134, fig. 209, cat. 394. I am grateful to Paulus Rainer for this reference.

20 Toesca 1965 and 1969 for the Clock Salt; Bimbenet-Privat 1992, 247; Bimbenet-Privat 1995b, 100; Foister 2006, cat. 82; Hayward 1976, 361, pl. 152.

21 Read 1902, cat. 118; Tait 1988, cat. 10.

22 SLBCameos.186, 'Bustum incogn[i]tum in torta'. Dalton 1915, cat. 341; Rudoe 2003, 136, fig. 118 (left). See also Tait 1986, 223, cat. 551.

23 Dalton 1915, cat. 408; Tait 1986, cat. 552; Gennaioli 2010, 39, fig. 5 and cat. 89 for comparison.

24 Godsell 1981, vol. 1, 195.

25 Caygill and Cherry 1997, 11, 24.

26 Bagenal 1884, 4–5.

27 Planché in Bohn 1857, preface.

28 Bernal Sale 1855, lot 1565.

29 Bohn 1857, lot 1565.

30 South Kensington Museum 1862, cat. 1685; Anon. 1874, no. 561; Thornton 2015, 115.

31 Thornton 2015, 33, 119, 125, 161, 219, 233; Thornton 2017, 201.

32 Schestag 1866, cat. 11; Read 1902, cat. 22; Tait 1981, 46, fig. 26; Godsell 1981, vol. 1, 141–2; Thornton 2001, fig. 2; Thornton 2015, 37, fig. 23.

33 Tait 1981, 46. For M.P. as an artist, see Mitchell 1918, 187–201; Godsell 1981, vol. 1, cat. 1.

34 Franks thought the works of 'IP' and 'Kip'[KIP?] were distinct, whereas more recent commentators believe the same enameller to be responsible for both.

35 Godsell 1981, vol. 1, especially 3–5, 63–73, conclusion 343; Baratte 2000, 122.

36 The British Museum holds several of his enamels described online – 1882,0717.1; 1891,0905.14; 1913,1220.29–31 – only a few of which are discussed here.

37 2052–1855, from the Bernal Collection, see Godsell 1981, vol. 1, cat. 2.

38 Godsell 1981, vol. 1, cat. 13.

39 Unpublished letter from Hollingworth Magniac to Franks dated 12 August 1862, Department of Britain, Europe and Prehistory Letters Archive. For Magniac, see Robinson 1862. My thanks to Dr Eloise Donnelly.

40 South Kensington Museum 1862, 150–2.

41 Ibid., 15.

42 Ibid., cat. 1687, and note. The plaque had been lent by the Duke of Hamilton, having passed through the distinguished Parisian collectors of Debruge-Duménil and Rattier. Franks was able to acquire it at the Hamilton Palace Collection sale in London in 1882 for £320 5s for the British Museum. Labarte 1847; Godsell 1981, vol. 1, cat. 35; Maxwell 2015 for Hamilton Palace Collection sale.

43 For Barwell, see Anon. 1913. For the plaque, 1913,1220.29, see South Kensington Museum 1862, cat. 1688; Godsell 1981, vol. 1, cat. 31.

44 Including five plaques with the life of Samson that were evidently intended for a casket but which have long been taken out of their original mounts. All five are signed 'IP', and they derive from the Prussian Royal Kunstkammer via the Nagler Collection where they were recorded in 1835: Godsell 1981, vol. 1, cat. 19 as unlocated, but see now Netzer 1996 and Netzer 1999, cat. 3*.

45 C.49–1982. South Kensington Museum 1862, cat. 1687; Hollingworth Magniac Sale 1892, lot 401; Godsell 1981, vol. 1, cat. 24; Snodin 2009, cat. 163 for full bibliography. Two of the plaques on the casket are signed 'IP' in white.

46 C.14.045, three plaques signed 'IP'. Spitzer Sale 1893, lot 452; Godsell 1981, vol. 1, cat. 18. For Wernher, see Thornton 2002.

47 Thornton 2001, 195.

48 For Spitzer, see Cordera 2014 and 2017.

49 'Ung[Un?] autre coffre d'esmail de Lymoges où sont les Sybilles, garny de cuyvr[e] doré', Molinier and Mazerolle 1892, cat. 1001. For the history of the inventory, see Mironneau 2017.

50 Crépin-Leblond and Barbier 2015, cat. 65.

51 Crépin-Leblond 2017, 46; Knecht 2003, 83; Malgouyres 2018, 44–5.

52 1854,0605.1. For sibyls in French art, see Mâle 1931, 253–79; in Limoges enamel, see Verdier 1962; Verdier 1967, cats 83–103 for comparisons; Godsell 1981, vol. 1, 190; Tait 1981, 45–6; Thornton 2015, 108.

53 C.2454:1, 2–1910.

54 Archives Nationales, Paris, J947 no. 2. I am extremely grateful to Cathérine Voiriot for checking the original manuscript for me. Crépin-Leblond and Barbier 2015, cat. 67; Warren 2016, 221.

55 Crépin-Leblond and Barbier 2015, cat. 64.

56 Ibid., cat. 62.

57 Molinier and Mazerolle 1892, cat. 595; Scailliérez 2017, cat. 125; Malgouyres 2018.

58 David-Chapy 2016.

59 Knecht 2003, 76.

60 Ibid., 76–7.

61 Thornton 2015, 196–203.

62 Zvereva 2015a, 23, fig. 4.

63 Knecht 2003, 75, letter from Gian Stefano Ronzone to Isabella d'Este of 23 May 1516.

64 Sèvres, inv. no. 9100. Crépin-Leblond and Barbier 2015, cat. 32.

65 Ibid., cat. 33.

66 Molinier and Mazerolle 1892, 53, cat. 268, 'Le [sic] paincture de feu madame Loyse de Savoye, mere [sic] du Roy, esmail de Lymoges, enchassée d'or', with other royal portraits at 269–71; for other subjects in Limoges enamel, see 129–30; Crépin-Leblond and Barbier 2015, cat. 58.

67 Zvereva 2015b.

68 Bardiès-Fronty, Bimbenet-Privat and Walter 2009, Ec 80 for the cup, Ec 61 for the painting.

69 Chastel 1995, 233.

70 Ibid., 226; Wardropper 2004.

71 NG90.

72 1961.9.9.

Chapter 5
Hans Holbein the Younger as Designer for Goldsmiths in Tudor England

Olenka Horbatsch

Hans Holbein the Younger (1497/8–1543) provided design drawings for goldsmiths and other specialists at the court of Henry VIII (r. 1509–47) for prestigious metalwork, arms and armour, clocks, jewellery, accessories and furniture. Approximately 200 drawings by Holbein depict decorative objects, fragments, details and independent strips of ornament. No surviving metalwork can be firmly connected to Holbein's drawings, although two items have been suggested: a rock-crystal bowl in Munich; and a plate, dish and jug in Bremen.[1] However, there are several drawings that do relate to realised pieces recorded in royal inventories and gift registers, giving evidence for Holbein's role as a designer. The drawings were made during Holbein's second residency in London, from 1532 until his death in 1543, when he was still in the service of the king. The group of drawings is today split between the Kunstmuseum, Basel, and the British Museum, London. Gold and silver were among the most costly materials of the time, and thus vessels or artefacts that became outmoded (either stylistically or ideologically) were melted down in the intervening years. Design drawings for metalwork therefore provide vital contextual information, but such drawings are by no means straightforward records of production.

Goldsmiths in 16th-century London produced a wide range of material. They made distinguished, personalised objects commissioned by courtiers and rulers designed by court artists like Holbein, and they also worked with standard designs. In the pre-modern era, goldsmiths used drawings within the workshop to design, elaborate and record their work. Such drawings were collaborative and interdisciplinary in nature: an artist would draw the original design, which would be copied, adapted and transmitted to the goldsmith. Goldsmiths would collect, share and copy design drawings in the workshop. Methods of transfer and transmission were therefore integral to the production process and workshop practice. Drawings would be copied, transferred or otherwise transmitted via offset, incision or tracing; objects could also be rubbed on paper to preserve or document the design. It is perhaps ironic that these paper designs survive in large numbers from the 16th century, whereas the vessels themselves do not.

The Royal Clock Salt is one of only four pieces of plate to have survived from Henry VIII's Jewel House. It may have been a diplomatic gift from Francis I (r. 1515–47) to Henry VIII, or between two of their courtiers, and it was made in Paris around 1530 by the royal goldsmith, Pierre Mangot (c. 1485– after 1551) (see Chapters 1 and 3). Holbein was thus *not* the designer of the Royal Clock Salt, but he was engaged in similar projects at the court of Henry VIII at this time, and one of his most finished design drawings is for a clock salt that was presented to Henry by Sir Anthony Denny (1501–1549) (see p. 1 and **Fig. 70**). Holbein's design drawings therefore illuminate the broader context of pan-European goldwork that was made for the highest levels of patronage. His designs incorporate antique ornament, and his designs for cups and other courtly gifts in particular embody the stylistic shift from Gothic to antique form. The aim of this chapter is to consider how the drawings can expand our understanding of goldsmiths' work in Tudor England.[2]

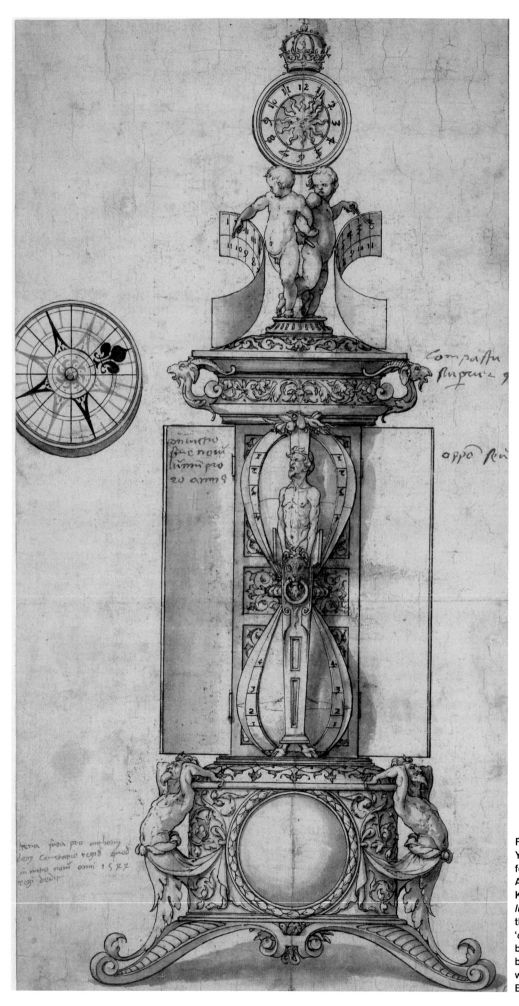

Figure 70 Hans Holbein the Younger, design for clock salt for Sir Anthony Denny, 1543. Annotated by Nicholas Kratzer: '*coniunctis/sive novi / lunium pro / 20 Annis*' and, to the right of the clock, '*compassu / superiarus*' and below, '*oppō scu ...*', pen and black ink with grey and red wash, h. 41cm, w. 21.3cm. British Museum, 1850,0713.14

Holbein's drawings reveal that he had an intimate knowledge of the trade, and must have worked in close collaboration with goldsmiths at Henry's court. His design drawings vary in format, execution and style, and evoke specific projects, materials and techniques. But far from straightforward, his drawings also raise important questions about the role of the artist/designer versus craftsman/smith in the production process that challenge our assumptions and expectations about the primacy of the artist. The relationship between drawings and realised metalwork in the 16th century is difficult to reconstruct, as corresponding drawings and vessels rarely survive; moreover, intermediary stages (both drawn and sculpted) are even less likely to have survived.

The album of Holbein's design drawings today in the British Museum (known as Sloane 5308) could be the same as that listed in the inventory dated 20 January 1550 in the charge of Sir Anthony Auchar (c. 1500-1558). This was part of a complete inventory of Henry VIII's possessions made under the authority of a commission appointed by Edward VI (r. 1547–53) on 14 September 1547 of the great mass of Henry VIII's jewellery stored in the 'Secret Juelhous in the Tower of London' as kept in 'Coffer A': 'a paper book conteynninge diverse patterns for Jewelles'.[3] Joachim von Sandrart (1606–1688) next saw the album in the collection of Charles I (r. 1625–49) when he came to London in 1627.[4] Von Sandrart described it as follows:

> Daggers, vessels, ornaments, pendants and floriated decorative work, also mountings for scabbards, for sword-belts, belts, buttons for the royal attire, for hatstrings, clasps for shoes, according to the former fashion, executed with supreme accomplishment and in the best possible way, again details for small and large silver and gold dishes, for knife-handles, forks, salts; the book contains in abundance large and small ornaments to satisfy the royal taste, which it would take very long to recount.[5]

The specific references to buttons, scabbards and ornaments accords with Sloane 5308 and, as John Rowlands noted, it seems likely that at least some of what he saw was later part of the volume that became Sloane 5308.[6] It is not clear exactly when the album of drawings left the Royal Collection, but it was probably during the Civil War (1642–51). Some drawings may have been extracted from the album seen by Sandrart and acquired by others, including Thomas Howard, the 2nd Earl of Arundel (1585–1646), an avid art collector with a special interest in Holbein.[7] The Holbein drawings in his collection did not survive, but Arundel had commissioned reproductive prints after the now-lost drawings from the Bohemian printmaker Wenzel Hollar (1607–1677, see **Fig. 81**), which give some indication of the lost drawings.[8]

What happened to the album after leaving the Royal Collection is not known, although a newly discovered reference mentions that 'emblems' by Holbein were included in a London sale in 1692.[9] If this is indeed the album in question, it would suggest that it never left London. Sir Hans Sloane (1660–1753) acquired the London drawings in an album of metalwork and jewellery designs by 1712–13, when it was described by George Vertue (1684–1756) as 'the book of Drawings and Jewelling work drawn by Holben.'[10] Sloane listed the album as 'Min 33' in his catalogue, and then later renumbered it as 'Min 96' and then 'Min 279' along with other albums in his manuscript library that came from the collection of William Courten (1642–1702).[11] This suggests that the album of Holbein drawings may have come from Courten's collection, which was bequeathed to Sloane in 1702.[12] Sloane 5308 contained approximately half of Holbein's ornamental and design drawings (279 in total) and the album was probably dismantled during the late 19th century.

The remainder came from the so-called 'English sketchbook', which was among an important group of drawings from Holbein's estate acquired by the Basel lawyer Basilius Amerbach (1533–1591), who amassed a large art collection in the second half of the 16th century, which was purchased for the city in 1661 and became the founding collection of the Kunstmuseum, Basel.[13] Little is known about how the drawings were split up after Holbein's death. Presumably Sloane 5308 remained with Henry VIII, while the group of drawings in Basel went to Holbein's widow, and from there entered the Amerbach collection.[14] While working in London, Holbein had sent back a group of his design drawings to Basel, probably intended for his son who trained as a goldsmith.[15] Many of the Basel sheets are working drawings and loose sketches, whereas the London group of drawings is more diverse in style, more diminutive and more finished.

Hans Holbein the Younger was born in Augsburg in 1497/8 and worked in Basel from 1515 onwards. With the onset of the Reformation in the Swiss lands, traditional sources of commissions dried up, and this led him to England in search of royal patronage: he first arrived in London in August 1526, following an introduction from Desiderius Erasmus (c. 1466–1536) to Sir Thomas More (1478–1535), and he spent the next two years working at the court of Henry VIII. After a brief interlude back in Basel, Holbein returned and settled in England in 1532.

A successful court artist had to be versatile in order to easily navigate diverse styles, scales and media. Large-scale projects included the design of decorations for the banqueting hall at Greenwich and later murals for Whitehall Palace; he also created dazzling portraits in various formats of the king and members of his court, the best-known examples being *The Ambassadors* (1533) in the National Gallery, London, and the extensive group of portrait drawings in the Royal Collection.[16] Holbein also worked in small scale, and designed objects of personal adornment, including medallions, brooches and buttons. The objects depicted in the drawings do not survive, thus the drawings are a valuable record of the opulence of the Tudor court, while demonstrating Holbein's protean ability to design across media and scale. Dating to between 1532 and 1543, it is not possible to establish a more precise chronology for the drawings (neither provenance, stylistic development nor watermarks are helpful in this instance) except in a few cases, where they can be conclusively connected to realised objects listed in inventories and gift registers.

Holbein himself did not train as a goldsmith (unlike artists such as Albrecht Dürer [1471–1528] and Martin

Figure 71 Hans Holbein the Elder, St Sebastian, *c.* 1497, silverpoint on white prepared paper, h. 13.1cm, w. 9.6cm. British Museum, 1885,0509.1612

Figure 72 Anonymous Augsburg goldsmith, reliquary of St Sebastian, 1497, Augsburg, silver, parcel-gilt, hammered, cast and engraved; set with rock crystals, pearls, sapphires and rubies, h. 50cm, w. 20cm, d. 14.5cm. Victoria and Albert Museum, London: M.27–2001 (purchased with assistance of the National Heritage Memorial Fund and Art Fund). © Victoria and Albert Museum, London

Schongauer [*c.* 1440/53–1491]), but had close ties to goldsmiths in Augsburg and later in Basel before he travelled to England.[17] Augsburg was renowned for its production of metalwork, with a notable trade in gold by the 15th century. Holbein's father and first teacher, Hans Holbein the Elder (*c.* 1460–1524), had a large workshop in the city where he produced altarpieces and portraits; he also collaborated with goldsmiths, as evidenced by archival references and existing drawings.[18] The elder Holbein worked on commissions for the Cistercian monastery at Kaishaim with goldsmith Jörg Seld (*c.* 1448–1527), of whom he made a portrait drawing in 1497.[19] Holbein the Elder's drawings of metalwork include a silverpoint drawing for a statuette of St Sebastian for a reliquary (**Fig. 71**) and a pen-and-ink drawing on vellum of a bishop's crosier with traces of silverpoint now in Vienna, dated 1514.[20]

Augsburg was also an important centre of diffusion for the new, 'antique' mode in the early years of the 16th century: the Fugger chapel (1521) in St Anne's church was the first structure built in the antique style after designs by Dürer. Augsburg was also home to Hans Burgkmair (1473–1531), who designed influential woodcuts around the first decade of the 16th century. Holbein the Younger would have also encountered antique ornament in his father's workshop: although his father primarily worked in the earlier Gothic style, his late works incorporated antique grotesques, such as the upper wings of the St Catherine altarpiece (1512, Augsburg) and in the architectural setting of the portrait of

a man in a fur hat (1513, Basel).[21] The influence ran both ways, and Holbein the Younger was an active participant in the artistic developments and networks of exchange before he left the city in 1515.

Holbein the Elder's silverpoint drawing for a statuette of St Sebastian is connected to an extant parcel-gilt silver reliquary of the saint of 1497, made by an anonymous Augsburg goldsmith for Abbot Georg Kastner (d. 1509) of the Cistercian monastery at Kaishaim where Holbein the Elder was active between 1502 and 1504 (**Fig. 72**).[22] While the drawing has been understood as a design drawing for the reliquary, there are significant differences in the branches and posture, and most strikingly, the base. Katharina Krause has recently suggested that the drawing might record a wooden model, an intermediary made in the workshop, rather than being a design for the Augsburg

goldsmith who created the reliquary to follow directly.[23] The oblique angle of the statuette in the drawing makes it likely that Holbein the Elder recorded the model in the goldsmith's shop before the statuette was cast. The base of the statuette is decorated with flat, angular tracery characteristic of late medieval Augsburg goldwork. The delicate lines encapsulate the Gothic tendency to challenge or even defy geometric principles. Holbein the Elder could have designed the base in a separate drawing.[24] A drawing attributed to the workshop of Holbein the Elder depicts the same statuette with yet a different base altogether.[25] This exemplifies the complexities of reconstructing the function of drawings in relation to metalwork.

Travelling craftsmen and artists maintained close ties between Augsburg and Basel: for example, the Basel goldsmith Jörg Schweiger (d. *c.* 1533/4) had connections to Holbein the Elder's workshop in Augsburg, and he helped Holbein's elder son, Ambrosius (*c.* 1494–*c.* 1519), attain citizenship in Basel in 1518.[26] Schweiger was acquainted with the goldsmith and alderman Balthasar Angelroth (*c.* 1480–1544) in Basel, who commissioned from Holbein the Younger the decorations for the façade of his house, 'Zum Tanz'.[27] Holbein's large-scale design drawings in Basel show a profusion of antique ornament in the latest fashion: architecture, medallions, garlands and grotesques.[28] In addition to such façade paintings, Holbein was engaged with designing title pages for printed books (**Fig. 73**).[29] Along with Urs Graf (*c.* 1485–*c.* 1527/8), he was among the first artists to introduce the antique idiom into Basel; Graf had been producing title-page borders following Venetian models since the early years of the 16th century.[30] Holbein worked in a variety of media during his years in Basel (1515–32), including devotional paintings and designs for stained-glass windows. Holbein's drawings from his Basel years demonstrate his ability to design across media by accommodating different materials and effects and to scale up or down as needed.[31]

Mercantile and metropolitan Basel differed greatly from the Tudor court in England with its exuberant displays of wealth and excess, and Holbein's two main phases of production have long been viewed in isolation. Susan Foister, however, has emphasised the continuity between his Basel and his London years.[32] Indeed, Holbein developed his versatility and his early command of the antique mode in Basel, which is evident in his title-page designs (**Fig. 73**). He modelled putti, grotesques and other antique figures in the round and introduced new vitality to previously flat designs. He played with symmetry and incorporated small deviations on opposing sides to add interest to the restrictive fields of decorative strips.[33] His work for printers in Basel served him well in London, and when he was first employed at Greenwich it was mainly as a painter of decorations.[34] The antique mode at Henry's court was mediated through northern artists, Holbein chief among them, who had long been designing title pages, initials and book illustrations in Basel featuring playful putti, medallions and grotesques.

Grotesque ornament engenders fluidity and hybridity: animal, vegetal and mineral features are combined and recombined into new compositions. Such ornament

Figure 73 Hans Holbein the Younger, title border with children in triumphal cortège, 1517; used in Thomas More's *De optimo reip. statu deque nova insula Vtopia (...)*, J. Froben, Basel, November 1518 (4°), woodcut and letterpress, h. 18cm, w. 12cm. British Museum, 1862,0517.10

permeates Holbein's design drawings, and his success at court was largely due to his command of this antique language of design. His ingenuity as a designer across media manifests itself in his creative and seemingly endless reconfigurations of form. In the early 16th century the unfettered nature of the grotesque was seen to represent the generative creative powers of the artist.[35] It turned decorative fragments into structures, parts into a whole, and in doing so it demonstrated the artist's mastery of design and invention.[36] Grotesque 'mediated between formlessness and form'[37] and took on a central (rather than a marginal) role in artistic compositions, often invoking plays of illusion, monstrous hybrids and jokes of nature.[38]

The turn of the 16th century was marked by a stylistic plurality across northern Europe: the dominant, Gothic mode of the previous century held important associations in ecclesiastical settings.[39] An updated, ornamental Gothic served to uphold continuity and important links with the past at court, while the antique style offered a new language of power. Contrary to earlier narratives that emphasise drastic rupture between the two styles, Ethan Matt Kavaler has demonstrated that an interchange between the Gothic and the antique spanned several decades in northern Europe, in which architecture and art across media bore hybrid aspects of both styles, or favoured one over the other in a conscious choice by patron or artist.[40]

Figure 74 Hans Holbein the Younger, design for table centrepiece (Anne Boleyn fountain) 1533–6, pen and black ink over chalk, h. 17.1cm, w. 10.1cm. Basel Kunstmuseum, 1662.165.89. Bilddaten gemeinfrei – Kunstmuseum Basel

Figure 75 Hans Holbein the Younger, design for table centrepiece (Jupiter fountain), c. 1533–6, pen and black ink over chalk, h. 26.5cm, w. 12.5cm. Basel Kunstmuseum, 1662.165.99. Bilddaten gemeinfrei – Kunstmuseum Basel

Metalwork that encapsulates this stylistic eclecticism is exceedingly rare; such vessels were deemed old-fashioned and melted down in the intervening years. Only four pieces of Tudor court plate survive, and the Royal Clock Salt is the sole object that combines Gothic and antique elements.[41] The Clock Salt comes from the highest levels of patronage, and this speaks to the importance and prestige afforded to this eclectic style. This piece fuses antique and Gothic elements: the hexagonal shape of the base and the cameo heads are popular antique elements, often observed in northern European metalwork and architecture.[42] The flat, blue background from which the heads protrude is decorated with arabesques, and similar designs are observed in Holbein's designs for book covers.[43] The ornamental tracery above the clock mechanism is an innovative interplay of styles: individual details are antique (putti, scrollwork, repeating motifs like vases and acanthus leaves), but the vertical gables are Gothic, as is the dense proliferation of ornament. The top of the Clock Salt (which is a later restoration) may have been surmounted by a figure of Jupiter and an eagle, and a comparable figure appears on top of a vessel in a design drawing by Holbein in Basel (**Fig. 75**).[44]

A similar hybridity is observed on the Howard Grace Cup, another example of Tudor metalwork: a medieval ivory cup with silver-gilt mounts with London hallmarks from 1525–6, when it is presumed that Catherine of Aragon (1485–1536) had it mounted as a gift. The Howard Grace Cup (see **Fig. 13**) features engraved friezes with masks and other grotesque elements, taken from German ornament prints, while the pierced cresting around the foot and the cover has Gothic ornament. Towards the middle of the century, such traces of Gothic style gradually disappeared from metalwork, and pairs of figures like caryatids, satyrs or putti holding up vessels were favoured in place of more robust stems or bases.[45]

Foreign craftsmen working in courts played a vital role in the stylistic diffusion of the antique mode. Henry VII (r. 1485–1509), father and predecessor to Henry VIII, relied on foreign goldsmiths from north and south of the Alps to supply him with elaborately chased and embossed vessels.[46] Henry VIII continued his father's artistic patronage, and Pietro Torrigiano (1472–1528) came to England from Italy shortly after the death of Henry VII; he designed the tombs of Henry VII, Elizabeth of York (1466–1503) and Lady

Margaret Beaufort (1443–1509) in the newest antique fashion, and incorporated the earlier Florentine tradition of bronze work, for which Lorenzo Ghiberti (1378–1455) was particularly renowned, together with the English tradition of gilding.[47] Torrigiano's sculpted portraits proved influential to Holbein's portraits on at least one occasion.[48] The ornamental programme on the ends of the tomb is especially interesting – angels and putti are depicted bearing arms, sculpted in the round and in deep relief – while the borders of the tomb are decorated with bronze-cast grotesque friezes and pilasters in shallow relief. When Torrigiano (unsuccessfully) sought help from the famous goldsmith Benvenuto Cellini (1500–1571) on the commission, he emphasised that the sculptural programme required the expertise of a goldsmith.[49] Torrigiano was tasked with designing the tomb of Henry VIII but this project remained unfinished and he left England by 1522; the subsequent onset of the Reformation ruptured ties with Italy.[50] Artists and craftsmen from northern Europe, who quickly absorbed the new antique style, Holbein chief among them, crafted the image of luxury at the court of Henry VIII. Foreign goldsmiths appear to have outnumbered their English counterparts at court throughout his reign.[51]

Gold was the most prestigious material at court, and goldwork and silver played an important social function in gift giving between the king, his subjects and other courts. The most renowned and best-documented occasion for gift giving was the ceremonial exchange between the monarch and his subjects at New Year, which acknowledged past service and functioned to continue and uphold relationships.[52] On New Year's Day, every member of the court, from the servants to the Lord Chancellor, expected a gift in the form of plate from the Jewel House, which was graded according to each individual's rank and personal standing with the king.[53] Customarily, the king would gift stereotyped plate prepared by a small group of London goldsmiths, but in some circumstances, he might chose to 'regift' an object from his own collection. In return, all members of the court would present the king with bespoke gifts of precious metals, including jewels, clothes embellished with gold, chains, necklaces, jewels and jewellery, and cups adorned with antique ornament, described in the scrolls as 'Almaigne [German] plate' rendered in the 'newest and best fashion'.[54] These items were carefully described and recorded in the annual gift scrolls, which are an invaluable source of information about Tudor metalwork that is no longer extant.

Several drawings by Holbein were designs for gifts commissioned by and for the king, and Holbein collaborated on these projects with goldsmiths from Antwerp, an important centre of metalwork in the 16th century. The first reference to Holbein appears in 1533, when he designed a cradle for Princess Elizabeth (1533–1603) (or another child at court) with the goldsmith Cornelis Hayes (*fl.* 1529–1547).[55] Hayes also paid Holbein for a design of Adam and Eve around 1533. Unfortunately, drawings do not survive for these projects. A further collaboration between Holbein and Hayes is recorded in the 1534 New Year's gift scroll, and substantiated by an extant drawing by Holbein in Basel (**Fig. 74**): a fountain gifted to Anne Boleyn

Figure 76 Hans Holbein the Younger, design for a cup, *c.* 1538, black pen over black chalk (right half off-set) with grey wash, h. 25.1cm, w. 16.4cm. Kunstmuseum Basel no. 1662.165.104. Bilddaten gemeinfrei – Kunstmuseum Basel

(*c.* 1500–1536) by Henry VIII.[56] This opulent table centrepiece is described as having a gilt basin with a fountain garnished with rubies and diamonds, and with Boleyn's badge of a white falcon with Tudor roses growing from a tree stump between two satyrs to the left of centre.

The fluid drawing of the Boleyn fountain records the initial design of just the upper portion of the fountain, surmounted by a crown: the foot of the fountain, which is rendered with simple lines, would connect with a larger basin below (not pictured), where the flowing water would pool.[57] Three satyrs hold up the lid of the vessel like Atlas, and two caryatids are positioned at either side of the stem, holding their breasts and expressing milk, which is also observed in a remarkably free sketch by Holbein of Ceres.[58] The caryatids stood in a basin of water at the foot of the fountain, as described in the gift registry. Christian Müller noted that the amorous and fecund motifs of the vessel reflect Henry VIII's hopes for a male heir in 1534.[59] In the drawing, little consideration is given to the problems encountered by a goldsmith: the decoration is abbreviated and volume is suggested through loosely hatched lines on the right side of the piece.[60] Another sheet in Basel shows a similar, multi-tiered vessel at an earlier stage in the design process: in the so-called Jupiter fountain, only the left-hand side is depicted, and the base is indicated in a cursory

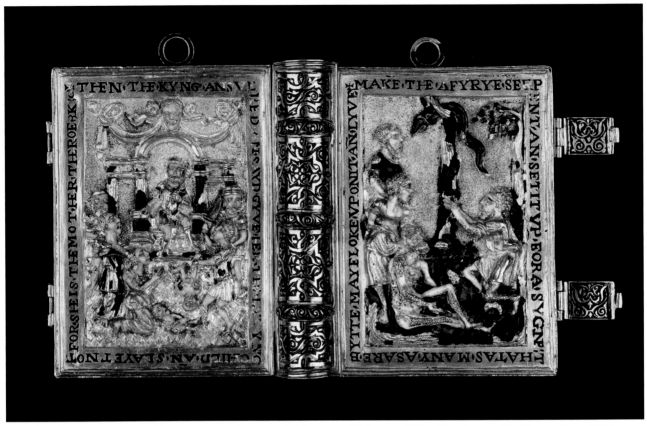

Figure 77 Attributed to Hans of Antwerp, girdle-book covers with Moses and Solomon, 1540, gold and enamel, h. 6.8cm, w. 8cm. British Museum, 1894,0729.1

fashion. Several quick sketches around the margins of the sheet may be evidence that Holbein was working out solutions or exploring alternatives (**Fig. 75**).[61]

The loosely sketched design drawings in Basel illuminate Holbein's working methods. Such intact sheets are a rare survival among the artist's drawings: most of the sheets in London as well as Basel have been silhouetted and pasted down, eliminating traces of marginal annotations or sketches.[62] Holbein planned the shape of the vessel with chalk, and filled in the details with pen and ink. The next step (observed in other drawings) would be to use wash to provide modelling and volume. Presumably Holbein (or his collaborators?) would have made further drawings in connection with the fountain, including a more finished version, with wash used to model volume and to specify and distinguish raised, embossed and flat techniques of decoration, in approximation of the final appearance of the vessel, possibly to show a patron.[63]

Hans of Antwerp (*fl.* 1515–1547) was another goldsmith with whom Holbein collaborated in London.[64] He arrived in England by 1515, and was among the growing number of foreigners from northern Europe working and living in England.[65] He was employed by prominent members of the court from 1532 onwards. In 1538 Thomas Cromwell (*c.* 1485–1540) gave Henry VIII a gold cup for which he paid Hans of Antwerp £7 7s; in 1541 Cromwell helped Hans of Antwerp gain admission to the Goldsmiths' Company.[66] Holbein and Hans of Antwerp were well acquainted and worked closely together: Hans of Antwerp witnessed Holbein's will in 1543.[67] The most compelling evidence of their collaboration is Holbein's design drawing in Basel

inscribed 'Hans von Ant' (**Fig. 76**).[68] The design comprises a simple, antique base, three bands of ornament decorations, and a female figure on the lid. Holbein drew the left side of the vessel in black chalk and ink, then moistened the sheet and folded it in half to complete the design via offset (the crease is still visible). Offsetting was a common practice for design drawings; the bands of ornament and grotesques show how effective the method was for completing the pattern in reverse.[69] Holbein drew an alternate design for the female figure surmounting the cup alongside, which anticipated the reversal, and the offsetting shows another view of the figure, important for goldsmiths working with objects in the round. He then added another version of the figure atop the vessel after the design had been completed.

While no extant object documented as the work of Hans of Antwerp survives, a girdle-book cover in the British Museum has been attributed to him (**Fig. 77**).[70] Girdle books were important accessories worn on chains by women. They became fashionable at the court of Henry VIII, following Spanish court fashions, and the books were often set into elaborate gold bindings. This cover features the Brazen Serpent on the front and the Judgement of Solomon on the back. Hugh Tait identified and dated the British Museum cover to 1540 based on reference to contemporary Antwerp goldsmiths' work.[71] The arabesque designs on the spine and clasps of the girdle book are similar to detail drawings by Holbein.[72] Sir Thomas Wyatt the Younger (*c.* 1521–1554) commissioned from Holbein a set of girdle-book covers, and the two extant design drawings might have been presented to the patron as two different options. Evidently, the Wyatt family chose the design with the smaller initials, because

Figure 78 Hans Holbein the Younger, design for a metalwork book cover for the Wyatt family with arabesques with initials 'TWI' above and 'IWT' below, c. 1537, pen and black ink, with black, grey and yellow, h. 7.9cm, w. 5.9cm. British Museum, SL,5308.8

such an object was recorded in their possession, and was illustrated and exhibited in 1873 (**Fig. 78**).[73] The book covers were decorated with black enamel over gold in the newly fashionable arabesque patterns.[74] The meticulously rendered drawings show how Holbein approximated materials and techniques: flat ornamental panels are demarcated from raised surfaces with the careful application of wash.

Hans of Antwerp probably executed the Seymour Cup after Holbein's designs as a gift from Henry VIII to Jane Seymour (c. 1508–1537) in c. 1536 (see Chapter 1).[75] The cup is recorded in two drawings of varying stages of completion by Holbein and sheds light on the nature and function of drawings within the artist's oeuvre. The cup was described in the 1574 inventory of Elizabeth I's plate as decorated with hanging jewels, the initials of Henry and Jane intertwined with love knots, and Seymour's motto: 'Bound to serve and obey'.[76] In the design drawing in the British Museum, Holbein drew the left side and completed the drawing through offsetting.[77] He then introduced several changes to the drawing: he clarified the post of the upper right-hand putto, the pipe blown by the left-hand siren and the left-hand head seen in relief on the middle section (**Fig. 79**). The antique heads recall the heads on the base of the Clock Salt (see Chapter 4, p. 66 and Chapter 8, pp. 117–18). The

final drawing of the Seymour Cup survives in Oxford (**Fig. 80**), which generally follows the design specified in the London drawing. The Oxford drawing, however, contains a higher degree of detail – the gems in particular – and features colour washes and gold heightening. Presumably this highly finished sheet was shown to the king for approval but it is exceedingly difficult to reconstruct the social function of such drawings. The cup was described in 1625 with only one pendant pearl, and it was then taken to Holland and pawned by the Duke of Buckingham (1592–1628). It was redeemed shortly after, in 1629, only to be melted down, the jewels extracted, and the gold sold to the Bank of Amsterdam.[78]

Holbein's last design drawing in relation to courtly gifts was for the Denny clock salt (see **Fig. 70**), which was presented by Sir Anthony Denny, Keeper of Whitehall Palace, to Henry VIII on New Year's Day 1544, just two months after Holbein's death. While the Denny clock salt itself does not survive, Holbein's design exemplifies the taste for complex and elaborate mechanisms at the Tudor court in the 1530s.[79] Henry reportedly had a passion for clocks, on which he spent over £100 in three years; nearly 200 timepieces, including 12 clock salts, are recorded in the 1547 posthumous inventory of Henry's possessions, but the Denny salt is not among them.[80]

Figure 79 Hans Holbein the Younger, Jane Seymour cup, preliminary design, 1536–7, pen and brush drawing in black ink, right side offset, h. 37.5cm, w. 14.3cm. British Museum, 1848,1125.9

Figure 80 Hans Holbein the Younger, design for the Jane Seymour cup, finished design, 1536–7, pen and ink, grey and pink wash, heightened with gold, sheet 37.6cm × 15.5cm (irregular hexagon). Ashmolean Museum, WA1863.424. Bequeathed by Francis Douce, 1834. © Ashmolean Museum, University of Oxford

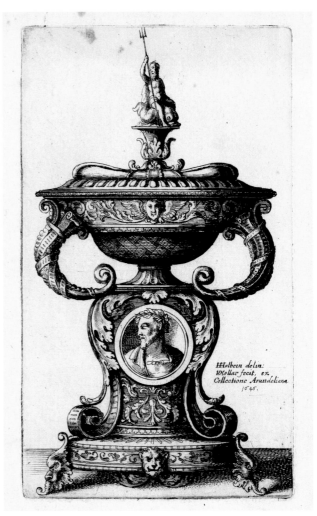

Figure 81 Wenzel Hollar after a lost design by Hans Holbein the Younger, ornate cup or salt with two handles, 1646, etching, h. 17cm, w. 10cm. British Museum, 1868,0822.579

The Denny salt is made up of a large hourglass within folding doors on a pedestal, which is supported on curling feet and framed by two satyrs, similar to the figures on the Boleyn fountain. To the left of the clock is a compass, which was intended to be inserted into the base of the hourglass. The top part lifted off or was hinged to reveal a small, ornamented dish for salt. A 12-hour dial with a single hand surmounted by a crown is at the very top, below which are two standing putti with pointing hands, their fingers indicating the hour. The drawing does not specify the location of the watch movement: it could have been behind the 12-hour dial at the top, or behind the sundial, or most likely in the base with a lead-off rod to connect the dial.[81] The decorative figures observed atop other vessels at Henry's court have been replaced by functional figures. An alternative, more dynamic design for the putti survives in a

cut-down state in London, which suggests that Holbein planned the complex vessel in further loose working drawings that do not survive.[82] Two fragments of drawings from the Sloane album, not by Holbein himself, record the mechanism of an automaton.[83] As a portable alternative to this lavish clock salt, Holbein also designed a diminutive pillar sundial, which was intended to be worn as jewellery.[84]

The Denny salt drawing is annotated in two hands: along the bottom a Latin inscription (previously believed to be in Denny's own hand) identifies the patron, recipient and year of the commission; further annotations on the left side of the door and beside the clock are technical notes about the mechanism. Otto Pächt identified the latter as the hand of Nicholas Kratzer (c. 1487–1550), the German astronomer to Henry VIII, with whom Holbein collaborated on other projects, including an illuminated manuscript treatise on scientific instruments presented to the king.[85] Kratzer added lunar and solar predictions inside the door and clarified which astrological tables and tables had to be inserted where, probably intended for the craftsman carrying out the design. The notes confirm that Kratzer collaborated on the Denny salt with Holbein.[86] A few mistakes are evident in the drawing and annotations: the numbers appear on the wrong side of the sundial, which requires a compass in order to attain accuracy. The hourglass is moreover an imprecise

measurement of time. Similar discrepancies can be observed in Holbein's paintings of scientific instruments in his portraits of Kratzer (1528), and of Jean de Dinteville (1504–1555) and Georges de Selve (1508–1541) in *The Ambassadors* (1533) (see Chapter 1, **Fig. 7**).[87]

The drawing for the Denny salt shows no traces of the Gothic openwork gables observed in the Royal Clock Salt designed at least 10 years earlier. The design for the Denny salt is indicative of changing tastes: towards the middle of the 16th century, antique free-standing figures framed and supported vessels in place of the denser supports favoured in the first half of the century, as seen in the S-scroll brackets that enclose the clock mechanism in the Royal Clock Salt. This stylistic shift is also observed in two further designs connected with Holbein: a drawing possibly made in the 18th century as an amalgam of Holbein's designs shows a covered salt with the figure of Ceres on the lid.[88] The satyrs supporting the cup, the shallow grotesque decoration and the standing figure on top as well as the antique heads are all taken from Holbein's vessel designs. An etching of an ornate cup by Hollar with a figure of Neptune on top has a comparable design, in which the craning antique heads are similar to the cameo heads on the Royal Clock Salt (**Fig. 81**).[89] Holbein created inventive and vibrant designs with seemingly endless variations for patrons and craftsmen, combining grotesque ornament with antique form, and in so doing, participated in a wider, pan-European stylistic shift.

Holbein's success at the English court is attributed to his versatility as a designer, together with his impressive command of the antique mode. His drawings for goldsmiths give valuable insight into the visual culture of the Tudor court. His designs do not display any traces of the Gothic style that can still be observed in the Royal Clock Salt, and his last design in particular, for the Denny salt, anticipates Mannerist elegance in its form. Holbein's designs, therefore, provide a broader context through which we can understand the singularity and significance of the Royal Clock Salt. Small-scale works could more easily and quickly incorporate new styles and ideas, unlike the monumental commissions at court. Small-scale objects, moreover, invited a different way of experiencing style and opulence, a move from the optic to the haptic, from viewing at a distance towards engaging with objects in relation to the body. Unfortunately, metalwork from the Tudor court is exceedingly rare, and in this context Holbein's drawings serve an important documentary function, offering tantalising clues about the design and production process. Holbein, Hans of Antwerp and other foreign goldsmiths working in London represent a key facet of Henry's patronage: antique ideas filtered through a distinctly northern lens.

Notes

1 The rock-crystal bowl was mentioned in an inventory of the possessions of Henry VIII drawn up in 1547 by Edward VI, and in successive royal inventories until 1649; it was then presumably sold in Amsterdam, where it appears in a 1678 still-life painting by Willem Kalf (1619–1693). See Hayward 1965 and Schroder 2020.

2 For a comprehensive overview of gold and silver at the Tudor court, see Schroder 2020.

3 In the British Library; see MS Add 46, 348, fol. 149v.

4 Inigo Jones (1573–1652) showed this sketchbook to Von Sandrart, see Peltzer 1925, 102.

5 *Teutsche Akademie* 1675, II, Buch 3 (*niederl. u. dt. Künstler*), 251.

6 Rowlands 1993, vol. 1, 153.

7 Ibid.; see also Bätschmann and Griener 1998, 202–7.

8 Thomas Howard tried to acquire the works by Holbein in Basel, especially the drawings, but failed; see Rowlands 1993, vol. 1, 153; and for Hollar's etchings, see Turner 2010, vol. III, nos 824–33.

9 The sale of paintings, limnings and drawings of the Duke of Norfolk at the premises of Parry Walton in Lincoln's Inn Fields, London, on 19 January 1692. This was a sale of pictures that Jane, dowager Duchess of Norfolk (1643/4–1693), had inherited from Henry, 6th Duke of Norfolk (1628–1684). The sale contained family heirlooms from the 2nd Earl of Arundel, which prompted the successor to delay the sale. The sale went forward in the end but it is unclear if, or how many, objects from Arundel's collection were indeed included; works by Holbein and Isaac Oliver (*c.* 1565–1617) were listed in the sale but not described further. Constantijn Huygens Jr (1628–1697) attended the sale on several days, and on 1 February 1692 wrote in his diary that they 'sold some small emblems by Holbein and Dorp', which could refer to Sloane 5308 as emblems figure prominently in the album. Maarten van Dorp (1485–1525) was a Leuven theologian, best known as a friend and correspondent of Erasmus. Evidently, Huygens did not rate the objects highly for he described the sale as containing only 'trivial things'. I wish to thank Giulia Bartrum and Antony Griffiths for sharing this reference with me. See 'Sale of paintings, limnings and drawings of the Duke of Norfolk at Parry Walton's premises in Lincoln's Inn Fields, 19 January 1692', *The Art World in Britain 1660 to 1735*, at http://artworld.york.ac.uk (accessed 20 January 2020) and 'Diaries of Constantijn Huygens, 1688–1696, National Library of the Netherlands, trans. Sanne van der Schee from Constantijn Huygens, Journaal van 21 October 1688 tot 2 Sept. 1696 (Utrecht, 1876–7; online editions 2009), vol. 2, 19, *The Art World in Britain 1660 to 1735*, at http://artworld.york.ac.uk (accessed 20 January 2020).

10 The volume designated by Sloane as no. 5308 was probably dismantled during the late 19th century. The binding does not survive, but it was described as quarto size and bount [bound] in red Moroccan leather. The book contained designs for jewellers' and goldsmiths' work and is evidently the 'book of Drawings [Drawings] of Jewelling work drawn by Holben' noted by George Vertue in 1713–21 in the possession of Sir Hans Sloane (Walpole Society XVIII 1929/30, Vertue Note Books, vol. 1, 56; and Walpole Society XX 1931/2, Vertue Note Books, vol. 11, 12). For the full provenance of Sloane 5308, including the history of the object after it came into Sloane's collection, see Rowlands 1993, vol. 1, 152.

11 Sloan 2012, 168 n. 3.

12 Ibid.

13 Rowlands 1993, vol 1, 153; Christian Müller, 'Hans Holbein as Draftsman' in Müller 2006, 32–3; see also Müller 1991.

14 Rowlands 1993, vol. 1, 153.

15 Holbein's son Philipp (born *c.* 1522) was a goldsmith; Holbein may have travelled with him to Paris in 1539 en route back to England in order to leave Philipp to work as a journeyman for a goldsmith where he was to remain for six years. See Foister 2004, 140.

16 For *The Ambassadors* (NG1314), see Foister and Roy 1997; for the portrait drawings, see Parker 1983.

17 Müller 2006, 21.

18 Augsburg 1965, 101.

19 Rowlands 1993, vol. 1, 138; Bayonne, Musée Bonnat, inventory no. 1532; for Jorg Seld, see Augsburg 1965, 196 ff., nos 270–4.

20 Foister 2004, 173; see also Krause 2002, 71 n. 123; for the crosier, see Rowlands 1993, vol. 1, 138; Österreichisches Museum für angewandte Kunste, inv. no. KI619; see also Augsburg 1965, 117, no. 104.

21 For the St Catherine altarpiece, see Krause 2002, 234–9, figs 154–6; and for the portrait, 260, fig. 182.

22 Formerly in the Wernher Collection at Luton Hoo, and now in the Victoria and Albert Museum, London (M.27–2000); see Sell *et al.* 2015, 67–8.

23 Krause 2002, 71 n. 123.

24 Rowlands 1993, vol. 1, 138, no. 300.

25 See Falk 1979, 91, no. 207: reg. no U.VII.9 (also from the Amerbach-Kabinett)

26 Müller 2006, 21.

27 Ibid.

28 Ibid., 238–9 and nos 60–3.

29 Foister 1991, 58.

30 Müller 2006, 27.

31 Ibid., 21; see also Foister 1991, 58.

32 See Foister 2004, 1 ff.; Foister 2006.

33 See Müller 1997, no. 16.

34 Foister 1991, 58.

35 Connelly 2012, 35.

36 Lapraik Guest 2015, 494.

37 Ibid., 591.

38 Connelly 2012, 46.

39 Kavaler 2012, 6.

40 Ibid., 5 ff.

41 Hayward 1976, 108. The four surviving pieces of Tudor court plate are as follows: the French Royal Cup in the British Museum, a rock-crystal and silver-gilt cup or vase in Florence, a jewel-mounted rock-crystal bowl in Munich, and the Royal Clock Salt. See Schroder 2020, 295–9 and 315–18.

42 Tait 1991c, 112.

43 Foister 2006, 78, no. 82.

44 Ibid.

45 Hayward 1976, 108.

46 Tait 1991c, 112. For an account of royal goldsmiths in the reign of Henry VII, see Schroder 2020.

47 Hayward 1976, 109

48 Foister 2004, 27.

49 Wyatt 2005, 46; Cellini 1850, 20–3.

50 Starkey 1991, 26, 32; for a discussion about the Italian influence in Tudor England, see Wyatt 2005 and Bolland 2011.

51 Awais-Dean 2017, 14.

52 Foister 2004, 137; see also Hayward 2005, 125.

53 Glanville 1991, 131–2.

54 Ibid., 135; Foister 2004, 137–8; it can be difficult to determine what exactly was meant by these descriptions, see Awais-Dean 2017, 13.

55 Holbein travelled through Antwerp en route to his first sojourn in London, see Müller 2006, 12. For a fuller account of the cradle, see Schroder 2020, 186–8.

56 Foister 2004, 138; Müller 1988, 255–6, no. 83; Müller 1996, 138–9, no. 243.

57 Müller 1988, 256, no. 84.

58 Müller 1996, 139, no. 246.

59 Müller 1988, 256, no. 83.

60 Hayward and Bury 1964, 67.

61 Müller 1988, 258–9, no. 84; Müller 1996, 139, no. 244.

62 Foister 2004, 140.

63 Ibid.; this is observed in other drawings; Müller 1996, 137–8, nos 240–1.

64 He is also known in the literature as John of Antwerp; he was named in the parish as John vander Gow alias Antwerp. See Cust 1906.

65 Tait 1991c, 113.

66 Ibid.; Foister 2004, 142.

67 Foister 2004, 141.

68 Müller 1988, 254–5, no. 82; Müller 1996, 137, no. 239.

69 Müller 1988, 254.

70 Foister 2004, 141; Tait 1985.

71 Hugh Tait identified the reference to the large sculptural silver-gilt book cover, which was completed by 1543 by leading Antwerp goldsmith Hieronymus Mamacker (*c.* 1493–1555) for the Abbey of Tongerlo, where it is still preserved. See Tait 1985, 39, figs 14–17.

72 For example, SL,5308.61; see Rowlands 1993, vol. I, no. 361.

73 They were probably commissioned in 1537 on the occasion of Sir Thomas Wyatt the Younger's marriage to Jane Haute (1522–*c.* 1600). See Tait 1985, 35, fig. 10.

74 Foister 2006, 84, no. 90.

75 Foister 2004, 138.

76 The cup is described in the 1574 inventory as: 'Item oone [one] faire [fair] standing Cup of golde [gold] garnisshed [garnished] about the Couer [cover] with eleuen [eleven] table Diamoundes [diamonds] and two pointed Diamoundes [diamonds] about the Cup Seventene [seventeen]/ table Diamoundes [diamonds] and thre [three] pearles [pearls] pendaunt [pendent] vpon [upon] the Cup with this worde [word] bounde [bound] to obeye [obey] and serue [serve] and H and J knitte [knitted] together in the toppe [top] of the Couer [cover] the Quenis Armes [King's arms] and Quene Janes Armes [Queen Anne's arms] holdone [held up] by two boyes [boys] vnder [under] a Crowne Imperiall [Crown Imperial] poiz', Jefferies Collins 1955, 279, no. 47.

77 Christian Müller has suggested that the right side of the Seymour Cup London drawing, and the final version in Oxford, might be the work of Holbein's studio rather than the artist himself. See Müller 1990.

78 Jefferies Collins 1955, 279.

79 Glanville 1991, 131–2.

80 Nicholas 1827, 310 ff.

81 My thanks to Oliver Cooke for discussing the mechanism with me.

82 SL,5308.86; see Rowlands 1993, vol. I, no. 336.

83 SL,5308.80-81; ibid. vol. I, nos 374–5.

84 SL,5308.148; ibid. vol. I, no. 335.

85 This manuscript, a short astronomical treatise entitled *Canones Horptri* (today in the Bodleian library, MS Bodley 504), was given to Henry VIII as a New Year's Gift in 1528/9; see Pächt 1944, 137.

86 Ibid., 138; Foister 2004, 140.

87 Dekker and Lippincott 1999, 108–110; Peter Drinkwater first noted that the dial represented in *The Ambassadors* was not assembled and the dial itself was missing. See Drinkwater 1993, 7–9.

88 The British Museum, registration no. Ff,4.98; see Rowlands 1993, vo. I, no. 390. Similar thatched patterns are observed in Holbein's fragment drawings, such as 1662.165.18 in Basel.

89 Turner 2010, number 830. A similar design occurs in a drawing of a vessel in Basel, attributed to the circle of Holbein. See Müller 1996, 162, no. 326.

Chapter 6
The Royal Clock Salt and its History after the Reign of Charles I

Rosemary Ransome Wallis

This chapter takes the story of the Royal Clock Salt from 1649 until the present day. Following the death of Henry VIII (r. 1509–47), it appears to have remained in the royal Jewel House at the Tower of London until after the execution of Charles I (r. 1625–49). The king died on 30 January 1649 and in the months that followed, at the instigation of Oliver Cromwell (1599–1658), his celebrated art collection was sold off. Although best known for its great masterpieces by Italian artists such as Raphael (1483–1520), Titian (1489–1576) and Caravaggio (1571–1610), the collection also included important goldsmiths' work. This is listed in 'A true and p[er]fect inventory of all the Plate and Jewells now being in the Upper Jewell House of the Tower in the charge of Sir Henry Mildmay, together with an appraisal of them and taken in the 13th, 14th, and 15th daies of August 1649'.[1] From our point of view, the key entry in this 'Inventory of the Rebels', as it became known, is one reading: '2 Faire large Saltes of silver-gilt with a clocke in it, garnisht with 6 ivory heads about the bottome, and enriched with stones and little gold heads enamelled, with a man upon a falcon a top of it, valued at £40'.

The certificates of the 'Treasurers of the Sale of the Royal Property' note the buyers and the prices paid; this item is annotated 'Sold [to] Mr. Smith ye 31 Decr 1649 for £43'.[2] Exactly who this Mr Smith was is not clear, but it is possible that the name was a pseudonym for Henry Mordaunt, 2nd Earl of Peterborough (1623–1697), who was an ancestor of the Sackville family, owners of the Clock Salt during the 19th and 20th centuries. The earl played a significant, if inconstant, role in the Civil War (1642–51), switching sides from the Parliamentarians to the Royalists in the early part of the conflict. As to the appeal of the Clock Salt may have held for the earl, one might speculate that in addition to being a significant royal memento, it had personal resonance for him, given that its falcon (or eagle) finial could be reconstrued as an allusion to the supporters from his own coat of arms.

Following the defeat of the Royalist cause the earl fled to Antwerp, but was obliged to return in May 1649 in order to bargain for the retention of his estates. One portion of those estates was the manor of Drayton in Northamptonshire, which passed on his death to his daughter, Mary, Duchess of Norfolk (c. 1659–1705). From her it went through her second husband, Sir John Germain (c. 1650–1718), to his second wife, Elizabeth (1680–1769), the latter bequeathing the property to Lord George Sackville (1716–1785; later Viscount Sackville of Drayton), younger son of the Duke of Dorset (1688–1765) in 1769.

This indirect line of inheritance continued down the Sackville family. Sackville's son Charles, the second viscount, died without issue in 1843 and under his will the estate passed to his niece, Caroline Harriet Sackville (1815–1908). She married William Bruce Stopford in 1837, who, in 1870, assumed by royal licence the additional surname and the arms of Sackville.[3]

It is with Stopford (1806–1872) that we enter the period of the documented family ownership of the Clock Salt, since he was named as its owner in two important loan exhibitions, at the Society of Arts in 1850[4] and the South Kensington Museum in 1862. The catalogue of the latter described it as follows:

Silver-gilt clock on a hexagonal pedestal, the panels of gold scrolls on blue enamel having in the centre of each medallion with a projecting head carved in ivory; enamel pilasters at the angles resting on six claws and agate balls, above this is a glass cylinder showing the works, and a silver dial with an index to show the minutes, a gilt border at top and bottom set with garnets and six scroll brackets supporting a pierced dome, set with garnets round the edge of which are triangular ornaments and dragons' heads, with small amorini between holding shields, and a large figure of Mars pointing with a spear to a white enamelled globe at the summit, on which are painted the numerals denoting the hour; between the globe and the dome is an hexangular boss, set with carbuncles on blue enamel. French work, circa 1520.[5]

If the Clock Salt had indeed descended with the estate from the 2nd Earl of Peterborough and if it had remained at Drayton, it was fortunate to have survived, since the house was sacked by a mob in 1688 around the time of the Glorious Revolution, when Peterborough, a Catholic convert and supporter of James II (r. 1685–8), was caught trying to flee the kingdom.[6] But sadly there is little documentary evidence to support this and the Drayton inventories of 1710 and 1770 make no mention of silver or jewellery. Other than the crucial evidence of the 1862 loan, the only Drayton inventory to include the Clock Salt is one dating from 1905,[7] which describes it as:

A fine Antique rare clock, in richly chased ornamental ormolu case, studded with jewels surmounted by a globular dial with warrior figure pointing to the time, the dome having numerous figures and flowers in relief on scroll supports and octagonal base with old blue enamelled panels, the centre having Busts of female in high relief, on ormolu high claw and onyx ball feet, under a glass shade.[8]

Two generations later Stopford's grandson, Colonel Nigel Stopford Sackville, CBE (1901–1972), sold the Clock Salt at Christie's in 1967 for 7,000 guineas, when the catalogue stated that it had been 'removed from Drayton House Northamptonshire'.[9]

Despite its presence in the 1862 exhibition, it is clear that the Clock Salt's full significance as an object had not yet been recognised and its identification as a royal object only emerged as a result of research carried out around the time of the 1967 sale. As Arthur Grimwade, Director of Christie's Silver Department (and subsequently Prime Warden of the Goldsmiths' Company), focused his attentions on the Tudor Jewel House inventories and the 1649 sale, he became convinced that the Clock Salt was an exceptional survival from Henry VIII's treasury. Hugh Tait, Assistant Keeper of Medieval and Later Antiquities at the British Museum, shared this view and strongly recommended its acquisition by the Museum.[10] But even then, its true origins eluded public detection and it was catalogued as 'probably German, circa 1540'.

The Museum did not bid at the sale since authorisation to do so had not been obtained from the Trustees. As a result, it was sold to the firm of London antique dealers, Ronald Lee, in partnership with S.J. Philips Ltd. They turned down an after-sale bid by the Museum of £10,500 and countered by offering it for the very much higher sum of £22,500; when that was declined, they sold it instead to the Badisches Landesmuseum in Karlsruhe, for £28,000. This in turn

triggered an application for an export licence and the appointment of Rupert Bruce-Mitford (1914–1994) (British Museum) and Ronald Lightbown (1932–2021) (Victoria and Albert Museum) as expert advisers to the Export Review Panel. During the course of their examination Bruce-Mitford and Lightbown observed that the style of the Clock Salt was French rather than German and suggested attributing it to a member of the Barbedor family of Parisian goldsmiths.[11] The application was considered on 15 May 1968 and, in view of its now established English royal associations and French courtly origins, it was unanimously agreed that it qualified under all three Waverley criteria[12] and that the sale price of £28,000 was fair. A temporary stop of three months on the licence was granted in order to give a national institution a chance to match the price and prevent the export.

In the months following the panel's decision the Museum mounted a campaign to raise the funds. The National Art Collections Fund, The Pilgrim Trust and the Goldsmiths' Company were all approached. At a meeting of the Company's Court of Assistants, however, the Company made a bold decision: if the Museum failed to raise the purchase sum, the Company would buy it for its own collection. Accordingly, Lord Boyd, Prime Warden of the Company, met with Lord Eccles, Chairman of the Museum's trustees, who felt that this would be a happy solution to the problem and the sale to the Company was duly completed on 8 August (**Fig. 82**).[13]

The period following the Company's acquisition of the Clock Salt was marked by intense study and a major intervention aimed at restoring it to a closer approximation to its original appearance. The movement within the cylindrical rock crystal section, the spherical white enamel finial with the hour ring and the Roman soldier were all agreed to be later replacements, and were removed before the Clock Salt arrived at Goldsmiths' Hall. These elements were retained by the Company as evidence of previous alterations. Further research, confirmed by more recent investigations (see Chapter 8), led to the conclusion that the movement dated from the 19th century,[14] while documents in the archives at Drayton House raise the possibility that its author was the famous clockmaker Benjamin Lewis Vulliamy (1780–1854), who was known for his radical refashioning of earlier works.[15]

John Hayward, the eminent historian of goldsmiths' work and liveryman of the Company, was entrusted with supervising his desired restoration of the Clock Salt, which he wrote up in the Company's 1972–3 Annual Review.[16] In his article he noted that the 'piece had a most unhappy appearance with the empty crystal cylinder and the calyx at the top, which had originally supported the salt receptacle now holding nothing. The hanging pearls were gone, the cresting damaged and many of the original stones were also missing' (**Fig. 83**).[17]

The overriding principle of the restoration was that any restored features could be removed and the Clock Salt returned to its assumed previous state. Technical decisions were informed by carefully assembled visual evidence, including the pen-and-wash drawing of Duke Albrecht V of Bavaria's (1528–1579) clock salt (see Introduction and

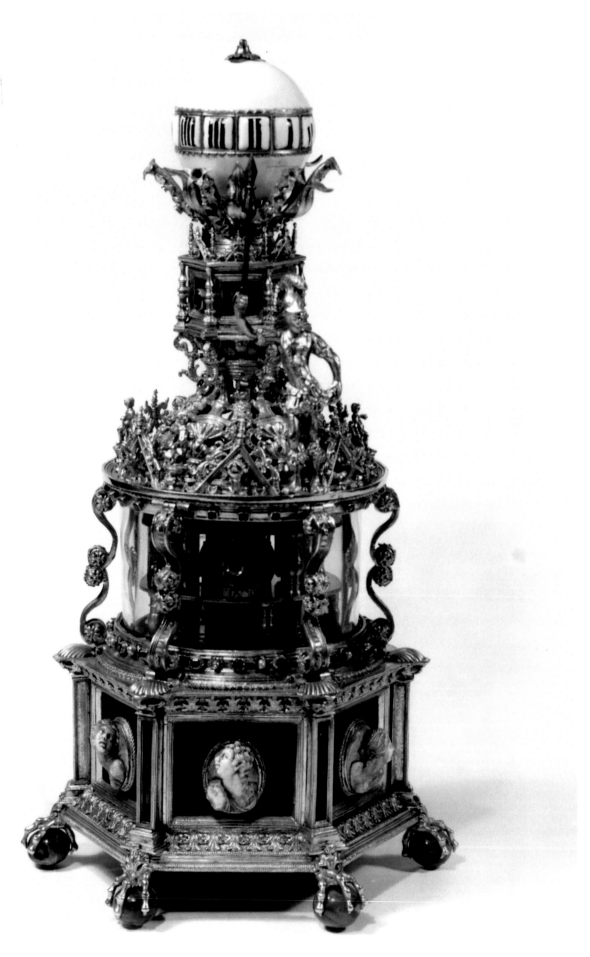

Figure 82 The physical appearance of the Royal Clock Salt in 1967. Image courtesy of the Goldsmiths' Company's Archive

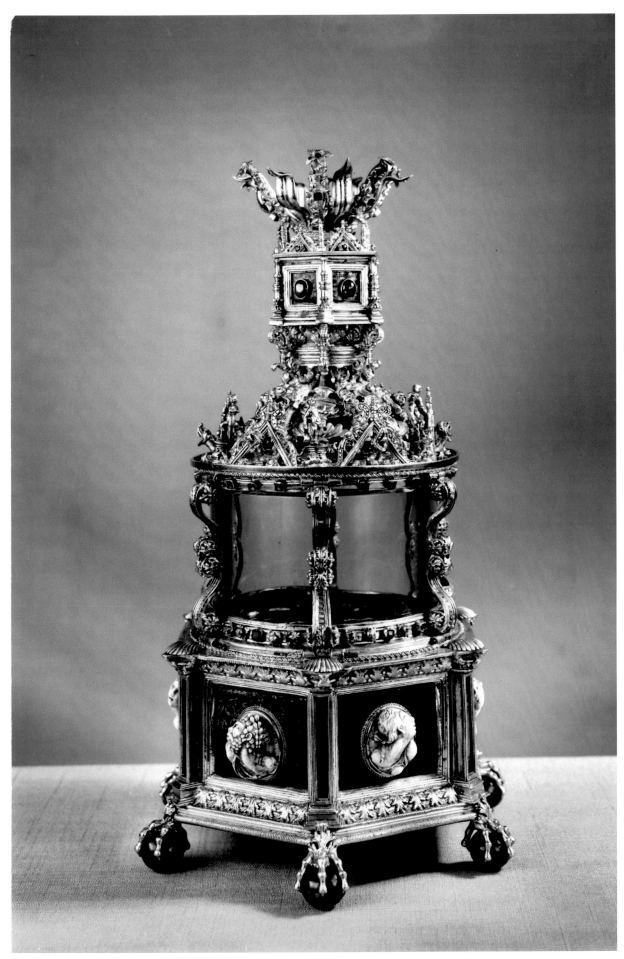

Figure 83 The physical appearance of the Royal Clock Salt in 1968. Image courtesy of the Goldsmiths' Company's Archive

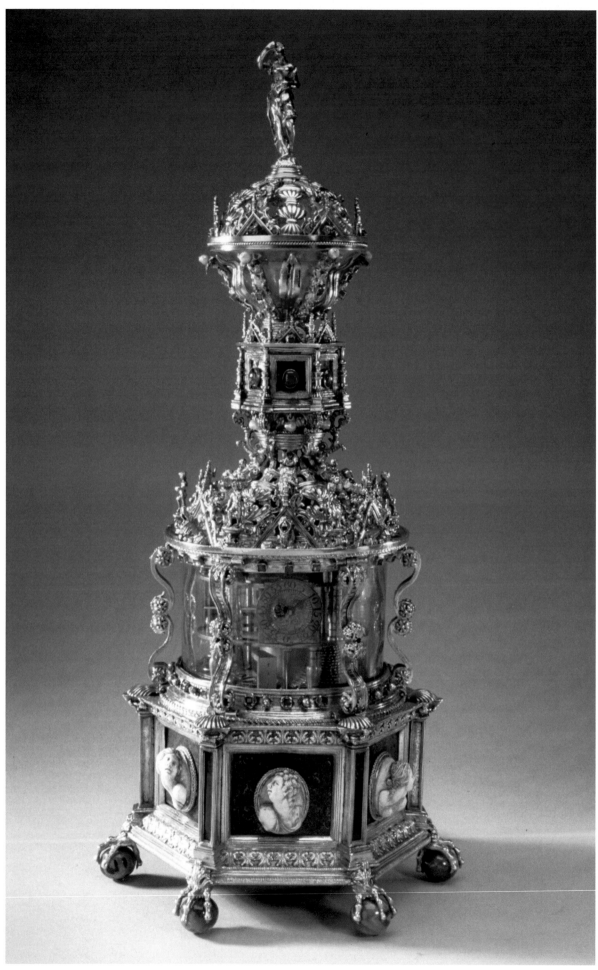

Figure 84 The physical appearance of the Royal Clock Salt between 1971 and 2012

Chapter 8, **Fig. 118a**) and the corpus of then-known works from the same workshop. This was not yet identified as Pierre Mangot's (c. 1485–after 1551), but Hayward recognised that the workshop 'was employed by the French court', leading him to speculate that 'the clock salt was made by order of king Francois I'. Indeed, he went so far as to suggest that 'the clock salt was a gift from the king of France to Henry VIII'.[18]

One feature that the restoration had to address was the missing stones and pearls. Hayward noted that although the 1550 [1547] inventory describes the cover embellished with small counterfeit emeralds, the base, when received by the Company, was decorated with garnets. It was decided not to introduce what would have been a discordant green colour on the cover but to use rubies or garnets throughout.[19]

A more fundamental concern for Hayward was the missing receptacle for the salt and here the path ahead was less clear. Assuming that it would originally have been supported by the calyx of leaves at the top of the object,[20] he suggested that the latter seemed to have been 'designed to receive a container of some material other than metal' and argued that 'this was most likely to have been rock crystal'. Given that the 1547 inventory description refers to 'a man sitting upon an eagle upon the top of the cover' (or a 'falcon' in 1649), he decided that the most plausible design, in keeping with common 16th-century practice,[21] was one that echoed the form of the pierced dome above the rock crystal cylinder. This thus became the pattern for the cover of the new small rock-crystal bowl at the top, which was screwed into the frond supports. The precise form of the finial group, however, presented a further problem. Hayward proposed, reasonably enough, that it represented the Rape of Ganymede. But 'a modern design would look out of place and [as] difficulty was experienced in finding a contemporary model to follow, it was decided, purely as a temporary measure, to substitute a figure of a woman cast from a contemporary piece, which was loaned for this purpose by the Victoria and Albert Museum.'[22]

This, then, was the form in which the Clock Salt was published and displayed until well into the present century (**Fig. 84**). In addition to it being illustrated and described in Hayward's own monumental 1976 study *Virtuoso Goldsmiths and the Triumph of Mannerism*, it appeared in two major late 20th- and early 21st-century exhibitions, the National Maritime Museum's 1991 show *Henry VIII: A European Court in England*, organised by David Starkey, and Tate Britain's 2006 exhibition, *Holbein in England* (where it was correctly attributed to Mangot).

Well-intentioned and carefully studied though the restoration was, contemporary tastes in conservation have moved away from such radical interventions. Moreover, more recent analysis has cast doubt on some of Hayward's assumptions. The openwork fronds surmounting the piece, thought by him to be part of the original fabric, were assayed in 2013 and found to be of Sterling Standard (92.5% silver) dated to the 17th century, whereas the rest of the metalwork is of a higher standard in accordance with Paris standard (95.7% silver) dated to the 16th century.[23] It follows that the fronds cannot have supported the salt cellar as Hayward believed. Further evidence supports this. The assay of the former finial figure of Mars (depicted as a Roman soldier) found this to be Sterling Standard, dated to the 17th century – its poor gilding matching that on the fronds. In addition, in 2014 the remaining dial plate on the Clock Salt was confirmed as late 17th century by Jonathan Betts, Senior Curator of Horology, Royal Observatory Greenwich. These extant features thus point to an alteration to the Clock Salt in the 17th century.

New consideration has also been given to how the original clockwork mechanism would have been housed: was it perhaps located not within the rock crystal cylinder at all but within the base, allowing the table clock face to be viewed through the crystal and accessed by removing the domed section? A visible gap, together with the soldered down rope wiring beading on the dome's edge, indicate a former lid. An earlier table clock would have been inserted through the bottom of the piece, held in place with flaps, which have been crudely altered and still visible beneath the salt. This concurs with the finding of Beresford Hutchinson of the British Museum Horological Department that there had been a 'brutal' alteration to the clock mechanism of the salt in the 19th century. Furthermore, if the fronds are accepted as a later intervention, is there any reason why the finial of 'a man sitting upon an eagle' could not have been positioned directly on top of the small crested hexagonal section? To test the visual plausibility of this theory a scale drawing was commissioned by the Goldsmiths' Company from Robert Whale in 2014 (**Fig. 85**). A sculptural reference was chosen to complement the existing sculptured high-relief heads, carved in a hard shell material. A surviving small bronze maquette of Ganymede,[24] thought to be the model source for a bas-relief design on Benvenuto Cellini's (1500–1571) life-size, now lost, Jupiter candelabrum commissioned by Francis I (r. 1515–47), was scaled down as a model for the finial. But appealing though this proposal is, it still leaves unanswered the question of where exactly the salt receptacle was originally located and of what material it was made.

In conclusion, the Royal Clock Salt, arguably the Goldsmiths' Company's most historically significant treasure, has been the subject of ongoing study ever since it entered the Company's collection in 1967. Not all the conclusions reached in the early years of the Company's custodianship are still accepted and some aspects of its restoration have turned out to be more 'temporary measures'. But each stage of this journey has helped enrich our continuing understanding of its original fabrication and significance.

Notes

1 Christie's sale catalogue, 12 July 1967, lot 180; *Archaeologia XV*, manuscript of Rev. John Brand, read to the Society of Antiquaries on 17 May 1804.
2 British Library Harleian MSS.7352/4898.
3 It would appear, however, that he had adopted the name of Sackville before that, since he is listed as Stopford Sackville in the 1862 South Kensington exhibition catalogue.
4 *Catalogue of Works of Ancient and Mediaeval Art, Exhibited at the House of the Society of Arts, London, 1850*, London 1850, cat. 18.

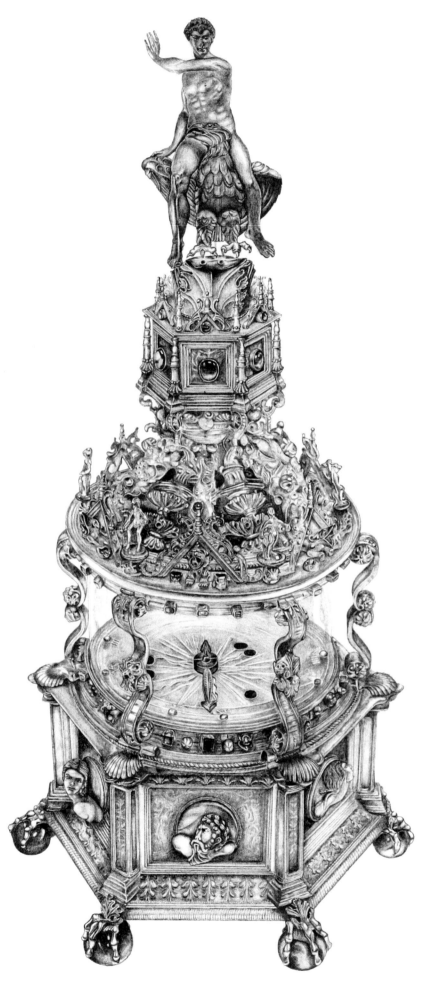

Figure 85 Proposed design of the original form of the Royal Clock Salt, pencil drawing by Robert Whale, 2014

5 Robinson 1863, 652, item 7448.

6 See *ODNB* article, 2nd Earl of Peterborough (https://doi. org/10.1093/ref:odnb/19163; accessed 19 May 2021).

7 In a letter of 20 May 1968 to Hugh Tait, Assistant Keeper, British Museum, Colonel Stopford Sackville writes that the inventory was 'done by a local man, who appeared to have little knowledge of antiques'. Archives: British Museum.

8 Archives: Drayton House, Northamptonshire. The glass shade, disappeared or separated from the glass by the time of the 1967 sale, was obviously a 19th-century addition.

9 Sale, 12 July 1967, lot 180.

10 Internal formal memos from Hugh Tait, Assistant Keeper to Rupert Bruce-Mitford Keeper British Museum. Archives: British Museum.

11 Presumably because of Ilaria Toesca's 1969 article, which first identified the distinct corpus of work associated with the then unidentified maker whose mark was mistakenly read as a 'B'.

12 The Three Waverley Criteria applied to an item's export ban are: its importance to UK history; its aesthetic quality; and consideration of its educational significance.

13 The acquisition was noted in the internal annual report to the Court of Wardens of the Goldsmiths' Company of changes to the Company's collection 1967–8.

14 Expert advice had been sought from Beresford Hutchinson, Conservation Officer of the Horological Collection at the British Museum.

15 Benjamin Vulliamy (working 1810–54) was known for his radical 'improvements', as they were called at the time, of old clocks; the Drayton archives include bills from Benjamin Vulliamy's grandfather, Justin (1712–1797), whose notable clockmaking business was in Pall Mall. Justin evidently conveniently maintained the clocks for Lord George Sackville at Sackville's house in Pall Mall. After Lord George died in 1785 his effects were moved to Drayton.

16 The total cost of the restoration was £457, invoiced by Elisha Harmsworth of Hatton Garden on 29 September 1972, for 'Restoring antique 16th century clock salt'.

17 Hayward 1973, 29.

18 Hayward 1973, 30.

19 Hayward 1973, 31.

20 Precedents for small rock-crystal salts set in larger silver-gilt objects include the so-called Huntsman salt at All Souls College, Oxford, and another at New College, Oxford.

21 For example, the 1542 salt in the Goldsmiths' Company's collection.

22 Hayward 1973, 31.

23 *Results of Impurity Analysis of Antique Silver-Tudor Clock Salt*, 2013, Assay Office, London. The London Assay office at Goldsmiths' Hall has a huge database of British known dated silver samples of different centuries allowing any impurity analysis of an unknown dated silver sample to be dated accurately within a century. Worked silver is not pure silver but alloyed with other metals and it is the composition of these alloys that has changed over the centuries.

24 The small bronze maquette *c.* 1548 by Cellini is housed in the Museo Nazionale de Bargello, Florence.

Chapter 7
Rothschild Family Collecting and the Taste for Continental Renaissance Silver in 19th-Century England

Julia Siemon

Nearing the end of his life, Baron Ferdinand James de Rothschild (1839–1898) observed that 'of late' – it was 1897 – 'the taste for bric-à-brac, which until recently was confined to a small and select class, has developed into an almost universal mania'.[1] He expressed concern that readers of *Bric-à-Brac*, his collecting memoir, might fix responsibility for this newly widespread passion for the decorative arts upon his family.[2] He argued, however, that it 'would hardly be fair' to blame the Rothschilds, whom he believed to have collected privately and discretely.[3] Over only one area of British collecting would he concede his family's influence, acknowledging the part they had played in the popularisation of French interior décor of the 17th and 18th centuries.[4] Certainly, no visitor to Waddesdon Manor, the baron's Buckinghamshire retreat, could doubt his devotion to French surroundings. Constructed in the 1870s, Waddesdon was modelled after chateaux such as Maintenon and Blois and decorated in emulation of (and with furnishings from) historic French homes.[5] Still, Baron Ferdinand was perhaps too dismissive of his family's role in exciting admiration in England for other varieties of what he called 'bric-à-brac'. It seems, for example, that to the London branch of the Rothschild family some credit is due for stirring in 19th-century British audiences a fresh appetite for Continental Renaissance silver.

At Waddesdon, the Baron's collection of European goldsmiths' work was tucked densely into cabinets in the New Smoking Room, where it formed part of his 'Renaissance Museum'.[6] Following his death in 1898, much of this splendid assembly of *Kunst-* and *Schatzkammer* objects – metalwork, maiolica, enamels, glass, mounted natural curiosities, medals, jewellery and armour, etc. – was transferred to the British Museum. There it is preserved as the Waddesdon Bequest.[7] The present volume, with its focus on the Royal Tudor Clock Salt, is dedicated to an object that never entered Rothschild hands; nevertheless, the Clock Salt's temporary installation in 2018 within the Waddesdon Bequest Gallery constituted something of a homecoming. At the British Museum it was displayed alongside other examples of medieval and Renaissance metalwork including the Sibyls Casket, which, like the Clock Salt, bears mounts created by the Renaissance goldsmith Pierre Mangot (*c.* 1485–after 1551). This splendid object, discussed by Michèle Bimbenet-Privat and Dora Thornton elsewhere in this volume (see Chapters 3 and 4), was purchased by Baron Ferdinand in the late 19th century, suggesting that the fact the Rothschilds never owned the Clock Salt is probably less a question of desire than one of opportunity. Indeed, unlike many treasures of Continental Renaissance goldsmiths' work found in Britain at the start of the 19th century, the Clock Salt did not come onto the market in the decades that followed. It remained instead in the possession of a single family; as Rosemary Ransome Wallis has outlined, it belonged to the Stopford-Sackvilles and their heirs well into the 20th century before finally entering the collection of the Goldsmiths' Company (see Chapter 6). This essay, inspired by the loan of the Clock Salt to the Waddesdon Bequest, offers an examination of the Rothschild family's role in defining the British taste for works like Mangot's masterpiece, thus providing essential

context for this volume's study of the Clock Salt and its history.

The Waddesdon Bequest, as Thornton has explained, was in part inherited by Baron Ferdinand and partly formed through his own acquisitions (see Chapter 4).[8] It represents decades of attention to the material and market by the baron and his Rothschild predecessors. And while somewhat at odds with Waddesdon's general emphasis on French 18th-century interiors, Baron Ferdinand, in creating his Renaissance Museum, was participating in a mode of collecting that had been favoured by his family for a century, since the dynasty was founded in Frankfurt by Mayer Amschel von Rothschild (1744–1812), a banker and dealer in antiquities and precious metalwork.

The British branch of the Rothschild family was established by Mayer Amschel's third son, Nathan Mayer von Rothschild (1777–1836). Nathan arrived in England in 1798, one of the so-called 'five arrows': brothers responsible for launching Rothschild outposts in capitals across Europe.[9] He quickly developed the family bank into one of the nation's principal financial institutions.[10] In 1806 Nathan married Hannah Barent Cohen (1783–1850); their eldest son, Lionel Nathan de Rothschild (1808–1879), was born in London, where he became a distinguished public figure, eventually serving as England's first (practising) Jewish Member of Parliament.[11] A close friend of the Conservative prime minister Benjamin Disraeli (1804–1881), Baron Lionel was a political ally of the Liberal William Gladstone (1809–1898), who recommended him, unsuccessfully, to the peerage.[12] Together with his younger brothers Sir Anthony Nathan (1810–1876) and Baron Mayer Amschel (1818–1874), Baron Lionel was, in addition, an avid collector and champion of the arts.[13]

By mid-century, these three brothers were prominent figures in the London art world. Their taste was celebrated in private as well as public forums, their objects establishing criteria for decorative arts connoisseurship during a period in England when, despite burgeoning interest, knowledge of the subject was still firmly anchored in the realm of private collectors. Sir Anthony, Baron Mayer and Baron Lionel each built significant collections, with varied holdings reflecting both broad family interests as well as individual passions.[14] Of the brothers, however, Baron Lionel has been cited as the 'first and foremost manifestation of the family style', and it is his goldsmiths' work that is the primary focus of the following discussion.[15] Baron Lionel played an important role in popularising the Rothschild taste for foreign antique plate in England; in the next generation, his collection would serve as an essential precedent when Baron Ferdinand was building his Renaissance Museum.

This essay situates Baron Lionel's Continental Renaissance silver within the well-documented history of growing appreciation for such material in 19th-century England. It highlights three circumstances of particular importance for the dissemination of the Rothschild taste: first, the *Exhibition of Ancient and Mediaeval Art*, organised by the Royal Society of Arts in 1850; second, the baron's involvement in the Fine Arts Club, established in 1856; and, finally, the display of his 16th- and 17th-century 'foreign' (that is, Continental European) decorative plate at the South

Kensington Museum in 1862. These related occurrences allowed for the examination of the baron's collection by London's influential elite as well as by the general public. The legacy of these events can be traced, decades later, in Baron Ferdinand's bequest to the nation, and, shortly thereafter, in the organisation of London's first exhibition solely and explicitly dedicated to antique European silver, held at the Burlington Fine Arts Club in 1901.

Background

At the dawn of the 20th century, it was commonly observed that *Kunst-* and *Schatzkammer* objects like those found in the Waddesdon Bequest had during the previous century undergone a drastic increase in value. One commenter, Hercules Read writing anonymously for *the Times* in April 1900, remarked that 'in the first half of the [19th] century, the few people that cared about such things could obtain them at no great cost'.[16] Collectors of that era, facing little competition, might buy 'their marvellous enamels, majolica, and goldsmiths' work' at about a fifth of what such items would cost after the middle of the century.[17] By the time Baron Ferdinand was assembling his Renaissance Museum, the author states, these very same items sold for prices 10 times over what they had previously reached. In his estimate, a collection such as the Waddesdon Bequest 'could never be made again, even by the richest of the Rothschilds'.[18]

Before considering certain factors that may have contributed to this change, it seems worth noting – as Philippa Glanville has in *Silver in England* – that the country was never wholly without appreciation for lavishly worked precious metal, which retains some value no matter the age or style of object.[19] However, beginning around 1800 there developed what Glanville terms 'a distinct market for antique plate', transacted in a series of public auctions and private sales.[20] These exchanges brought forth a steady stream of objects from England's aristocratic homes, works that were eagerly assembled (and resold) by a small group of devoted amateurs and dealers. The most famous early sales of European goldsmiths' work include, for example, that of the contents of William Beckford's (1760–1844) Fonthill Abbey (1823), the precious metalwork belonging to the Duke of York (1763–1827) (1827), Horace Walpole's (1717–1797) treasures at Strawberry Hill (1842), the Duke of Sussex's (1773–1843) 'ancient and modern' plate (1843) and the Duke of Buckingham and Chandos's (1797–1861) holdings at Stowe Park (1848).[21] Meanwhile, across the Channel, the French Revolution, Napoleonic Wars and other political upheavals dislodged numerous historic collections, making old objects available to new buyers in England, where the economy was by comparison relatively stable.[22]

The British Rothschilds took advantage of this flow of objects, purchasing at public sales as well as through dealers and private treaties, enabling them quietly to make large acquisitions from impoverished noble households.[23] It was a time later described by Baron Ferdinand (not without wistfulness) as one when precious metal treasures were sold by their weight and could be purchased for a trifle.[24] Baron Lionel's collection expanded rapidly, and at his death in 1879 it included more than 300 *Kunst-* and *Schatzkammer* pieces. These were distributed between his three sons, Nathaniel (1st

Figure 86 Christoph Lindenberger, cups of the Tucher family, *c.* 1568, Nuremberg, silver gilt, h. 25.5cm. Waddesdon Bequest, British Museum, WB.101.a–b

Lord Rothschild, 1840–1915), Alfred (1842–1918) and Leopold (1845–1914); many of the precious items owned by Baron Lionel are documented in photographs of his sons' collections.[25] Provenances for these works are difficult to establish, not least because early sale catalogues generally omit discussion of dates, regional styles and attributions – a result in part of the period's lack of serious scholarship upon which such assessments might have been based. Most of the baron's items, however, were probably assembled over approximately 30 years beginning in the early 1830s. At the start of that decade, the young Baron Lionel travelled widely in Continental Europe, learning the family business and visiting private collections.[26] In June 1836 he was married, in Frankfurt, to Charlotte von Rothschild (1819–1884), a daughter of Baron Carl Mayer (1788–1855), head of the Neapolitan house. A few weeks later, his father Nathan Mayer passed away in the family's ancestral city; Baron Lionel, at 28 years old, became head of the London house.[27]

The Rothschild taste for silver

Charlotte and Lionel each were born to parents who collected Renaissance goldsmiths' work. The plate belonging to Charlotte's father passed to the couple in 1855.[28] Included was a silver-gilt standing cup and cover made by Christoph Lindenberger of Nuremberg (d. 1586), dated 1568 and bearing a dedication to the patron, Leonhardt Tucher. This cup is today on view in the Waddesdon Bequest Gallery, where it is paired with a nearly identical mate (**Fig. 86**).[29] The two were purchased jointly by Baron Carl Mayer and his Viennese nephew Baron Anselm Salomon von Rothschild (1803–1874) and kept in separate Rothschild households until

they were reunited in the late 19th century by Anselm's son, Baron Ferdinand.[30] Such cooperation was common.[31] The various Rothschild collections of goldsmiths' work assembled during this period were highly consistent, a uniformity underscored by the distribution across the collections of matching components initially conceived as a set. Besides the Tucher cups, another example of such overlap involves the suite of silver-gilt Aldobrandini Tazze (datable to the late 16th century, probably created for the Habsburg archdukes of the Netherlands): in the late 19th century, at least five of the dozen tazze were in Rothschild hands.[32]

A coherent Rothschild taste in goldsmiths' work was additionally reinforced by the accumulation of items that, while not necessarily stemming from a single commission, nevertheless derived from designs fabricated in multiples. For example, Baron Lionel's was one of four family collections boasting a silver-gilt figural group representing Diana and the Stag.[33] At least 25 very similar automata were executed by different German goldsmiths in the first quarter of the 17th century, all apparently working from an established late-Renaissance model.[34] Baron Lionel's Diana and the Stag, according to Lorenz Seelig, was partly manufactured by Paulus Ättinger the Elder of Regensburg (act. 1574–1619).[35] This automaton was inherited by Baron Lionel's son Alfred, who added to it a second version of the same subject by the Augsburg goldsmith Matthias Walbaum (1554–1632), which is now in the Royal Ontario Museum (**Figs 87–8**).[36] The desirability of multiples, of course, offered a temptation to 19th-century makers who might profit by producing new versions of an old design – a subject addressed below.

Figure 87 Paulus Ättinger the Elder (base), Diana seated on a Stag, early 17th century, Augsburg or Regensburg, h. 36.5cm, reproduced in Charles Davis, *A Description of the Works of Art Forming the Collection of Alfred de Rothschild* (2 vols) (London: Chiswick Press, 1884) (hereafter Davis 1884), vol. 2, pl. 155. British Library, shelfmark L.R.407.f.24, vol. 2, pl. 155. Image © The British Library Board

Figure 88 Matthias Walbaum, a silver-gilt figure of Diana seated on a Stag, *c.* 1600–5, Augsburg, h. 34cm, reproduced in Davis 1884, pl. 192. British Library, shelfmark L.R.407.f.24, vol. 2, pl. 192. Image © The British Library Board

Figure 89 Heinrich Jonas, unicorn cup, 1579–1605 (head and base), 1800–98 (body and shields), Nuremberg, silver gilt, h. 32.6cm. Waddesdon Bequest, British Museum, WB.140

The 19th-century Rothschild collectors – throughout the five houses and across three generations – purposefully and reliably sought out items of Continental goldsmiths' work that conformed to a recognised family taste.[37] This was not simply a question of inheritance. In one further example, from the Duke of Sussex's sale in 1843, Baron Lionel purchased on behalf of his brother Baron Nathaniel (1812–1870) a silver-gilt cup in the form of a unicorn.[38] Later, in Baron Lionel's own collection was recorded 'a silver cup, in the form of a unicorn salient, on an oval pedestal, on which are frogs, lizards, beetles, & c'., attributed to a 17th-century Augsburg maker.[39] A Nuremberg cup otherwise entirely analogous in description – down to the tiny amphibians, insects and reptiles – was included in Baron Ferdinand's bequest to the British Museum (**Fig. 89**).[40] These works, and those discussed above, are typical of what we now recognise as the Rothschild taste in goldsmiths' work: gilt, densely ornamented, highly sculptural, often German, and dating to the 16th or 17th century (or at least designed to appear so). The drive to collect such items, befitting the cabinet of a Renaissance or Baroque prince, has been convincingly linked to a desire by members of the Rothschild family to assemble tokens of dynastic legitimacy after the manner of great Continental European houses such as the Habsburgs.[41]

Figure 90 Linhard Bauer (or Bawer), The Strassburg covered cup, c. 1560, Strassburg, h. 51.44cm. Reproduced in *Catalogue of the Celebrated Collection of German, Dutch & Other Continental Silver and Silver-Gilt of the 15th, 16th, 17th, and 18th Centuries [...] Removed from 148 Piccadilly...* (London: Sotheby & Co., 26, 27, 28 April 1937), pl. X, no. 129. Image © Victoria and Albert Museum, London

Baron Lionel, drawing on these models, played an important role in defining the parameters of this taste in England.

Exhibition of Ancient and Mediaeval Art, 1850

Baron Lionel's mother Hannah maintained her residence at 107 Piccadilly until her death in September 1850. The previous March, she and Lionel both lent silver to an *Exhibition of Ancient and Mediaeval Art* organised by the Royal Society of Arts in the Adelphi.[42] There were 10 classes of objects on view, including sculpture, enamel, leatherwork, painting, and watch and clock work. (In this last group appeared the Goldsmith Company's Royal Clock Salt, on loan from William Bruce Stopford, see Chapter 6, p. 90.[43])

In a review, however, *The Times* reported that the exhibition's 'great feature' was the section devoted to metalwork.[44]

The *Exhibition of Ancient and Mediaeval Art* was the first occasion on which Rothschild plate was put on public view in London; it was, moreover, the British public's first opportunity to examine any array of antique goldsmiths' work.[45] Despite the exhibition's title, objects displayed were dated as late as the 18th century, with the majority of metalwork loosely dated to the 16th or 17th centuries. Although the catalogue now feels frustratingly vague, there were few resources to which the organiser, Sir Henry Cole (1808–1882), might turn for information. It would be another year before Octavius Morgan (1803–1888), Secretary of the Royal Society of Arts, presented to colleagues his interpretation of the dating system of hallmarks on British silver, and a dozen before the publication of William Chaffers' (1811–1892) book on the same subject; Marc Rosenberg's (1852–1930) authoritative treatment of Continental marks, *Der Goldschmiede Merkzeichen*, was still 40 years away.[46] Nevertheless, the *Exhibition of Ancient and Mediaeval Art* was remarkable for its attention to historic decorative arts. It represents a turning point in the familiarity of British audiences with antique goldsmiths' work, and the production of serious scholarship on the subject.

The Rothschild contribution to the exhibition was relatively small. Of the 109 items falling within the category of metalwork, only one was lent by Baron Lionel, and four by his mother. The majority came from dealers, colleges, and livery companies, supported by loans from the Queen and notable members of the Society, such as Hollingworth Magniac (1786–1867), Augustus Welby Northmore Pugin (1812–1852), the Hon. Robert Curzon, Jr. (1810–1873), Ralph Bernal (1783–1854) and Alexander James Beresford Beresford Hope (1820–1887).[47] Baron Lionel lent a silver-gilt hanap (standing cup), elaborately decorated with Moresques, masks, shells, medallions and heads in relief, the lid surmounted by a figure of Pomona (**Fig. 90**).[48] From his mother there was a silver-gilt double cup – two interlocking pieces, one designed to stack upside down atop the other – of the lobed 'pineapple' type characteristic of Nuremberg makers, dated 1631.[49]

The three other works lent by the baroness were more sculptural: a silver-gilt group of St George and the dragon, a figure of an arquebusier and a silver-gilt cup in the form of a dove, with mother-of-pearl feathers and set with jewels.[50] Following the Rothschild pattern, Baron Lionel would come to possess very similar pieces. The baroness's arquebusier may have been acquired from the Duke of Sussex, whose sale included the figure of a man in 16th-century German costume, holding a matchlock gun, rest and rapier.[51] Baron Lionel later owned a parcel-gilt figure by Georg Christoph Erhart, I (1593–1628) perfectly matching this description, presumably inherited from the baroness and now in the Ashmolean Museum (**Fig. 91**).[52] A Nuremberg silver-gilt cup by Georg Rühl (master 1598–d. 1625) in the form of a partridge with mother-of-pearl feathers set with jewels also once belonged to Baron Lionel and closely resembles the description of the 'dove' shown by the baroness at the Royal

Society of Arts and now in the Victoria and Albert Museum (**Fig. 92**).[53] Lionel's collection also included a silver-gilt group of St George and the dragon with a princess, the dragon enamelled in green and red, the hero set with precious gems, made in around 1615 by Jacob Miller the Elder of Augsburg (d. 1618), now in the Bayerisches Nationalmuseum, Munich (**Fig. 93**).[54] If, as has been suggested, this last object was purchased by Baron Lionel rather than inherited, it seems clear that he was deliberately fashioning his collection after that of his parents.[55]

The Royal Society of Arts exhibition, while groundbreaking, conveyed to the public little sense of Baron Lionel's precious metalwork. Visitors to his residence at 148 Piccadilly or his estate at Gunnersbury Park, however, might appreciate its magnificence.[56] A report of the wedding of his eldest daughter, Leonora (1837–1911), in March 1857 to her Parisian cousin Baron Mayer Alphonse de Rothschild (1827–1905) describes tables at Gunnersbury 'groaning … at the weight of silver which was piled upon them. Great centre-pieces, epergnes, candelabra, race-cups, and massive tankards, … while behind the seats of honour rose up a beaufet [sic] of gold plate'.[57] While impressive, such private displays did little to contribute to general knowledge. The problem, according to James Charles (J.C.) Robinson (1824–1913), first curator of the South Kensington Museum (from 1899 the Victoria and Albert), was that in the mid-19th century 'the country was rich in works of art [...] but these treasures were the possessions of private individuals, scattered broadcast in a thousand palaces and town and country houses, for the most part hidden treasures, often unappreciated by their possessors even, and but casually revealed to the world at large'.[58] While Baron Lionel's silver

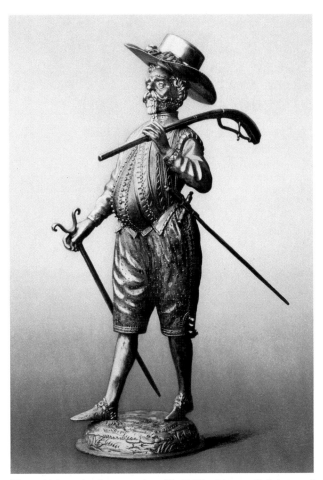

Figure 91 Arquebusier, reproduced in E. Alfred Jones, *Catalogue of the Old Plate of Leopold de Rothschild, Esq.* (London: Bemrose, 1907), pl. XVIII. British Library, shelfmark L.R.30.a.8. Image © The British Library Board

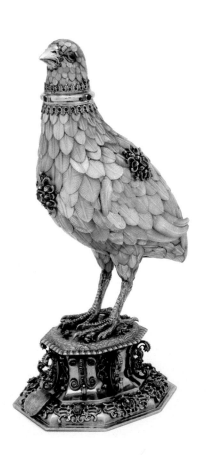

Figure 92 (far left) Georg Rühl, partridge cup, hallmarked 1598–1602, Nuremberg, silver gilt, gold, mother-of-pearl, gems (eyes and collar, some emeralds possibly reset), green and red pastes (body), h. 27cm. The Rosalinde and Arthur Gilbert Collection on loan to the Victoria and Albert Museum, London, Loan: Gilbert.60:1, 2–2008. Image © Victoria and Albert Museum, London

Figure 93 (left) Jacob Miller the Elder, St George and the Dragon with a Princess, c. 1615, Augsburg, h. 21.59cm. Bayerisches Nationalmuseum, Munich, 86/227, photo no. D170228 Image © Bayerisches Nationalmuseum München Photo: Krack, Bastian

was hardly unappreciated, it was mostly unseen. However, the *Exhibition of Antique and Mediaeval Art* of 1850 marked the beginning of a decade of unprecedented activity in the promotion of the decorative arts in London, culminating in an opportunity for Baron Lionel's collection of Continental silver to be examined by nearly a million people.

The Collectors' Club

The Royal Society of Arts exhibition was conceived in conjunction with the much larger *Great Exhibition of the Works of Industry of All Nations* that took place in 1851 – the first Great Exhibition that was to be the paradigm for the many World's Fairs that followed. The small loan show of historic decorative arts served as a prelude and foil to the Crystal Palace's temple of modern industry. The latter was a tremendous financial success, buoyed by the involvement of the Rothschilds. Baron Lionel served as one of the exhibition's treasurers, and he and his brother Sir Anthony each contributed £500 to the project, which was arranged under the aegis of Prince Albert (1819–1861) and with the direction of Sir Henry Cole, mentioned above.[59] The relationship between the economic triumph of 1851 and the establishment of the South Kensington Museum is well documented, as profits from the Great Exhibition enabled the foundation of the first iteration of the institution, the acquisition of works and the purchase of the land upon which the building now stands.[60] The Museum of Ornamental Art, predecessor to the South Kensington Museum, was originally established at Marlborough House with Cole as Director in 1852; J.C. Robinson was hired as the first curator the following year. In a series of useful articles, Ann Eatwell has outlined the activities of Cole and Robinson during the museum's first two decades, drawing attention to the role played by private collectors in the formation of the nascent South Kensington Museum.[61] Robinson was especially far-sighted in his recognition of the benefit that might arise from closer involvement with Britain's private collectors, both in terms of driving support for the young museum, and as a necessity for scholarly access to treasures otherwise out of reach. Therefore, with Cole's approval, Robinson initiated the establishment of a society for amateurs dedicated to the study and promotion of the decorative arts.[62]

Inaugurated in the winter of 1856–7, 'The Collectors' Club' embraced a focus on Continental objects dating to the post-medieval periods and, as such, was the first society of its kind to be established in London.[63] Meetings of the group – which soon became known as the 'Fine Arts Club' – were held on the first Friday of each month, December to July.[64] At every gathering, a certain predetermined genre (or genres) of object was discussed, the conversation illustrated with examples drawn from members' private collections. Members recognised it as a rare opportunity for 'comparing acquisitions, and [for] criticising and obtaining information in connection with Art subjects'.[65] Topics in the first year included 'Ancient Prints', 'German Porcelain', 'Sèvres Porcelain and Goldsmiths' Work', 'Ivory Carving', 'Early Pictures and Drawings and Oriental Porcelain', 'Works in Metal, and Porcelain of Various Manufacture', etc.[66] Club rules demanded that members regularly contribute items for

discussion, although those without the means to do so might have objects submitted by others on their behalf (protecting museum professionals and other intellectuals who might not otherwise be able to meet the requirement).[67] Dealers were not permitted to join, but frequently attended as guests and supplied material for display. The transportation and care of privately owned items shown at the gatherings was entrusted to the antiquarian William Chaffers, whom the club logbooks show occasionally reprimanded by members because of objects being broken (and in one case, lost) in connection with the events.[68]

Baron Lionel and his brothers Sir Anthony and Baron Mayer were among the club's 96 founding members, a group that quickly grew to include 200 collectors, politicians, public figures and elite representatives of British art institutions.[69] These were, to quote Robinson, the club's Secretary, 'almost every connoisseur of note in the country, and a large proportion of the leading members of the highest London society'.[70] In addition to the three Rothschild brothers, the roster listed, for example, the Duke of Hamilton, A.J.B. Beresford Hope, Octavius Morgan, Hollingworth Magniac, Felix Slade, the Duc d'Aumale, Edward Blore, Matthew Digby Wyatt, Augustus Wollaston Franks, John Ruskin, William Gladstone, Robert Curzon, Charles Eastlake, the Earl of Powis, Baron Marocchetti and the Marquis d'Azeglio.[71] Gustav Waagen (1794–1868), whose *Treasures of Art in Great Britain* was published in 1854, was elected an honorary foreign member in June 1857. (He had visited Baron Lionel in Piccadilly during the preparation of the text but was far more interested in the baron's paintings than in his objets d'art.)[72]

The Fine Arts Club had no fixed meeting place. Instead, the monthly 'conversazioni' were held in members' homes. Baron Lionel and his brothers Sir Anthony and Baron Mayer regularly contributed objects for the gatherings, and on 20 May 1858, Baron Lionel hosted the twelfth conversazione at 148 Piccadilly. Works considered that evening were 'majolica wares in general, terra cottas, art bronzes, and ancient Venetian and other glasswares'; illustrative examples were provided by 19 different club members.[73] There is no mention in the logbooks of an examination of Baron Lionel's silver, but reason would suggest that a club visit to his home would include attention to this important aspect of his collection. His participation in a community committed to the appreciation and analysis of the decorative arts would moreover naturally involve regular exchanges of ideas on the subject. There is cause, furthermore, as will be seen, to conclude that his Continental silver in particular made a profound impression on the club's leadership.

To fix responsibility upon the Fine Arts Club for specific shifts in taste among British collectors presents a significant challenge – the society was itself a product of the expanding period interest in the decorative arts. This change was widely recognised at the time. In 1856, for example, after the sale of Ralph Bernal's collection (at which Robinson and Franks had purchased energetically for the nation), an article in the *Illustrated London News* bemoaned the fact that, in 1842, Horace Walpole's 'rarities and nicknacks' had passed into private hands; such would not happen again, the

author writes, as 'we are wiser now'.[74] This new appreciation was manifest in the organisation of exhibitions featuring antique decorative arts, including the *Manchester Art Treasures Exhibition* (1857) and that held at the Ironmongers' Hall in London (1861).[75] Nevertheless, the role of the Fine Arts Club in refining tastes should not be overlooked. Eatwell has found clear evidence of the club's effect, linking quantifiable changes in the purchasing habits of Charles (1826–1884) and Lady Charlotte Schreiber (1812–1895) to their participation in the community.[76] The Schreibers, according to Eatwell, were strongly influenced by the Fine Arts Club, which 'contributed both to the development of their taste for certain object types and their knowledge of and ability to distinguish the best examples that the contemporary market had to offer'.[77] Simply put, as a result of their exposure to the club, the Schreibers began buying differently than they had before; they were probably not alone in this respect.[78] For new collectors like the Schreibers, and for connoisseurs like Robinson, Chaffers and Franks, the Fine Arts Club presented a rare opportunity to learn directly from established collectors like the Rothschilds. That the period of the club's activity corresponded with a fiercely competitive and growing British market for foreign goldsmiths' work of the type favoured by Baron Lionel and his family is unlikely to be a coincidence.[79] Eatwell thus seems justified in her conclusion that 'the importance of the Fine Arts Club to the nurturing, directing and supporting of collectors' enthusiasms cannot be overestimated'.[80]

Special Loan Exhibition of Works of Art, South Kensington, 1862

Participants in the Fine Arts Club sought to extend the impact of their activities beyond the confines of their membership. By means of the association, they professed themselves to have created a 'school of criticism', through which 'material influence is collectively expressed on the taste and judgment of the public'.[81] The outlet for this expression was the South Kensington Museum. In the summer of 1857 the former Museum of Ornamental Art reopened in its new location, where spaces were purpose-built for the display of loans from the Fine Arts Club.[82] Pieces were often sent directly on from the club's soirees to South Kensington, and evening conversazioni were occasionally hosted on-site.[83] Then, at the beginning of the new decade, Cole and Robinson, looking ahead to the second international exhibition and recalling the success of the *Exhibition of Ancient and Mediaeval Art* of 1850, set about organising another loan exhibition of historic decorative arts – this time, on a much larger scale.

The *Special Loan Exhibition of Works of Art of the Mediaeval, Renaissance, and More Recent Periods* opened at the South Kensington Museum in June 1862. Timed to coincide with that year's Great London Exposition, the *Special Loan Exhibition* was modelled in deliberate contrast: whereas the former promoted new innovations, the latter celebrated historical objets d'art and was conceived as an opportunity to showcase the hidden riches of the nation's private collections.[84] The Rothschilds were involved in the project from the start. Baron Lionel, Sir Anthony and Baron Mayer served on the exhibition's organising committee, a body

described in the catalogue as consisting of 'nobleman and gentlemen, eminent for their knowledge of art'.[85] It was constituted almost entirely of members of the Fine Arts Club, who were, as Robinson explains, largely responsible for the organisers' success in procuring loans.[86]

Roughly 9,000 objects were put on view, drawn from over 500 collections. Mangot's Royal Clock Salt, again on loan from W.B. Stopford, was displayed at South Kensington among the clocks and watches, as in the exhibition of 1850. Some contributors, however, lent far more than others, offering the public rare insight into the preferences of the nation's major collectors.[87] Visitors to South Kensington would frequently encounter the Rothschild name, particularly when admiring the French porcelain, Limoges enamels, painted miniatures, maiolica, snuffboxes, wood carvings and English plate. However, it was in the section dedicated to 'Decorative Plate, Chiefly of the 16th and 17th Centuries, of Various Foreign Origin' that the family taste was triumphant. There, an entire display was devoted to Baron Lionel's personal collection. No other lender of this material was thus singled out. His 73 pieces, equalling roughly a quarter of the foreign (that is, Continental) decorative plate on view, constituted a category in their own right.[88]

The exhibition's extensive catalogue provides a detailed account of Baron Lionel's antique foreign silver, most of which was shown.[89] Robinson and Franks were the volume's principal authors, although the section dedicated to foreign decorative plate was written by Chaffers (revised by Robinson) and demonstrates his great familiarity with the particular works and general subject. The entries are precise and substantial, making note of inscriptions, offering dates or date ranges, and reporting and interpreting marks. Robinson proudly declared that for the decorative arts the catalogue constituted an 'even greater authority than the analogous work of Dr. Waagen's in regard to the pictorial treasures of this country'.[90] As *The Times* reported in 1900, the exhibition and activities of the South Kensington Museum 'set the example', not only 'showing the rich men what to collect', but also driving museum acquisitions and creating a new 'international class of experts', who 'enormously increased the general knowledge'.[91] The catalogue would serve as a primary resource for scholars of Continental silver for decades to come: Rosenberg's treatise of 1890, for example, refers to objects in Baron Lionel's collection by their South Kensington catalogue numbers. It is difficult to imagine the preparation of the South Kensington catalogue without the extraordinary access granted to Chaffers and Robinson through the means of the Fine Arts Club.

The Continental goldsmiths' work contributed by Baron Lionel, as outlined in the catalogue, was in many ways remarkably consistent. The majority of items are identified as German and dated to the 16th or (more frequently) 17th century. For about a dozen works, no origin is specified; a small group are deemed 17th-century Dutch or Flemish. Only one example is linked to Italy, one possibly to Switzerland, and none to France or Spain. Nearly every piece, save a handful of pure gold or white silver outliers, had some amount of gilding applied to its surface. (Chaffers'

Figure 94 (far left) A pair of silver-gilt cups, maker unknown, reproduced in Davis 1884, pl. 165. British Library, shelfmark L.R.407.f.24, vol. 2, pl. 165. Image © The British Library Board

Figure 95 (left) Minerva cup, maker unknown, reproduced in Davis 1884, pl. 161. British Library, L.R.407.f.24, vol. 2, pl. 161. Image © The British Library Board

catalogue does not attempt to distinguish between gilding that might be original, and more recent interventions.) Although most of Baron Lionel's foreign decorative plate displayed at South Kensington was in fact manufactured out of silver, for visitors, the visual effect would have been dominated by golden tones, glittering on sculptural objects characterised by highly elaborate exteriors. The surfaces were decorated in varying degrees of relief. Classical, mythological, biblical and genre scenes were added by means of chasing, engraving, etching and embossing techniques – methods that were also employed to create intricate ornament; strapwork, scrollwork, masks, fruit, flowers, grotesques and arabesques are mentioned repeatedly.

Much of Baron Lionel's silver was ostensibly dining-related, if far from utilitarian. The pieces he sent to the *Special Loan Exhibition* were appropriate for ceremonial display on a princely buffet or sideboard, or to be brought to the table to delight diners during an extravagant feast. Many of the objects were vessels of some kind: there were beakers, tankards, flasks, hanaps and wager cups. The most common form was the standing cup. Among these, double cups are often recorded; five were of the 'pineapple' variety. The South Kensington catalogue is unillustrated, but many of Baron Lionel's pieces shown in 1862 can be identified in catalogues of works owned by his heirs. One of the pineapple cups is illustrated in Alfred de Rothschild's catalogue and

gives a good sense of the group (**Fig. 94**).[92] Its form is standard, if distinguished by the appliquéd flowers encircling the stems and the engraved hunting scenes decorating the feet. Other standing cups exhibited by Lionel repeat the formula of the Pomona cup he lent to the *Exhibition of Ancient and Mediaeval Art* in 1850, with the upper element usually topped by a small terminal figure. One, surmounted by a statuette of Minerva and described in the catalogue as a 'most elaborate and beautiful example of German plate', rises from a trefoil foot, the stem chased with goats' heads and the body enlivened with scrolls, lions' heads and masks (**Fig. 95**).[93] Less exuberant in its outlines but no less richly ornamented was the standing cup by Christoph Lindenberger, mentioned above as inherited from Baron Lionel's father-in-law, Baron Carl Mayer.[94]

Baron Lionel also lent an assortment of dishes, tazze, salvers and an ewer. One example is a late 17th-century German dish bearing the mark of Johann Wagner (1646–1724) of Augsburg (**Fig. 96**).[95] Its smooth silver-gilt surface is finely engraved with a scene of Amphitrite in her chariot. This understated refinement is in sharp contrast to the high-relief embossing of Baron Lionel's Dutch parcel-gilt salver by Nicolaes de Keyser (c. 1645–1710) dating to a few decades earlier (**Fig. 97**).[96] Other of the baron's pieces shown at South Kensington were more unusual in appearance, often taking the form of hollow drinking cups representing humans and animals – a style popular in Germany around

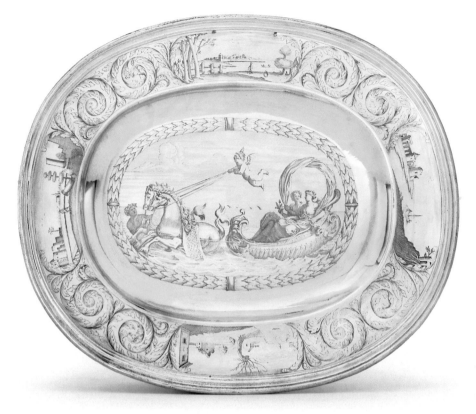

Figure 96 Johann Wagner, dish, 1690–5, Augsburg, silver gilt, l. 40.5cm. Private collection. Photo © Christie's Images / Bridgeman Images

Figure 97 Nicolaes de Keyser, Salver, 1667, Delft, parcel gilt, diam. 37.6cm. Museum Boijmans Van Beuningen, Rotterdam, MBZ 198 a (KN&V). Photographer: Tom Haartsen

1600.[97] Lionel's objects of this type included lions, a camel, a rooster, an owl, a greyhound, a stag and two separate representations of bears playing bagpipes, as well as the unicorn and arquebusier mentioned above.[98] There was the 'dove cup' by Georg Rühl, and the automata of Diana and of St George.[99] The more dramatic items included a figural group of Europa and the Bull, a kneeling Hercules supporting a globe, a nautilus cup and a nef atop a stem in the form of a merman blowing a conch (**Fig. 98**) – all thought to originate in the 17th century.[100]

Although the display of Foreign Decorative Plate was dominated by Baron Lionel, he was far from the only lender of such material. The Duke of Hamilton (1811–1863), the collector whose works featured most robustly in this section after Baron Lionel, lent 24 objects, or less than a third of the baron's contribution. The other British Rothschilds were

Figure 98 Nef with merman blowing a conch, maker unknown, c. 1660, German, parcel gilt, h. 66.04cm. Sotheby's 1937, pl. XX, no. 171. Image © Victoria and Albert Museum, London

featuring 40 classes of material. Still, it was above all the goldsmiths' work that captivated British audiences. 'What first of all catches the eye', reported *The Times*, 'and what occupies most space in the new Exhibition at South Kensington, is the metal work'.[102] In particular it was the privately owned plate that earned the reporter's praise – perhaps an unconscious admission of a preference for foreign goldsmiths' work. He confesses that:

> the great companies have nothing to show which, as works of art, can be compared with the treasures exhibited by private individuals. One would suppose, for example, that the Goldsmiths' Company would have something of surpassing interest to show in the way of metal work. Their plate is, indeed, valuable, but half-a-dozen private owners might be named who have far finer things in this Exhibition.[103]

Declaring the pieces belonging to Lord Spencer (1835–1910), the Duke of Hamilton, the Duke of Manchester (1823–1890) and Baron Lionel to be 'of the rarest beauty and interest', he notes that the baron 'has a case all to himself'.[104]

The baron's display of Continental silver was widely applauded by the press, which treated it seriously, noting important points of historical interest. In December 1862 the *Illustrated London News* devoted several pages to descriptions of the works on view at South Kensington.[105] Of the four pages bearing illustrations, antique plate appears on each, with an item from Baron Lionel's foreign silver represented on all but one. A German silver-gilt covered standing cup of about 1600 is given pride of place at the centre of the first page; on the next, the baron's silver-gilt and mother-of-pearl partridge cup is reproduced (**Fig. 99**); on another, his silver-gilt nef (**Fig. 100**). Still, the extravagance of the precious metalwork inspired some degree of distrust. One reporter for the *Daily News* worried that audiences would see 'nothing for the money'.[106] Another, writing for *The Standard*, sourly suggested that the treasures had been 'brought together for the sole purpose of an ostentatious display of the name of the Royal, titled, and wealthy persons by whom they have been contributed'.[107] The same writer, however, noting Baron Lionel's large contribution of 'massive plate', acknowledged that the 'extensive display of metal work is likely to prove useful to our artisans of the present day'.[108] This criticism, while expressing discomfort at the abundance of the display, did not in fact question the essential artistic merit of the items. In that, it was far removed from William Hazlitt's (1778–1830) notorious dismissal, 40 years earlier, of William Beckford's collection – rich in goldsmiths' work – as 'a desert of magnificence, a glittering waste of laborious idleness … an immense Museum of all that is most curious and costly, and, at the same time, most worthless'.[109]

As Peter Mandler has demonstrated, in Victorian England, the ability of Renaissance decorative arts to 'shout luxury' appealed to the period's 'new men of wealth', including the Rothschilds; precious metalwork is most effective in this type of messaging.[110] The extravagant pseudo-dining forms favoured by Baron Lionel were valued in the Renaissance for much the same reason: princes arranged ostentatious displays of expensive plate – rich not only in material but also in the exceptional skill needed to work it – in order to convey their power and prestige. Objects intended for *kunst-* and *schatzkammern* were designed,

more scantly represented: Baron Mayer, who would assemble a significant metalwork collection at Mentmore, his Buckinghamshire estate, sent only three pieces of foreign plate to South Kensington. At this critical moment, in this particular realm, it was without doubt Baron Lionel's collection that epitomised the Rothschild taste for Continental silver in England.

The response

The *Special Loan Exhibition* proved extraordinarily popular, receiving nearly 900,000 visitors between June and November 1862.[101] The displays were varied and expansive,

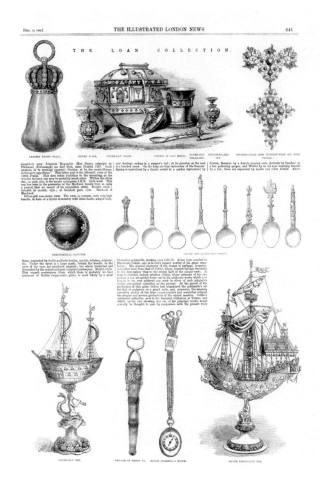

Figure 99 *Illustrated London News*, 13 December 1862, p. 640.
© Illustrated London News Ltd/Mary Evans

Figure 100 *Illustrated London News*, 13 December 1862, p. 641.
© Illustrated London News Ltd/Mary Evans

as Pamela Smith and Paula Findlen have written, 'to establish the *fama* of the ruler, representing his majesty (being shown to the most important "public" at court – visiting nobles and ambassadors – and being displayed at *Schauessen*, or banquets) and wealth.'[111] In 1857, the year before Baron Lionel was finally permitted to take his seat in Parliament, the spectacle of gold and silver encountered by the wedding guests at Gunnersbury Park surely served an analogous function. However, it is also true that by the 1860s, partly through the efforts of connoisseurs like Robinson, Franks, Chaffers, and indeed Baron Lionel, virtuoso goldsmiths' work had been popularly elevated to a fine art – worthy of study, emulation and acquisition by the nation. Works by Renaissance masters, loaded with special symbolic weight as a result of their magnificence, scarcity and historical resonance, had the greatest appeal.

Baron Ferdinand collects

Among the visitors inspired by the *Special Loan Exhibition* was Baron Ferdinand de Rothschild. Born in Paris in 1839 to Baron Anselm and Charlotte de Rothschild (1807–1859), Baron Ferdinand was raised in Vienna. He emigrated to England in 1860, having already developed a close bond with Baron Lionel (his maternal uncle) and his British relatives. In 1865 Baron Ferdinand wed his cousin Evelina de Rothschild (1839–1866) at 148 Piccadilly; the couple moved into number 143 nearby, but Evelina died shortly after their marriage. Baron Ferdinand spent the remainder

of his life in England, dividing his time between his house in town and – after 1880 – Waddesdon Manor in Buckinghamshire.[112]

In the 1860s Baron Ferdinand, still in his twenties, had not yet come into his estate and so did not have the means to begin collecting goldsmiths' work in earnest.[113] Still, he regularly conferred with his uncle on questions of art and was eager to participate in the dynamic community of connoisseurs to which Baron Lionel belonged.[114] With J.C. Robinson he was a founding committee member of the Burlington Fine Arts Club, a society for collectors established in 1866 by a dissatisfied faction of the Fine Arts Club.[115] The reason for the split, according to the club's records, was a sense that the original group had lost direction, coming to prioritise social concerns over the artistic.[116] A central commitment of the Burlington Fine Arts Club, therefore, was the advancement of the arts through the arrangement of regular public loan exhibitions.[117] These were held at the society's headquarters: first at 177 Piccadilly and after 1870 at 17 Savile Row.

Following the death of his father in 1874, Baron Ferdinand dedicated his new wealth to constructing and furnishing Waddesdon Manor.[118] In building his collection, Baron Ferdinand's primary role model was Baron Lionel, whose connoisseurship, acumen and taste the younger baron held in high regard.[119] He particularly admired Baron Lionel's foresight in having (for the most part) acquired his Continental goldsmiths' work during a period when it was

Figure 101 Cockerel cup, maker unknown, formerly attributed to Wolf Straub (Nuremberg, d.1644), 1825–98, silver gilt, h. 33.7cm. Waddesdon Bequest, British Museum, WB.141

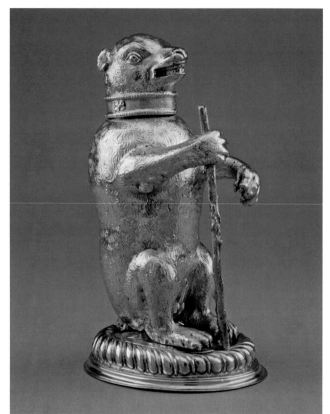

Figure 102 Bear cup, maker unknown, formerly attributed to the workshop of Marx Weinold (Augsburg, d. 1700), 1800–98, silver gilt, h. 20.5cm. Waddesdon Bequest, British Museum, WB.139

Figure 103 Stag cup, maker unknown, 1550–1600, Vienna, silver gilt, h. 27.5cm. Waddesdon Bequest, British Museum, WB.138

underappreciated. Baron Ferdinand expressed regret that he was unable to benefit similarly: 'Oh! For those good old days', he lamented, 'when the artistic merit of a cup was of no account to its possessor, and he merely valued it according to the number of ounces it contained!'[120] By the time he was collecting, fierce competition had driven prices for precious metalwork to new heights. In 1880 a piece of Continental Renaissance silver achieved the highest price ever recorded for a work of art when Baron Mayer Carl von Rothschild (1820–1886) of Frankfurt bought the *Merkelsche Tafelaufsatz* – a Nuremberg silver-gilt centrepiece made in 1549 by Wenzel Jamnitzer (1508–1585) and now in the Rijksmuseum – for £32,000.[121]

Nearly two-thirds of the items that make up the Waddesdon Bequest were purchased by Baron Ferdinand, most in the last quarter of the 19th century. Others, like one of the pair of Tucher cups mentioned above, were inherited from his father, whose approach to collecting disappointed his son.[122] Born in 1803, Baron Anselm was five years older than Baron Lionel, but unlike him had not taken advantage of the relative inexpensiveness of antique plate during the first half of the 19th century; his most active period as a collector of precious objects fell during the last years of his life, when the cost of such items had risen enormously.[123] Pressed on this point by his son, Baron Anselm admitted that it was not until late in life that he had become truly 'keen' on such things.[124] As a result, his collection of Renaissance metalwork was far more susceptible to fakes than Baron Lionel's had been, assembled as it was after canny forgers had begun responding to the opportunities of a heated market.[125] (By the end of the century, new American

collectors added to the fervour; both J. Pierpont Morgan [1837–1913] and Henry Walters [1848–1931] acquired apparently Continental Renaissance silver in a Rothschild style. Each bought, for example, a group of Diana and the Stag, but only one – Morgan's – was legitimate, the other a fake copied after Baron Lionel's.[126]) Baron Ferdinand nevertheless inherited some exceptional treasures from his father; to these he added many objects that reflect the Rothschild taste as defined in England during the previous generation by Baron Lionel.

As might be expected, Baron Ferdinand sought out items of Continental goldsmiths' work similar to those belonging to his uncle. He acquired several objects that closely recall pieces lent by Baron Lionel to South Kensington in 1862. In the Waddesdon Bequest, in addition to the rampant unicorn cup purchased by Baron Ferdinand and discussed above, there are two silver-gilt cups in the form of cockerels (**Fig. 101**), another shaped like a bear (**Fig. 102**) and one like a stag (**Fig. 103**).[127] Baron Ferdinand also purchased nautilus cups, a ewer and basin, tazze, standing cups and double cups. In keeping with family precedents, nearly everything is (or was thought to be) 16th- or 17th-century German, or occasionally Dutch. When arranging the bequest, Baron Ferdinand stipulated that his treasures be displayed in a special room, 'separate and apart'.[128] It has been suggested that this requirement, intended to highlight the baron's role in assembling the objects, was inspired by the isolated display of Baron Lionel's collection at South Kensington.[129]

For Baron Ferdinand, as for many late 19th-century private collectors and public museums, the *Special Loan Exhibition* not only shaped their taste, but also served as a presentation of desiderata for future acquisition – an object's display in 1862 elevated its status. Baron Ferdinand purchased nearly a dozen pieces (mainly Limoges) that had been on view at South Kensington. One example is the Sibyls Casket mentioned at the start of this essay, which had been lent in 1862 by Martin Smith, MP (1803–1880) (see Chapter 4, p. 67).[130] The transfer of Mangot's Clock Salt to the Waddesdon Bequest Gallery in 2018 thus temporarily reunited it with several objects with which it had been on view at the *Special Loan Exhibition* slightly more than 150 years previously.[131]

Exhibition of a Collection of Silversmiths' Work of European Origin, 1901

The Waddesdon Bequest Gallery opened to the public in April 1900. The following year, the Burlington Fine Arts Club organised London's first exhibition dedicated solely to antique European (British and Continental) silver. While attesting to the quality of the works on view, J. Starkie Gardner (1844–1930), the catalogue's author, nevertheless acknowledged that the club's array would necessarily fall short in one respect, because 'the finest German silversmith's work of the Renaissance is fully illustrated in the munificent bequest of Baron Ferdinand de Rothschild to the nation'.[132] With his gift to the British Museum, Baron Ferdinand had supplanted his uncle in the public eye as the primary representative of the Rothschild taste for Continental silver in England.

The elder baron's legacy, however, was still strongly felt. Baron Lionel's collection had been dismantled in 1879 and distributed between his sons Nathaniel (Lord Rothschild),

Alfred and Leopold, each of whom built important collections of his own. All three lent to the Burlington Fine Arts Club in 1901, exhibiting over a dozen items between them. Some of these, such as the figure of Hercules supporting a globe, or the Diana and the Stag, had been displayed by their father at South Kensington.[133] There was even the standing cup topped by the figure of Pomona that had served as Baron Lionel's sole contribution to the *Exhibition of Ancient and Mediaeval Art* in 1850.[134] Then described in only a few slight lines, in 1901 the object merited nearly a page of text – evidence of the great progress in scholarship that had taken place in the 50 years separating the two exhibitions. Gardner identifies the object as the work of the goldsmith Linhard Bauer (or Bawer), who became master in Strasburg in 1555; the catalogue's discussion of the decorative elements is presented in a specialist vocabulary equally indicative of advancement in the field.

It is impossible to imagine the Burlington Club's *Exhibition of a Collection of Silversmiths' Work of European Origin* taking place in London in 1901 without the influence of Baron Lionel's passion for antique plate or the Waddesdon Bequest gallery. We find evidence of Lionel's important role not only in the Rothschild objects put on view but also in the works contributed by other members such as J.P. Morgan, who eagerly emulated the Rothschild taste in Continental Renaissance silver. Baron Lionel's impact is moreover felt in the appreciation for the material and its serious, scholarly presentation. The success of the exhibition, which would prove the third most popular ever mounted by the Burlington Club, is evidence of a public interest rooted in the triumph of the *Special Loan Exhibition* of 1862 and especially its display of Baron Lionel's collection.[135] With Baron Ferdinand's gift to the nation, that legacy is preserved in the Waddesdon Bequest.

Notes

1 The author is grateful to Dora Thornton, Timothy Schroder, Pippa Shirley and Ellenor Alcorn – scholars whose work lies behind everything useful that appears here. Melanie Aspey at the Rothschild Archive has been enormously supportive of research contributing to this effort. Caitlin Condell's help with primary sources at the National Art Library, Victoria and Albert Museum, was indispensable. Baron Ferdinand's memoir was privately published and made available in Hall 2007; the quotation appears on page 54.

2 When Baron Ferdinand was writing, the term 'bric-à-brac' was in vogue. In 1878 James Grant Wilson attempted to lay out its history and etymology, suggesting that by 'bric-à-brac' was meant, for example: clocks, ceramics and other 'old ware' (Sèvres in particular), arms, jewels and hardstone, relics, coins, first editions and rare manuscripts, enamels, tapestries and textiles, musical instruments, pens, rare flowers and – most importantly for this discussion – works in precious metal. The author notes how 'Baron [Lionel] Rothschild bought an antique silver salt cellar for $1,750', Wilson 1878, 313–15.

3 Rothschild in Hall 2007, 54.

4 Ibid., 55.

5 Rothschild 1897, 3, 9–10. On the Rothschild acquisition of salvaged interiors from French homes, see Harris 2007, 65–7.

6 This was not the original location of the Renaissance collection. See Boak 2017, 30–9, 31. For the relationship of his 'Renaissance Museum' to the baron's other collections, see Shirley 2017, 10–21.

7 The original catalogue is Read 1902. An important contribution is Tait 1998. Most recently, see Thornton 2015.

8 See Thornton 2001, 191–213; Thornton 2019, 181–98.

9 On the date of arrival in England, see Ferguson 1998, 48–9 . For the French branch of the family, and an overview of the several houses, see Prevost-Marcilhacy 2016.

10 Kaplan 2006.

11 Elected member for London in 1847, Lionel was prevented from take his seat in the House of Commons until 1858, when laws regarding Jewish Members of Parliament were changed in order to accommodate him, Ferguson 1999, 41. On the ennoblement of the family, see Ferguson 1999, 254–5.

12 Although Gladstone's attempt to raise Lionel to the peerage failed, his campaign in favour of Baron Lionel's eldest son Nathaniel Mayer ('Natty') achieved its aim: he was the first Jewish member of the House of Lords. On the political and social status of the British branch of the family under Baron Lionel's leadership, see, for example, Kessler 1982–6, 231–51; Hyamson 1951–2, 287–90; Davis 1996, 9–19.

13 A fourth brother (the third son), Nathaniel left England at an early age and spent most of his life in France.

14 See, for example, Pickering 2017.

15 Hall 2014, 103.

16 'The Ferdinand Rothschild Bequest', *The Times*, 7 April 1900, 4.

17 Ibid.

18 Ibid.

19 Glanville 2013, 279. On 18th-century interest in *Schatzkammer* objects, see Reitlinger 1963.

20 Glanville 2013, 279.

21 *The Unique and Splendid Effects of Fonthill Abbey: Catalogue of the Extensive Assemblage …* (London: Phillips, 1823); *The Magnificent Silver and Silver-Gilt Plate of His Royal Highness, The Duke of York, Deceased* (London: Christie's, 1827); *A Catalogue of the Classic Contents of Strawberry Hill …* (London: Smith and Robins, 1842); *Catalogue of the Truly Magnificent Collection of Ancient and Modern Silver, Silver Gilt, and Gold Plate of … the Duke of Sussex …* (London: Christie and Manson, 1843); Forster 1848.

22 Yallop 2011, 29.

23 Hall 2014, 110; Ferguson 1998, 557 n. 126.

24 Rothschild in Hall 2007, 56.

25 Davis 1884; Jones 1907; *Catalogue of the Celebrated Collection of German, Dutch & Other Continental Silver and Silver-Gilt of the 15th, 16th, 17th, and 18th Centuries […] Removed from 148 Piccadilly …* (London: Sotheby & Co., 26, 27, 28 April 1937).

26 Ferguson 1998, 341. In 1827, Baron Lionel and his brother Sir Anthony had also travelled together through Germany visiting several collections, see Hall 2014, 106–7.

27 Ibid., 456–66.

28 Rothschild in Hall 2007, 56.

29 Thornton 2015, 23–5.

30 Ibid.

31 Ferguson 1998, 342

32 Alcorn and Schroder 2017, 153, 206 n. 39.

33 Hall 2014, 104.

34 Seelig and Spicer 1991–2, 107–18. A 17th-century drawing is in the Lobkowitz Silver Inventory, reproduced in ibid., fig. 9. See also Jones 1928, 205–6. Pechstein 1971, cat. 103. A version by Joachim

Fries (d. 1620) at the Liechtenstein Museum in Vienna has its original mechanism (Inv.-No. SI261). Another version by Jacob Miller the Elder (d. 1618) was sold in 1937 with the contents of 148 Piccadilly (Sotheby's, 1937, lot 196).

35 Seelig and Spicer 1991–2, 112. Seelig 1987, 10–11, 23.

36 Seelig and Spicer 1991–2, 110–12. The two objects appear in Davis, vol. 2, as nos 155 (Ättinger) and 192 (Walbaum). The Ättinger version was in a German private collection in the early 1990s. The Walbaum version at the Royal Ontario Museum (997.158.152.1) has undergone significant changes since its documentation in the Davis catalogue in 1884.

37 On the relationship between familial and individual tastes across the five houses see Ferguson 1998, 341–343. For an investigation of this question in relation to French enamels, see Barbe 2017, 65–75.

38 Pickering 2017, 186. Presumably this is lot 154 in the Sussex sale, described succinctly as 'the unicorn, under a shade'.

39 Chaffers in Robinson 1863, no. 6172.

40 WB.140. Baron Ferdinand's unicorn is probably a pastiche, combining 19th-century and Renaissance components. See Tait 1998, 139–42.

41 On the *Schatz-* and *Kunstkammer* as princely practice in Central Europe during the Renaissance and Baroque periods, see Kaufmann 1995, esp. chapter 7. On the influence of the great late-medieval banking families such as the Fuggers and Medici on shaping the 'essentially merchant' taste of the Habsburgs and ultimately the Rothschilds, see Hall 2014, 105–6.

42 Royal Society of Arts, *Catalogue of Works of Antient and Mediaeval Art, Exhibited at the House of the Society of Arts, London, 1850* (London: Chiswick, 1850). Prince Albert served as President and Chairman and Augustus Wollaston Franks as Honorary Secretary.

43 Ibid., cat. 18.

44 'Exhibition of works of ancient and mediaeval art', *The Times*, 20 March 1850, 8.

45 Glanville 2013, 290.

46 Morgan 1852, 125–40, 231–46, 313–19; Chaffers 1863; Rosenberg 1890.

47 Royal Society of Arts 1850, 1.

48 Royal Society of Arts 1850, cat. 61. The cup was inherited by Baron Lionel's son Nathaniel (Lord Rothschild), and sold by the latter's grandson Nathaniel Mayer (Victor) (1910 – 1990) with the contents of 148 Piccadilly on Tuesday 27 April 1937 (Sotheby's, 1937, lot 129).

49 Royal Society of Arts, 1850, cat. 78. 'Pineapple' is a misnomer; the lobes are in fact intended to evoke a cluster of grapes, as is indicated by the German name, 'Traubenpokal'. See Hayward 1976, 131.

50 Royal Society of Arts 1850, cats. 22, 23, 25.

51 Christie and Manson, 1843, lot 153.

52 Jones 1907, 18, and pl. XVIII. Ashmolean Museum, WA2013.1.162.

53 Chaffers in Robinson 1863, no 6148. The cup is now on loan to the Victoria and Albert Museum, London from The Rosalinde and Arthur Gilbert Collection (Loan: Gilbert.60:1, 2–2008).

54 Miller is alternately known as "Jakob I. Miller." Seelig 1987. Bayerisches Nationalmuseum 86/227. Other examples are in Darmstadt at the Hessisches Landesmuseum (inv. no. Kg 52 :61), the Staatliche Kunstsammlungen Dresden, Grünes Gewölbe (inv. no. IV 154), attributed to Joachim Fries (Augsburg).

55 Hall 2014, 104.

56 Baron Lionel also acquired modern plate, including impressive 18th-century-inspired wine coasters by Robert Garrard II (1793–1881), a pair of which are now in the Gilbert Collection. See Schroder 1988, 477–9.

112 | *A Royal Renaissance Treasure and its Afterlives: The Royal Clock Salt*

57 'The Rothschild family', *The Royal Cornwall Gazette, Falmouth Packet, and General Adviser* (Truro, England), Friday 13 March 1857, 3.

58 Robinson 1897, 941. On Robinson, see also Drew 2018; Davies 1998, 169–88.

59 Cantor 2012, 103–26, esp. p. 105. On the role of Prince Albert, see Thornton 2015, 45.

60 Robinson 1856, vol. 1, 5.

61 Eatwell 2000, 20–9.

62 Eatwell 1994, 25–30, 25.

63 Ibid.

64 The club records are held in the National Art Library, Victoria and Albert Museum: Fine Arts Club: general committee minute books, February 1857 – 26 November 1874, unpaginated.

65 The Burlington Fine Arts Club, *Rules, Regulations, and Bye-laws with List of Members* (Westminster: Metchim, 1899), 7.

66 Ibid.

67 Fine Arts Club: general committee minute books, unpaginated.

68 Ibid. For example, an item is recorded broken in 1863, another lost in 1865.

69 Eatwell 1994, 27.

70 Robinson 1897, 958 n. 3.

71 Fine Arts Club: general committee minute books, unpaginated.

72 Ibid. He was elected on 5 June 1857. Waagen 1854, vol. 2, 129–31.

73 Fine Arts Club: general committee minute books, unpaginated. Eatwell 1994, 27.

74 *Illustrated London News*, Saturday 14 June 1856, 655.

75 Baron Lionel did not lend silver to either of these exhibitions.

76 Lady Schreiber was never a member, but according to Eatwell, she was as engaged in the society as her husband. Eatwell 1994, 27.

77 Ibid., 28.

78 Ibid.

79 On rising prices for Renaissance decorative arts, see, for example, Mandler 2017, 22–9, 26.

80 Eatwell 1994, 28.

81 This statement appears in a letter sent to the Chancellor of the Exchequer in December 1860. Fine Arts Club: general committee minute books, unpaginated.

82 Eatwell 2000, 25.

83 Robinson 1897, 958 n. 2. For an example, see 'South Kensington Museum', *The Times*, 19 December 1859, 12.

84 Although some public institutions (such as the National Gallery of Scotland), private corporations (guilds, societies, colleges) and foreign individuals (including members of the French branch of the Rothschild family) are listed among the exhibition's lenders, by far the majority of objects were gathered from private individuals resident in Britain. Robinson 1863. On the perceived need to 'unlock' British private collections, see Eatwell 2000.

85 Robinson 1863, iii.

86 Robinson 1897, 959.

87 A striking example appears in the case of the seventh section, dedicated to the rare French Renaissance earthenware then called 'Henri Deux' and now known as 'Saint-Porchaire'. In 1862 only 55 pieces were known; that year, all 25 pieces in England were on display at South Kensington. Nine of these belonged to Baron Lionel's brother Sir Anthony – more than owned by anyone else in the world. Such predominance was reasonably interpreted by viewers as evidence of personal (or at least family) taste. Saint-Porchaire also offers a useful microcosm through which to understand the broader connection between elite appetites and the larger British art market at the mid-century: the Rothschild hunger for the French earthenware must have been to some degree responsible for inspiring the production, beginning in 1858, of an expensive imitation line sold by Minton's. Extremely difficult to produce, the historicist line was created using techniques developed by Leon Arnoux (1816–1902), then Minton's Art Director. See Jones 1993.

88 The accounting of objects used for this essay reflects catalogue entries, without an attempt to distinguish between grouped components and isolated items; Lionel's decorative foreign plate covers catalogue numbers 6116 to 6186.

89 Seelig 1987, 67.

90 Robinson 1897, 959 n. 4.

91 'The Ferdinand Rothschild bequest', *The Times*, 7 April 1900, 4.

92 Chaffers in Robinson 1863, nos 6119, 6120. Davis, vol. 2, no. 165. Davis dates the cup to *c*. 1600 (slightly later than Chaffers, who puts it at 1580) and assumes it to be German.

93 Davis, vol. 2, no. 161; Robinson 1863, no. 6161.

94 Chaffers in Robinson 1863, no. 6150.

95 Ibid., no. 6134. This dish passed to Leopold de Rothschild, and was sold by Christie's, 12 June 2006, lot 31.

96 Ibid., no. 6182. This dish passed to Leopold and is now in the Museum Boijmans van Beuningen (MBZ 198 a (KN&V)).

97 Thornton 2015, 300.

98 Chaffers in Robinson 1863, nos 6172, 6165.

99 Ibid., nos 6148, 6185, 6173.

100 Ibid., nos 6124, 6180, 6181, 6136.

101 Robinson 1863, xiv.

102 'South Kensington Museum', *The Times*, Monday 9 June 1862, 5.

103 Ibid.

104 Ibid.

105 'The Loan Collection, South Kensington', *Illustrated London News*, supplement, 13 December 1862, 637, 640–642, 644.

106 'The Society of Arts', *The Times*, Friday 10 October 1862, 7.

107 'Special Exhibition of Loans of Art Objects', *The Standard*, Friday 6 June 1862, 6.

108 Ibid.

109 Hazlitt, 'Fonthill Abbey', *London Magazine* 6, November 1822. Reprinted in Hazlitt 1843, 284. For Beckford's silver, see, for example, Glanville 2013, 279, and Wainwright 1971, 254–64, esp. 263.

110 Mandler 2017, 25–6.

111 Smith and Findlen, 4–5. For further discussion of the *Schauessen*, and the Burgundian roots of these and similar Habsburg ceremonies, see Kaufmann 1995, 173. On princely collecting in the Renaissance and the theoretical justification of magnificence *per se*, see Kaufmann 1995, chapter 7.

112 He first slept in the house that year (see Boak 2017, 30). On Ferdinand and his relationship to his family, see Thornton 2019.

113 Shirley 2017, 12.

114 Ibid., 11.

115 Pierson 2017, 12, and 36–7 n. 17.

116 This reason is stated in the club's resolution to disband, dated 13 March 1874. Fine Arts Club: general committee minute books, unpaginated.

117 Pierson 2017, 21–2.

118 Hall 2010, 38. As with his choice of home in town, in choosing Buckinghamshire for his estate Baron Ferdinand was emulating his British uncles and cousins, who had already established several properties in the area: Tring, Halton, Aston Clinton and Mentmore.

119 Shirley 2017, 11–12. Lionel's influence on Baron Ferdinand's collecting is particularly evident in the younger baron's predilection for 18th-century British paintings. Ibid., 16.

120 Baron Ferdinand quoted in Thornton 2015, 22.

121 Rijksmuseum, Amsterdam (BK-17040-A). Ferguson 1999, 230.

122 Thornton 2015, 22–4.

123 Alcorn and Schroder 2017, 153.

124 Shirley 2017, 11.

125 For the most notorious forger, see Hackenbroch 1984–5, 163–268. On fakes by Vasters acquired by Baron Anselm, see Thornton 2015, 26.

126 Seelig and Spicer 1991–2. Metropolitan Museum, 17.190.746; Walters Art Gallery, 57.923.

127 Cockerel cups (WB.141, 142); bear (WB.139); stag (WB.138).

128 Shirley and Thornton 2017, 2.

129 Donnelly 2017, 40–51, 43.

130 Cat. 1685.

131 Robinson 1863, xiv.

132 Gardner 1901, xviii.

133 Case P, no. 13, identified as the work of Georg Kobenhaupt (master 1540).

134 Case P, no. 2.

135 For attendance at the club's 111 exhibitions, see Pierson 2017, 189.

Chapter 8
A Technical Study of the Royal Clock Salt

Andrew Meek, Oliver Cooke,
Fleur Shearman, Denise Ling,
Caroline Cartwright, Daniel O'Flynn
and Joanne Dyer

Introduction

This chapter draws together the technical studies of the Royal Clock Salt carried out under the direction of Dr Dora Thornton, conservators and scientists during its loan to the British Museum from the Goldsmiths' Company. In January 2018 the Clock Salt arrived at the Museum about a week before it was due to go on display in the Waddesdon Bequest Gallery and, following conservation assessments, it was available for examination, analysis and photography. This is a relatively short length of time to carry out a large project on such a complex object, and we were limited by the availability of analytical equipment; however, it was still possible to collect a large set of data.

While the Clock Salt was on display, we examined this dataset to find out more about the construction and history of this fascinating object. The data resulting from the application of a number of non-destructive analytical techniques allowed us to investigate aspects of the Clock Salt's production and history. It was possible to identify various materials and techniques used in its creation, which help to assign a production date and potentially identify the maker of the piece. It was also possible to detect previous restoration, which might inform future conservation. Finally, through technical examination we were able to shed light on the current clock mechanism and suggest the form of the original mechanism.

This chapter is divided into three parts: first, the scientific analysis carried out by scientists in the Department of Scientific Research; second, the technical observations on the Clock Salt prepared by conservators in the Ceramics, Glass and Metal Conservation Section of the Collections Care Department; and finally, a discussion of the clock movement, which was prepared by the Curator in the horological section of the Department of Britain, Europe and Prehistory.

Scientific analysis

X-radiography

The British Museum commissioned a new X-ray imaging laboratory in early 2017. This laboratory is unique in that it can accommodate very large objects (for example, statues up to 2m tall) (**Fig. 104**). Objects can be studied in real-time using X-radiography. Additionally, the lab has X-ray computed tomography (CT) capability, which is used to generate three-dimensional X-ray images. These techniques can be employed on objects such as the Clock Salt, to investigate production technology, to identify later restoration comprising different materials, to check for internal damage and many other purposes.

X-radiography was used to produce a series of two-dimensional X-ray images of the Clock Salt, each separated by a small degree of rotation of the object.[1] These images illustrate features that are not visible to the naked eye (**Fig. 105**), for example the means by which the cameos and various gems are attached to the Clock Salt, which are hidden within the structure of the object. It is also possible to see that the agate feet contain hollow gold tubes running through their centres and are attached using gold pins inserted from below (**Fig. 105**, left). Being able to observe these important features is useful when attempting to

Figure 104 The Clock Salt undergoing study in the British Museum Department of Scientific Research laboratory. Digital microscopy (left); X-radiography (centre); multispectral imaging (right). Image: British Museum

reconstruct the various interventions that have taken place during the life of the object and also for informing future conservation work.

Enamels and gilding

There are 18 enamelled elements on the Clock Salt. On the base there are six large rectangular panels with attached cameo heads and six smaller upright rectangular panels. On the upper hexagonal stage there are another six square panels, each with a gem setting. These enamels were investigated using a combination of X-ray fluorescence[2] and multispectral imaging[3] to discover more about their production and previous restoration work.

X-ray fluorescence

The enamels were analysed using X-ray fluorescence (XRF) to provide information about their chemical composition. The data produced by XRF can be compared with previously analysed objects and used to suggest the provenance or date of an object.

The compositional data, in combination with microscopy, revealed a number of important features. By analysing areas of damage on the enamel plaques of the Clock Salt it was possible to confirm that the enamelling is

on silver. Also, some areas that appeared to be enamel that had discoloured or deteriorated could be identified as blue paint covering up loses of enamel. It was also possible to identify areas of regilding that had been carried out using a copper alloy, rather than gold.

There are two upright enamel panels on the hexagonal base that appear much cleaner and brighter than the other similar panels. This has previously been interpreted as evidence that they might be replacements, but their composition is consistent with 16th-century production. It may be the case that these panels are original but have been cleaned and polished to remove all trace of the gilding or any consolidant that had been applied to them.

XRF was able to confirm that the distinctive blue colour of the enamels on the Clock Salt was created by the addition of cobalt (see Chapter, 4, p. 66). The enamels on the British Museum's Sibyls Casket were analysed as a comparison, and were also found to be coloured with the addition of cobalt. The enamels of the large plaques on the Sibyls Casket are coloured black with a combination of larger quantities of cobalt and manganese, and the balls on the top of the casket are coloured with cobalt alone (**Fig. 106**).

Cobalt has been used as a colourant in the production of vitreous materials for thousands of years and over time

Figure 105 X-radiographs of the Clock Salt. Top section (left) and base and central section (right). Image: British Museum

many different cobalt sources have been exploited. The particular material employed can be characterised from the other metals associated with its ores, such as arsenic, nickel and bismuth. In their survey of French glass, Bernard Gratuze *et al.* identified a group of glasses that are characterised by cobalt in association with nickel but without arsenic, which date to the 13th to early 16th centuries.[4] In combination with other more recent work it can be shown that there was a change from the use of cobalt-nickel- to cobalt-nickel-arsenic-bearing pigments that can be dated to 1520–30.[5]

The X-ray fluorescence results show that, while the Clock Salt enamels were all made with a cobalt source associated with nickel, arsenic and bismuth, the enamels on the Sibyls Casket were produced using two different cobalt sources. The plaques on the casket contain cobalt, nickel, arsenic and bismuth, and the balls on the top of the casket contain only nickel in association with cobalt. This suggests that the enamel plaques on both objects were made after the change of cobalt source occurred around 1520–30 and the balls were produced using enamel that is likely to have been made before this time. The reason for the use of two different cobalt sources on the casket is not certain at this stage.

Investigation of the data from the XRF analysis has been able to show that various interventions over the years have altered the appearance of the enamel plaques. The presence of a certain source of cobalt in the plaques can be used to suggest an earliest possible date for the production of the Clock Salt of 1520–30 (see Chapters 1, 3 and 4 on the subject of dating).

Multispectral imaging
Multispectral imaging has been carried out on the enamels of the Clock Salt in the past and was repeated on a very small scale at the Museum laboratory. This technique involves lighting an object using particular wavelengths of light, such as ultraviolet or infrared. Specially adapted cameras together with a series of filters are employed to reveal differences in the materials from which objects are made.

Imaging of all the enamel plaques was previously undertaken using ultraviolet light and this revealed areas of consolidation or restoration on the enamels.[6] These images could also be used to suggest which of the panels are the

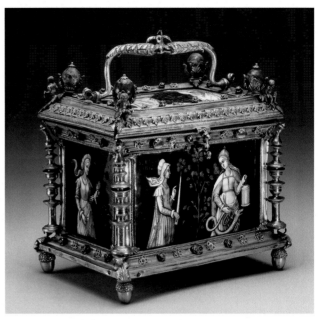

Figure 106 The Sibyls Casket, *c.* 1530–5, Paris, h. 16.6cm, l. 14.5cm. Waddesdon Bequest, British Museum, WB.23

most original, without restoration, by their lack of luminescence. One of the panels was photographed at the British Museum during the 2018 campaign of analysis (**Fig. 107a–b**). An area of luminescence can be seen at the top left of the plaque suggesting this part has been consolidated (**Fig. 107b**). Future analysis may be able to identify the consolidant used and help develop a greater understanding of the various interventions during the Clock Salt's life.

Cameos
The cameo heads on the base of the Clock Salt were examined using digital microscopy.[7] It was possible to take high-magnification images of the heads to allow an investigation of the materials from which they might have been created. The aim was to confirm that they were shell rather than stone (such as agate or onyx). During the 15th and 16th centuries, marine shells such as cowrie and helmet shells were used to make cameos (see Chapter 3, pp. 50–1, Chapter 4, p. 66).

The digital microscope images show the fine details of the carving as well as the characteristic structural features

Figure 107a–b Multispectral imaging of an enamel plaque on the base of the Clock Salt. Images taken under visible light (left) and ultraviolet light (right) to produce an UV-induced visible luminescence image. Image: British Museum

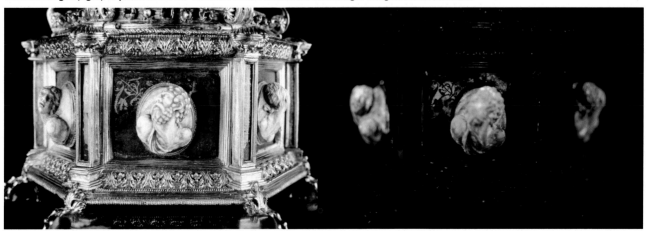

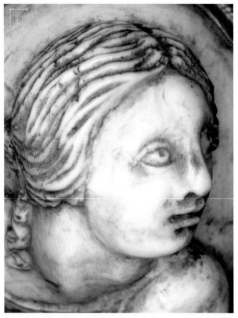

Figure 108a–c (from left to right) Digital microscope images of a cameo on the Clock Salt's hexagonal base. Images: British Museum

common to the hard, dense shell of helmet shells and cowries. This microstructure includes the natural parallel features visible in **Figure 108c**. Identifying the material used to produce these cameos will allow the Clock Salt to be catalogued correctly and also inform future conservation work.

Conclusions

The results of the scientific analysis have shed new light on many aspects of the Clock Salt's production and the restoration that has taken place during its life. The large dataset collected during the short campaign of analysis in 2018 will be available for future studies and will continue to allow new discoveries to be made. The identification of materials used in the Clock Salt's production and techniques of manufacture will help to inform future conservation work on this unique object.

Technical observations

As with the scientific analysis, there was only a limited amount of time available to carry out a technical analysis of the Clock Salt. However, it was still possible to collect a large amount of information, which led to some very interesting

new findings. The aim of this assessment was to provide further information to assist with the attribution of the Clock Salt to the goldsmith Pierre Mangot (c. 1485–after 1551). The following section discusses various observations and presents a comparison with other objects attributed to Mangot.

Date and makers' marks

It is possible to compare the Clock Salt with other pieces attributed to Pierre Mangot (see Chapters 3 and 4). **Figure 109a–c** illustrates three other objects that are in collections in France and Italy. The group of attributed objects includes the two caskets and one ciborium in **Figure 109a–c**, and the Sibyls Casket in **Figure 106**. Mangot maker's mark is a letter 'M' surmounted by a crown. It is found on the Mantua casket, and the Louvre casket has blurred markings on the entablature between the jewelled nails, which are thought to be the remains of a maker's mark. The Mantua casket has a hallmark for Paris and a date mark (e) for 1533–4, and the Louvre casket has a date mark (d) for 1532–3.[8]

No date or makers' marks have been found on the Clock Salt or Sibyls Casket (see Introduction, p. 5). However, on the Sibyls Casket, marks were detected above the head of the

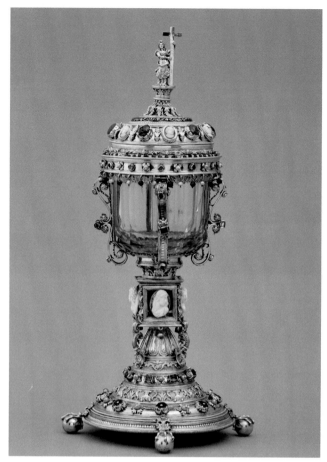

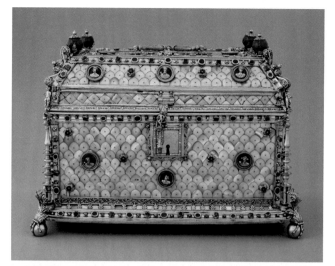

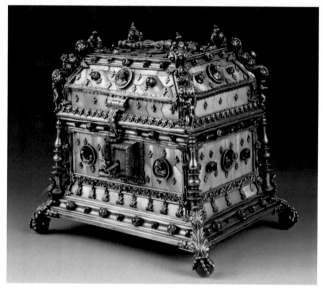

Figure 109a–c Other works attributed to Pierre Mangot: (above) Ciborium, Chapelle de St Esprit, before 1528, h. 34.3cm. Musée du Louvre, Paris, inv. no. MR 547 (see Fig. 28); (top right) Shell garniture casket, 1532–3, h. 28.3cm, l. 40.8cm, w. 27.3cm. Musée du Louvre, Paris, OA 11936 (see Fig. 31); (bottom right) Shell garniture casket, 1533–4, h. 13cm, w. 16cm, d. 13cm. Mantua Cathedral treasury, Italy (see Fig. 27)

Sibyl of Cumae that are suggestive of a punch or tool applied from the reverse (see Chapter 4, p. 64). This appears to be the remains of an intentional marking, perhaps a Gothic numeral, and is in the same location as the blurred, stamped markings found on the Louvre casket. In the case of the Louvre casket, this marking was used to support its attribution to Mangot.

Diagnostic features

A number of similar diagnostic or stylistic features occur on the five known pieces, marked or attributed to the workshop of Mangot (see Chapters 3 and 4). It has not been possible to complete an audit of replacements or a reinstitution of lost elements during the 2018 campaign of investigation. A full list of the motifs is as follows:

- architectural elements: baluster columns, entablature, pediments
- Classical motifs and references
- figurative cast sculptures of putti
- use of reused Classical or Renaissance cameo and intaglios
- high-relief protruding sculptural heads in the Mannerist style
- double scrolls with gem-set central fixings
- dot-punched decorative patterns and effects

- four-claw bezels with a gem setting
- corded or rope-effect borders
- horizontal striations on palmate borders
- use of luxury materials: rock crystal, gems, pendant pearls and carved shell
- double dolphin handle opposing a baluster vase
- ball and claw feet
- openwork and filigree appliqués
- large blue enamel bosses *en ronde boss*
- grotesque or dragonesque animals
- fruiting buds, vegetal and scrolling motifs

Another feature present on multiple objects in this group is horizontal striations on palmate leaf borders (**Figs 109a–c –110a, c**; see also Chapter 4). They are clearly visible on the Clock Salt, and Sibyls and Mantua caskets, and are present on corner acanthus scrolls, but not on other areas. The technical reason for these features is currently unknown, but they may relate to the production processes employed to make these objects. **Figure 110a, c** illustrate a similar corded or rope-effect edging to the entablature on the Clock Salt and Sibyls Casket. This rope design also appears in the bezels of the cameos on the Clock Salt. On the Clock Salt there are many four-claw gem-set bezels (**Fig. 110b**). These claw bezels are also seen on the ciborium and Sibyls and Mantua caskets (**Figs 109a, c, 110d**).

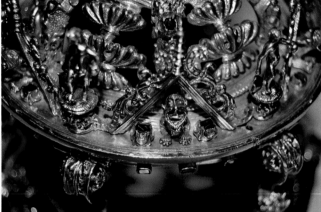

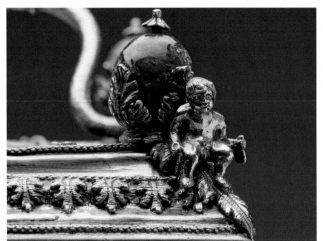

Figure 110a–d Images of horizontal striations on palmate leaf borders and the gem settings on the Clock Salt (a–b, top left and top right) and Sibyls Casket (c–d, bottom left and bottom right). Images: British Museum

It is possible to compare parts of the five objects and understand where there may be missing elements. This can help develop a better understanding of the Clock Salt's original appearance. For example, on the Clock Salt there are perforations in the middle of the double scrolls around the rock-crystal cylinder housing the clock mechanism that match up with gem-set fixings on the Mantua casket and the ciborium (**Figs 109a, c, 111a–b**).

Conclusions
Without a date or maker's mark, details of the production of the Clock Salt have been a matter of debate in recent decades. The technical observations presented here allowed a large number of features to be identified that can be compared with other objects of Renaissance goldsmiths' work. The features discussed in this section strengthen the attribution of the Clock Salt to Mangot.

The clock mechanism

Introduction
The following section focuses on the movement, or mechanism, that is located almost entirely within the rock-crystal cylinder at the centre of the Clock Salt (**Fig. 111a–b**). In the study of antiquarian horology we are often fortunate to have makers' signatures or marks to help us identify the place and date of production. However, this is not the case with this clock movement and so it is necessary to scrutinise the nature of the components of the clock.

As with the scientific and technical analysis, there was only a limited time in which to study the clock mechanism. The observations presented in this section are based on two brief viewings of the clock by the author. A full study of any clock necessitates its full disassembly, which was not possible, and without doubt there is further information to be found.

Figure 111a–b The present mechanism within the Clock Salt (left) and removed (right). Images: British Museum

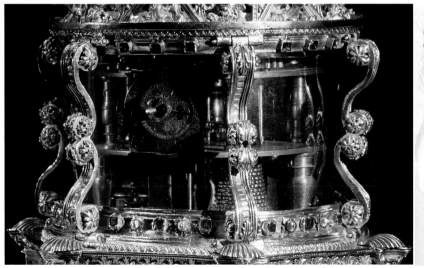

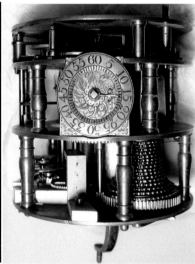

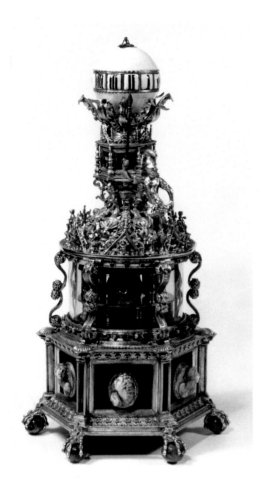

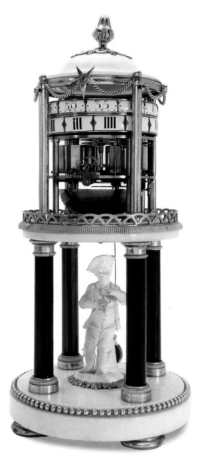

Figure 112a–b (far left) The Clock Salt as it appeared when it was purchased by the Goldsmiths' Company (Hayward 1973, 29); (left) Louis XVI white marble, ormolu and blue glass cercle tournant mantel clock, by Barancourt, *c.* 1785, Paris, Sotheby's, London, 4 December 2012, lot 355, h. 37.5cm. Photograph courtesy of Sotheby's

As will be shown, the present movement is not original to the Clock Salt. This section of the chapter is thus divided into two parts: first, a description of the present movement; and second, some conjecture as to the nature of the original movement.

The present movement

Overview

As a clock this might generally be described as an eight-day duration spring-driven table timepiece with pull-quarter repeat. It is intended to indicate minutes and hours on its dials and, on demand, the quarters and hours aurally, on two bells. The aural indication is initiated by the pull of a cord, by a system known as repeating work. The presence of repeating work immediately informs us that the movement does not date to the Tudor period, as repeating work was not invented until the 1670s.

Several other aspects of the clock mechanism, including the general quality, finish and form of the components, confirm that it is not of Tudor origin and was made in the late 18th or early 19th century. The dial visible though the rock crystal is for the minutes (**Fig. 111a**). The hours would be indicated on a revolving sphere at the top of the clock, but this has been removed for the current display. **Figure 112a** from John F. Hayward's article shows it in place.[9] This arrangement, i.e. with horizontally rotating dials elevated above the main body of the clock, calls to mind the somewhat similar form of the French *cercle tournant* mantel clocks that were relatively popular in the third quarter of the

18th century (**Fig. 112b**) and which would seem to have been a source of inspiration for the present clock. However, the present movement is without doubt bespoke to the Clock Salt. It is certainly not a 'drop-in' from one of these mantel clocks. Indeed, there is much evidence to suggest that it is not French, but possibly English.

Form and structure

The Clock Salt combines horizontal circular and hexagonal forms: both were common for spring-driven table clocks in 16th-century Europe. The present movement has circular plates, fitting closely to the rock-crystal cylinder, providing evidence that it has been made to fit (**Fig. 113**). There are four movement plates forming three internal layers. The pillars separating the plates are of a different pattern in each layer: those of the bottom and middle layers have different baluster styles and the top layers are plain. Baluster pillars are typically associated with domestic clocks from the 16th and 17th centuries, but are rarely seen after the 17th century. The use of the baluster style here might have been an attempt to invoke a contemporary design.

Inside the top of the hexagonal base section of the Clock Salt is a ledge on which the rock-crystal cylinder sits. Two brass mounting brackets are riveted to the ledge on which the bottom plate of the movement rests. These brackets are not original to the case, providing further confirmation that the present movement is not original. Removal of the movement requires it to be lifted upwards off the hexagonal base. To enable this, the top section of the Clock Salt must be disconnected, which is achieved by detaching either the tops

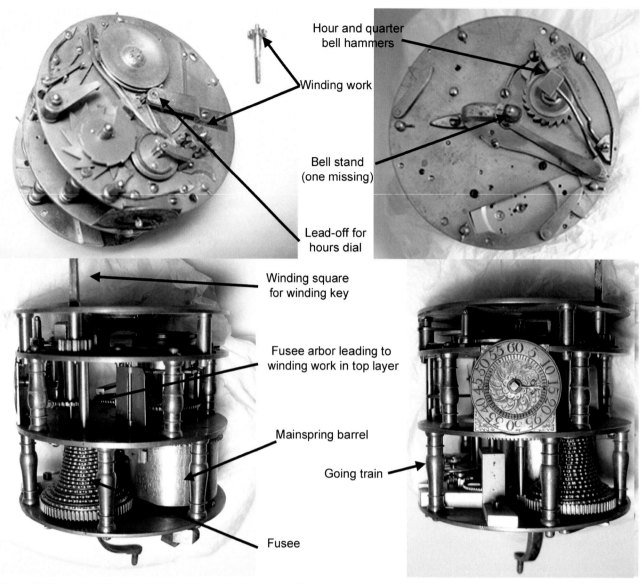

Figure 113 Elements of the Clock Salt's clock mechanism. Image: British Museum

or bottoms of the six legs by removing their pins (see **Fig. 111a–b**). Once the top section has been taken off, the rock-crystal cylinder can be lifted out, giving good access to the movement. There is a single hole in the rock-crystal cylinder that aligns with the minutehand arbor, facilitating setting of the time (**Fig. 111a–b**).

Power source

The going train is spring-driven with a fusee of 16 turns for the chain (**Fig. 113**). Sixteen turns is consistent with eight-day duration English fusee clocks, although duration would have to be verified by a train count, which requires full disassembly. If we compare this with a French *cercle tournant* mantel clock we see a similar layout, but with the absence of a fusee (**Fig. 112b**). The use of fusees in the late 18th and early 19th centuries is very much associated with English work. French or German manufacture, while not entirely precluded, is therefore unlikely.

The fusee arbor extends through the middle layer of the movement to the top layer, where it terminates with a brass gear wheel (**Fig. 113**). This wheel engages with another brass wheel on a short winding arbor, which extends

through the top plate – thus the clock is wound from the top. Note that it is therefore necessary to insert the key for winding through the decorative fretwork. This is a very unconventional arrangement. Such domes were a common feature of 16th-century domestic clocks, but their purpose was usually to conceal a bell, while allowing its sound out. The Orpheus clock is a fine example (**Fig. 114**); it was made in Germany around 1580, and is in the collection of the British Museum. Note also some similarity in the legs to the Clock Salt (see **Fig. 111a–b**).

Wheels

The use of brass wheels with steel arbors and pinions was rare before the end of the 16th century. The wheel work seen here appears to be of a standard of finish closer to the late 18th or early 19th century (**Fig. 113**). Moreover, there may be some replacements of wheels. Disassembly of the movement would allow a full inspection.

Escapement and controller

The present movement is fitted with an English lever escapement. The platform and cock are unusually robust

and show the escapement to be bespoke to this clock. It is consistent with English work of the 19th century.

Just below the ledge, mounted on a brass block, is a blued-steel lever that engages with the regulation lever of the platform escapement, enabling the clock to be adjusted from the outside. There is a corresponding 'S F' regulation mark somewhat crudely inscribed on the clock case (**Fig. 115**). Note that these are in English, that is, 'S' and 'F' for 'Slow' and 'Fast'. As has been noted, the present escapement appears to be of 19th-century manufacture. Several clues further indicate that it is not original to the movement. Again, this calls to mind the *cercle tournant* mantel clock (**Fig. 112b**), which has an anchor escapement, but note that it only requires a cut-out in one plate. It seems probable that the present movement was once controlled by a pendulum passing through the slots in both plates and extending into the hexagonal base. Disassembly of the movement would permit a closer study of the cut-outs and old holes, which could reveal the true nature of the original escapement.

Indications
The minutes are visible behind the rock crystal (**Fig. 111a–b**). The silvered chapter ring on a brass dial plate with decorative engraving, together with the sculpted hand, are of the English style.

The hour numerals are individual enamelled plaques, and this is in the 18th-century French manner. As has been noted, the *cercle tournant* mantel clocks were popular in the late 18th century and there was also a late 19th-century revival that took a variety of forms, a small sample of which can be seen in **Figure 116a–g**. However, common to all such *cercle tournant* mantel clocks is that both hours and minutes are indicated on rotating dials – on the Clock Salt just the hours are indicated in this way. Rotating hour dials also featured in some 17th-century automata clocks as seen in **Figure 116e–g**, so this could have been further inspiration for the 18th-century restorer to take this approach.

The top two layers of the movement contain the quarter striking mechanism. The remnants of orange-coloured cord are still visible on the barrel. When this cord is pulled, a

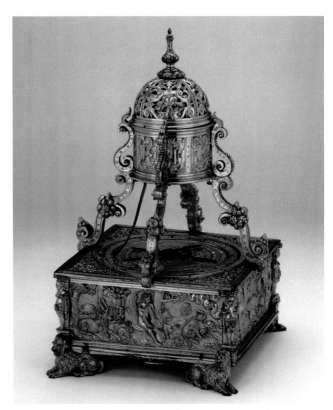

Figure 114 Orpheus clock, 1575–85, Germany, h. 29.1cm, l. 19.8cm, w. 17cm. British Museum, 1888,1201.102

spring below is charged and on its release powers the quarter striking – typically a number of blows on a large, low-pitched bell according with the hours and one to three quarters on a smaller higher-pitched bell. Only one bell stand is present, but the holes in the bottom plate exist for another to be mounted (**Fig. 113**). The *cercle tournant* clock and the Clock Salt have the underslung bells in common. This is necessary so as to provide a clear path for the drive to the rotary dials on top.

Conclusions
Much evidence in the present clock movement indicates that it was made in the late 18th or early 19th century, which is consistent with the burgeoning passion for collecting and

Figure 115 Regulation adjustment. Image: British Museum

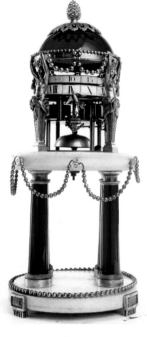

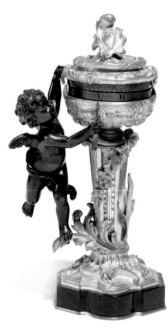

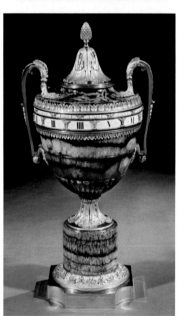

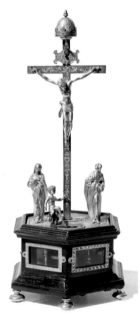

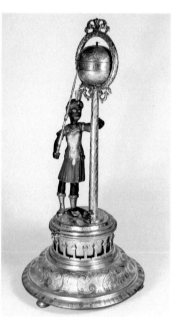

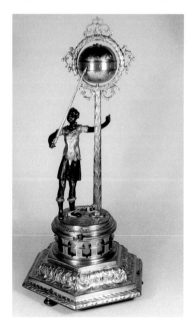

Figure 116a–g Louis XVI rotary clocks and Augsburg automata clocks:

(top row, left to right) a) Revolving-band clock, by Martin à Paris, *c.* 1720, Paris, h. 65cm. Bowes Museum, CW.10; b) Louis XVI ormolu, marble and blue glass mantel clock, *c.* 1778, France, h. 48.5cm. Sotheby's, New York, 18 November 2011, N08803, lot 136. Photograph courtesy of Sotheby's, Inc. © 2011; c) Rotary clock with thermometer, late 19th century, France, h. 25.5cm, https://www.bonhams.com/auctions/ 20076/lot/ 264. Photograph courtesy of Bonhams

(middle row, left to right) d) A Second Empire ormolu mounted 'Millers Vein' Blue John clock, unknown maker, *c.* 1870, France, h. 57cm. © Ronald Phillips Ltd, 26 Bruton Street, London; e) A gilt-copper and ebonised automaton, by Nicolaus Schmidt, *c.* 1630, Augsburg. Sotheby's, London 26 October 2016, L16305, lot 1141, h. 38cm. Photograph courtesy of Sotheby's; f) Automaton clock, *c.* 1625, Augsburg, h. 28cm. British Museum, 1888,1201.119

(bottom row) g) Automaton clock with Moor, by Carol Schmidt, *c.* 1625, Augsburg, h. 30cm. British Museum, 1888,1201.120

subsequent restorations of many antiquities around this time. Despite the strong influence of the late 18th-century French *cercle tournant* mantel clock, there is considerable evidence to suggest that the movement may have been made, or at least heavily modified after it was made, in England. A full disassembly of the movement would allow a fuller inspection, which would surely reveal more information in this regard.

The original movement

There is no compelling evidence in the Clock Salt for it having had a clock movement before the present one (although that would leave the rather awkward question of 'what was it then?'). However, in his 1973 article, Hayward identified the Clock Salt as item 914 in the 1574 Jewel House inventory of England, although the Clock Salt can be related to two separate items listed in that inventory, neither of which is an exact match; see the analysis in the Introduction (p. 6).[10] Hayward gives us this extract from the inventory: 'a round crystal and therein a clock with a chime and other joints of latten and iron appertaining to the same'. Note the 'chiming' probably refers to common hour striking. The following section considers how some contemporary clocks fit that description and the present Clock Salt.

Horizontal table clock

We can look again at the British Museum's Orpheus clock (**Fig. 114**). Known as a horizontal table clock, the clock movement is contained entirely within the base, which has a horizontal dial on its top. The part above it, from the feet of the legs upwards, is an alarm attachment (the thin lever seen here engages with the hour hand to release the alarm). This was a relatively common design for domestic clocks of the period and so should be given some consideration as a possible original form for the Clock Salt.

We might imagine a mechanism in the hexagonal base with a horizontal dial on top. A similar design has been illustrated by Robert Whale (see Chapter 6, **Fig. 85**). This arrangement would give purpose to the space in the hexagonal base of the Clock Salt, which is presently unoccupied; however, it also presents a number of problems. We should assume that the cylinder was originally present as the inventory specifies 'a round crystal and therein a clock' (or 'one clock within crystal', depending on which of the two possible inventory descriptions we identify it with; see Introduction, p. 6). The rock-crystal cylinder would prevent access to the hand of the clock in this position. This would necessitate the provision of an alternate means for setting the time, which would be unusual for this period. Moreover, that statement 'a round crystal and therein a clock' could conceivably describe the dial as seen in the illustration, but a far more comfortable fit would be for the entire movement to be within it.

Illustrated in **Figure 117** is another horizontal table clock, but here the movement is housed within a rock-crystal cylinder. If the movement of the Clock Salt were placed in the crystal section (as it is presently), then item 1353 in the 1547 inventory, described as 'a round crystal and therein a clock', might fit (see the analysis in the Introduction, p. 6).

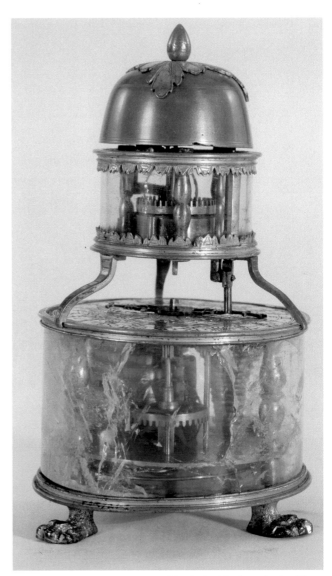

Figure 117 Cylindrical horizontal table clock with alarm, both with rock-crystal case, 1550–75, South Germany (probably Nuremberg), h. 15.2cm, w. 9.5cm. British Museum, 1958,1006.2110

However, the horizontal dial would then be located immediately under the openwork dome and it would not be visible with the present ornamentation. So, unless it is possible that much of this openwork is not original, we can discount this possibility. In conclusion, it seems that the popular form of the horizontal table clock is not appropriate to the Clock Salt.

Vertical table clock

Hayward presents this far preferable precedent with many advantages: a drawing of a clock salt from the pictorial inventory of the treasury of Duke Albrecht V of Bavaria (1528–1579) (**Fig. 118a**).[11] Here, the movement is located within the rock-crystal cylinder, that is, 'a round crystal and therein a clock'. The dial is vertical and seen though the rock crystal; it is not obscured by the openwork dome. The current hole in the rock-crystal cylinder could have been present originally, and with the same purpose, that is, for setting the time. Note that this would be an hour dial only: minute dials were very rare in this period as clocks were only accurate to about 15 minutes per day, and thus a minute indication would be unreliable. Furthermore, with the hour

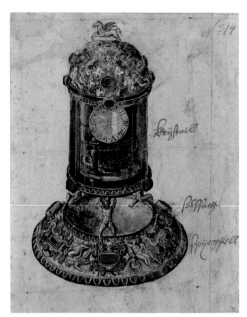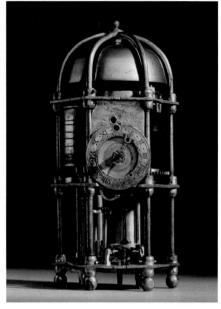

Figure 118a–c Vertical table clocks (from left to right): a) drawing by Hans Mielich of a clock salt from the pictorial inventory of the treasury of Duke Albrecht V of Bavaria, 1570. Staatliche Graphische Sammlung, Munich, inv. no. 38876 Z. © Staatliche Graphische Sammlung München; b–c) Table clock (with case, centre, and without case, by Guillaume Couldroit, c. 1540, Blois, h. 13.1cm. British Museum, 1888,1201.125

dial behind the crystal, an hour dial on top of the Clock Salt would not be required. Without the drive to the top of the clock, the openwork dome is available to accommodate a bell for the hour striking: the 1574 inventory specifies 'a clock with a chime'. The way is also clear for a container of salt to be located above the clock. The case for this arrangement seems to hit all the marks.

The final example is a table clock by Guillaume Couldroit (act. 1532–46), illustrated in **Figure 118b–c**. It is 13.1cm high and has a similar arrangement to the movement of the Albrecht clock salt (stacked trains, with the going train above the striking train, and a vertical hour dial). The proportions, if scaled up, support Hayward's suggestion that the movement 'may have occupied part of the octagonal base as well as the cylinder'.[12] Note also that the bell for the hour striking is contained within the openwork dome on top. This arrangement would suit the Clock Salt well. Finally, the frame of this movement also exhibits the use of both brass and iron, in the movement plates and pillars respectively, fitting with the 1574 inventory description of 'joints of latten and iron'.[13]

Conclusions
From Hayward's presentation of the illustration of the Albrecht clock salt we have been led to extant examples of contemporary French stacked-movement clocks. This supports the precedent set by the Albrecht clock salt and can be confidently applied to the Goldsmiths' Clock Salt. Moreover, this arrangement was a specific trait of French clocks of the period and therefore supports the idea that the Goldsmiths' Clock Salt is of French origin.

Overall conclusions
This chapter presents the work of a number of specialist researchers, helping to shed new light on this significant piece of 16th-century goldsmith's work. This collaborative project, which draws together scientists, conservators and curators, shows the importance of a multidisciplinary approach in the study of museum collections.

The results of the scientific analysis identified materials used in the Clock Salt's production. Some of these findings helped to discern its likely production date. Imaging techniques were employed to identify the manufacturing technology used in the construction of the Clock Salt and potential areas of restoration.

A detailed technical investigation drew further conclusions about manufacturing techniques and decorative elements. It was not possible to discover a maker's mark or date stamp on the Clock Salt. However, by comparing it with other objects attributed to Pierre Mangot, it was possible to add to the evidence that suggests he made the Clock Salt.

The horological study of the present clock mechanism has drawn conclusions about its probable production date and location. The present mechanism is likely to have been produced in England in the 18th or 19th century. Through a comparative study it was also possible to develop a better understanding of how the Clock Salt may have appeared originally. It seems likely that it was similar in form to a vertical table clock.

The authors hope that this examination of the Clock Salt will inspire further study and that the results of the present project will be used to inform any future research or conservation work on this unique Renaissance treasure.

Technical appendix

X-radiography
Digital X-radiography was carried out using a custom-build YXLON Access Y.100 system, housed in the British Museum, with a Comet MXC-451HP/11 X-ray tube and a 4-megapixel (410 x 410mm2) PerkinElmer 6210 flat panel detector. The Clock Salt was positioned on an automated

turntable, such that images could be taken at each degree of rotation about the vertical axis. The X-ray tube was operated at 450kV and 1.55mA, with 3.3mm of brass filtration to remove lower-energy X-rays from the incident spectrum. Images were integrated over 60 seconds, and recorded as 16-bit TIFF files. The top and bottom halves of the Clock Salt were imaged separately.

X-ray fluorescence

The surface of the enamels was analysed with a Bruker ARTAX spectrometer using a helium atmosphere, 50kV X-ray tube voltage, 0.8mA current, 0.6mm diameter collimator and 200s counting time. The surface analysis of enamelled objects can provide results that are not consistent with the bulk composition. This is due to a process of weathering that occurs over time, which results in the leaching of alkali components from the surface and an associated enrichment in silica. However, the enamels analysed for this study were relatively free from weathering and the results are therefore believed to be a useful representation of the bulk glass. Using this methodology, the XRF analysis was able to provide semi-quantitative results, that is, to identify the presence or absence of elements and their relative proportions. Elements with an atomic number lower than silicon could not be quantifiably detected under the conditions used.

Multispectral imaging

Images were taken using a modified NikonD7000 camera body (without the inbuilt UV-IR blocking filter) and a Canon EF 50mm f/1.8II lens. The filters placed in front of the lens to select the wavelength range under investigation were: an interference UV-IR blocking XRite CC1 filter (bandpass, 325–645nm, 50%) for the visible-reflected images (VIS). A Schott KV418 cut-on filter (50% transmission at *c.* 418nm) was added for the ultraviolet-induced visible

luminescence imaging (UVL). For VIS imaging the object was illuminated by two photographic Classic Elinchrom 500 Xenon flashlights, each equipped with a softbox and symmetrically positioned at approximately 45° with respect to the focal axis of the camera and at about the same height. For the UVL imaging, the excitation was provided by two Wood's radiation sources (365nm) filtered with a Schott DUG11 filter. All images were acquired as RAW images and transformed into 16-bit TIFF format using Adobe Photoshop. No post-processing procedures were applied in this case, so the images are 'as shot'.

Digital microscopy

The Clock Salt was imaged using a Keyence VHX-5000 microscope with attached VH-Z20T lens capable of a magnification range from 20x to 200x. The microscope's large depth of field, anti-glare correction, focus stacking, and measurement capabilities were employed to produce images that could be used to investigate techniques used in the Clock Salt's production.

Notes

1 See technical appendix: X-radiography.
2 See technical appendix: X-ray fluorescence.
3 See technical appendix: Multispectral imaging.
4 Gratuze *et al.* 1995.
5 Zucchiatti *et al.* 2006; Biron 2002.
6 Van Lookeren Campagne-Nuttall and Navarro 2011.
7 See technical appendix: Digital microscopy.
8 Toesca 1969; Bimbenet-Privat 1992.
9 Hayward 1973, 29.
10 Ibid., 27.
11 Ibid., 28.
12 Ibid., 27.
13 Ibid.

Conclusion

Timothy Schroder and Dora Thornton

The Royal Clock Salt is a microcosm, standing for an entire world and throwing a unique light on it. It is also a singular object, not because it always was so, but because it is an exceptional survivor, outliving most of the works of art with which it originally coexisted. When it came into Henry VIII's possession it would have joined a vast array of 'like-minded' objects that collectively represented a particular kind of princely taste: costly, fashionable, learned in design and refined in execution. Nearly all of this magnificence has disappeared and as one of the very few surviving pieces of goldsmiths' work from this extraordinarily acquisitive king's collection, its significance is hard to overstate. But just as the Clock Salt contributes greatly to our understanding of the 16th-century courtly world, so a wider scrutiny of that world through other sources enriches our understanding of the object itself.

This publication addresses its subject in exactly that way, examining the Clock Salt itself in various lights and reflecting on aspects of the court culture in which it played a part. The micro, or object-specific, approach includes tracing its history from the 16th century to the present day, a study of the techniques and materials used in its creation, and a rigorous scientific and horological assessment to establish the extent of the changes it has undergone over the centuries. The macro, or wider, themes take in a detailed consideration of its place within the oeuvre of its maker, Francis I's wider patronage of goldsmiths, the important role of gift giving at princely courts, and the distinctions between the style of court goldsmiths' work in France and in England.

This innovative approach has been made possible through the collaboration of the contributing scholars and the enlightened cooperation of the sponsoring institutions: the British Museum, the Rothschild Foundation, Waddesdon Manor and the Goldsmiths' Company. How this came about is discussed in the Introduction, but the collaboration itself had a bearing on the book too. For example, the initial partnership between the Goldsmiths' Company and the British Museum made possible the loan of the Clock Salt to the Museum and created the opportunity for side-by-side comparison of it with the Sibyls Casket in the Waddesdon Bequest. The latter had also been attributed to Pierre Mangot (*c.* 1485–after 1551), but the comparison served to reinforce the grounds for the attribution and to illuminate the relationship between the two pieces. The co-sponsorship of the conference and publication by the Rothschild Foundation and Waddesdon Manor naturally suggested a further theme, namely the collecting interests of latter-day Renaissance princes like Baron Ferdinand Rothschild (1839–1898). Had the Clock Salt appeared on the market when he or Sir Richard Wallace (1818–1890) were collecting it would doubtless have been snapped up and entered one of our national museums long ago. As it is, the Company is delighted to have been able to interrogate one of the finest objects in its Collection, as a step towards sharing it with a wider audience on a new online collections database which is currently being developed to mark its 700th anniversary in 2027.

This book addresses many important questions, but others remain: was the Clock Salt actually used on the royal dining table, or was its only role to be seen with other luxury objects in the privy chamber? Have we accounted fully for its

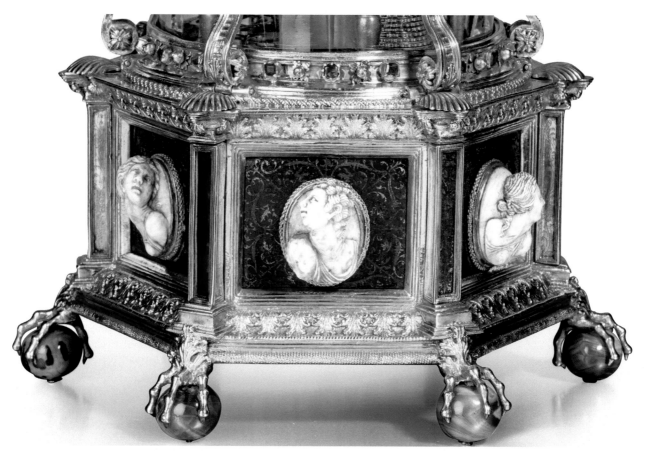

Figure 119 Detail of the Royal Clock Salt showing the agate feet and carved shell cameos

modifications over the centuries? Can we be sure, above all, that it actually combined the functions of a salt cellar and a timepiece, or was it described as such in the inventory because of its resemblance to a salt? But despite these and other unanswered questions, the Clock Salt's significance as a national treasure has emerged more strongly than ever, not only in its English context, but as a significant historical relic of European importance. In the words of the title of the 1991 National Maritime Museum's exhibition, it shows the court of Henry VIII to be 'a European court in England'.

Contributors

Timothy Schroder is a historian of silver and goldsmiths' work and a fellow of the Society of Antiquaries. A former Curator of Decorative Arts at the Los Angeles County Museum of Art and Consultant Curator at the V&A, he is a trustee of the Wallace Collection and was recently Prime Warden of the Goldsmiths' Company. Publications include '*A Marvel to Behold*', *Gold and Silver at the Court of Henry VIII* (2020).

Dora Thornton is the Curator of the Goldsmiths' Company Collection and was formerly Curator of Renaissance Europe and the Waddesdon Bequest at the British Museum. Publications include (with Sir Jonathan Bate), *Shakespeare: Staging the World* (2012); *A Rothschild Renaissance: Treasures from the Waddesdon Bequest* (2015); and (with Pippa Shirley), *A Rothschild Renaissance: A New Look* (2017). She is a Fellow of the Society of Antiquaries, a Fellow of the Royal Historical Society and a Freeman of the Goldsmiths' Company.

Michèle Bimbenet-Privat is a former student of the School of Palaeography and Librarianship (l'Ecole nationale des chartes), curator at the Archives nationales (1982–2006), chief curator at the Musée national de la Renaissance, Ecouen (2007–2011) and now senior curator in the department of Decorative Arts at the musée du Louvre. She is currently working on a catalogue of 16th to 18th-century silver in the Louvre.

Caroline Cartwright is a Senior Scientist in the Department of Scientific Research at the British Museum. Her scientific expertise includes identification and interpretation of wood, charcoal, fibres, macro plant remains, shell, ivory and bone from all areas and time periods. Reconstructing past environments, charting vegetation and climate changes, and investigating bioarchaeological evidence form important elements of her research.

Oliver Cooke has been a Curator of Horology in the Department of Britain, Europe & Prehistory at the British Museum since 2007 and is responsible for the collection of clocks, watches and scientific instruments. His practical background in conservation is essential in informing his technical and historical research into these highly complex objects and their place in humankind's experience of time across the ages.

Joanne Dyer is a Colour Scientist in the Department of Scientific Research at the British Museum and specialises in the study of colour, colourants and their sources. Trained as photochemist and vibrational spectroscopist, her research interests lie in the interaction between light and the materials encountered on ancient polychrome surfaces and archaeological/historical textiles.

Olenka Horbatsch is a specialist of the Netherlandish graphic arts from the 15th to the 17th centuries. She is (since 2017) Curator of the Dutch and Flemish collection of Prints and Drawings at the British Museum. She is also a Board Member of the Historians of Netherlandish Art. She is currently working on a research and exhibition project on early Netherlandish drawings.

Denise Ling is a Senior Conservator at the British Museum, specialising in the conservation of enamels, glass and ceramics with specific interest in the deterioration of these materials. She joined the department in 1987, prior to which she worked in the jewellery quarter of Hatton Garden, London, for a jewellery manufacturer and subsequently a precious stone dealer.

Andrew Meek is a Scientist in the Department of Scientific Research at the British Museum. His specialism is the analysis of vitreous materials. He graduated from the University of Nottingham with a PhD in Archaeology in 2011. He is a member of the Early Glass Technology Research Network and was co-editor of *Glass News*, the Association for the History of Glass newsletter, from 2011 to 2020.

Daniel O'Flynn is an X-ray Imaging Scientist in the British Museum Department of Scientific Research. His research applies advances in imaging to gain insights into ancient cultures, through the manufacture and use of objects and the lives of people and fauna. He completed a PhD in Physics at the University of Warwick and is an Honorary Senior Research Associate in the Department of Medical Physics and Biomedical Engineering, UCL.

Paulus Rainer is the Curator at the Kunstkammer and the Imperial Treasury at the Kunsthistorisches Museum in Vienna. He studied History of Art at the universities of Innsbruck and Vienna. His research focuses on early modern European goldsmith art, glyptics, clocks and automata and the history of collecting and has published extensively in these fields.

Rosemary Ransome Wallis is the former Curator and Art Director of the Goldsmiths' Company collections. Her publications include: *Treasures of the 20th Century* (2000), *The Silversmith's Art – Made in Britain Today* (2015) and *Simply Brilliant – Artist Jewellers of the 1960s and 1970s* (2020). She is a trustee of Bishopland Educational Trust, Lamport Hall Preservation Trust and Chairman of The Counties Heritage Foundation.

Fleur Shearman has specialised in metalwork conservation and allied X-radiography at the British Museum since 1980. She acquired the Museums Association Conservation Certificate in Archaeology in 1985 and is an ICON-accredited conservator-restorer. Her specialist interests are the British Museum collections of the Departments of Britain, Europe and Prehistory; Greece and Rome; and Ancient Egypt.

Julia Siemon is Assistant Curator of Drawings, Prints & Graphic Design at Cooper Hewitt, Smithsonian Design Museum. She holds a PhD from Columbia University. Previously, she was Assistant Research Curator in the Department of European Sculpture and Decorative Arts at the Metropolitan Museum of Art.

Bibliography

A Description of Strawberry Hill 2010. *A Description of the Villa of Mr Horace Walpole, Youngest Son of Sir Robert Walpole Earl of Oxford, at Strawberry Hill, near Twickenham, Middlesex. With an Inventory of Furniture, Pictures, Curiosities etc.* Facsimile of 1774 edition, London.

Alcorn E. and Schroder, T. 2017. 'The 19th- and 20th-century history of the tazze', in J. Siemon (ed.), *The Silver Caesars: A Renaissance Mystery*, New York, 148–57.

Alcouffe, D. 1987. 'À propos de l'orfèvrerie commandée par Henri III pour l'ordre du Saint-Esprit', *Hommage à Hubert Landais*, Paris, 135–42.

Alcouffe, D. 2001. *Les Gemmes de la Couronne. Catalogue*, Musée du Louvre, Departement des Objets d'art, Paris.

Anon. 1874. *Catalogue of the Special Loan Exhibition of Enamels on Metal Held at the South Kensington Museum in 1874*, London.

Anon. 1913. 'Limoges enamels. Barwell Collection for the British Museum', *The Times*, issue 40395, 15 December, 6.

Archives, Drayton House, Northamptonshire.

Aristotle. 2004. *The Nicomachean Ethics*, trans. by J.A.K. Thomson, rev. edn, London.

Ashbee, C.R. 1967. *The Treatises of Benvenuto Cellini on Goldsmithing and Sculpture*, translated from the Italian, New York.

Augsburg 1965. *Hans Holbein der Ältere und die Kunst der Spätgotick*, Augsburg.

Awais-Dean, N. 2017. *Bejewelled: Men and Jewellery in Tudor and Jacobean England*, London.

Babelon, E. 1897. *Catalogue des camées antiques et modernes de la Bibliothèque nationale*, Paris.

Bagenal, P.H. 1884. *The Life of Ralph Bernal Osborne*, London.

Baratte, S. 2000. *Les émaux peints de Limoges. Catalogue. Musée du Louvre, Departement des Objets d'art*, Paris.

Barbe, F. 2017. 'A question of taste?: Limoges painted enamels collected by French and English Rothschilds in the 19th century', in Shirley and Thornton, 65–75

Barbet de Jouy, H. 1868. *Notice des antiquités, objets du Moyen-Age, de la Renaissance et des temps modernes composant le Musée des souverains*, Paris.

Bardiès-Fronty, I., Bimbenet-Privat, M. and Walter, P. 2009. *Le Bain et le miroir. Soins du corps et cosmétiques de l'Antiquité à la Renaissance*, exh. cat., Musée de Cluny, Paris, and, Musée national de la Renaissance, Écouen.

Barthet, L. (ed.) 2014. *Le Cœur d'Anne de Bretagne*, exh. cat., Château de Chateaubriant, Chateaubriant.

Bätschmann, O. and P. Griener. 1998. *Hans Holbein*, London.

Bernal Sale 1855. *Catalogue of the Celebrated Works of Art … of that Distinguished Collector, Ralph Bernal*, Christie's, London, 5 March–30 April.

Bimbenet-Privat, M. 1991. 'La vérité sur l'origine de la Coupe de Saint Michel', *Jahrbuch der Kunsthistorischen Sammlungen in Wien* 87, 127–35.

Bimbenet-Privat, M. 1992. *Les Orfèvres Parisiens de la Renaissance 1506–1620*, Paris.

Bimbenet-Privat, M. 1995a. 'L'orfèvrerie de François Ier et de ses successeurs d'après des inventaires inédits de 1537, 1563 et 1584 conservés aux Archives nationales', *Bulletin de la Société de l'histoire de l'art français*, 41–67.

Bimbenet-Privat, M. (ed.) 1995b. *L'orfèverie Parisienne de la Renaissance, Trésors dispersés*, Paris.

Bimbenet-Privat, M. 2017–18. 'Orfèvrerie et politique: le cas Vezeler', in C. Scailliérez (ed.). *François Ier et l'art des Pays-Bas*, exh. cat., Musée du Louvre, Paris, 298–309.

Biron, I. 2002. 'Regards croisés sur l'émail peint; le regard du physicien', in V. Notin (ed.). *La rencontre des héros: regards croisés sur les*

émaux peints de la Renaissance appartenant aux collections du Petit-Palais, Limoges, 22–33.

Boak, R. 2017. 'Baron Ferdinand Rothschild's "Renaissance Museum": treasures from the New Smoking Room at Waddesdon Manor', in Shirley and Thornton, 30–9.

Bohn, H.G. 1857. *A Guide to the Knowledge of Pottery, Porcelain, and Other Objects of Vertu, Comprising an Illustrated Catalogue of the Bernal Collection of Works of Art with the Prices at Which They Were Sold at Auction and the Names of the Present Possessors*, London.

Bolland, C. 2011. 'Italian material culture at the Tudor court' PhD Dissertation, Department of History, Queen Mary, University of London.

Brand, Rev. J. (ed.) 1806. 'An inventory and appraisement of the plate in the Lower Jewel House of the Tower, anno 1649. Communicated by the Rev. John Brand, Secretary of the Society of Antiquaries, from a manuscript in his possession', *Archaeologia, or, Miscellaneous Tracts Relating to Antiquity* 15, Society of Antiquaries, London, 271–90.

Bresc-Bautier, G., Crépin-Leblond, T., Taburet, E. and Wolff, M. 2010. *France 1500. Entre Moyen Âge et Renaissance*, exh. cat., Galeries nationales, Grand Palais, Paris.

Brioist, P., Fagnart, L. and Michon, C. (eds) 2015. *Louise de Savoie, actes de colloque Romorantin, 1–2 December 2011*, Rennes.

Brown, E., Brown, C., Deuffic, J.-L. and Jones, M. 2013. 'Qu'il mecte ma povre ame en celeste lumiere', *Les funérailles d'une reine Anne de Bretagne (1514). Textes. Images et manuscrits*, Turnhout.

Cantor, G. 2012. 'Anglo-Jewry in 1851: the Great Exhibition and political emancipation', *Jewish Historical Studies* 44, 103–26.

Caygill, M.L. and Cherry, J. (eds) 1997. *A.W. Franks: Nineteenth-Century Collecting and the British Museum*, London.

Cellini, B. 1568. *Due trattati, uno intorno alle otto principali arti dell'oreficeria. L'altro in materia della scultura etc.*, Florence.

Cellini, B. 1850. *Memoirs of Benvenuto Cellini*, trans. by T. Roscoe, London.

Chaffers, W. 1863. *Hall Marks on Gold and Silver Plate*, London.

Chancel-Bardelot, B. de 2010. 'Bourges et le Val de Loire', in Bresc-Bautier, Crépin-Leblond, Taburet and Wolff, 128–30.

Chastel, A. 1995. *French Art: The Renaissance, 1430–1620*, Paris and New York.

Checa, F. (ed.) 2010. *The Inventories of Charles V and the Imperial Family*, 3 vols, Madrid.

Christie's Horological Auction Sale Catalogue, 12 July 1967: photocopy of lot 180.

Cloulas, I. and Bimbenet-Privat, M. 1997. *Treasures of the French Renaissance*, New York.

Collins, A.J. (ed.) 1955. *Jewels and Plate of Queen Elizabeth I, The Inventory of 1574, Edited from Harley MS 1650 and Stowe MS 555 in the British Museum*, London.

Connelly, F. 2012, *The Grotesque in Western Art and Culture*, Cambridge.

Cordera, P. 2014. *La fabbrica del Rinascimento. Frédéric Spitzer, mercante d'arte e collezionista nell'Europa delle nuove Nazioni*, Bologna.

Cordera, P. 2017. 'Art for the Rothschilds: the career of the dealer Frédéric Spitzer', in Shirley and Thornton, 168–77.

Cremonesi, A. 2002. 'Tesori del Museo Diocesano. Il cofanetto di Pierre Mangot', *Civiltà Mantovana* 37(113), March.

Crépin-Leblond, T. 2017. 'L'art de l'émail au temps de Jeanne d'Albret', in Mironneau, 44–9.

Crépin-Leblond, T. and Barbier, M. 2015. *Une reine sans couronne? Louise de Savoie, mère de François Ier*, exh. cat., Musée national de la Renaissance, Château d'Ecouen, Écouen.

Cust, L. 1906. 'John of Antwerp, goldsmith, and Hans Holbein', *Burlington Magazine* 8(35), 356–60.

Cust, R.H.H. 1910. *The Life of Benvenuto Cellini*, 2 vols, London.

Dalton, O.M. 1915. *Catalogue of the Engraved Gems of the Post-Classical Periods in the Department of British and Mediaeval Antiquities and Ethnography in the British Museum*, London.

Dalton, O.M. 1927. *The Waddesdon Bequest, Jewels, Plate and Other Works of Art Bequeathed by Baron Ferdinand Rothschild, British Museum*, London.

David-Chapy, A. 2016. *Anne de France, Louise de Savoie: inventions d'un pouvoir au féminin*, Paris.

Davies, H. 1998. 'John Charles Robinson's work at the South Kensington Museum, Part 1: the creation of the collection of Italian Renaissance objects at the Museum of Ornamental Art and the South Kensington Museum, 1853–62', *Journal of the History of Collections* 10(2), 169–88.

Davis, C. 1884. *A Description of the Works of Art Forming the Collection of Alfred de Rothschild* (2 vols), London.

Davis, R.W. 1996. 'Disraeli, the Rothschilds, and anti-Semitism', *Jewish History* 10(2), Fall, 9–19.

Debruge Dumenil Sale 1850. *Catalogue des Objets d'art qui composent la Collection Debruge Dumenil, 23–31 January, 1–9 February, 4–12 March 1850*, Paris.

Dekker, E. and Lippincott, K. 1999. 'The scientific instruments in Holbein's Ambassadors: a re-examination', *Journal of the Warburg and Courtauld Institutes* 6, 93–125.

Donnelly, E. 2017. 'Securing a new national treasure: Baron Ferdinand Rothschild and the British Museum, in Shirley and Thornton, 40–51.

Drew, C. 2018. 'The colourful career of Sir John Charles Robinson: collecting and curating at the early South Kensington Museum', *Journal of Art Historiography* 18 (June), 1–16.

Drinkwater, P. 1993. *The Sundials of Nicholas Kratzer*, Shipton-on-Stour.

Eatwell, A. 1994. 'The Collector's or Fine Arts Club, 1857–1874. The first society for collectors of the decorative arts', *Journal of the Decorative Arts Society 1850–the Present* 18, Omnium Gatherum, 25–30

Eatwell, A. 2000. 'Borrowing from collectors: the role of the loan in the formation of the Victoria and Albert Museum and its collection (1852–1932)', *Journal of the Decorative Arts Society 1850–the Present* 24, Decorative art collecting: passion and fashion, 20–9.

Falk, T. 1979. *Katalog der Zeichnungen des 15. und 16. Jahrhunderts im Kupferstichkabinett Basel*, vol. I: *Das 15. Jahrhundert, Hans Holbein der Ältere und Jörg Schweiger, die Basler Goldschmiederisse*, Basel.

Ferguson, N. 1998. *The World's Banker: The History of the House of Rothschild*, London.

Ferguson, N. 1998. T*he House of Rothschild. Volume 1: Money's Prophets (1798–1848)*, New York.

Ferguson, N. 1999. *The House of Rothschild. Volume 2: The World's Banker (1849–1999)*, New York.

Filarete, A.A. ('Filarete') 1972. *Trattato di Architettura*, vol. 2, book 24, *Classici Italiani di Scienze Techniche delle Arti*, ed. by A.M. Finoli and L. Grassi, Milan.

Fenton, J. and Macdonell, A. 2010. *The Autobiography of Benvenuto Cellini*, New York.

Foister, S. 1991. 'Holbein as court painter', in Starkey, 58–63.

Foister, S. 2004. *Holbein and England*, New Haven and London.

Foister, S. 2006. *Holbein in England*, London.

Foister, S. and Roy, A. 1997. *Holbein's Ambassadors: Making and Meaning*, London.

Forster, H.R. 1848. *The Stowe Sale Catalogue, Priced and Annotated …*, London.

Gardner, J.S. 1901. *Exhibition of a Collection of Silversmiths' Work of European Origin*, London.

Gasparri, C. 1994. *Le Gemme Farnese, Soprintendenza Archaeologica di Napoli e Caserta*, Naples.

Gassendi, P. 1655. *Viri Illustris Nicolai Claudii Fabricii de Peiresc, Senatoris Aquisextiansis Vita*, The Hague.

Gay, V. and Stein, H. 1887–1928, *Glossaire archéologique du moyen âge et de la Renaissance*, 2 vols, Paris.

Gennaioli, R. 2010. *Pregio e bellezza. Cammei e intagli dei Medici*, Florence.

Giraudet, E. 1885. *Les Artistes tourangeaux: architectes, armuriers, brodeurs, émailleurs, graveurs, orfèvres, peintres, sculpteurs, tapissiers de haute-lisse: Notes et documents inédits*, Tours.

Glanville, P. 1991. 'Plate and gift-giving at court', in Starkey, 131–5.

Glanville, P. 2013. *Silver in England* (1987), London.

Godsell, J.S. 1981. 'The French Renaissance enamels by the Master KIP', unpublished PhD thesis, University of Cambridge, 2 vols.

Gratuze, B., Isabelle Soulier, I., Barrandon, J.-N. and Foy, D. 1995. 'The origin of cobalt blue pigments in French glass from the thirteenth to the eighteenth centuries', in D. Hook and D. Gaimster (eds). *Trade and Discovery: The Scientific Study of Artefacts from Post-medieval Europe and Beyond* (British Museum Occasional Paper 109), London, 123–34.

Hackenbroch, Y. 1966. 'Catherine de Medici and her court jeweller François Dujardin', *The Connoisseur* 163, 28–33.

Hackenbroch, Y. 1984–5. 'Reinhold Vasters, goldsmith', *Metropolitan Museum Journal* 19/20, 163–268.

Hyamson, A.M. 1951–2. 'The first Jewish peer', *Transactions (Jewish Historical Society of England)* 17, 287–90.

Hall, E. 1904 reprint. *The Triumphant Reign of Kyng Henry the VIII* (1550), 2 vols, London.

Hall, M.C. 2002. *Waddesdon Manor: The Heritage of a Rothschild House*, New York.

Hall, M.C. 2007. 'Bric-à-brac: A Rothschild's memoir of collecting', *Apollo* 166(545), 50–77.

Hall, M.C. 2010. *Waddesdon Manor: The Heritage of a Rothschild House*, London.

Hall, M.C. 2014. 'Le gout Rothschild: the origins and influences of a collecting style', in I. Reist (ed.), *British Models of Art Collecting and the American Response*, Farnham, 101–15.

Hamilton Palace Sale 1882. *The Hamilton Palace Collection: Illustrated Priced Catalogue*, 14 July, London.

Hamy, P. A. 1898. *Entrevue de François Ier avec Henry VIII à Boulogne-sur-Mer, en 1532. Intervention de la France dans l'affaire du divorce, d'après un grand nombre de documents inédits*, Paris.

Harris, J. 2007. *Moving Rooms: The Trade in Architectural Salvages*, New Haven and London.

Hayward, J.F. 1965. 'A rock-crystal bowl from the treasury of Henry VIII', *Burlington Magazine* 100(661), 120–5.

Hayward, J.F. 1973. 'The restoration of the Tudor clock-salt', *Review of the Worshipful Company of Goldsmiths* (1972–3), 27–31.

Hayward, J.F. 1976. *Virtuoso Goldsmiths and the Triumph of Mannerism, 1540–1620*, London.

Hayward, M. (ed.) 2004. *The 1542 Inventory of the Palace of Whitehall: The Palace and its Keeper*, 2 vols, London.

Hayward, M. 2005. 'Gift giving at the court of Henry VIII: the 1539 New Year's gift roll in context', *The Antiquaries Journal* 85, 126–75.

Hayward, M. 2007. *Dress at the Court of Henry VIII*, Leeds.

Hayward, J.F. and Bury, S. 1964. *Handbook to the Department of Prints and Drawings at the Victoria & Albert Museum*, London.

Hazlitt, W. 1843. *Criticisms on Art and Sketches of the Picture Galleries of England*, London.

Helke, G. 2018. 'Prekäre Balance. Der König und die Dame France', in Rainer and Haag, 159–78.

Hermant, M. (ed.) 2015. *Trésors royaux. La bibliothèque de François Ier*, exh. cat., Château royal de Blois, Blois.

Hernmarck, C. 1977. *The Art of the European Silversmiths, 1430–1830*, London.

Hollingworth Magniac Sale 1892. *Catalogue of Works of Art Chiefly Formed by Hollingworth Magniac Esq. (Known as the Colworth Collection)*, Christie's, 2 and 4 July, London.

Hope, C. and Nova, A. 1983. *Autobiography of Benvenuto Cellini*, Oxford.

Jefferies Collins, A. 1955. *Jewels and Plate of Queen Elizabeth I: The Inventory of 1574*, London.

Jones, E.A. 1907. *Catalogue of the Old Plate of Leopold de Rothschild, Esq.*, London.

Jones, E.A. 1928. *Old Silver of Europe & America from Early Times to the 19th Century*, Philadelphia.

Jones, J. 1993. *Minton: The First Two Hundred Years of Design & Production*, Shrewsbury.

Jordan, F. 2004. *Problems Encountered in the Conservation of Deteriorated Enamelled Objects*, The Ceramic and Glass Conservation Group, a section of UKIC, London.

Kähler, H. 1968. 'Alberti Rubeni Dissertatio de Gemma Augustea', ed., trans. and commentary by Heinz Kähler (Monumenta Artis Romanae, 9), Berlin.

Kaplan, H. 2006. *Nathan Mayer Rothschild and the Creation of a Dynasty: The Critical Years (1806–1816)*, Stanford.

Kaufmann, T.D. 1995. *Court Cloister, and City: The Art and Culture of Central Europe 1450–1800*, Chicago.

Kavaler, E.M. 2012. *Renaissance Gothic: Architecture and the Arts in Northern Europe, 1470–1540*, New York.

Keith, D.G. 1977. *The Triumph of Humanism*, San Francisco.

Kessler, D. 1982–6. 'The Rothschilds and Disraeli in Buckinghamshire', *Jewish Historical Studies* 29, 231–51.

Knecht, R.J. 2003. '"Our Trinity!": Francis I, Louise of Savoy and Marguerite d'Angoulême', in Munns and Richards, 71–89.

Knecht, R.J. 2008. *The French Renaissance Court*, New Haven and London.

Krause, K. 2002. *Hans Holbein den Älteren*, Berlin.

Kris, E. 1932. *Goldschmiedearbeiten des Mittelalters, der Renaissance und des Barock. Erster Teil. Arbeiten in Gold und Silber*, Vienna.

Labarte, J. 1847. *Description des objets d'art qui composent la collection Debruge Dumenil précédé d'une introduction historique*, Paris.

Laborde, L. de. 1872, *Glossaire français du moyen-âge*, Paris.

Laborde, L. de. 1877–80. *Les Comptes des bâtiments du roi (1528–1571)*, 2 vols, Paris.

Lacroix, P. 1856–7. 'Inventaire des joyaux de la couronne de France en 1560 (1561)', *Revue universelle des arts* 3–4, 334–536.

Lapraik Guest, C. 2015. *The Understanding of Ornament in the Italian Renaissance*, Leiden.

Lecoq, A.-M. 1987. *François Ier imaginaire. Symbolique et politique à l'aube de la Renaissance française*, Paris.

Leithe-Jasper, M. 1970. 'Der Bergkristallpokal Herzog Philipps des Guten von Burgund, das "vierte Stück" der Geschenke König Karls IX. von Frankreich an Erzherzog Ferdinand II.', *Jahrbuch der Kunsthistorischen Sammlungen in Wien* 66, 227–42.

Le Roux de Lincy, A. 1849. 'Détails sur la vie privée d'Anne de Bretagne, femme de Charles VIII et de Louis XII', *Bibliothèque de l'Ecole des chartes* 1, 148–71.

Lightbown, R.W. 1978. *French Silver. Victoria and Albert Museum Catalogues*, London.

Ling, D. and Shearman, F. 2017. *British Museum Condition Report for the Royal Tudor Clock Salt*, Unpublished Report.

Mabille, G. 2000. 'Une nouvelle œuvre de la Renaissance au Louvre le coffret de nacre de Pierre Mangot', *La Revue du Louvre et des Musées de France* 4, 13–14.

Mâle, E. 1931. *L'art réligieux de la fin du moyen âge en France*, Paris.

Malgouyres, P. 2018. *Le Livre d'heures de François 1er*, Paris.

Mandler, P. 2017. 'Contexts for collecting: inheritance, purchase, sale, tax and bequest', in Shirley and Thornton, 22–9.

Marichal, P. (ed.) 1887–1908. *Catalogue des actes de François Ier*, 10 vols, Paris.

Marquet de Vasselot, J.-J. 1911. 'La vaisselle d'argent de l'ordre du Saint-Esprit', *Bulletin de la Société de l'histoire de l'art français*, 338–47.

Marquet de Vasselot, J.-J. 1914. *Musée national du Louvre. Catalogue sommaire de l'orfèvrerie, de l'émaillerie et des gemmes du Moyen âge au XVIIe siècle*, Paris.

Maxwell, C.L. 2015. '"The most perfect taste": the Rothschild acquisitions at the Hamilton Palace Sale of 1882', *Burlington Magazine* 157(1351), October, 691–9.

Meller, P. 1994. 'Geroglifici e ornamenti "parlanti" nell'opera del Cellini', *Arte Lombarda* 3–4, 9–16.

Mély, F. de. 1886. 'Le grand Camée de Vienna', *Gazette archéologique: recueil de monuments pour servir à la connaissance et à l'histoire de l'art antique, publié par les soins de J. de Witte, et François Lenormant, etc.* 11, 244–53.

Mély, F. de. 1894. 'Le Camayeul de Saint-Sernin et le grand Camée de Vienna', *Mémoires de la Société archéologique du Midi de la France* 15(1), 67–98.

Meulen, M. van der. 1994. 'Rubens copies after the Antique', in *Corpus Rubenianum Ludwig Burchard*, vol. 2, part 23, London.

Mironneau, P. (ed.) 2017. *Trésors princiers, richesses de la cour de Navarre au XVI siècle*, Paris.

Mitchell, H. 1909. 'Who was the Limoges enameller "Kip"?', *Burlington Magazine* 14(71), February, 278–90.

Mitchell, H.P. 1918. 'Two "Little Masters" of Limoges enamelling', *Burlington Magazine* 32(182), May, 190–4, 195–201.

Molinier, E. and Mazerolle, F. 1892. *Inventaire des meubles du Château de Pau, 1561–2*, Paris.

Morgan, O. 1852. 'Assay marks on gold and silver plate', *The Archaeological Journal* 9, 125–40, 231–46, 313–19.

Müller, C. 1988. *Hans Holbein d. J. Zeichnungen*, Basel.

Müller, C. 1990. 'Holbein oder Holbein-Werkstatt? Zu einem Pokalentwurf der Gottfried Keller-Stiftung im Kupferstichkabinett Basel', *Zeitschrift für schweizerische Archäologie und Kunstgeschichte* 47, 33–42.

Müller, C. 1991. *Das Amerbach-Kabinett Zeichnungen Alter Meister*, Basel.

Müller, C. 1996. *Katalog der Zeichnungen des 15. und 16. Jahrhunderts, vol. 2A: Die Zeichnungen von Hans Holbein dem Jüngeren und Ambrosius Holbein*, Basel.

Müller, C. 1997. *Hans Holbein d. J. Die Druckgraphik im Kupferstichkabinett Basel*, Basel.

Müller, C. (ed.) 2006. *Hans Holbein the Younger: The Basel Years 1515–1532*, Basel.

Munns, J. and Richards, P. (eds) 2003. *Gender, Power and Privilege in Early Modern Europe*, London.

Netzer, S. 1996. 'Karl Friedrich von Nagler, Berlin (1770–1846). Ein preussicher Generalpostmeister sammelt', in P. Keller (ed.). *Glück, Leidenschaft und Verantwortung. Das Kunstgewerbemuseum und seine Sammler*, Berlin, 12–15.

Netzer, S. 1999. *Maleremails aus Limoges, Der Bestand des Berliner Kunstgewerbemuseums Berlin*, Berlin.

Nicholas, N.H. (ed.) 1827. *The Privy Purse Expences of King Henry the Eighth from November 1529 to December 1532*, London.

Nocq H. 1926–31. *Le Poinçon de Paris. Répertoire des maîtres orfèvres de la juridiction de Paris depuis le moyen-âge jusqu'à la fin du XVIIIe siècle*, 5 vols, Paris.

Nova, A. and Schreurs, A. (eds) 2003. *Benvenuto Cellini, Kunst und Kunsttheorie im 16. Jahrhundert*, Cologne/Weimar/Vienna.

Oman, C. 1966. 'Trésor de la cathédrale de Reims. La nef d'Anne de Bretagne', *Monuments historiques de la France* 1–2, 123–4.

Pächt, O. 1944. 'Holbein and Kratzer as collaborators', *Burlington Magazine* 84(495), 134–9.

Parker, K.T. 1983. *The Drawings of Hans Holbein in the Collection of Her Majesty the Queen at Windsor Castle*, London.

Pébay-Clottes, I., Menges-Mironneau, C. and Mironneau, P. 2017. *Trésors princiers. Richesses de la cour de Navarre au XVIe siècle*, exh. cat., Musée national du Château de Pau, Pau.

Pechstein, K. 1971. *Goldschmiedewerke der Renaissance*, Berlin.

Peltzer, A.R. (ed.) 1925. *Joachim von Sandrarts Academie der Bau-Bild und Mahlerey-Künste von 1675*, Munich.

Pérouse de Montclos, J.-M. 2000. *Les Châteaux du Val de Loire*, Paris.

Pickering, N.A. 2017. 'The English Rothschild family in the Vale of Aylesbury: their houses, collections, and collecting activity 1830–1900', PhD thesis, King's College, London.

Pierson, S.J. 2017. *Private Collecting, Exhibitions, and the Shaping of Art History in London: The Burlington Fine Arts Club*, London.

Piquard, M. 1975. 'Une reliure à l'anagramme de François Ier recouvrant deux éditions de Geoffroy Tory et le livre de raison d'une famille d'orfèvres', *Bibliothèque de l'École des chartes* 133, 342–9.

Pope-Hennessy, J. 1985. *Cellini*, London.

Prater, A. 2018. 'Cellinis Saliera. Im Reich des Feuersalamanders', in Rainer and Haag, 41–86.

Prevost-Marcilhacy, P. (ed.) 2016. *Les Rothschild: Une Dynastie de Mécènes en France*, Paris.

Rainer, P. 2017. '"Nothing which made me doubt its authenticity" (Sir Augustus Wollaston Franks, British Museum 1877): Salomon Weininger's forgeries and some aspects of their British fortune', in Shirley and Thornton, 178–89.

Rainer, P. and Haag, S. (eds) 2018. *Cellinis Saliera. Die Biographie eines Kunstwerks* (Schriften des Kunsthistorischen Museums, 19), Vienna.

Read, C.H. 1902. *The Waddesdon Bequest: Catalogue of the Works of Art Bequeathed to the British Museum by Baron Ferdinand Rothschild, M.P., 1898*, London.

Reitlinger, G. 1963. *The Economics of Taste, Vol. 2: The Rise and Fall of the Objects d'Art Market since 1750*, New York.

Robinson, J.C. 1856. *A Catalogue of the Museum of Ornamental Art, at Marlborough House, Pall Mall*, 3rd edn, London.

Robinson, J.C. 1862. *Notice of the Principal Works of Art in the Collection of Hollingworth Magniac, Esq. of Colworth*, London.

Robinson, J.C. (ed.) 1863. *Catalogue of the Special Exhibition of Works of Art of the Medieval, Renaissance, and More Recent Periods, on Loan at the South Kensington Museum, June 1862* (rev. edn), London.

Robinson, J.C. 1897. 'Our public art museums: A Retrospect', *The Nineteenth Century* 42, December, 940–64.

Rosenberg, M. 1890. *Der Goldschmiede Merkzeichen*, Frankfurt am Main.

Rossi, P.L. 2003. 'Benvenuto Cellini: Reputazione and Transmutiation in France and Florence', in Nova and Schreurs, 301–14.

Rothschild, Baron F. de. 1897. *The Red Book*, privately printed.

Rowlands, J. 1993. *Drawings by German Artists in the Department of Prints and Drawings at the British Museum*, 2 vols, London.

Royal Society of Arts, 1850. *Catalogue of Works of Antient and Mediaeval Art, exhibited at the House of the Society of Arts*, London.

The Royal Tudor Clock Salt – Archive Files, Goldsmiths' Company / British Museum.

Rudoe, J. 2003. 'Engraved gems: the lost art of antiquity', in K. Sloan and A. Burnett (eds). *Enlightenment: Discovering the World in the Eighteenth Century*, London, 132–9.

Santrot, M.-H. 1988. *Entre France et Angleterre, le duché de Bretagne, essai d'iconographie des ducs de Bretagne*, Nantes.

Santrot, J. 2017. *Les Doubles Funérailles d'Anne de Bretagne. Le corps et le cœur (janvier–mars 1514)*, Geneva.

Scailliérez, C. (ed.) 2017. *François Ier et l'art des Pays-Bas*, exh. cat., Musée du Louvre, Paris.

Schestag, F. 1886. *Katalog der Kunstsammlung des Freiherrn Anselm von Rothschild in Wien*, Vienna.

Schlegel, K. 2018. 'Das Schicksal der Saliera in Österreich. Vom königlichen Geschenk zum Spielzeug für das Volk', in Rainer and Haag, 221–56.

Schroder, T. 1988. *The Gilbert Collection of Gold and Silver*, Los Angeles.

Schroder, T. 1995. 'A royal Tudor rock-crystal and silver-gilt vase', *Burlington Magazine* 137(1107), June, 356–66.

Schroder, T. 2020. *'A Marvel to Behold': Gold and Silver at the Court of Henry VIII*, Woodbridge.

Seelig, L. 1987. *Der heilige Georg im Kampf mit dem Drachen. Ein Augsburger Trinkspiel der Spätrenaissance*, Munich.

Seelig L. and Spicer, J. 1991–2. 'Die Gruppe der Diana auf dem Hirsch in der Walters Art Gallery', *Journal of the Walters Art Gallery* 49/50, 107–18.

Sell, S. *et al.* 2015. *Drawing in Silver and Gold: Leonardo to Jasper Johns*, London and Washington, DC.

Shirley, P. 2017. 'Baron Ferdinand Rothschild at Waddesdon', in Shirley and Thornton, 10–21.

Shirley, P. and Thornton, D. (eds) 2017. *A Rothschild Renaissance: A New Look at the Waddesdon Bequest in the British Museum*, London.

Sloan, K. 2012. 'Sloane's pictures and drawings in frames and books of miniature & painting, design, &C.', in A. Walker, A. MacGregor and M. Hunter (eds), *From Books to Bezoars: Sir Hans Sloane and his Collections*, London, 168–89.

Smith, P. H. and Findlen, P. (eds) 2002. *Merchants and Marvels: Commerce, Science, and Art in Early Modern Europe*, London.

Snodin, M. (ed.) 2009. *Horace Walpole's Strawberry Hill*, London.

Snodin, M. and Baker M. 1980. 'William Beckford's silver', *Burlington Magazine* 122(932–3), November–December, 735–46 and 820–34.

South Kensington Museum 1862. *Catalogue of the Special Exhibition of Works of Art of the Medieval, Renaissance and More Recent Periods, on Loan at the South Kensington Museum, June 1862. Edited by J.C. Robinson*, London.

Spitzer Sale 1893. *Catalogue des Objets d'art … de la Collection Spitzer, Paris, 17 April–16 June 1893*, Paris.

Starkey, D. (ed.) 1991. *Henry VIII: A European Court in England*, London.

Starkey, D. (ed.) 1998. *The Inventory of King Henry VIII, Society of Antiquaries MS 129 and British Library Ms Harley 1419*, London.

Tait, H. 1967. *Report on the Condition of the Royal Tudor Clock Salt Based on an Examination Made in the British Museum in June 1967*, Unpublished Report.

Tait, H. 1981. *The Waddesdon Bequest: The Legacy of Baron Ferdinand Rothschild to the British Museum*, London.

Tait, H. 1985. 'The girdle-prayerbook or "tablet": an important class of Renaissance jewellery at the court of Henry VIII', *Jewellery Studies* 2, 29–57.

Tait, H. 1986a. *Catalogue of the Waddesdon Bequest in the British Museum: The Jewels*, London.

Tait, H. (ed.) 1986b. *7000 Years of Jewellery*, London.

Tait, H. 1988. *Catalogue of the Waddesdon Bequest in the British Museum. II. The Silver Plate*, London.

Tait, H. 1991a. *Catalogue of the Waddesdon Bequest in the British Museum: The Curiosities*, London.

Tait, H. (ed.) 1991b. *Five Thousand Years of Glass*, London.

Tait, H. 1991c. 'Goldsmiths and their work at the court of Henry VIII', in Starkey, 112–17.

Tait, H. 1998. *Catalogue of the Waddesdon Bequest in the British Museum II: The Silver Plate*, London.

Tauber, C. 2009. *Manierismus und Herrschaftspraxis. Die Kunst und Politik und die Kunstpolitik am Hof von François Ier* (Studien aus dem Warburg-Haus, 10), Berlin.

Thornton, D. 2001. 'From Waddesdon to the British Museum: Baron Ferdinand Rothschild and his cabinet collection', *Journal of the History of Collections* 13(2), January, 191–213.

Thornton, D. 2002. 'Painted enamels of Limoges in the Wernher Collection', *Apollo* 155(483), May, 10–16.

Thornton, D. 2015. *A Rothschild Renaissance: Treasures from the Waddesdon Bequest*, London.

Thornton, D. 2017. 'Research, interpretation and display of jewels in the Waddesdon Bequest', in Shirley and Thornton, 190–207.

Thornton, D. 2019. 'Baron Ferdinand Rothschild's sense of family origins and the Waddesdon Bequest in the British Museum', *The Journal of the History of Collections* 31(1), 181–98.

Thornton, D., Meek, A. and Gudenrath, W. 2015. 'Opal glass in the British Museum attributed to the Buquoy Glasshouse', *Journal of Glass Studies* 57, 167–82.

Tillander, H. 1995. *Diamond Cuts in Historic Jewellery, 1381–1910*, London.

Toesca, I. 1965. 'Un coffret parisien du XVIe siècle', *Gazette des Beaux-Arts* 66, November, 309–12.

Toesca, I. 1969. 'Silver in the time of François Ier. A new identification', *Apollo* 90, October, 292–7.

Trento, D. 1984. *Benvenuto Cellini. Opere non esposte e documenti notarili*, Florence.

Trollope, E. (ed.) 1884. 'King Henry VIII's Jewel Book', *Associated Architectural Societies Reports and Papers* 17(2), 155–229.

Turner, S. 2010. *The New Hollstein German Engravings, Etchings and Woodcuts 1400-1700: Wenceslaus Hollar*, Ouderkerk aan den Ijssel.

Van Lookeren Campagne-Nuttall, K. and Navarro, J. 2011. *Condition Assessment of the Enamel Plaques*, Unpublished Report.

Vassallo e Silva, N. *et al.* 1996. *A Herança de Rauluchantim. The Heritage of Rauluchantim*, exh. cat., Museu de São Roque, Lisbon.

Verdier, P. 1962. 'Les sibylles dans l'émaillerie limousine', *Bulletin Limousin* 89, 197–8.

Verdier, P. 1967. *Walters Art Gallery, Catalogue of the Painted Enamels of the Renaissance*, Baltimore.

Waagen, G. 1854. *Treasures of Art in Great Britain …*, London.

Wainwright, C. 1971. 'Some objects from William Beckford's collection now in the Victoria and Albert Museum', *Burlington Magazine* 113(818), May, 254–64

Wardropper, I. 2004. 'The flowering of the French Renaissance', *The Metropolitan Museum of Art Bulletin* 62(1), Summer, 3–48.

Warren, J. 2016. 'Louise de Savoie, Ecouen' (exhibition review), *Burlington Magazine* 158(1356), March, 220–1.

Warren, J. 2017. 'Sculpture in the Waddesdon Bequest', in Shirley and Thornton, 83–99.

Wilson, J.G. 1878. 'About Bric-à-Brac', *The Art Journal*, New Series 4, 313–15.

Wyatt, M. 2005. *The Italian Encounter with Tudor England*, Cambridge.

Yallop, J. 2011. *Magpies, Squirrels and Thieves: How the Victorians Collected the World*, London.

Zeleny, K. 2018. 'Die Metamorphose der Saliera. Cellini und Giraldi im Humanistendialog', in Rainer and Haag, 87–138.

Zucchiatti, A., Bouquillon, A., Katona, I. and D'Alessandro, A. 2006. 'The Della Robbia blue: a case study for the use of cobalt pigments in ceramics during the Italian Renaissance', *Archaeometry* 48, 131–52.

Zvereva, A. 2015a. 'L'éloquence de deuil: portraits de Louise de Savoie', in Brioist, Fagnart and Michon, 19–28.

Zvereva, A. 2015b. '"Chose qui me donne de la peine et continuel travail plus que je ne vous puis dire": Louise de Savoie et les receuils de portraits de crayon', in Brioist, Fagnart and Michon, 183–204.

Zwierlein-Diehl, E. 2008. *Magie der Steine. Die antiken Prunkkameen des Kunsthistorischen Museums*, Vienna.

Index